CONTEMPORARY

AMERICAN
FOLK ART

A COLLECTOR'S GUIDE

CONTEMPORARY
AMERICAN
FOLK ART
A COLLECTOR'S GUIDE

CHUCK AND JAN ROSENAK

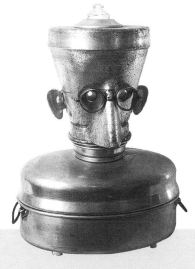

ABBEVILLE PRESS ▪ PUBLISHERS
NEW YORK ▪ LONDON ▪ PARIS

To the artists—Ted Gordon, Howard Finster, S. L. Jones,
and all the others who taught us to appreciate the work
of American self-taught artists.
And in memory of Steve Ashby and Sam Doyle;
their art will live beyond them.

Front cover: Shields Landon "S. L." Jones, *Soda Fountain,* 1980s. Wood, paint, and glass; 16 × 20 × 6 in. (40.6 × 50.8 × 15.2 cm). John and Diane Balsley. Photo: Courtesy Haggerty Museum of Art, Marquette University, Milwaukee. Back cover: Alpha Andrews, *Dream Castle,* 1992. Oil on canvas; 29 × 22¾ in. (73.7 × 57.8 cm). Sue and George Viener. Spine: L. Barker, *Sitting Cat,* 1989. Carved basswood; 15 × 9 × 5 in. (38.1 × 22.9 × 12.7 cm). Kentucky Folk Art Center, Morehead. Photo: Greg Gent. Page 3: Jim Bauer, *Coffee Pot Figure,* 1994. Aluminum pots and pans, glasses, and lights; 20 × 13 × 10 in. (50.8 × 33 × 25.4 cm). American Primitive Gallery. Photo: John Back.

Editor: Susan Costello
Project Editor: Jacqueline M. Atkins
Designer: Celia Fuller
Production Editor: Owen Dugan
Editorial Assistant: Meredith Wolf
Production Manager: Lou Bilka

Text copyright © 1996 Chuck and Jan Rosenak. Compilation, including selection of text and images, copyright © 1996 Abbeville Press. All rights reserved under international copyright conventions. No part of this book may be reproduced or utilized in any form or by any means, electronic or mechanical, including photocopying, recording, or by any information storage and retrieval system, without permission in writing from the publisher. Inquiries should be addressed to Abbeville Publishing Group, 488 Madison Avenue, New York, N.Y. 10022. The text of this book was set in Adobe Caslon and Bureau Eagle Bold. Printed and bound in Hong Kong.

First edition
2 4 6 8 10 9 7 5 3 1

Library of Congress Cataloging-in-Publication Data
Rosenak, Chuck.
Contemporary American folk art : a collector's guide / Chuck and Jan Rosenak.
p. cm.
Includes bibliographical references and index.
ISBN 1-55859-897-9
1. Folk art—United States—History—20th century. 2. Folk artists—United States—Biography.
3. Folk art—Information services—United States. I. Rosenak, Jan. II. Title.
NK808.R5 1996
745'.092'273—dc20
[B] 95-25210

CONTENTS

P R E F A C E

CONTEMPORARY FOLK ART IS A GENRE OF AMERICAN art that refers to the creative expression of individuals in the twentieth century whose sources of inspiration are derived from their own experience, apart from systematic or formal fine arts training. Some of the artworks of these creators are closely rooted to community traditions and craft forms; others are more personal and intimate expressions of self.

In 1931 Holger Cahill, an author and an organizer of an early folk art exhibition, described folk art in the catalog accompanying the exhibition. He called it:

> an expression of the common people and not an expression of a small cultured class. Folk art usually has not much to do with the fashionable art of its period. It is never the product of art movements, but comes out of craft traditions, plus that personal something of the rare craftsman who is an artist by nature if not by training. This art is based not on measurements or calculations but on feeling, and it rarely fits the standards of realism. It goes straight to the fundamentals of art—rhythm, design, balance, proportion, which the folk artist feels instinctively.

For the most part Cahill's definition remains valid today, with the exception of his reference to the crafts tradition, which embraces some contemporary expression but is not by any means exclusive to the folk art of this century. Billy Ray Hussey, for example, stands out among present-day southern potters for his innovative techniques, which transform a traditional craft to a contemporary nonutilitarian art form.

The Industrial Revolution brought about profound changes in American society as mass production rendered the need for the handmade object virtually obsolete. Yet the diminishing functional need for the folk portraitist, the ship carver, the quilter, did not dim the creativity of gifted individuals whose need to create was not solely based on utilitarian requirements.

Historical and social changes in the twentieth century— the optimism following World War II, the civil rights and

7

feminist movements, and the Bicentennial, among others—all broadened American tastes for an ever-widening range of expression and stimulated an efflorescence of folk art as well as a growing interest in the work of self-taught artists. Developing from its earlier, preindustrial roots, contemporary folk art looks different from its previous modes of expression. It does not follow mainstream art trends, but it is very much part of America's ever-evolving culture. Characteristic of American culture is its diversity—and contemporary folk art is nothing if not diverse, crossing boundaries of race, class, gender, and education. Although often identified as a rural art form—as exemplified by the lyrical narrative paintings of Charley Kinney and his legends from "Toller Holler," a small mountain valley in Kentucky—American folk art today is found equally often in sprawling metropolitan areas, as illustrated by the bold and graphic cityscapes of Ohio painter William Hawkins.

A dispersion of close-knit communities and a more accessible interchange among people expanded the flavor and debate over a definition of contemporary folk art, exacerbated by the fact that there are nearly as many styles as there are artists. The "establishment" art world, which once ignored contemporary folk art, has also now become involved, and self-taught artists are increasingly brought into the orbit of the so-called mainstream art world.

Part of a continuum, contemporary folk artists share with their eighteenth- and nineteenth-century predecessors a strong narrative impulse, the use of figurative and representational forms that are highly abstracted, an intuitive compositional strength, and a tendency toward the decoration and embellishment of a surface that goes "beyond necessity." Folk artists continue to share themes with historical antecedents based on religion, ethnicity, and patriotism. Beginning in the 1960s, however, experts in the field—such as collector/curator Herbert Waide Hemphill, Jr., and more recently Robert Bishop, director of the Museum of American Folk Art from 1977 until his death in 1991, as well as others—have recognized differences in contemporary folk art from the folk art of earlier times. These differences are embodied in such features as a broadened subject matter that reflects social themes, a more adventurous and wide-ranging use of materials, and an increase in highly individualized vocabularies of form.

The variety of expression of seemingly unrelated objects is astonishingly wide and ranges from everyday objects transformed through the imaginative use of surface decoration to the artistic handling of materials. Vastly different in style, technique, scale, and concept, for example, are Ray Materson's tiny multicolored tapestries created from unraveled and reworked socks to Simon Rodia's wildly idiosyncratic Watts Towers, a soaring and spectacular environment of steel reinforcing rods and wire mesh overlaid with concrete embedded with a mosaic of thousands of fragments of ceramics, glass, and other materials. What these artworks share within the contemporaneous

world as well as the historical world is the universality of the artistic vision and the selection of appropriate techniques and means to enhance the artistic statements that they make.

The folk artist uses the materials at hand as sources of inspiration, and currently the array is vast. "Found" materials—frequently societal detritus such as plastic, cardboard, discarded pieces of wood and metal, organic materials such as tree roots and mud, even industrial waste products—are combined with house paint and colored marker pens to become the expressive tools of the contemporary folk artist along with more traditional oil paint, watercolors, canvas, wood, and stone.

By the mid-1950s and 1960s, a surge of interest in twentieth century folk art had begun that continues to gain momentum even today. Sparked by the enthusiasm of a small group of collectors—among whom Chuck and Jan Rosenak have figured prominently—and scholars, twentieth-century folk art has, over the years, attained broader public attention, with landmark exhibitions and publications such as the *Museum of American Folk Art Encyclopedia of Twentieth-Century Folk Art and Artists* (authored by Chuck and Jan Rosenak) to help focus and stimulate the interest. The number of collectors, scholars, exhibitions, and publications has also increased dramatically as the mainstream art world has also indicated its interest in these aesthetically strong works.

Hundreds of contemporary folk artists have been "discovered" and documented, but there are still many others who have yet to be recognized. The pleasure derived from experiencing the art of those who have achieved widespread recognition and the dynamic potential for seeking out the lesser known but highly talented provides the collector, scholar, museum professional, dealer, and general art enthusiast with an infinite source of fascination and the potential for much aesthetic satisfaction.

Trying to find one single definition or meaning for this robust, fluid, dynamic, and authentic art remains elusive. Contemporary folk art is not monolithic or narrowly circumscribed, and it may be viewed from many perspectives, including recognition and judgment within the body of the more formal contemporary art world as well as the aesthetic/contextual focus of the folk art historian or the contextual focus of the folklorist or cultural anthropologist. Its definition should not marginalize the art or the artist, but place them squarely within the dialogue of art history. Jean Dubuffet recognized art's resistance to categorization when he wrote, "Art does not lie down in the bed that is made for it. It runs away as soon as one says its name; it lives to be incognito. Its best moments are when it forgets what it is called." Dubuffet's words are most apt when it comes to contemporary folk art.

Lee Kogan, *Director*
Folk Art Institute
Museum of American Folk Art

INTRODUCTION

IN THE LATE 1980S MANY IN OUR GENERATION—
ourselves among them—experienced a lessening of
interest in the academic art of Europe and America. As we
turned away, however, we found a growing response within
ourselves to the richly diverse folk art of our native land, art
engendered within a broad range of social and economic cir-
cumstances, and art that underscored the meaning of the
American experience. We began to realize that, after all, acad-
emic theoreticians can advance the arts only so far; after a time
great thoughts bore us, and we say to ourselves, "Ho for the
adventure of discovery. Ho for dirt-track America. It will
restore us."

This volume is a compilation and distillation of the experi-
ences we have had, the lessons we have learned, the artists we
have met, and the art that has now become an integral part of
our lives. Although *Contemporary American Folk Art: A Collec-
tor's Guide* is intended for use by collectors in their travels—as
a help in locating works to enhance their collections—it is
also our intention that this book should be more than a guide
for the acquisition of art. The choice of artists in the book is to
some extent subjective, but it is our hope that the artists
within its pages will, when placed in a historical context, col-
lectively help to define the best in contemporary art under the
umbrella term "folk art."

Contemporary American folk art is the collective voice
of the genius of our land, a mirror of the soul of America. As
W. B. Yeats said, "It is the soil where all great art is rooted." It
comes from the hills of Tennessee, the delta of the Mississippi,
Window Rock on the Navajo Nation, the often-unfriendly
projects in our otherwise great cities—and it even reaches the
spotlighted white walls of Madison Avenue, where it joins the
parade of art of our time. Contemporary folk art is no longer a
secret—suddenly it has become a recognized part of the
American art scene. But because recognition of contemporary
folk art by a large audience is relatively new, people ask: Who
are the artists? Where are the artists? How can I find them

and buy their work? Our adventures in dirt-track America over the past several decades have provided answers to these questions, and these answers are what we wish to share here—and in the process, we hope, help others in their quest to discover the new, the innovative, the wonderful, in the folk art of America today.

ON BEING COLLECTORS

In the latter part of the 1970s, we got a call from the *Washington Post* informing us that they would like to send a photographer to our home to do a story on folk art collectors. "Gee!" we said. "Gosh! We must be collectors!"

For us, collecting happened by accident. For our own pleasure we had been buying one work of art at a time since the late 1950s—pieces that we felt we couldn't live without. The term "collector" was reserved, we thought, for people like the Rockefellers, Carnegies, and Mellons—not us. (And speaking of the Mellons, I actually did meet Paul Mellon once in the 1960s. We were both bringing crates of art from Europe through customs at National Airport in Washington, and he asked to see the Millares we had just purchased in Spain. He then proffered advice to me on how to build a collection: "Young man," he said, "I never spent less than one million a year on art, and I have never regretted it." Unfortunately, not very helpful advice for two young government lawyers!)

Another time, I overheard Joseph Hirshhorn giving advice to a collector. He said, "I can tell in ten seconds if a work of art is well made, but it takes much longer to know if it is important"—well-meaning advice, perhaps, but not necessarily helpful for the folk art collector; "well made" is often not a criterion of particular meaning or importance!

It is almost impossible for one collector to tell another the "hows" and "whys" of building a collection; each person must find his or her own direction. But remember—the first purchase is the hardest!

BUILDING A FOLK ART COLLECTION

The art world moves fast—artists' reputations are sometimes established (or lost) overnight. Six years ago there were fewer than ten museums in America competing to build collections of the very finest of contemporary twentieth-century folk art; today we list more than fifty, and the number is still growing. Six years ago we knew all of the major collectors and dealers. Now it is almost impossible to keep up with the ever-expanding art scene.

Collectors have an important role to play in the art scene. Collectors are usually the ones who make the initial judgment decisions on whether this artist is important, that one is not. And quite often collectors are responsible for preserving the contemporary art of our day. When I first visited Howard Finster's Paradise Garden in 1977, he believed that the Lord would protect his art—nailed to boards, outdoors in the humid Georgia weather—in situ. Later, when he spoke at the Philadelphia Art Alliance on the occasion of the opening of his first

major retrospective, "Howard Finster: Man of Visions—The Garden and Other Creations" (1984), his eyes watered at the sight of the early pieces of his that we had bought. "Brother Chuck," he said. "Thank you for saving the Lord's work."

If you don't have large resources—we never did—being "there" at the right time, whether it's a first one-person show in New York, a weaver's hogan, or a project apartment, always gives the collector a leg up. Being there, however, requires information, and information always gives the astute collector an edge. Each collector must first define the parameters of the material that he or she is collecting (and collecting can be done at any level, from museum masterpieces to mementos of a trip and everything in between). Then a collector should become knowledgeable about what has gone before (for example, by seeing folk art in museums and reading about the genre). And finally a collector should buy the best material available within budget limitations.

Most folk art collectors have become hooked on the material because it does speak directly to them about our roots and our regional and ethnic ties to the land we love. Most folk art collectors only buy what they love. Most folk art collectors try to learn as much as they can about the art and the artists. This learning process is what we call "honing the eye." A collection can, in the hands of a person whose eye is not honed, become nondirected—merely stamps on a wall waiting to be sorted by someone else. A collection need not be large to be good; quantity rarely replaces quality, and five really great works can capture the eye and the imagination where five hundred mediocre pieces become just clutter.

Every collection should have its own unique characteristics, shaped by the collector's eye. We have collected art from every region in America, but that type of broad-band collecting is rare; most collections are centered around the art of a particular region, usually near hometowns or places frequently visited. In Chicago there are large collections of Lee Godie, Joseph Yoakum, and William Dawson; in Atlanta, it's Nellie Mae Rowe, Charlie Lucas, and Jimmy Lee Sudduth; in Columbus, Ohio, Elijah Pierce, William Hawkins, and Smoky Brown are widely collected. The choice is up to the collector, but the focus should be clear. The collection makes a statement about the collector, and the statement should be, "This is the best art of its kind; this is the best folk art of our time."

KNOWING THE ARTIST, UNDERSTANDING THE ART The gallery scene, whether you are walking through Soho in New York, gallery hopping in Los Angeles, or discovering a gallery in Iowa City, is always exciting. It can be every bit as much fun as driving down a dirt track into a holler in Kentucky —and it doesn't even require a different wardrobe these days. For us, however, the real adventure—and personal restorative—is visiting the artist. We have also found that knowing as much as possible about an artist can help in making decisions about his or her work. We do not believe that any particular

work of art contains "absolute qualities" that can be totally separated from the legend of its creator. For example, we once bought two of Ellis Ruley's paintings from a dealer in Philadelphia who did not know or really care about the life of the artist. We paid about $400 for the pair and put it aside, thinking that some day we would "discover" Ellis Ruley. Glenn Smith beat us to it and wrote his book, *Discovering Ellis Ruley,* in 1993. Once the Ruleys' story was known—Ruley, a black man who married a white woman, was possibly murdered alongside a rural road in Norwich, Connecticut—that same dealer called us and offered to buy the pair back at many times its original cost. (We understand that today several galleries have waiting lists of customers hoping to find a Ruley.) Folk artists are not anonymous; their dreams, hopes, visions, and lives are their legacy, and when they make art, it is part of that art and its value.

We also visit the artists to photograph, record, and preserve their stories and to determine for ourselves that their art falls within our definition of folk art—that is, that it is self-taught (although the underlying craft may be learned) and that it comes from the soul of the artist and is not inspired by some other source.

In 1993 we purchased two paintings on board signed simply "Joe M." from a respected dealer. "Frankly," he informed us, "I know nothing about the artist, except that I've been told that he lives in a trailer, decorated with similar paintings, on an island off the coast of South Carolina." Had the dealer discovered another Sam Doyle? We were curious and determined to find out for ourselves.

Jan managed to track down Joe M. (don't ask me how she did it, but Americans can be located). He lived on an island off the coast of South Carolina all right, and we visited him. Joe M.'s decorated trailer was one of those wooden-sided affairs that are pulled behind oversize lawn tractors. This particular lawn tractor belonged to a retired officer of a large company who was painting under the pseudonym "Joe M." as a hobby. Our paintings turned out to be what we call "faux folk art"; they were not from the soul of the artist—Joe M. was certainly no Sam Doyle! Money and pictures were traded back all around.

Empty-handed adventures come with the territory, but memories of good times and encounters with artists far outweigh the bad and help to open a window on the source of an artist's genius. The good times are what keep us going. We do not become a part of an artist's life in a day-by-day sense (this can only be done when an artist lives close enough for frequent visits), but sometimes we are able to help. We have found gallery representation for some artists, and through our writings have been able to bring others to the attention of a broader audience. We all look for idiosyncratic elements in art (music, literature, theater, whatever)—that is, after all, what sets one work apart from another—and idiosyncratic elements

in folk art sometimes come from the life of the artist. Knowing the artist helps us to gain a better understanding of the art.

One fall evening, after Jan and I had eaten well at a Chinese restaurant in Chicago, we came upon Lee Godie sleeping on a grate in front of a savings and loan association on Michigan Avenue. Carried away by the excitement of the moment, I burst out, "Lee! Have you any pictures for sale?"

Godie's reply was sharp and rebuffing: "Can't you see I'm sleeping? You can buy me breakfast tomorrow at the Burger King." She went back to sleep, but sleep came hard to me that night. During the late hours of the night, I finally realized that the literature on the artist was wrong; Godie was not "a homeless waif," as often described. She was at home by choice on the streets of Chicago, and I was the outsider who had intruded upon her rest.

At 7:00 A.M. the next morning, Godie appeared at the Burger King full of schemes. She produced some cheap cameos from somewhere under the many layers of clothing she customarily wore. "Jan," she said (she wasn't going to talk to me that day), "they sell these at Marshall Field [an elegant Chicago department store] for a lot of money, but they won't do business with me. You sell 'em, and I'll split fifty-fifty with you." And I was further punished for my transgressions—there were no paintings for sale that morning.

The Reverend Howard Finster baptized me, but he was never sure that it "took." On each of our subsequent visits to the artist, Finster has given me a sermon on one topic or another. At our last meeting Finster's sermon was his unique version of evolution. "Apes, Brother Chuck," he said, "are descendants of the dumb folks who can neither read nor write nor do numbers. *We* are not descendants of apes—no sir!" After my sermon, I said, "Howard, you will always be my pastor," and he replied, "Brother Chuck, you will always be a member of my flock." Such moments as these are treasured, expanding our relationship both with the artist and with his art, and we have been lucky to have had many such moments.

With a little effort other collectors can have such treasured moments too, but perhaps as important is the opportunity for every collector to also make a contribution to knowledge and understanding of the field through what Jan and I call "investigative study." A revival of interest in contemporary American folk art began in the 1970s and has grown steadily throughout the 1980s and into this decade. Our knowledge of contemporary folk art is still so young that exact definitions of terms are continuing to evolve, and every region of this country, whether urban or remote, is ripe for further exploration. Lucky are the risk takers who explore their regions, for they will find great art.

We were especially lucky in that regard. After moving to Santa Fe from the East Coast in the 1980s, we instantly recognized that taboo-defying innovations were taking place in the art of the Diné (the word the Navajo use to describe

themselves). Traditional turquoise jewelry, rugs, and baskets were still being made, but artists like Mamie Deschillie and Johnson Antonio were creating new art forms never seen by their people before. We did what we always have done and ventured onto the dirt tracks of this vast land (*Dinétah*, or homeland) of purple sunsets and geological formations beyond description. What we found was truly amazing—pottery, wooden carvings, cardboard collages, and surprisingly, unique pictorial rugs—artists were creating new art forms and adding their modern visions to old traditions. These innovative artists were, at least originally, ignored by most of the traditional Indian traders, and Jan and I had the opportunity of a lifetime, giving name to the contemporary and revolutionary art of the Diné. We wrote about the artists, photographed them, found gallery homes for their work, encouraged museum exhibitions, and published a book, *The People Speak: Navajo Folk Art*. We are convinced that every region of America has its own *Dinétah*, and we encourage our readers to go out and find it.

In the end each generation must sing its own song. Great artists have genius—idiosyncrasies, vision, call it what you will—that helps them to express their unique view of the time and environment in which they live and helps us to understand the universality of what we call art. Each of us feels restored in the search for that universality, and, in some ways, it may be the search for great art that keeps us going.

At home, on our ridge in the Sangre de Cristo Mountains, we are surrounded by tangible memories of where we have been and whom we have met. The art on our walls reminds us of our adventures and, with a piñon-wood fire burning bittersweetly on a winter afternoon, I can sit in front of my computer, resting on a hundred-year-old mesquite table from Mexico, and spin stories of our collecting adventures. But after a while remembrances are not enough; the thought of new discoveries to be made and old friendships to be renewed hangs in the air, and we say once again, "Ho for dirt-track America, land that restores us when great thoughts bore us!"

EVALUATING
FOLK ART

EVERY PERSON FILTERS IMAGES THROUGH HIS OR her artistic eye differently, and this individuality is what creates controversy in art. I know that Jan sometimes sees objects from a perspective that is foreign to mine; on occasion, I've whispered to her, "Don't you think that painting is a bit too explicit?" and she has replied, "Oh! I didn't see that!" We each were looking at the same work of art, at the same time, but we each saw something different.

Each of us must debate with ourselves, develop our own eye, and see the art. What Jan and I have done is define for ourselves the field in which we collect and single out objects that, for us, stood out among other objects, certain that they contained what we call "creative vision" as well as the "personal vision" of their maker; we also try to learn as much as we can about the artist in order to understand whether the vision rings true. Then, we live with the object.

When you live with artworks or visit museums frequently, you find that you conduct an internal dialogue that often runs like this: "I like this, this is good; I think that is better, but my favorite is over there and it is the best!" If a spouse or neighbor, critic or expert disagrees with your assessment, you have controversy, but that is not all bad. Controversy can bring those involved to consider their positions from an objective rather than purely subjective viewpoint, from a reasoned rather than emotional position, and, eventually, a thorough exploration of the opposing ideas can often bring about a consensus.

Ultimately, each of us must make individual decisions about what we consider "good," "better," or "best" in art. When the collective voice of art history (collectors, dealers, critics, curators, art historians, and so on) moves past controversy to agree to speak as one on a work of art, then you have a masterpiece, a Mona Lisa, for example. Although some masters of contemporary folk art have emerged (a number are included in this book—William Edmondson, Howard Finster, Sam Doyle, Steve Ashby, and Bill Traylor, to name a few), there are no Mona Lisas; there is, however, always controversy, as well as

doubt, uncertainty, and debate—the collective voice may take years or even generations to come to agreement on an artist's work (if it ever does). We once heard Hilton Kramer, a respected art critic, pan the artist Milton Avery and declare him to be an "also-ran genre painter" (meaning no competition for the international style of the day). About ten years later, Kramer made a complete about-face and wrote a column calling Avery "an American master"—Kramer had debated with himself, and Avery won.

Within the oeuvre of an artist, there will sometimes also be disagreement as to his or her best period or best works. Sometimes it is easy to be judgmental, sometimes not. Myrtice West, for example, spent years making cutout angels, memory paintings, and decorated gourds that were something less than great. Then a traumatic family experience changed her work dramatically; the result was her marvelous Revelations series. R. A. Miller's career went in just the opposite direction. He initially made uniquely inventive whirligigs and drawings, and then, when he had achieved a bit of fame, he began to mass-produce his most popular themes. His work became less imaginative with success.

We hope that, having been presented with a broad spectrum of contemporary folk art here, our readers will learn to make aesthetic decisions for themselves—this is good, that is better, that one is the best. Art is not mathematics; there is no way to prove that one work is a masterpiece, another is not. Only unanimity of opinion—the triumph of consensus over controversy—elevates a work of art to Mona Lisa status. As for us, we are happy to get along without the Mona Lisa on our walls; we know she exists, and that is good, but on a very personal and everyday level we live for the new, the controversial, and the excitement it brings.

B U Y I N G
F O L K A R T

A WORK OF ART HAS A LIFE CYCLE OF ITS OWN, from the moment of its creation through a succession of owners, then often to a final destination in a museum or public institution. Sometimes the chain of ownership is short (a museum buys directly from the artist, for example), but sometimes the art work spends a great many years in interim resting places—a dealer's showroom, the homes of private collectors, or even undiscovered in a dusty attic.

You can buy a work of art almost anywhere. People still go to flea markets, estate sales, and antique shows in the hope that one day they will find that previously unknown Picasso or Horace Pippin, but the "rare find" is indeed just that—rare.

The closer a collector comes in the life cycle of a work to the artist and the date of the work's creation, the lower the price but, often, the greater the risk. The collector who has a well-honed eye can visit an artist that he or she has never heard of before and say: "This is good, this is better, and this is the best, I'll buy it"—but most people are not prepared to make that definitive a statement. However, when confronted with art in the artist's workplace, the collector must be able to answer—and answer quickly—three essential questions:

1. Will the artist become important enough to justify my purchase?
2. Is the work a good example of the artist's oeuvre?
3. Is the work worth the asking price?

Those who are not prepared to answer these three essential questions—and in a very short time frame—would be better off in most cases purchasing art from or consulting an expert who can help answer them. On the other hand, it is fun to meet the artist, and if the price for the work is at the low end of the spectrum, answers to the questions are perhaps not as crucial, and aesthetic response becomes more important. Keep in mind, however, that in the field it's all cash-and-carry, and an artist may not have examples of his best work on hand.

If, for whatever reason, you decide not to buy directly from

the artist—lack of propinquity, the artist is deceased, a desire to find a certain type of example of the artist's work—there are several avenues that a potential buyer may explore, from pickers through dealers through private consultants and curators through the secondary market, or auction houses.

The folk art picker, often among the first to discover a new artist, serves as middleman. The picker often attempts to answer the three essential questions noted above after finding the artist, usually pays cash for the work, and then sells it to a collector or dealer, often for twice the amount that was paid for the work.

Once an artist—folk or otherwise—has achieved status in the art world, the artist may enter into an exclusive contract with a dealer (although this is less common with self-taught artists than trained artists). Despite rumors to the contrary, a large percentage of our collection was acquired through gallery purchases, and we have discovered that there are many advantages to buying art from a respected dealer. The advantage to the collector of buying from a dealer is obvious—you get the benefit of the eye and knowledge of an expert and can take your time in finding answers to the three essential questions. In many cases, galleries may have acquired the best works, as well as the best period, of an artist, and they may also have exclusive contracts or the right to represent an artist's estate; in these cases art that is not available elsewhere can be found. It is also easier to say "no" to a dealer than to an artist!

The dealer/artist agreement generally calls for about a fifty-fifty split of the sales price, allowing for a gallery discount to good customers, and galleries will sometimes make arrangements with a buyer for extended payments. Folk artists are also becoming more aware of consignment agreements, and where one exists with either an estate or an artist, the contract sets the price.

Some collectors find that dealing regularly with one or two galleries helps to give their collection a focus that could not be acquired through random shopping, especially once the gallery owners or managers get to know their wants and needs. Others rely on private curators or art advisers to buy for them, particularly if they are trying to locate specific works to round out a collection.

In recent years, a significant secondary market, where previously collected works are offered for resale, has developed for folk art. This market gives further opportunities to collectors to complete collections or to acquire important works of art. Entire major collections are sometimes available on the secondary market; these may be purchased or traded privately, or they can be consigned to dealers or placed with an auction house. Major auction houses such as Sotheby's and Christie's have now become significant players in the secondary market, and they often offer the opportunity to potential buyers to see a variety of artists' work.

Auctions have both advantages and disadvantages for the

buyer; you know exactly when a sale will occur, you have ample opportunity beforehand to view any work in which you might have interest, and the provenance of the work is generally known. Although the potential exists for getting works at "bargain" prices at auction, much depends on the interest and enthusiasm of other attendees, causing prices at times to match or exceed those of galleries and other dealers. Also, it should be remembered that buyers pay a premium over the bid price (in New York, generally 15 percent), thus increasing the final cost of a work.

If a collector is seeking out a rare example of a well-known artist, such as Ellis Ruley, William Blayney, or William Edmondson, for example, where most existing works are already in private or public collections and demand for the artist's work is known to be strong, then dealers, auction houses, and private collectors who are known to have objects by the artist must be consulted. In such cases, if a work does become available—and especially if it is a superior work of high quality—the collector must be prepared to pay a premium price in the secondary market.

Dr. Robert Bishop, an avid collector as well as director of the Museum of American Folk Art from 1977 until 1991, once told us that "the one-hundredth work by an artist is usually his or her best." We have used this tip in making decisions on what to buy and, in general, have found it surprisingly good advice to follow. We have also found that it is usually better to buy more than one work by a favorite artist. When it comes time to place the artist in important collections, including museums, a broad representation of the artist's work is usually of more significance than a single painting, drawing, or sculpture.

It is fun to buy art, and whether or not all the artists you pick turn out to be "winners," keep in mind what a dealer once told a friend: "If you buy with passion, your own passion, the passion of your heart and not your head, you will never be disappointed in your art."

SELLING FOLK ART

NOW THAT AN ESTABLISHED MARKETPLACE EXISTS for contemporary folk art, it has become relatively easy to dispose of artworks when the need arises. Some of the great pioneer collectors of contemporary folk art—for example, Herbert Waide Hemphill, Jr., part of whose collection is now housed in the Smithsonian Institution's National Museum of American Art; Dr. Robert Bishop, director of the Museum of American Folk Art from 1977 until his death in 1991; and Michael and Julie Hall, whose collection is now owned by the Milwaukee Art Museum—have always sold pieces as they went along in order to finance the purchase of new objects. And recently we auctioned off a few pieces at Sotheby's to obtain funds for the purchase of new discoveries.

In addition to using parts of a collection to finance new purchases, another long-established method for upgrading is trading with other collectors. However, as the price of folk art has risen, it has become increasingly difficult to trade because monetary value has become a consideration. In the past dollar value was not the focus, and trading could be fun—a collector would simply say, "I don't own works by this artist, you don't own works by that artist; let's swap." This sort of trade can still occur when new artists are discovered.

Collectors can sell or swap with each other or they can sell on the secondary market. There are now over one hundred galleries specializing in contemporary folk art; they will either purchase works outright or enter into consignment agreements for their sale. The advantage of consignment agreements is that the consignee can set the sales price and negotiate the amount of the commission to be paid (generally about 20 to 30 percent).

The days of yard sales, country auctions, and estate sales for important works of contemporary art are almost over; major auction houses such as Sotheby's, Christie's, and others are now aware of the recent increases in the value of this art and include it in their sales. The advantage of an auction is that you know the exact date upon which a sale will occur and the date of payment (generally thirty days after the work is

hammered down). Also, at auction the price can be protected through a mutually agreed reserve. And if an auction is well advertised and attended, competition among bidders can drive prices well above estimates. Another advantage of putting works in an auction is that commissions are split between buyer and seller—in New York, for example, the buyer generally pays a 15-percent premium, while the commission paid by the seller may be negotiable.

At this moment, it is a seller's market in contemporary folk art—there are just not enough high-quality items available to satisfy the growing demand.

FOLK ART AT AUCTION

IN RECENT YEARS THE FIELD OF CONTEMPORARY American folk art has been a vibrant one, undergoing great change. Artists are making their reputations, landmark collections are being formed, museums are being built, study and interpretation are developing, and brilliant coups and acquisitions are being made. Auctions in this fast-paced evolving field play a significant role as they are becoming a reliable means of presenting and dispersing these works of art to an audience that is vastly wider and more diverse than ever before.

Auctions of fine arts, furniture, household effects, and treasured personal possessions, as we know them in the western world today, started in London, in 1744 at the firm of John Sotheby's, Booksellers. Roughly 200 years later, the firm of Parke-Bernet on Madison Avenue in New York held the first sale of American folk art, which belonged to George Horace Lorimer. Lorimer, the editor-in-chief of the venerable *Saturday Evening Post*, was an avid and sensitive collector of superb quality, high-style, formal American (primarily Pennsylvanian) eighteenth- and early nineteenth-century Queen Anne and Chippendale furniture, and brass, silver, and ceramic decorations. In addition to these more traditional objects, Lorimer sought examples of Pennsylvania-German folk art—art and artifacts that were made by German settlers who came to the rich farmlands of southeastern Pennsylvania in the early decades of the eighteenth century. He was captivated by the beauty and history of their magnificently decorated and fragile illuminated paper documents (birth and baptismal certificates), called *fraktur*, and wonderfully bold and highly decorated redware pottery plates, vessels, and utensils, along with beautiful wrought-iron and decorated tin and brass. George Horace Lorimer's estate sale marked the first time that examples of non-academic, non-formal, American-made folk art ever crossed the block at a major auction gallery. The enormous success of the Lorimer sale established both a market level for eighteenth- and nineteenth-century American folk

art and a level of credibility and acceptance for this unique, vibrant, historical, and indigenous art form.

The landmark sale in 1944 was an important catalyst in inspiring Americans to preserve and study their own fine, decorative, and folk arts. In an atmosphere of political and cultural self-confidence and pride following World War II, many museums dedicated to the American decorative arts were founded, including the Henry Ford Museum in Dearborn, Michigan, Colonial Williamsburg and the Abby Aldrich Rockefeller Folk Art Center in Williamsburg, Virginia, the Shelburne Museum in Shelburne, Vermont, and the New York State Historical Association at Cooperstown, New York. For the first time in their history, American cultural institutions began to value and systematically study and exhibit a full range of Americana, including examples of American folk art. Aided by the proliferation of public educational programs, and scholarly and trade publications in Americana, the success and stability of the market and auction sales grew steadily in the next fifty years. Since 1944, there have been well over 100 "single-owner" sales in American folk art. The legendary collections of Arthur J. Sussel (1958), Channing Hare (1971), Edith Gregor Halpert (1973), Edgar William and Bernice Chrysler Garbisch (1974–1980), Stewart E. Gregory (1979), Robert Bishop (1990), and Bertram K. and Nina Fletcher Little (1994) found their way to auction in New York establishing a vital marketplace for traditional eighteenth- and nineteenth-century material—including folk portraits, landscape and still-life paintings in watercolor and oil, carousel animals, cigar store figures, decoys, weathervanes, quilts, coverlets, and samplers. During the 1994–1995 season just concluded, roughly twenty million dollars worth of American folk art changed hands at public auction.

Only within the last eight years has there been evidence of a growing interest within this expanding market for American folk art. Collections and single objects of twentieth-century origin which also may be described as "outsider" in intent and impulse have been sold for the first time. The terms twentieth-century folk art and "outsider" art are often used interchangeably and encompass, as Chuck and Jan Rosenak have explained in the *Museum of American Folk Art Encyclopedia of Twentieth Century American Folk Art and Artists,* a widely diverse group of artistic expressions, ranging from large scale environmental art to memory painting and visionary art, among others. However one chooses to label this highly original art, it is almost exclusively made up of painting and sculpture. And unlike eighteenth- and nineteenth-century folk art, contemporary objects, in general, have been created without a functional or utilitarian mandate. Whether a towering iron sculpture, a pencil and tempera painting on cardboard, or a small wooden, biblical carving, contemporary folk art reveals a deeply personal vision drawn from each artist's interior landscape. These hand-made, intimate expressions of self appeal to a national

and increasingly international audience. However the process of establishing a position for twentieth-century folk art in the auction market is a gradual one. The majority of twentieth-century folk art has been acquired on a primary level, between the artist and the collector, or the artist and the dealer. And like the sale of traditional material that preceded it, the natural process of selection by which the masters and masterpieces emerge is an ongoing one. Vast quantities of twentieth-century folk art and outsider art, of widely divergent levels of quality, are available now. Certain masters are emerging—Bill Traylor, William Hawkins, Thornton Dial, Sr., S. L. Jones, Horace Pippin, William Edmondson, Minnie Evans, Morris Hirschfield, Martin Ramirez, Henry Darger, Clementine Hunter, Elijah Pierce, and Edgar Tolson, to name a few. However, the process of understanding which new artist will join their ranks is just beginning. This is a new and vibrant field of art where artists and collectors alike are still "on the ground floor." In addition, many of the major collectors in this field are still relatively young, and they have not yet chosen to bring their art to the auction market.

The increasing popularity and expanding audience for twentieth-century folk art will create an equally exciting auction market—as does exist for every other serious field of collecting. But the market must be established carefully and patiently. Any rush to push quantities of poor quality contemporary folk art at auction will only destabilize the market and call into question the validity of this newly discovered art. Strong auction sales with good material allow collectors to buy wisely and with confidence. For relatively modest sums, great works of twentieth-century folk art can be acquired; the only caveat is that thought, patience, and study are necessary to find enduring treasures.

Buying and selling at auction works in a simple and straightforward way. The prospective seller sends or brings a photograph, or arranges for the folk art specialist to visit the collection. The work is evaluated, and the client is given a preliminary presale estimate of what it is anticipated to bring at auction. Normally, the presale estimated value given is a range from low to high. Most pieces at auction are sold subject to a reserve, a mutually agreed upon confidential price between the seller and the auction gallery, below which the piece will not be sold. Should the bidding fail to reach that mutually agreed upon figure, the consignor or seller retains ownership of the piece or pieces in question. The dynamic in selling at auction is different than that at retail. The most important goal of an auction is to create the widest audience and therefore the greatest competition. Whereas a retail price is often negotiated *down* to the dealer's "best price," auctions start low and end high. For this reason auction estimates are on the conservative side. The danger is in scaring off or intimidating a potential buyer with an aggressively high estimate. The estimates, low to high, are listed in the sale catalog mailed to our

subscription list of approximately 9,000 approximately three weeks prior to the date of the sale. This gives prospective bidders, dealers, and collectors a chance to review the works of art and to make their plans. A public exhibition opens approximately one week prior to that date of the sale. The specialists and staff at the gallery are available, either in person or by phone to discuss the overall merits, condition, and level of competitive interest in each piece. The day of the auction, the prospective bidder, having made decisions about which pieces are right for his or her budget, registers for a bidding paddle. The art is sold in catalog order following the lot numbers assigned to each piece of art listed.

The best advice to give any beginning collector is to buy the best quality you can afford. To ascertain that the quality *is* indeed there, one should consult with the specialists and staff of the auction house, and speak with as many knowledgeable professionals as possible. In general, the best education beyond the images reproduced in catalogs and books comes from seeing first hand as much material as possible. Visit museums, historical societies, auction galleries, and dealers. Experiencing contemporary folk art in person provides an invaluable resource for the beginner and experienced collector alike. In New York, the last week in January heralds a major art show, The Outsider Art Fair, and other folk art events which draw dealers, museum personnel, and private collectors. Because the success of an auction depends on a large competitive audience, Sotheby's holds its sale of twentieth-century folk art at this time each year.

From New York to California, from Maine to Texas, twentieth-century folk art is available, accessible, and affordable. In its infancy, this new market is ripe with possibilities for all collectors.

NANCY DRUCKMAN,
Senior Vice President
Sotheby's

H O W T O U S E
T H I S G U I D E

ABOUT THE GUIDE *Contemporary American Folk Art: A Collector's Guide* describes folk art in the continental United States as this century draws to a close. We believe that it contains information that will be helpful to museum curators, art critics, art historians, and researchers and scholars in this field as well as to the many collectors who call and write to us—picking our brains, as it were—for inside information that will enable them to build their collections. Because our language is intentionally direct and, like the art included here, nonacademic, we also hope that our book will appeal to a diverse audience of just plain art lovers, browsers in art, and casual museum goers.

What we have tried to do in *Contemporary American Folk Art: A Collector's Guide* is survey the contemporary folk art that is now available, choose what we think is the best, and illustrate it. The guide will not only provide information for those interested in understanding this remarkable art form but also, we believe, serve as a useful and usable reference tool for collectors, helping them to locate artists and their art and to make intelligent buying choices that will enhance their collections.

ARTISTS DESCRIBED AND ILLUSTRATED The scope of the guide is wide ranging; it includes the work of new artists as well that of those whose reputations have been well established over the years. Because the book's focus is on contemporary folk art, those artists who worked primarily in the first half of the century—such as Henry Church, Clark Coe, John Kane, Grandma Moses, Horace Pippin, and others—generally are not included. Two exceptions are Bill Traylor, who died in the late 1940s, and William Edmondson, who died in 1951. Both these artists created outstanding works that fit well with the folk art being created today, and both are frequently included in exhibitions of contemporary folk art. Also, since it is hoped that this guide will be used by those with an interest in collecting, the emphasis is on artists whose work can be collected. For that reason, only a few environments are included. Simon Rodia's Watts Towers is one exception; it is a landmark and the most famous folk art environment in the

country, and a visit to the Watts Towers cannot help but expand the understanding of those interested in contemporary folk art, whether as collectors or scholars. One or two other, smaller environments have been included because some work is available from the artists—Robert Howell, for example, occasionally sells smaller pieces from his environment.

INTRODUCTORY ESSAYS The chapters in the front matter cover various topics that should interest beginning and experienced collectors, ranging from the authors' adventures discovering folk art and artists to advice about selling works. Take note of the overview of folk art by Lee Kogan, director of the Folk Art Institute at the Museum of American Folk Art, and "Folk Art at Auction" by Nancy Druckman, Senior Vice President of Sotheby's.

REGIONAL SECTIONS Information in the guide is divided into six sections, each one representing a region of the country—East, Appalachia, South, Midwest, Southwest, and West—in order to help travelers and readers in each area locate individual artists.

Each of the regional sections consists of three subdivisions: illustrated biographies; color plates; and a museum and gallery guide.

The regional divisions are not, however, intended to imply that there are necessarily regional differences that distinguish the art of one area from the art of another; major folk art turns up everywhere, and many galleries and museums carry the work of a broad spectrum of artists from many localities. Nevertheless there are a few remaining regional characteristics in some areas; for example, the face and effigy jugs of North Carolina and Georgia, the carvings of Appalachia, the *santero* tradition of the Southwest, and the pottery and weavings of the American Indians in New Mexico and Arizona.

An introductory overview for each region is given, and where any regional traditions or other distinguishing characteristics still exist, they are noted in the text or in the artists' entries that follow each overview.

A map of each region is also included, showing the principal cities where folk art may be found—either in galleries, museums, or through the artists themselves. Before visiting a region, collectors may wish to familiarize themselves with the appropriate section in order to be able to locate those artists (or their galleries) whose work they may wish to see.

THUMB TABS Thumb tabs are given for each of the regional sections, as follows: **E** (East), **A** (Appalachia), **S** (South), **MW** (Midwest), **SW** (Southwest), and **W** (West).

COLOR PLATES Illustrations, mostly in color, of the work of the majority of the artists are included. These are arranged alphabetically within each region. The number of the illustration corresponds to the number given in the artist's biography.

ILLUSTRATED BIOGRAPHIES The entries for the individual artists in each region are arranged in alphabetical order by name. Each account contains basic biographical information, a concise discussion of the artist's work, collecting tips, and addresses where the work may be seen and purchased. Some of the entries include an example of the artist's work in black-and-white. There are also some photographs of the artists themselves, taken by Chuck Rosenak. A number appearing in the artist's entry corresponds to the number given for the artist's work in the color plate section or in the accompanying works shown in black-and-white; biographies without numbers are not illustrated.

MUSEUM AND GALLERY GUIDE The guide includes an extensive annotated list of museums and galleries that handle contemporary folk art on a regular basis—a nationwide compendium of where to see the best of the folk art that is being created today. This listing also contains the names of some of the artists included in museum collections or in specified galleries. For the most part, the museums and galleries have themselves indicated the artists that should be included in the listing. An asterisk (*) follows the name of each artist profiled in this guide.

The museums, galleries, and other exhibition venues in this section are listed by state, and are alphabetized by city.

Although the gallery list was comprehensive at the time of this writing, keep in mind that the field is not constant; galleries may relocate, others may open, and some may close or change names. Therefore, when visiting a region, always check with local collectors, galleries, or museums to make sure that you do not miss a new source or look fruitlessly for an old one.

APPENDICES Conservation advice, a glossary, and a general price guide round out the information that a serious collector will find useful.

There are obvious limits as to how many artists can be included in a volume of this size, and in many cases the choice of whom to include or exclude was not easy, thus responsible for many sleepless nights! While some experts advised us about their preferences, we believe the final list of 181 artists featured represents the best of contemporary American folk art. Of course, the ultimate responsibility for the choice is ours. Our apologies if we have neglected to include your favorite artist, but space limitations narrowed our choice in many instances.

A well-known southern collector recently said to us, "I know the folk art to be found in Atlanta galleries, and the folk art to be found in New York galleries, but I'm going to Chicago; can you help me?" The answer to his question is in this book, and we hope that the information provided here will not only prove provocative and stimulating but also motivate its users to search further on their own. Once you have developed the eye of a collector and are willing to take the risk of an adventure or two, folk art can be found almost anywhere. Good collecting!

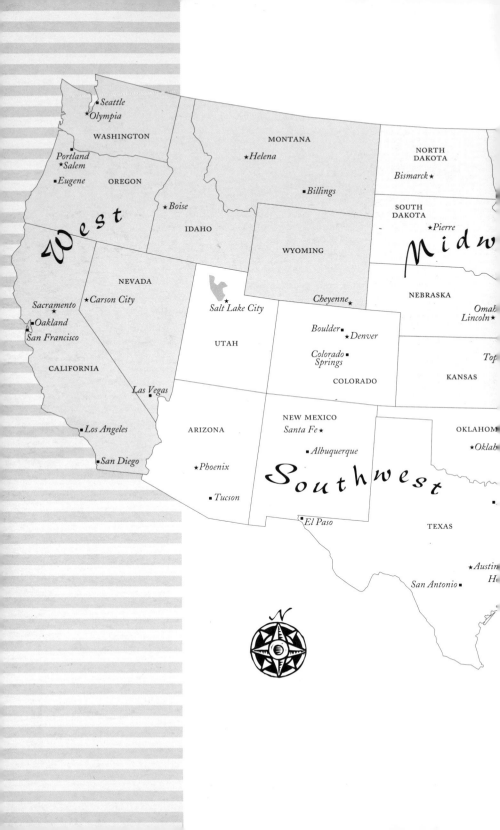

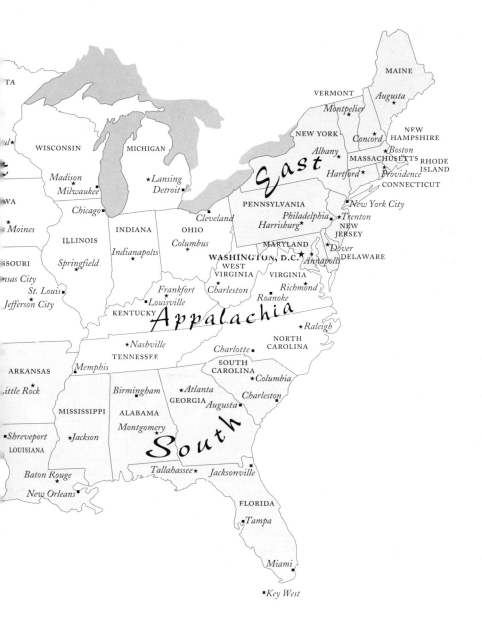

THE EAST

DURING THE TIME WE COLLECTED CONTEMPORARY art in the 1960s and early 1970s, "making it" for an artist meant success in New York—that is, having museum and gallery shows that were popularly acclaimed in what is generally considered the art capital of America. This hasn't always been true in the case of folk art. Most of the large collections of contemporary folk art were acquired "out-of-town"—and in many cases directly from the artists themselves—in places such as Columbus, Ohio; Atlanta; Philadelphia; and Chicago. In New York, until the late 1980s, there were few galleries—in fact, less than a dozen in the whole country—selling contemporary folk art.

But now folk art is no longer regionally limited, and there are over one hundred galleries nationwide specializing in this field. Quite naturally, however, some of the most prestigious have headquarters in New York, for once a gallery system is established for a genre of art (be it folk or mainstream), dealers in New York tend to assume a leadership role in obtaining and selling the best to collectors with the means to acquire the best. Established galleries—for example, American Primitive, Cavin-Morris, Phyllis Kind, Frank J. Miele, Ricco/Maresca, Luise Ross, and Edward Thorp—are competing with each other as well as with up-and-coming newcomers to the field such as Jim Linderman and Kerry Schuss (not to mention such private dealers as Epstein/Powell). Today folk art is "hot," and contemporary folk art collectors come to New York from all over the world to add to their collections. They know that the best will gravitate there because it always has. And collectors are aware that, in the long run, quality is important.

But the gallery scene is not the only art scene for which New York is known. The Museum of American Folk Art makes its home in this city, and under Robert Bishop, director from 1977 until his death in 1991, the museum took a leadership role in bringing contemporary folk art to New York—and through it, to much of the country. The museum is continuing in Bishop's footsteps under Gerard Wertkin, director since

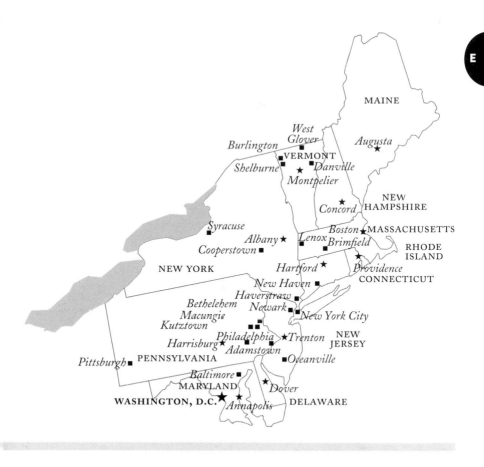

1992; it was the first museum in the country to mount a large retrospective exhibition of the work of Thornton Dial, Sr. (1993), and it also sponsored an important exhibition of the work of Ellis Ruley that same year. The museum's educational arm, the Folk Art Institute, has also been extremely important to the expansion of knowledge in the field through its course offerings in contemporary folk art. The Metropolitan Museum of Art, though more conservative in its bent, did however feature a major retrospective exhibition of the work of Horace Pippin this year, an exhibition originally organized by the Pennsylvania Academy of the Fine Arts.

In addition to the gallery and museum scenes, Sotheby's, Christie's, and other auction houses have studied the demand for contemporary folk art and are now seeking it out for upcoming sales, thus creating a major new setting for seeing—and selling—folk art. There, those collectors who for various reasons wish to sell works from their collections may do so, and those who wish to add to their collections or improve the quality of their holdings may find the works of a broader range of artists than in many individual galleries.

There is also a lot of great folk art in the city of New York that, for one reason or another, falls through the cracks of the gallery, auction, and museum systems. New York has its own version of "dirt tracks"—be they housing projects, barrios, or other less familiar neighborhoods—yet one often has to approach the dirt tracks of New York with some degree of resourcefulness. For example, there is the gloriously imaginative sculpture of Gregorio Marzan, an artist who works with "surplus" materials in a small apartment, but whose vision is larger than life. Marzan, however, lives in Spanish Harlem in upper Manhattan, and the only way to see and buy his art is to visit him—which is easier said than done. Several years ago we bought a partially completed Statue of Liberty that Marzan was making of papier maché and industrial tape, but when it was finished we couldn't find anyone to go to his apartment—it is not located in the best of neighborhoods—to pick the work up. Finally a friend of many years, gallery owner Luise Ross, said she would do it if we hired a security guard to accompany her. We hired the guard, and she picked up our Statue of Liberty! Later, when the piece was included in an exhibition, it was reproduced in newspapers all over the country and received a great deal of attention—but it could not have been purchased in a gallery. You had to be willing to go into the barrio to find the artist and his work.

Max Romain, a Haitian-born artist, lives and paints in a Haitian neighborhood in Manhattan, and Jim Linderman (a new dealer to take note of) once took us there by subway. Romain's neighborhood was an experience for us. Hanging from lampposts, drawn on cement, and sitting on window ledges everywhere throughout the neighborhood were the voodoo symbols and hex objects of Haiti—it is no wonder that elements of these symbols appear in Romain's work! Knowing something about the artist and his environment does truly give a collector that second leg up—it is hard to comprehend fully the influences on the life of an artist in the somewhat sterile environment of an art gallery or museum.

We have friends who regularly visit the artist Bama, a mysterious character who works outdoors, making his large carvings on a bench just outside Central Park at 110th Street. Although he was not there on the two occasions we visited his outdoor workshop (and so we were unable to include him here), he may be a real find for some energetic and persistent collector. And there are many other such artists—Jim Linderman discovered Max Romain by riding a bicycle around the city—so keep your eyes open!

Although New York may represent a viewing and market center for contemporary folk art, other parts of the East have much to offer, both in terms of history and possibility. Before about 1950, adventurous collectors visited galleries from Boston and Cape Cod north to the Canadian border and west through Pennsylvania. These pioneer collectors acquired folk art objects ranging from Shaker furniture to duck decoys, weather-

vanes to fraktur and primitive portraits. Today these areas are still fertile hunting grounds for traditional folk art, but as the interest in contemporary folk art has increased, New York City has become the focal point for such work.

While there are many galleries of note in the Northeast, most outside New York continue to specialize in more traditional folk art; however, important finds can be made at the antique shows and flea markets that abound throughout this region. And as interest in the field continues to grow, additional galleries will undoubtedly begin to carry contemporary folk art, thus offering more opportunities for the collector.

For us, the grand old days of twentieth-century folk art centered around the home of Sterling and Dorothy Strauser in East Stroudsburg, Pennsylvania, in the 1970s and into the 1980s. Their collection honed our eye and gave us the necessary understanding to see folk art within the context of modern art. The Strausers collected the works of David Burliuk, Chaim Gross, Ben Johnson, Louis Eilshemius, Milton Avery, Red Grooms, and other internationally recognized artists; among these works they interspersed the paintings of self-taught artists such as Justin McCarthy, "Old Ironsides" Pry, Victor Joseph Gatto, and Jack Savitsky, all folk artists who became part of the now-famous "Strauser Circle." We recall with great fondness the many times when we would exchange friendly gossip over Dorothy's tea and cookies and trade our finds for theirs.

Sterling Strauser once said, "Follow your eye—buy only that which you can't live without." And that has been our motto too. Many a time we passed up a work of art and were punished by a sleepless night in a cold motel, only to arise at daylight to seek out the artist once more. As you search the byways and back ways of New York, New England, and other places on the East Coast for just the right piece of art for your collection, keep that thought in mind—and buy with passion.

AARON BIRNBAUM

Born July 18, 1895, Skola, then Austria-Hungary. Immigrated to New York in 1913. Now resides New York City.

Remembrances of his childhood in rural Poland as well as images from a long life in prefrenetic New York are the two themes Aaron Birnbaum pursues in his expressionistic paintings. The paintings—portraits of friends and family as well as of himself, of children in school, and of New York's garment district, where he worked for many years—have a sort of Old World charm, tempered by one man's imagination and the haze of years. His pictures are a highly original form of memory painting, one lacking in sentimentality and romance yet capturing the essence of the moment. "All my pictures are original," Aaron Birnbaum explains; "My way of thinking about what I passed through in my life."

Birnbaum, a retired tailor and designer of women's clothes, lost his wife around 1960. "I tried raising canaries for company," he said, "but they're a nuisance in the house, so I switched to painting [about 1960]. I'm a slave to work—it keeps my time going."

COLLECTING TIPS Birnbaum's work depicting the history of New York and its immigrant population is visually interesting and may become historically important. His dynamic portraits are also very collectible.

WHERE TO SEE ART Birnbaum's work has been shown at several art fairs in New York.

WHERE TO BUY ART Aaron Birnbaum is represented by K. S. Art in New York City.

2
REX CLAWSON

Born November 2, 1933, Dallas, Texas. Present whereabouts unknown (he may be in the New York City area).

Social and political satire with sexual overtones permeates Rex Clawson's colorful and stylistically bold paintings. Although his known work today was done some twenty to thirty years ago, it retains a very contemporary feel. A 1963 review in the *New York Herald Tribune* of a Rex Clawson exhibition noted that "Clawson paints wild, orgiastic and very amusing oils reminiscent of primitive painting in which a story is told . . . [through] a symbolic image." Another reviewer of his work wrote, "His paintings are rich in stylized visual incident . . . emblazoned with tattoos, and a parody of Byzantine linearism. . . ."

In the 1960s and early 1970s Clawson's work was exhibited at the ACA, Nordness Contemporaries, and Alan Stone galleries in New York; he then simply disappeared and was all but forgotten. The published accounts of his life, including his education (if any), cannot be verified. For example, he was supposed to have received art training as an apprentice to an old monk at a Benedictine monastery in Arkansas. According to the monastery records, Clawson attended school there for less than a week.

COLLECTING TIPS In the 1960s and early 1970s contemporary folk art was not a heralded genre, and galleries accordingly tried to fit artists into other categories, showing their work as mainstream art. Our investigation leads us to believe that Clawson is an extraordinary folk artist, and the collector who is able to find out more about the artist and his work will be lucky indeed!

WHERE TO SEE ART In 1971 the ACA Gallery in New York published a short illustrated brochure to accompany an exhibition of Clawson's paintings. Although the brochure lists five museums as having acquired Clawson paintings for their permanent collections, none of these museums, according to their records, have the artist's works.

WHERE TO BUY ART The Epstein/Powell Gallery in New York has located a few works by Rex Clawson through an antique dealer, and they are for sale. For those wishing to find one of Clawson's works, it is worth scouring flea markets, galleries, and antique shops; a painting by the artist does occasionally show up (one collector recently found one of Clawson's paintings at a flea market in New York City).

Born October 26, 1943, Gaston, North Carolina. Now resides New York City.

Monsters, humanoids, and animals from outer space fill the black-and-white drawings of Pearline Cruz. Less is more in the hands of this artist; she has developed a child's learning tool—the scratchboard—into an art form that expresses her inner visions. "These creatures come out of the top of my head," she explains. "The dreams I dream at night come back to me during the day."

Pearline Cruz spent years in a "squat house" in New York and was discovered through Tina White's Art Program for the Homeless. "I was kinda bored—I was sleeping all these years and art woke me up," she recently said.

COLLECTING TIPS

In addition to her carefully incised scratchboard work, Pearline Cruz also draws abstract designs on large sheets of drawing paper, using color to highlight her fierce otherworldly figures. Her scratchboard art, however, is particularly interesting, perhaps because of the novelty of the medium.

WHERE TO SEE ART

Cruz's work has been the subject of several newspaper articles (see, for example, *New York Daily News*, March 21, 1994), and her drawings, along with those of other homeless artists, were showcased at the Outsider Art Fair in New York City in 1994 and 1995. In October 1994 she was one of three American artists invited to participate in a group show of contemporary art at the Goethe-Institut, Staufen, Germany.

WHERE TO BUY ART

Cruz is represented by Art on the Edge in New York. Her work has also been shown at Ricco/Maresca in that city.

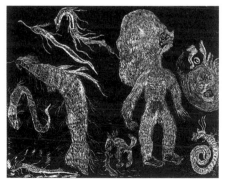

3 Pearline Cruz
Pearl's Party, 1994.
Scratchboard; 11 × 14 in.
(27.9 × 35.6 cm).
AMERICAN PRIMITIVE GALLERY.
PHOTO: JOHN BACK, COURTESY ART
PROGRAM FOR THE HOMELESS

4
POWELL (PAUL)
"GLASSMAN"
DARMAFALL

Born September 25, 1925, Moundsville, West Virginia. Now resides Baltimore, Maryland.

In order to create the colorful glass collages that gave him the nickname of "Glassman," Paul Darmafall finds broken bottles, smashes them into smaller pieces, and glues the resultant glass fragments to old boards. He is a self-described "Yankee Doodle Dandy"; his best collages depict patriotic images such as the early presidents, drum and bugle corps, the Statue of Liberty, and the American flag, but he can turn his glass shards into almost any image with the help of a little standard household glue. When the glue has dried and the sun reflects off the

glass, his art becomes a sparkling rainbow of beautiful colors. He also often incorporates printed messages into his pieces.

Darmafall can frequently be seen riding around Baltimore on a bicycle decorated with a glass flag as he goes about collecting broken glass for his work. ("It's a free country," he explains.) He has become a well-known attraction in that city—"In fact," he asserts, "that's how I got discovered. People got eyes in their heads!"

COLLECTING TIPS Darmafall's collages are fun to own and widely collected. Occasionally, however, shards of glass may fall from the works. When this happens, most collectors glue back only the larger pieces and let the small ones go; trying to glue everything back in place is tantamount to doing a real jigsaw puzzle! Those interested in collecting Darmafall's work should try to purchase works that have some age, so that they can satisfy themselves that the glass is securely glued in place.

WHERE TO SEE ART Darmafall's work is included in "Passionate Visions of the American South," a traveling exhibition organized by the New Orleans Museum of Art (1993).

WHERE TO BUY ART Darmafall is represented by Marilyn Gabor in Baltimore, Maryland. His work also turns up at such galleries as the Folk Art Gallery (formerly Cognoscenti), also in Baltimore; the Gasperi Gallery in New Orleans, Louisiana; and the Tartt Gallery in Washington, D.C.

"Glassman" (Darmafall)

5
KEN GRIMES

Born July 16, 1947,
New York City. Now resides
New Haven, Connecticut.

An exponent of extraterrestrial art, Ken Grimes sends signals to outer space as he tries to understand certain phenomena—flying saucers and crop circles, for example—that he believes to be messages to him from extraterrestrial intelligence. Grimes's paintings are always black-and-white, with black representing outer space and white representing light or cosmic truth. He has developed a language of signs, shapes, and symbols that formulate his personal response to psychic phenomena. "I always paint words in addition to cryptographic replies," the artist explains, "because pictorial scenes do not appear in my visions."

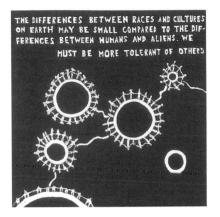

THE DIFFERENCES BETWEEN RACES AND CULTURES ON EARTH MAY BE SMALL COMPARED TO THE DIFFERENCES BETWEEN HUMANS AND ALIENS. WE MUST BE MORE TOLERANT OF OTHERS

5 Ken Grimes
Must Be More Tolerant of Others, 1993.
Acrylic on canvas; 48 × 48 in.
(121.9 × 121.9 cm).
RICCO/MARESCA GALLERY.

Ken Grimes reads a lot about astronomy and science fiction: "I've over one hundred books on these subjects," he says, "but I believe that the best way to communicate with outer space is through the universality of art." On his forty-seventh birthday, Grimes received another message—chunks of a comet crashed into Jupiter.

COLLECTING TIPS Some collectors will be interested in Grimes's paintings and cryptographic messages for their contribution to popular science or science fiction. We, however, see them as a form of black-and-white calligraphy. Those who wish to collect his work will make their own determinations.

WHERE TO SEE ART Grimes was included in "Twentieth Century Self-Taught Artists from the Mid-Atlantic Region," a 1994 exhibition developed by the Noyes Museum, Oceanville, New Jersey. In the fall of 1995 his paintings were shown in Cologne, Germany. The work of Ken Grimes has also been exhibited at several art fairs.

WHERE TO BUY ART Ken Grimes is represented by the Bridges + Bodell and Ricco/Maresca galleries in New York City.

6
BERTHA A. HALOZAN

Born in Graz, Austria; birth date unknown. Has resided in New York City since 1956.

Bertha Halozan loves New York (rare enough these days), but her unique vision of New York "the beautiful" sometimes includes the red tile roofs of the Austrian village where she grew up. Halozan paints a pigtailed, blue-eyed Statue of Liberty, surrounded by the busy activities of daily life in New York—often a Mets baseball player, John Franco, is thrown in for good measure in the middle of the harbor. "I went down to the Statue of Liberty, lay in the grass, got happy again, and just started to paint," she explains of her unusual portrayal.

"When the weather is good, health permitting, I go into the streets and display my art—just to show it," she says. A former singer, Halozan pastes reviews of a Carnegie Hall recital on the back of her paintings—a recital at which she sang such songs as "How Much Is That Doggie in the Window?"

COLLECTING TIPS	Halozan's favorite subject matter includes the Statue of Liberty, John Franco, and the Goodyear blimp. Among collectors of her work, the Statue of Liberty is her most popular portrayal. Her paintings are fun to own and likely to appreciate as they find their way into museums.
WHERE TO SEE ART	We were able to make an appointment with Halozan through Jim Linderman, a private dealer who has a good relationship with the artist, and went to her apartment to see her work. If you are lucky enough to catch Halozan on the street, however, it can be a lively experience.
	Halozan's paintings are in the permanent collection of the New York State Historical Association at Cooperstown, New York.
WHERE TO BUY ART	Bertha Halozan will sell paintings only when she is in the mood (Jim Linderman helped us get ours). Sometimes galleries and dealers in New York that specialize in folk art, such as Epstein/Powell, are able to pick her paintings up, and they sell fast. Gallery 53 Artworks in Cooperstown, New York, and the Folk Art Gallery (formerly Cognoscenti) in Baltimore, Maryland, also handle her work.

7
RAY HAMILTON

Born April 20, 1919, Williamston, South Carolina. Now resides Brooklyn, New York.

Ray Hamilton has developed two apparently unrelated painting styles. One is rural and naive, the other urban and sophisticated; together they represent the two environments in which he has lived. Memories of his life on a farm result in paintings of farm animals—such as horses, chickens, and pigs—and people in undefined open spaces; when working in his alternate style, he traces objects such as eyeglasses, canes, and pens, then fills in the space around them with columns of numbers. In his rural scenes the artist starts with line drawings that he then fills in with watercolors—in whatever color comes to mind, whether realistic or not. His urban still lifes, however, are essentially monochromatic, with little use of color.

Ray Hamilton, who is mentally and physically disabled, began his artistic career in 1985. Encouraged by Hospital Audiences, Inc. (HAI), he has developed into a very successful artist.

COLLECTING TIPS	We like Hamilton's drawings of animals and his occasional characterizations of people, but his urban style also has its own appeal, reminding some collectors of several of the European painters popular in the 1950s and 1960s who repeated images (such as the Italian painter Giuseppe Capogrossi, for example).
WHERE TO SEE ART	Ray Hamilton participated in a number of exhibitions sponsored by HAI in the New York area during the late 1980s and 1990s. He was also included in "Art's Mouth," a 1991 exhibition at Artists Space, New York City (his work is illustrated in the catalog for that show), and in "Drawing Outside the Lines: Works on Paper by Outsider Artists," Noyes Museum, Oceanville, New Jersey, in 1995.

Bertha Halozan

<table>
<tr><td>WHERE TO BUY ART</td><td>Ray Hamilton is represented by the Luise Ross Gallery and by K. S. Art in New York City.</td></tr>
</table>

8

JOHN HARVEY

Born June 9, 1951, Junction City, Georgia. Resided and worked in Bridgewater, Massachusetts. Now resides New York area; spends some time in Georgia.

John Harvey, a painter who was introduced to art while incarcerated in Bridgewater, Massachusetts (he was convicted of robbery at the age of seventeen and has been in and out of prison ever since), depicts sex, violence, and an intense personal identification with the Bible. Despite a warning by a preacher that the violence depicted in some of his art might interfere with his release from prison, Harvey has continued to take every opportunity to create his mysterious and sometimes menacing paintings.

In spite of a tormented youth that included serious bouts with alcohol, Harvey is imbued with a fervor that grew out of his Baptist upbringing; this fervor comes through in his work, although some of his religious symbolism is obtuse. According to this artist, dogs are the "backbone of the Bible and represent all that is evil"; in one of his paintings, for example, he depicts a dog, dressed as a priest, acting as a pimp and taking money. Harvey sometimes paints bold messages across his work that seem to come from the deep reaches of his subconscious.

COLLECTING TIPS — All of Harvey's paintings are very powerful, but some collectors will prefer his quieter paintings laced with biblical texts to the ones that depict violence or explicit sexual acts. His painted messages can add interest to his compositions.

WHERE TO SEE ART — Harvey was included in a prison art show in 1987; his paintings sold, and word of his work spread. He was subsequently exhibited at the Cavin-Morris and Phyllis Kind galleries in New York City. His paintings were illustrated in an article, "John Harvey: No More Dark Places," in *Raw Vision, International Journal of Intuitive and Visionary Art,* No. 8, Winter 1993–1994.

WHERE TO BUY ART — John Harvey is represented by Cavin-Morris, Inc., in New York City.

9
LAWRENCE LEBDUSKA

Born 1894, Baltimore, Maryland.
Died 1966, New York City.

Lawrence Lebduska's pastoral and fantasy paintings brought him some renown in the 1930s and early 1940s, but it is only since his death that he has been generally acknowledged by the art world as a major twentieth-century folk artist. Lebduska painted to please himself, but today his work touches a much larger audience.

Lebduska's painted fantasies and pastoral fables were based on childhood recollections, fairy tales, Czech folklore (he was trained in Czechoslovakia as a stained-glass maker), biblical scenes, and personal observation. He was fond of horses, and so horses—and occasionally unicorns and people—surrounded by colorful and almost surreal reminders of nature, frolic under often-bucolic conditions in his paintings. He also did a few portraits of people to whom he felt close, or who had helped him.

COLLECTING TIPS

Lebduska made a number of delightful crayon drawings in the same style as his canvases. These are now very much sought after and less expensive than his paintings.

At one time Lebduska's paintings were all but forgotten. In recent years, however, his reputation has been restored, a fact reflected in the rising prices of the artist's work.

WHERE TO SEE ART

Lebduska's work has been acquired by many museums, including the Metropolitan Museum of Art and the Museum of Modern Art, New York City; the Abby Aldrich Rockefeller Folk Art Center, Williamsburg, Virginia; and the Milwaukee Art Museum, Wisconsin.

WHERE TO BUY ART

Because Lebduska's work is for the most part scattered among important private collections, it is difficult and expensive to acquire. Collectors interested in obtaining his work should inform their dealers so that they can be notified when one becomes available. The Epstein/Powell Gallery in New York City has a few of Lebduska's works on hand.

From time to time Ledbuska's paintings and drawings come up at auction; houses such as Sotheby's and Christie's maintain lists of those interested in purchasing contemporary folk art and notify these people when appropriate objects are to be auctioned.

10
THEODORE "TED" LUDWICZAK

Born January 2, 1926, Mlawa,
Poland. Has resided in Dutch
Town (north of New York City in
Rockland County), New York,
since 1956.

Ted Ludwiczak carves gremlinlike faces from rocks he finds along the banks of the Hudson River. He has created his own environment, a seawall composed of these faces chiseled out of rock at the edge of his yard on the west bank of the Hudson; some of these rock faces are removable, and these the artist sells. Ludwiczak's faces, staring back at river traffic, have put Dutch Town on the map.

When he was a student in Poland, Ludwiczak was assigned to work on the docks, loading ships; he decided to "take a ride" and eventually came to America. An American citizen since 1961, Ludwiczak retired from a job grinding eyeglasses in 1986.

Ted Ludwiczak

Shortly thereafter, he explains, "I started a seawall and came upon a rock that looked like it had something in it. I gave that rock a hit and a face popped out." Once he started, face after face appeared in his rocks. The artist's only tools are a sharpened railroad spike and a lawnmower blade.

COLLECTING TIPS All of Ludwiczak's rock faces are interesting. Sometimes the artist affixes the heads to irregular stone bases with railroad spikes. These heads look like they belong to the bases; they are generally preferable to the heads that have to be supported on fabricated bases.

Ludwiczak's dealer, Aarne Anton, informs us that he has one head that is four feet high. A stone piece of this size would make a spectacular outdoor display.

WHERE TO SEE ART Ludwiczak's seawall is an amazing sight. We contacted Aarne Anton at the American Primitive Gallery in New York, and he arranged a tour for us.

WHERE TO BUY ART The American Primitive Gallery in New York is the exclusive representative of the artist.

11
JUSTIN
McCARTHY

Born May 13, 1892, Weatherly, Pennsylvania. Died July 14, 1977, Tucson, Arizona.

Through his paintings and drawings Justin McCarthy commented on the lifestyles and interests of the people of his time. He portrayed popular figures, movie stars, sports heroes, high fashion figures, and everyday people, all without glamour or glitter and with a sparkling sense of humor. The artist was as eclectic in his choice of materials as he was in his subject matter.

The legend of Justin McCarthy—the recluse who lived in a decaying mansion next door to Tweedle Park in Weatherly, Pennsylvania, and painted his way into an exhibition at the Museum of Modern Art—is a matter of history. McCarthy was one of the most famous artist members of the so-called Strauser Circle (he was discovered by Sterling Strauser's wife Dorothy at an outdoor show in Stroudsburg, Pennsylvania), and his reputation as a painter continues to grow.

COLLECTING TIPS McCarthy had a prodigious output of work, including oil paint-
ings, drawings, and collages. His subject matter was equally
broad—people, flowers, and animals. His best and most dra-
matic works were his figurative paintings dating from about
1962 to 1965. McCarthy's art has shown a steady appreciation
since his death in 1977; his oil paintings are more valuable than
his drawings, but there isn't a work by this artist that isn't col-
lectible today.

WHERE TO SEE ART Justin McCarthy is included in the permanent collections of
many important museums, such as the Abby Aldrich Rocke-
feller Folk Art Center, Williamsburg, Virginia; the Museum
of American Folk Art, New York City; the Smithsonian In-
stitution's National Museum of American Art, Washington,
D.C.; the Milwaukee Art Museum; the Akron Art Museum,
Akron, Ohio; the Birmingham Museum of Art, Alabama; and
the New Orleans Museum of Art.

McCarthy was included in the exhibitions "Made with
Passion" at the Smithsonian Institution's National Museum
of American Art in Washington, D.C. (1991), and "Made in
USA" at the Collection de l'Art Brut in Lausanne, Switzer-
land (1993).

WHERE TO BUY ART Much of McCarthy's work is closely held in several private
collections, but some pieces occasionally appear in various gal-
leries, including Epstein/Powell, Luise Ross, and Jim Linder-
man in New York; the Lyzon Gallery, Nashville, Tennessee;
the Tartt Gallery, Washington, D.C.; and the Janet Fleisher
Gallery, Philadelphia.

1 2
R A Y M O N D
M A T E R S O N

Born March 14, 1954,
Milford, Connecticut.
Now resides New York State.

Substance abuse led Raymond Materson into a life of crime;
until recently paroled, he was serving a fifteen-year sentence at
Carl Robinson Correctional Institute in Enfield, Connecticut,
where he made intricate miniature tapestries (2¼ × 2¾ in./
5.7 × 7 cm is his standard size) that depict autobiographical
and historical events. The vivid horrors of drug addiction and
the catastrophic consequences of alcohol use are two recurring
themes in his work. "The high I get sewing," he explains, "sur-
passes the high from a hypodermic needle. It helps me to leave
everyday life."

Prison rules designed to protect the inmates limited Mater-
son's choice of materials. He weaves the hard way—on a home-
made Rubbermaid-jar-top loom, using colored threads that
he obtains by unraveling socks; his work is sewn onto pieces
of cotton taken from boxer shorts.

Materson married while in prison, and his new wife, Mela-
nie Olander Materson, brought his miniature tapestries to the
attention of art dealers in New York.

COLLECTING TIPS Materson's tapestries will be of special interest to collectors
who appreciate miniaturization. Some of the subject matter is

fairly graphic, but other pieces are easy to live with; the works sell almost as fast as he can make them.

Where to See Art Materson was included in "Thread Bare: Revealing Content in Contemporary Fiber" at the Southeastern Center for Contemporary Art, Winston-Salem, North Carolina (1995). He will be featured in a touring exhibition, "Recycled, Re-Seen: Folk Art from the Global Scrap Heap" (1996), organized by the Museum of International Folk Art, Santa Fe, New Mexico, and his work is in the permanent collection of that museum. Materson's work has also been exhibited at various art fairs.

Where to Buy Art Materson is represented by the American Primitive Gallery in New York City.

1 3
LAMONT ALFRED "OLD IRONSIDES" PRY

Born February 12, 1921, Mauch Chunk (now Jim Thorpe), Pennsylvania. Died November 28, 1987, Weatherly, Pennsylvania.

The three loves of Lamont Alfred Pry—circuses, aircraft (especially those of World War I vintage), and Susan, a nurse (whether real or imaginary is unclear)—appear as major themes in the paintings of this artist who signed his works "Old Ironsides Pry." Often he combined two or more of the themes, showing, for example, Susan on a trapeze in the circus or on the wing of a biplane. All of Pry's works are bright and boisterous and show an uninhibited use of color. Some contain written messages that tell the viewer exactly what is going on.

Pry began to paint shortly after he was admitted to the Carbon County Home for the Aged (1968). In 1974 he was discovered by Pennsylvania artist and folk art collector Sterling Strauser and soon became a member of the famous Strauser Circle of folk artists.

Collecting Tips Pry's early paintings, done before his health began to deteriorate in the 1980s, are his most important; many consider his circus scenes to be the artist's finest work. Some collectors are fearful that the cardboard Pry painted on might not hold up well, but we have owned works by this artist for almost twenty years, and to date there has been no sign of deterioration.

Where to See Art The work of "Old Ironsides" Pry is in a number of museums, including the Birmingham Museum of Art, Alabama; the Miami University Art Museum, Oxford, Ohio; the New Orleans Museum of Art; and the Smithsonian Institution's National Museum of American Art, Washington, D.C. His paintings have been illustrated in many catalogs and books on twentieth-century folk art.

Where to Buy Art The work of "Old Ironsides" Pry can be found in New York City at Epstein/Powell and Jim Linderman Folk and Outsider Art. It is also handled by the Lyzon Gallery, Nashville, Tennessee, and Webb and Parsons, Burlington, Vermont.

14
SULTON ROGERS

Born May 22, 1922, near Oxford, Mississippi. Now resides Syracuse, New York.

Sulton Rogers carves out his dreams—what he calls "futures" —but dreams that are apparently filled with vampires, strange men and women with long tongues, snakes with large fangs, and male and female devils. Rogers, a fast-rising star in the folk art world, brags that he "can make most anything I can imagine a future of." Occasionally he builds large houses populated with the ghosts that haunt his dreams. Sometimes he will carve his own funeral, complete with a self-portrait in a coffin; in other carvings, men and women may be captured in explicit sex acts.

Sulton Rogers is a master of the art of figurative carving as well as an expert carpenter. He started to make art to keep awake while on the job (his job was overseeing equipment for Allied Chemical—as long as the machinery operated properly, he had little to do); he has now created a large variety of figurative sculpture that is finding its way into important exhibitions and museum collections.

COLLECTING TIPS

In the long run Rogers's tableaux—his ghost houses, funeral scenes, and so forth—will probably prove to be more valuable than the individual figurative sculpture, but the individual pieces are also quite intriguing.

WHERE TO SEE ART

Rogers's work, which was included in "Black Art—Ancestral Legacy: The African Impulse in African-American Art," Dallas Museum of Art (1989), and "Passionate Visions of the American South," New Orleans Museum of Art (1993), is in various museum collections, such as the University of Mississippi Art Museum and the State Historical Museum in Jackson, Mississippi; the African American Museum in Dallas, Texas; the New Orleans Museum of Art, Louisiana; and the New York State Historical Association, Cooperstown, New York.

WHERE TO BUY ART

Sulton Rogers travels between Syracuse, New York, and Oxford, Mississippi. If you can catch up with him, he'll sell his work. His carvings are also carried by many galleries, such as Gallery 53 Artworks in Cooperstown, New York; Ginger Young Gallery/Southern Self-Taught Art, Chapel Hill, North Carolina; Bruce Shelton Self-Taught Art, Nashville and Palm Beach; and the Folk Art Gallery in Baltimore, Maryland, among others.

15
MAX ROMAIN

Born March 7, 1930, Port-au-Prince, Haiti. Has resided in Riverdale (the Bronx), New York, since 1957.

A self-taught American of Haitian birth, Max Romain combines his Haitian heritage with his subconscious feelings about sex, religion, and the people around him. He often includes elements of voodoo culture in his paintings—"Voodoo is strong in New York," he declares. "And why not? It's a free country!"

Max Romain creates his drawings with trancelike concentration. "I don't know what they are about [the drawings], I just take the pencil and work," he states. There is a well-documented history of primitive painting in Haiti, but Ro-

main's art is very different from the traditional Haitian paintings—he combines his own unique outlook with a touch of New York and a touch of island life.

COLLECTING TIPS The drawings that relate to or incorporate facets of Haitian religious practices are very strong, but the choice is largely a matter of personal taste; we like almost all of this artist's work. In some of Romain's earliest drawings (about 1989), the artist, in learning how to use his material, pressed too hard against the paper with pens and pencils, resulting in minor tearing. As long as it does not interfere with the major images, this does not bother us—it is one way to date his work—but some collectors may be concerned about such damage.

WHERE TO SEE ART Romain was first exhibited at the Donnell Branch of the New York City Public Library on Fifty-third Street in 1991. He was also featured in and illustrated in the catalog for the exhibition "Made in USA," Collection de l'Art Brut, Lausanne, Switzerland (1993), and in the Noyes Museum show, "Twentieth Century Self-Taught Artists from the Mid-Atlantic Region," Oceanville, New Jersey (1994). The artist's work is frequently exhibited at outsider/folk art events, such as the annual Outsider Art Fair in New York.

WHERE TO BUY ART Romain's drawings are available from Jim Linderman, a private dealer who discovered the artist at the New York City Public Library show. He also exhibits with American Primitive Gallery in New York City, and Epstein/Powell, another New York gallery, has some examples of Romain's work.

16
ELLIS RULEY

Born December 3, 1882, Norwich, Connecticut. Died January 16, 1959, Norwich.

Ellis Ruley's paintings are a striking distillation of popular images as seen through the sensitive eye of an artist. The son of a former slave, Ruley entered into an interracial marriage and was found dead along a roadside under mysterious circumstances. Like his death, much of his life remains a mystery, but it is clear that Ruley was filled with an underlying compulsion to paint.

Ruley's work has long been collected by folk art aficionados, but it was due to the dedication and research of Glenn Robert Smith *(Discovering Ellis Ruley)* that his life story became an important part of the literature in the field.

COLLECTING TIPS Most of Ruley's paintings were done on Masonite and posterboard. Over the years some of the material has been worn and even torn, and in some cases the paint has flaked off. Although the condition of the paintings does not discourage most collectors, works that are relatively intact are generally the most desirable. The paintings are signed with a stamp, "Ellis W. Ruley."

There are more bidders than sellers for Ruley paintings, so the prices are going to be high.

E

WHERE TO SEE ART All of the sixty-two known paintings by Ruley (and there may be more out there) are reproduced in *Discovering Ellis Ruley.* Some of these paintings were shown in 1993 at the Museum of American Folk Art in New York City, and a major traveling exhibition of his work, organized by the San Diego Museum of Art, opened at the High Museum of Art, Folk Art and Photography Galleries in Atlanta, Georgia, in April 1995. Ruley's paintings are in several museum collections, including the Slater Memorial Museum, Norwich, Connecticut, and the Wadsworth Atheneum, Hartford, Connecticut.

WHERE TO BUY ART All of Ruley's known paintings are in public or private collections. The Janet Fleisher Gallery in Philadelphia, Pennsylvania, was responsible for the original sale of many of these works; that gallery informs us that it has lists of potential purchasers, and offers are spiraling upward.

· 1 7
JOHN "JACK" SAVITSKY

Born January 24, 1910, New Philadelphia, Pennsylvania. Died December 4, 1991, Lansford, Pennsylvania.

Jack Savitsky, who referred to himself as "Coal Miner Jack," chronicled the life and times of the Pennsylvania coal country—its miners, its hillside towns, and the miner's workplace deep within the shafts sunk beneath the earth's surface. He is the only major folk artist to have illustrated the dangers, drudgery, and hard lives of the men working in coal mines during the early years of the twentieth century. For this reason, his work is historically as well as artistically important.

Savitsky himself was a coal miner until he became disabled by black lung disease; then he began to paint the miners' stories. By the early 1960s he had become one of the famous Strauser Circle of folk artists (Sterling and Dorothy Strauser are Pennsylvania artists who discovered and encouraged a number of local area artists), and by the mid-1970s he had established a reputation as one of the premier self-taught artists working in America.

COLLECTING TIPS Savitsky's best work was done in the period from about 1961 to 1978. As he became better known, he began to be influenced by the demands of collectors, and by 1979 he was repeating his popular themes. He thought that a folk artist should draw flat, sticklike figures, and he drew more and more of them, even though he was a very capable draftsman.

Savitsky also made a number of pencil-and-crayon drawings of miners at work. These highly personal renditions on paper are in many instances as interesting as his oils, and they are far less expensive to purchase.

WHERE TO SEE ART Savitsky's paintings are in a number of museum collections, including the Museum of American Folk Art in New York City, the Milwaukee Art Museum, and the Smithsonian Institution's National Museum of American Art in Washington, D.C.

(continued on page 61)

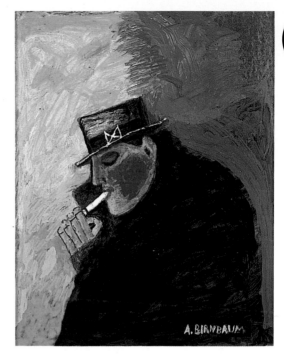

▌ Aaron Birnbaum
*Self-Portrait at Age
Nineteen,* 1990.
Acrylic varnish, Masonite,
metal frame; 24 × 18 in.
(61 × 45.7 cm).
K. S. Art. Photo: Kerry Schuss

▌ Aaron Birnbaum
Kolosseum, 1994.
Acrylic and varnish on wood;
24 × 24 in. (61 × 61 cm).
K. S. Art. Photo: Kerry Schuss

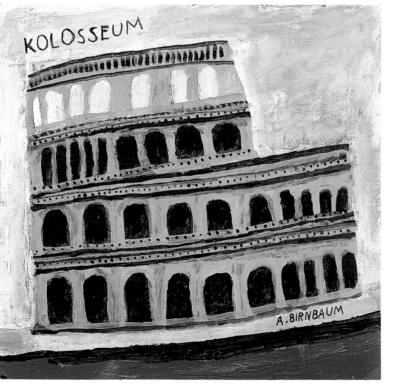

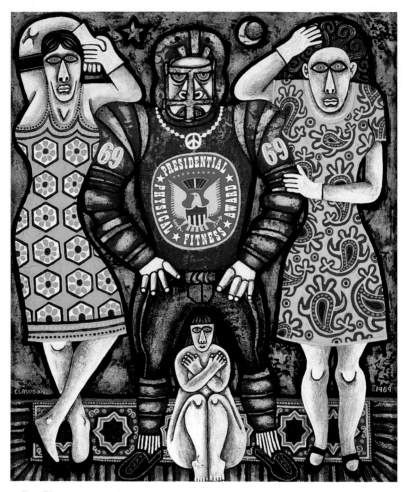

2 Rex Clawson
*Athletic Hero with
Groupies,* undated.
Enamel paint on board;
17 × 14 in. (43.2 × 35.6 cm).
EPSTEIN/POWELL GALLERY.

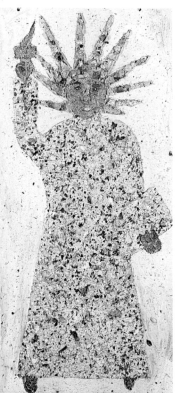

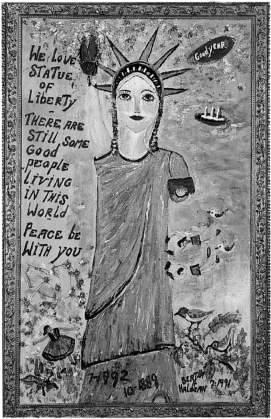

4 Powell (Paul) "Glassman"
Darmafall
Statue of Liberty, 1992.
Glass, mixed media on board;
44 × 18 in. (111.8 × 45.7 cm).
RICHARD D. GASPERI.
PHOTO: WILL DRESCHER

6 Bertha A. Halozan
Statue of Liberty, 1991.
Oil paint and glitter on canvas;
35½ × 21½ in. (90.2 × 54.6 cm).
NEW YORK STATE HISTORICAL
ASSOCIATION, COOPERSTOWN.

7 Ray Hamilton
Multi-Colored Horses, 1993.
Watercolor, ink, paper;
17 × 14 in. (43.2 × 35.6 cm).
K. S. Art. Photo: Kerry Schuss

8 John Harvey
Three for the Price of a Dog,
c. 1992.
Acrylic paint on canvas;
36 × 51 in. (91.4 × 129.5 cm).
Chuck and Jan Rosenak.
Photo: Lynn Lown

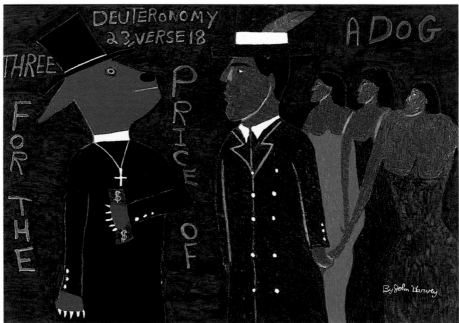

9 Lawrence Lebduska
Panicky Horses, 1957.
Oil on canvas; 29½ × 39½ in.
(74.9 × 100.3 cm).
Private collection.

10 Theodore "Ted" Ludwiczak
Untitled, 1993.
Carved sandstone.
American Primitive Gallery.
Photo: John Back

11 Justin McCarthy
Rachmaninoff Concerto,
1962–1963.
Oil on Formica; 26½ × 42 in.
(67.3 × 106.7 cm).
ABBY ALDRICH ROCKEFELLER FOLK
ART CENTER, WILLIAMSBURG.

12 Raymond Materson
*Public School Girls
(Ave Maria),* 1994.
Cotton (unraveled socks,
boxer shorts); 2¼ × 2¾ in.
(5.7 × 7 cm).
AMERICAN PRIMITIVE GALLERY.
PHOTO: JOHN BACK

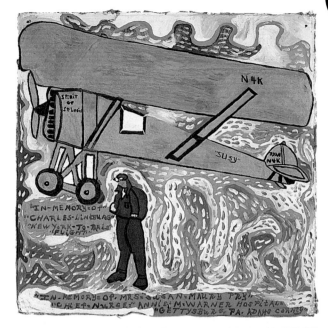

13 Lamont Alfred "Old Ironsides" Pry
In Memory of Charles Linburg, c. 1978.
Paint on cardboard;
18¾ × 18½ in. (47.6 × 47 cm).
PAT PARSONS GALLERY.

13 Lamont Alfred "Old Ironsides" Pry
Red Airplane, undated.
Acrylic and marker on cardboard; 12 × 16 in.
(30.5 × 40.6 cm).
LYZON FINE ART.

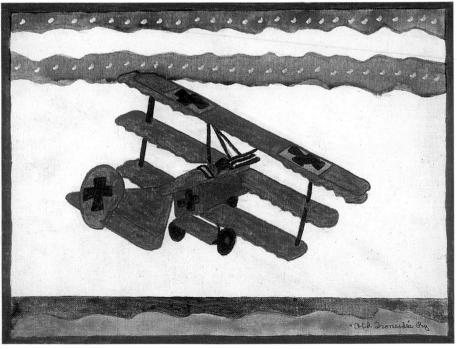

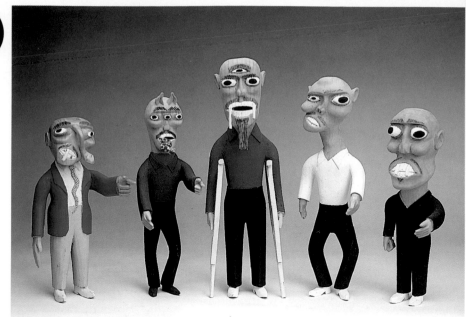

▲ **14** Sulton Rogers
Five Haints, 1989. Wood, paint; 10 ×
4 × 3 in. (25.4 × 10.2 × 7.6 cm) to
13½ × 4½ × 3½ in. (34.3 × 11.4 × 8.9 cm).
WARREN AND SYLVIA LOWE.

▼ **14** Sulton Rogers
Devil Family, 1989.
Wood, paint; 11 × 13 × 9 in.
(27.9 × 33 × 22.9 cm).
WARREN AND SYLVIA LOWE.

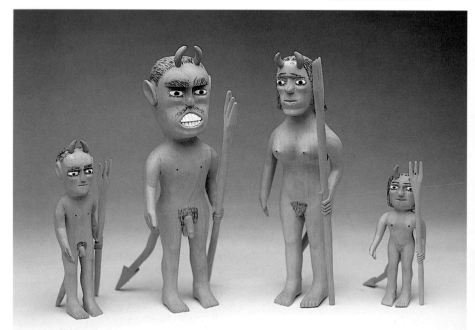

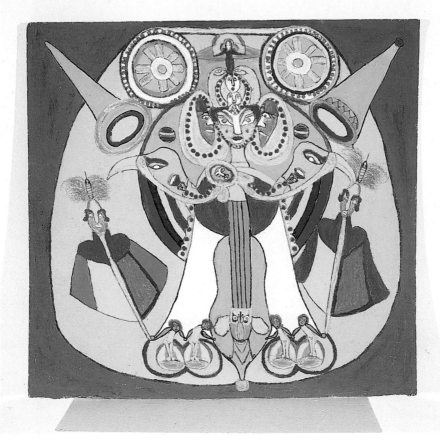

15 Max Romain
Untitled, c. 1992.
Acrylic on Masonite; 25 × 26 in.
(63.5 × 66 cm).
AMERICAN PRIMITIVE GALLERY.
PHOTO: DONALD WALLER

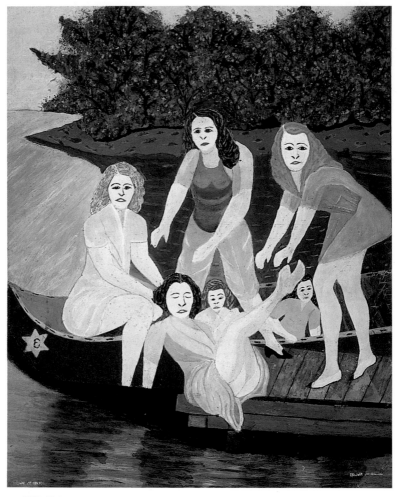

16 Ellis Ruley
Southmore, Taking a Bath with the
Seneoras, mid-twentieth century.
Oil-based house paint on
posterboard; 28 × 22 in.
(71.1 × 55.9 cm).
COURTESY OF GLENN AND
LINDA SMITH.

17 John "Jack" Savitsky
Miners Drilling Coal, 1966.
Colored pencil.
Jim Linderman Folk Art.

18 Phillip Travers
Tut Project, 1994.
Marker, ballpoint, colored pencil,
paper; 24 × 18 in. (61 × 45.7 cm).
K. S. Art. Photo: Kerry Schuss

19 Inez Nathaniel Walker
Red Person and Brown Person,
1977. Mixed media; 22 × 28 in.
(55 × 71.1 cm).
Pat Parsons, Webb and
Parsons North.

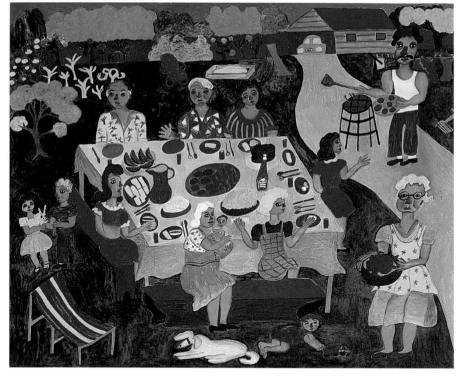

20 Malcah Zeldis
Family Picnic, 1977.
Acrylic on canvasboard;
24½ × 30 in. (62.2 × 76.2 cm).
Chuck and Jan Rosenak.
Photo: Lynn Lown

(continued from page 48)

WHERE TO BUY ART

Savitsky's estate is represented by his son Jack Savitt, who runs the Jack Savitt Gallery in Macungie, Pennsylvania. Works by the artist can also be found at other galleries, such as Epstein/Powell and Jim Linderman Folk and Outsider Art in New York.

E

18

PHILIP

TRAVERS

Born March 21, 1914, New York. Now resides New York City.

Working with colored pencils and pens on posterboard, Philip Travers has invented a cartoonlike language of his own; says the artist in explanation, "I interact with the science fiction in my imagination." In the strange world of Travers's imagination, King Tut is always present (Travers has been an Egypto-phile since the King Tut exhibition a number of years ago), but often a little bit of Alice in Wonderland may add humor to the drawings, and a bit of the occult adds mystery. The artist helps us to understand the adventures he depicts by including printed explanatory matter within the drawings.

Travers has had hundreds of jobs, "some for less then fifteen minutes," he admits. He tried to study art at the Art Students' League in 1940, but he had no use for watercolors, fought with his famous teacher George Grosz, and left before the first session was concluded. Philip Travers has to do things his way, but he is now having some late-in-life success.

COLLECTING TIPS

Some of Travers's drawings, especially the ones that emphasize Alice in Wonderland characters, may appear too cartoonish. For this reason, we prefer the drawings that illustrate his other themes—science fiction and political satire.

WHERE TO SEE ART

Philip Travers was included in the exhibition and illustrated in the catalog of "Art's Mouth" at Artists Space, New York City (1991), and his work was shown in "Drawing Outside the Lines: Works on Paper by Outsider Artists," Noyes Museum, Oceanville, New Jersey (1995). He has also been exhibited at folk and outsider fairs and gallery exhibitions in New York City and Los Angeles.

WHERE TO BUY ART

Travers is represented by K. S. Art in New York City and the Liz Blackman Gallery in Los Angeles.

19

INEZ

NATHANIEL

WALKER

Born 1911, Sumter, South Carolina. Died May 23, 1990, Willard, New York.

Inez Nathaniel Walker is famous for her striking images of women. She started to draw in prison to protect herself, she said, from "all those bad girls" with her in the correctional facility (Walker served time for the "criminally negligent homicide" of a male acquaintance who had abused her). Walker's characterizations of those "bad girls" stare straight at the viewer, regardless of the position of their heads. The artist concentrated on her subjects' eyes, hairstyles, and clothing. Dressed in bright frocks, chatting together or posed alone, they stand or sit stiffly, often in front of geometrically patterned backgrounds that perhaps represent wallpaper or perhaps are simply intended as geometric abstractions. Many of her images show only heads and shoulders; when the figures are shown

full length, they stand on tiny, delicate feet; their bodies are usually foreshortened, and their skin tones range in color from bright red to dull brown.

Although an occasional male might make an appearance in her work, her portraits of women have earned Walker her reputation as one of the most important black artists of the century. She also did a few drawings of a fat and clearly unhappy baby; these are hard to find, and their imagery remains unexplained.

COLLECTING TIPS
Walker's early drawings are signed "Inez Nathaniel," the later ones "Inez Nathaniel Walker" or "Inez Walker" (she remarried after leaving prison). In general, her work is of uniformly high quality. The majority of her works are fairly small (about 12 × 18 in./30.5 × 45.7 cm); her larger works (42 × 30 in./106.7 × 76.2 cm) are rare—only about twenty exist—and these are usually considered the most valuable.

WHERE TO SEE ART
Walker's drawings are in the Collection de l'Art Brut in Lausanne, Switzerland, and L'Aracine, Neuilly-sur-Marne, near Paris, as well as in a number of museums in this country, such as the Museum of American Folk Art, New York; the Museum of International Folk Art, Santa Fe, New Mexico; the Milwaukee Art Museum; and the Smithsonian's National Museum of American Art, Washington, D.C. Since the early 1980s Walker has been included in almost every major folk art book and catalog that includes the work of black folk artists.

WHERE TO BUY ART
Inez Nathaniel Walker's principal representative is Pat Parsons, Webb & Parsons, Burlington, Vermont. Her work is also in other galleries, including the Berman Gallery, Atlanta; the Hill Gallery, Birmingham, Michigan; and the Phyllis Kind and Frank J. Miele galleries in New York City.

**20
MALCAH AND
DAVID ZELDIS**

Malcah, born September 22, 1931, the Bronx, New York. Now resides New York City. David, born January 22, 1952, Beersheba, Israel. Came to the United States, 1957; now resides New York City.

The vividly colored paintings of Malcah Zeldis, one of America's most popular self-taught artists, celebrate her life, her heroes (she is a great admirer of Abraham Lincoln, for example), and major religious and historical events. She employs a lively narrative style to express her philosophy of life and her religious and personal beliefs, and she often includes herself as a character in her paintings, even when she is depicting a historical event or a fairy tale.

Zeldis began to paint when she was living on a kibbutz in Israel in the 1950s, but after a well-known Israeli artist critiqued her work—noting, in the process, that he thought "a great artist is living in this kibbutz"—she was so overwhelmed that she did not paint again until after she returned to New York in 1958.

Malcah's son, David, is also an artist, but his work is very different from his mother's. Hers is bold, colorful, and expressionistic, while he is known for his small, quiet, and deliberately surrealistic drawings, many of which are done in black and white, of desert scenes, desert animals, and occasionally people.

Collecting Tips Malcah Zeldis has been a favorite of those collectors who moved from the romantic art of the early twentieth century to the folk art that is popular today. In this sense, her work has served as a bridge between the two. Her paintings are of uniformly high quality and a delight on the walls; serious collectors of contemporary folk art will want to consider her work for their collections.

E

20 David Zeldis
Man Sleeping in Street, 1979.
Pencil on paper; 10 × 12 in.
(25.4 × 30.5 cm).
COURTESY LUISE ROSS GALLERY.

Where to See Art Malcah Zeldis's paintings have been widely exhibited in any number of places. Of special note is her one-person exhibition, "Malcah Zeldis: American Self-Taught Artist," presented by the Museum of American Folk Art through New York University, New York City, in 1988, and samples of her work are included in the current traveling exhibition, "Louis Armstrong: A Cultural Legacy," organized by the Queens Museum, New York City, in conjunction with the Smithsonian Institution, Washington, D.C. Her work is included in the permanent collections of many museums both here and abroad (seventeen at last count); any general reference book dealing with contemporary folk art is likely to contain her work. She has also done a series of paintings that were used as illustrations for five children's books, including one on Martin Luther King, Jr.

The work of Malcah's son, David, was included in "Primal Portraits: Adam and Eve Imagery as Seen by Twentieth Century American Self-Taught Artists," San Francisco Craft and Folk Art Museum (1990); "Twentieth Century Self-Taught Artists from the Mid-Atlantic Region," the Noyes Museum, Oceanville, New Jersey (1994); and a one-person show at the New York State Historical Association in Cooperstown (1993), which also has his work (as well as his mother's) in its permanent collection.

Where to Buy Art Malcah Zeldis is represented by Toad Hall Galleries in Cooperstown, New York, and New York City. Her work is also available at Rising Fawn Folk Art in Chattanooga, Tennessee. The artist notes that visitors are also welcome at her apartment-studio in New York City.

David Zeldis is represented by the Luise Ross Gallery in New York City.

MUSEUM AND GALLERY GUIDE

CONNECTICUT

Marion Harris G
27 Woodhaven
Simsbury, CT 06070
(203) 658-9333

The Marion Harris Gallery is located in Simsbury, west of Hartford and east of Litchfield. Mask-maker Jerry Coker* and potter Georgia Blizzard* are among the gallery's artists. Marion Harris also has works by S. L. Jones*, Morton Bartlett, and Rev. Herman Hayes, as well as quilts by Mississippi artist Sarah Mary Taylor.

MARYLAND

American Visionary Art Museum M
800 Key Highway, Inner Harbor
Baltimore, MD 21230
(410) 244-1900

Opened in the fall of 1995 in restored brick warehouses facing the harbor, the American Visionary Art Museum provides an exciting new venue for folk and visionary art. Its inaugural exhibition, "The Tree of Life," emphasized a reverence for nature and the "Tree" as a human symbol in self-taught art; it features objects created from wood or depicting flora and fauna. Ted Gordon*, Gerald Hawkes, and Frank Bruno* are among the artists in the museum's permanent collection. Vollis Simpson of North Carolina has created a large environmental piece for the museum garden.

Folk Art Gallery G
1500 Bolton Street
(P.O. Box 4759)
Baltimore, MD 21211
(410) 669-3343

Formerly a private dealer operating under the name Cognoscenti, Richard Edson has now opened a gallery that deals in American and international folk art. Among the artists handled on a regular basis are Linvel* and Lillian Barker*, Anderson Johnson*, Bertha Halozan*, Ned Cartledge, Michael* and Melvin Crocker*, and Rev. J. L. Hunter*. From time to time, the gallery has works by the Baltimore Glassman (Darmafall)*.

Marilyn Gabor Studio G
Mill Center, 3000 Chestnut Ave.
Studio 1404, Baltimore, MD 21222
(410) 366-3171

If you would like to meet the Baltimore Glassman (Darmafall)*, he frequently works at the Mill Center (especially when the weather is inclement). Marilyn Gabor is the artist's principal representative in Baltimore.

MASSACHUSETTS

David Wheatcroft G
220 East Main Street
Westborough, MA 01581
(508) 366-1723

Located near Boston, this gallery specializes in earlier American folk art. It carries nineteenth- and early twentieth-century carvings, watercolors, and Pennsylvania German material, including *fraktur*.

Brimfield Antique Market O
Brimfield, MA

A center for summer antique shows, Brimfield (not far from Sturbridge) is also popular with folk art collectors because almost anything is likely to turn up there. May's Antiques Market and J & J Promotions, both on Route 20, are two of the largest shops in the area.

House of Blues ⊙
96 Winthrop Street
Harvard Square
Cambridge, MA 02138
(617) 491-2583

The original House of Blues restaurant opened in Cambridge in 1992. Featuring a variety of music, the decor is folk art—the walls are covered with works by artists like Mose Tolliver*, Jimmy Lee Sudduth*, and Leroy Almon. Subsequently, the House of Blues has opened similar restaurants in New Orleans (see page 188) and Los Angeles (see page 300). Additional restaurants are planned for New York, Orlando, and Chicago.

Ute Stebich Gallery Ⓖ
69 Church Street
Lenox, MA 01240
(413) 637-3566

Ute Stebich Gallery advertises that it "will present the finest 18th, 19th, and 20th Century Folk Art (paintings, sculptures, and textiles) from around the world." Among the American artists represented are Eddie Arning*, Justin McCarthy*, and Joseph Yoakum*. The gallery also has a selection of Haitian and Jamaican art. Open daily in the summer and Thursday–Saturday between September 16 and June 23.

Sailor's Valentine Gallery Ⓖ
40 Centre Street
Nantucket, MA 02554
(508) 228-2011

Sailor's Valentine Gallery has examples of work by about 35 self-taught artists, most of them American. Among the artists the gallery carries on a regular basis are Karolina Danek, Clementine Hunter*, and Dwight Mackintosh*.

NEW JERSEY

Newark Museum Ⓜ
University Heights
49 Washington Street
(P.O. Box 540)
Newark, NJ 07101-0540
(201) 596-6550

In addition to works by earlier artists such as Edgar McKillop and Joseph Pickett, the Newark Museum has a number of contemporary folk artists in its permanent collection including David Butler*, Thornton Dial*, Bill Traylor*, and Purvis Young*. The museum also frequently exhibits folk art, most recently "A World of Their Own" (1995).

Lynne Ingram Ⓖ
174 Rick Road
Milford, NJ 08848
(908) 996-4786
(Closed at present)

A transplanted southerner, Lynne Ingram brought the South to New Jersey in the form of folk art. Her gallery in Milford, near the Pennsylvania border, handled paintings and sculptures by more than twenty artists including Mary T. Smith*, Q. J. Stephenson*, Willie Massey, and Mark Casey Milestone*. She also carried pottery and face jugs by Georgia Blizzard*, Billy Ray Hussey*, and Lanier Meaders. Although the gallery is not open at present Lynne Ingram still has and sells works by these artists. Call to check status.

Noyes Museum Ⓜ
Lily Lake Road
Oceanville, NJ 08231
(609) 652-8848

Opened in 1982 with a focus on bird decoys (a large collection of which had been donated by its founders, Fred and Ethel Noyes), the museum has now expanded into contemporary twentieth-century folk art. It has organized a number of exhibitions in this area, including "Twentieth-Century Self-Taught Artists from the Mid-Atlantic Region" (1994) and "Drawing outside the Lines: Works on Paper by Outsider Artists" (1995).

New York State Historical Association (NYSHA) 🅜
Fenimore House, Lake Road
(P.O. Box 800)
Cooperstown, NY 13326
(607) 547-1400

Although NYSHA is best known for its pre-1900 material, t. situation is changing. In recent years it has expanded r twentieth-century collection, and today the collection include works by Ralph Fasanella, Bertha Halozan*, Annie Wellborn*, David* and Malcah Zeldis*, and others. NYSHA has had several exhibitions that included contemporary folk art ("Works of Art . . . Worlds Apart" in 1993) and plans to continue to show such work on a regular basis.

Gallery 53 Artworks 🅖
118 Main Street
Cooperstown, NY 13326
(607) 547-5655

Gallery 53's primary focus is on artists from New York, although it does handle some additional artists. At present, the gallery lists Lavern Kelley, Charles and Janet Munro, Sulton Rogers*, and Mary Shelley among its artists.

Toad Hall Galleries 🅖
63 Pioneer Street
Cooperstown, NY 13326
(607) 547-4044

Toad Hall Galleries in Cooperstown has work by Milton Bond, Vestie Davis, Justin McCarthy*, and Malcah Zeldis*, as well as others. The gallery has a second location in New York City (see page 68).

Museum of American Folk Art 🅜
61 West 62nd Street
New York, NY 10023-7015
(212) 977-7170

The Museum of American Folk Art (MAFA) has a large and still-expanding in-depth collection of twentieth-century pieces, as well as earlier works. Almost one hundred contemporary artists are represented in the MAFA collection: Eddie Arning*, Steve Ashby*, Andrea Badami*, David Butler*, Thornton Dial*, Josephus Farmer*, William Hawkins*, Jesse Howard, Martin Ramirez*, and Malcah Zeldis*, among others. A portion of the twentieth-century collection is on permanent display. The museum also has had a number of exhibitions of contemporary folk art: "The Cutting Edge," "Thornton Dial: Image of the Tiger," "Driven to Create," "Minnie Evans," and "Discovering Ellis Ruley"; a major contemporary show, "Mind's Eye," is planned.

American Primitive Gallery 🅖
596 Broadway #205
New York, NY 10012
(212) 966-1530

A high-quality folk art gallery with works by more than thirty contemporary artists available, American Primitive represents both established artists (Thornton Dial*, Terry Turrell*, Howard Finster*, and Raymond Coins*) and emerging artists (Theodore Ludwiczak*, Raymond Materson*, John Mason*, Jim Bauer*, and Max Romain*, for example). The gallery also has some earlier pieces, including fish decoys.

Art on the Edge 🅖
596 Broadway #205B
New York, NY 10012
(212) 966-1634

Formerly Art Program for the Homeless, the non-profit gallery Art on the Edge represents primarily artists from New York City. These artists include Pearline Cruz*, Gerty Celestin, and Carla Cubitt. Open by appointment.

Bridges + Bodell ⑥
313 East 10th Street
New York, NY 10009
(212) 677-2799

One of the newer folk art galleries (it opened in 1994), Bridges + Bodell represents such artists as Linda St. John. The gallery also features developmentally disabled artists from Gateway Crafts of Boston and The Artists of the Kennedy Center, Inc., Bridgeport, Connecticut.

Cavin-Morris, Inc. ⑥
560 Broadway
New York, NY 10012
(212) 226-3768

Cavin-Morris regularly represents John Harvey*, Bessie Harvey*, Anthony Joseph Salvatore, Howard Finster*, and Chelo Amezcua*; it is the principal representative on the East Coast of the late Jon Serl*. Among lesser-known self-taught artists, Cavin-Morris has the work of Gregory Van Maanen and Keith Goodhart. A first-rate gallery.

Epstein-Powell ⑥
22 Wooster Street
New York, NY 10013
(212) 226-7316

Epstein-Powell has examples of the work of about fifty artists, with works in depth by ten or twelve of these. The gallery represents the estate of Victor Joseph Gatto and has sizeable holdings of such artists as Justin McCarthy*, "Old Ironsides" Pry*, and Jack Savitsky*. Other artists include Jesse Aaron, S. L. Jones*, Rex Clawson*, and Mr. Eddy (Mumma)*. A good source for a variety of folk art. Open by appointment.

Galerie Saint Etienne ⑥
24 West 57th Street
New York, NY 10019
(212) 245-6734

Galerie Saint Etienne is known for its representation of one of the best-known American folk artists, "Grandma" Moses (Anna Mary Robertson). The gallery also represents her brother, Fred, and other American and European artists— John Kane, Nikifor, Scottie Wilson, and, recently, Earl Cunningham. Saint Etienne also has a collection of works by Haitian visionaries.

HMS Folk Art ⑥
317 East 85th Street
New York, NY 10028
(212) 535-5265

According to owner Howard Sebold, HMS "tends to concentrate on new and lesser known artists." Among the artists represented on a regular basis, he lists Ronald Cooper, Michael Finster*, Roy Finster*, M. C. "5¢" Jones*, Ionel Talpazan, and Wesley Willis*.

Yvette Jacob ⑥
New York, NY
(212) 772-0813

Yvette Jacob represents Ionel Talpazan, David Butler*, Annie Wellborn*, and Nellie Mae Rowe*, among others. Open by appointment.

Phyllis Kind Gallery ⑥
136 Greene Street
New York, NY 10012
(212) 925-1200

In New York, as in Chicago (see page 221), the Phyllis Kind Gallery carries work by American and European artists. The Americans represented include Rosemarie Koczy, J. B. Murry, and Joseph Yoakum*. Among the European *art brut* artists in the gallery are Carlo, Adolph Wolfli, and Scottie Wilson. Phyllis Kind also frequently shows prison art.

K.S. Art ⑥
91 Franklin Street #3
New York, NY 10013
(212) 219-1489

An artist himself, owner Kerry Schuss has an interesting selection of works by a number of artists, most of whom are only now becoming known; they include Freddie Brice, Aaron Birnbaum*, Ray Hamilton*, and Philip Travers*. Schuss is a dealer to watch. Open by appointment.

Jim Linderman Folk and Outsider Art ☐
530 West 46th Street #3w
New York, NY 10036
(212) 307-0914

Jim Linderman carries "self-taught masters, recent discoveries, sculptural objects, and anonymous pieces." His list of artists includes William Dawson*, "Creative" DePrie*, Anderson Johnson*, S. L. Jones*, Max Romain*, Jack Savitsky*, and Mary T. Smith*. Linderman is always on the lookout for the new and exciting. A good source. On view by appointment.

Frank J. Miele Gallery ☐
1262 Madison Avenue
New York, NY 10128
(212) 876-5775

A folk art gallery conveniently located on Madison Avenue, Frank Miele represents a large number of self-taught artists of the nineteenth and twentieth centuries. Among the contemporary artists shown regularly, Miele lists Sylvia Alberts, Harry Lieberman, Mary Shelley, Maurice Sullins, and Levent Isik*. Miele occasionally has paintings by Andrea Badami*.

Ricco/Maresca ☐
152 Wooster Street
New York, NY 10012
(212) 780-0071

In new and expanded quarters since 1994, Ricco/Maresca consistently handles "top of the line" contemporary folk art. Its artists include Eddie Arning*, David Butler*, Thornton Dial*, Ken Grimes*, William Hawkins*, Laura McNellis*, Dwight Mackintosh*, Bill Traylor*, and Purvis Young*. On occasion the gallery gives New York shows to lesser-known self-taught artists like Eileen Doman*.

Luise Ross Gallery ☐
568 Broadway
New York, NY 10012
(212) 343-2161

One of the first dealers to appreciate and acquire Bill Traylor's* paintings, Luise Ross still carries his work, along with that of Thornton Dial*, Minnie Evans*, Ted Gordon*, Lonnie Holley, Ray Hamilton*, Mr. Eddy (Mumma)*, David Zeldis*, and others. The art to be found at the gallery is consistently of high quality.

Toad Hall Galleries ☐
ABC Carpet and Home
888 Broadway, 4th Floor
New York, NY 10003
(212) 473-3000 Ext. 281

Toad Hall Galleries in New York carries the same artists as in its Cooperstown gallery (see page 66), such as Justin McCarthy* and Malcah Zeldis*, among others.

Edward Thorp Gallery ☐
103 Prince Street, 2nd Floor
New York, NY 10012
(212) 431-6880

Although primarily a fine arts gallery, Edward Thorp carries works by Purvis Young*, Sam Doyle*, and Justin McCarthy* on a regular basis. In addition, the gallery tries to schedule at least one show a year of self-taught artists (a recent show included, for instance, "Uncle Pete" Drgac, Clementine Hunter*, and Justin McCarthy*). The gallery emphasis is on "art," whether by trained or untrained artists.

PENNSYLVANIA

Lehigh University Art Galleries ☐
Lehigh University
Bethlehem, PA 18015
(610) 758-3615

Lehigh University has long been a supporter of Howard Finster*. In 1986 the university sponsored "The World's Folk Art Church: Reverend Howard Finster and Family." The permanent collection includes works by Howard Finster* and other members of the Finster family*.

Renninger's ◐
Adamstown and
Kutztown, PA

Renninger's claims to run America's two largest antique markets, located close together in Adamstown and Kutztown, not far from the Pennsylvania Turnpike. Kutztown has over 400 dealers under one roof, and both markets feature special events. In view of the size of Renninger's, there is always the possibility that contemporary folk art items may appear.

Jack Savitt Gallery ◗
2015 Route 100 (between
Macungie and Texlertown)
Macungie, PA 18062
(610) 398-0075

Jack Savitt represents his father, the well-known Pennsylvania folk artist Jack Savitsky*. The gallery has oils, acrylics, and drawings by Savitsky.

Janet Fleisher Gallery ◗
211 South 17th Street
Philadelphia, PA 19103
(215) 545-7562

The Janet Fleisher Gallery was among the few galleries showing folk art in the early 1980s. It has handled the work of Howard Finster* for many years, as well as the work of Bill Traylor*, Justin McCarthy*, Ellis Ruley*, and Joseph Yoakum*. The gallery still carries those artists as well as Eddie Arning*, David Butler*, Sam Doyle*, William Hawkins*, Elijah Pierce*, and Purvis Young*. If you are in Philadelphia, the prestigious Janet Fleisher Gallery is recommended as a source for blue chip folk and outsider art.

VERMONT

Webb & Parsons ◗
19 Overlake, 545 South Prospect
Burlington, VT 05401
(802) 658-5123

Inez Nathaniel Walker* was discovered by Pat Parsons, and this gallery is the best source for the work of this artist. Webb & Parsons has a broad selection of folk art, but the main gallery focus, in addition to Walker, is on Vermont artists Gayleen Aiken and Larry Bissonnette.

Boone Gallery Folk Art ◗
P.O. Box 85
Danville, VT 05828
(802) 684-3963

A renovated nineteenth-century farmhouse is the new home of Boone Gallery, formerly located in Versailles, Kentucky. Art Snake (Rodney Hatfield), Gayleen Aiken, Dale Brown, Marvin Francis, and Bob Morgan are among the artists represented by Boone.

Shelburne Museum Ⓜ
Route 7
(P.O. Box 10)
Shelburne, VT 05482
(802) 985-3344

The Shelburne collection centers on early American folk art. It does, however, have some twentieth-century objects, primarily carousel horses, circus carvings, and decoys. Recently, the museum acquired a group of about sixty woodcarvings by Vermont carver Gustaf Hertzberg.

**Grass Roots Art and
Community Efforts (GRACE)** ◐
RFD Box 49
West Glover, VT 05875
(802) 525-3620

Founded in the 1970s by artist Don Sunseri, GRACE attempts to provide a voice for individuals at the grassroots level. Its mission is to "discover, develop, and promote visual art produced by self-taught artists in rural Vermont." Each year about 500 people make art in weekly workshops held by GRACE in nursing homes, hospitals, and psychiatric day care centers. Much of the work is for sale. Gayleen Aiken is probably GRACE's most successful artist, but there are many others, including Larry Bissonnette and Dot Kibbee.

APPALACHIA

WASHINGTON, D.C., AND BALTIMORE, MARYLAND, were our jumping-off places for our travels through Appalachia, and both cities are very good places for viewing contemporary folk art. A large and diverse collection of this material is housed in the Smithsonian Institution's National Museum of American Art, and changing exhibitions of objects from the collection are constantly on display. In Baltimore, only a short drive from the District of Columbia, the American Visionary Art Museum, at the foot of Fort McHenry in the Inner Harbor, opened in November 1995 with a major exhibition, "The Tree of Life," featuring works of wood and works relating to nature. Ted Gordon, Gerald Hawkes, and Frank Bruno are among the artists in the museum's permanent collection, and North Carolina artist Vollis Simpson created a large environmental sculpture for the museum's garden. A number of changing exhibitions are being planned for this new museum.

In the 1970s the popular theory among many in the art world was that folk art was dead—no folk were left, all gone!—that it had been replaced by a media-oriented and media-educated society made too sophisticated by the evening news and game shows to create folk art. Rather than debate this question, in the mid-1970s we took a trip to Campton, Kentucky, and visited woodcarver Edgar Tolson in the hills southeast of Lexington. We knew immediately that the art world naysayers were wrong, that folk art was alive and well— and even flourishing—and we became permanently hooked on the adventure of discovering American art that was totally divorced from the constraints and, to us, limited vision of the art world's elite (now called "insiders," who sometimes refer to the artists as "outsiders"). We met our second folk artist—the great woodcarver Shields Landon Jones—a few months later in Hinton, West Virginia. A dealer had told us that Jones was dying of prostrate cancer, unable to receive visitors, and not working. We decided to follow our instincts, however, and we drove into Appalachia to find him as fit as the fiddle he played for us that day in 1975. In fact, we helped him celebrate his

WEST VIRGINIA

Huntington
Frankfort Moorehead ★Charleston
Owensboro Louisville Lexington Isonville Hinton
KENTUCKY Berea
Bowling Green Glade Spring

VIRGINIA
Richmond ★
Roanoke Williamsburg Newport News
Waverly
Suffolk
Garysburg

WASHINGTON, D.C.

Winston- Greensboro Rocky Mount
Salem Chapel ★ Robbersonville
Franklin ★Nashville Norris Morganton Troutman Hill Raleigh
Bell Buckle Beechgrove Asheville Bynum
Memphis TENNESSEE Charlotte Robbins Lucama
Chatanooga NORTH CAROLINA

A

ninety-second birthday in October of 1993, and he was still drawing (although no longer carving).

Much of the contemporary folk art of Appalachia has evolved from older roots. There is, however, a narrow line between the undeniable craft of the mountain man—be he (or she) whittler, basket maker, quilter, or cane carver—and art, and each collector must find the edges of that line for his or herself. Highly decorative objects and sometimes amusing handmade crafts abound in Appalachia, and gift stores and even museum shops from Berea, Kentucky, to Nashville, Tennessee, are well stocked with apple jelly, hooked rugs, quilts, wood pigs and roosters, and everything in between—fun items, tasty items, useful items, and sometimes beautiful items, but not the art we are looking for.

Adrian Swain, director of Morehead State University's Kentucky Folk Art Center, has devoted his life to separating the wheat from the chaff and to helping in the development of Appalachian folk art. Swain has the eye and the knowledge of a collector and has put together a landmark collection of regional art at Morehead, a collection that includes Minnie and Garland Adkins, Linvel and Lillian Barker, Tim Lewis, Edgar Tolson, and Charley Kinney, to name but a few. Morehead gives local artists exhibitions and runs one of the finest museum shops in the country, specializing in regional art.

Near Morehead, most collectors detour to Isonville to visit the home/workshop of the Adkinses in Pleasant Valley—easily identified by Minnie's trademark red fox on the mailbox. Most summers, the Adkinses have a large picnic/folk art sale, where it is possible to meet old friends and collectors from as far away as Chicago and New York.

For true folk art aficionados, there are two other museums that should be visited during any tour of the beautiful hills of Appalachia: the Huntington Museum of Art in West Virginia and the Owensboro Museum of Fine Art in Kentucky. Both

have outstanding examples of the art of the region—sculpture and paintings by artists that may be met at the Adkinses' picnic.

The Folk Art Society of America, headed by Ann Oppenhimer, is headquartered in Richmond, Virginia. Most collectors of contemporary American folk art subscribe to its publication, the *Folk Art Messenger,* and join in the camaraderie of the society's annual fall meeting. The society welcomes visits to its office, is generous in sharing information with members, and is accumulating one of the best folk art libraries in the country. From Richmond, collectors can easily visit such artists as John Anderson and Anderson Johnson, and Robert Howell's delightful environment in Powhatan is only a half-hour away.

Most visitors to the Virginia and Carolina beaches also take the time to stop at Williamsburg, Virginia. The Abby Aldrich Rockefeller Folk Art Collection (AARFAC) in this historic town has perhaps the finest collection of early American folk art in the country, and it has now extended its collection into the twentieth century. This prestigious museum began collecting twentieth-century material with the acquisition of a Miles Carpenter watermelon in 1973. (Carpenter, a well-known carver, died in 1985. Some of his work may also be seen at the artist's former home, now known as the Miles B. Carpenter Museum, in Waverly, Virginia.) AARFAC is slowly building a fine collection of contemporary American folk art; it has recently purchased a work by Minnie Evans, and its holdings of Texas artist Eddie Arning's drawings are especially impressive.

The Appalachian mountains have been home to potters since colonial days, but much of the pottery made there today has changed from the utilitarian ware of earlier years to art pottery. Georgia Blizzard, for example, a potter with a unique vision, works in a tiny town in the southwestern corner of Virginia. Her small sales shop, run by her daughter Mary, is just off the main highway, and collectors of pottery have left a well-trodden path to her door. One of the things that most impressed us about Blizzard is her use of elements of American Indian firing techniques (see Christine McHorse, for instance) that she then combines with her own surreal perspective to create highly personal figurative jugs and ceramic plaques that bring to mind an imaginative fantasy of Dante's inferno on earth.

Of the folk potters we used to visit in the 1980s, only Burlon Craig (known for his imaginative effigy jugs) in Vale, North Carolina, is still working, but one of the best and most innovative potters of the new generation is Billy Ray Hussey, an artist who uses the old glazes and methods but combines them with innovative techniques. Hussey redefines traditional shapes and turns pottery into a modern art form, and a visit to his pottery/salesroom/museum is an eye-opening—and pleasurable—experience. Collectors of folk pottery come from all over the South to participate in the early-morning kiln openings of both Hussey and Craig; in fact, about the only way to

obtain their ware is to be there at a kiln opening and hope your number will allow you the chance to buy a piece.

Being there—that is a good part of what the excitement of collecting is all about, whether at a kiln opening, in the salesroom of a museum or gallery when an artist brings in a new work, or sitting on the artist's porch and watching a carving be created before your eyes. Being there is what keeps us on the road, hoping that the right time, the right place, the right artist, and the right object will always be there to be found and enjoyed.

21
MINNIE AND GARLAND ADKINS

Garland was born February 27, 1928; Minnie was born March 13, 1934, Isonville, Kentucky. Now reside Isonville (outside Sandy Hook).

Minnie and Garland Adkins lived in Ohio for many years, but when they moved "home" to Kentucky in the 1980s, Minnie took up carving full time. Garland later joined her in the venture, and now this couple makes everything from carvings to quilts and from large collage paintings to record album covers. Minnie carves, quilts, and paints; her signature piece is a long-nosed, pearly-toothed red fox. Garland carves horses; his signature piece is a graceful unpainted, swan-necked horse. Although they usually work separately, they occasionally do a collaborative piece.

The Adkinses have named their farm "Peaceful Valley Wood Shop," and they have received national recognition for the helping hand they have given regional folk art. In fact, Minnie Adkins is fond of saying, "There's about twenty-five people around here making folk art, and they couldn't sell unless we gives 'em a helping hand." To bring further attention to the area, the Adkinses give annual picnics, often attended by several hundred collectors in addition to the local artists.

Minnie Adkins has received the Award of Distinction from the Folk Art Society of America (1993), as well as the Appalachian Treasure Award (1994).

COLLECTING TIPS The Adkinses' work, especially Minnie's, captures the spirit of the Kentucky hills. Garland's carved horses, however, make strong and elegant—and very collectible—sculptural statements. "But," he admits, "if the wood is blemished, I paint them black, so they's the seconds."

If you are not on the guest list for the annual picnic, contact the Adkinses. Many friends of folk art attend; it's a sure good time!

WHERE TO SEE ART In 1994 Minnie Adkins had a one-person museum show at Morehead State University, and both Adkinses were included in the exhibition "Local Visions: Folk Art from Northeast Kentucky," sponsored by the Folk Art Collection of Morehead in 1990. Their work is in the permanent collection of Morehead State University and the Owensboro Museum of Fine Art, both in Kentucky; the Huntington Museum of Art, West Virginia; and the Craft and Folk Art Museum, Los Angeles.

The Peaceful Valley Wood Shop is open to the public, and many galleries and dealers in Kentucky carry the Adkinses' work, including the Heike Pickett Gallery in Lexington and the Kentucky Art and Craft Gallery in Louisville. Outside the region, folk art by the Adkinses can be found at, among others, Galleria Scola in Oakland, California; Anton Gallery, Washington, D.C.; Main Street Gallery, Clayton, Georgia; Shelton Galleries in Nashville, Tennessee, and Palm Beach, Florida; and Modern Primitive in Atlanta.

**22
JOHN
ANDERSON**

Born December 12, 1953, Louisa County, Virginia. Now resides Louisa, near Richmond, Virginia.

John Anderson transforms rusted automobiles into sculpture that ranges from the wildly whimsical to the inspiring. He takes junked cars apart, then welds various components together again to form recognizable—if sometimes fanciful—animal or human forms. He has made a crucifixion that stands twelve feet tall, and he has made mice that are only two feet in height. It is hard to recognize Detroit's output in the finished product—the cars are transformed by the vision of the artist. There's humor in Anderson's animals, but, he says, "I get strength from Christ." Much of his work shows his religious dedication and zeal.

"Black families are behind these days," Anderson philosophizes. "If a man works hard, he can keep a family together, but art is a handicap. The type of women I deal with can't understand it when the money don't come in when it's needed. But I have a strong inner feeling to create and get things done."

John Anderson

COLLECTING
TIPS

Anderson made some of his earlier work from wood, but his welded pieces present stronger images, perhaps reflecting the fact that the artist finds metal more satisfying. The welded sculpture also looks great outdoors—often collectors are looking for folk art that can be displayed outside, and there really is not too much available. Rust does not spoil the beauty of these welded iron and steel works, and Anderson makes pieces large enough to fill a public space.

WHERE TO SEE ART

We first saw John Anderson's art in a 1993 calendar circulated by the Folk Art Society of America. His work, however, can be enjoyed in situ, and the artist enjoys visitors.

WHERE TO BUY ART

John Anderson will work on commission, and he usually has some finished sculptures available for sale at his home.

**23
STEVE ASHBY**

Born July 2, 1904, Delaplane, Virginia. Died June 13, 1980, Delaplane.

Steve Ashby, generally considered as among the top ranks of the black folk artists of his generation, is famous for the "fixing ups" that he made from pieces of wood, found objects, cloth, and even hickory nuts. His fixing ups are humorous, sometimes erotic, figures, with subject matter that draws on the world he knew—the horse races at Upperville, farm ani-

mals, and farm activities—as well as the world of his imagination, which was stocked with pinups from girlie magazines and refrigerators stuffed with good things to eat. The fixing ups range from a few inches in height to almost life-size; each had a very personal meaning for the artist.

Ashby lived in the backwater culture of Fauquier County, Virginia; although this is prime thoroughbred and cattle country and one of the more affluent areas, the Ashby family was virtually indentured to their land. They had to depend on a hand pump for water and a wood-burning stove for heat. The fixing ups, however, were not inhibited by Ashby's environment; they came from his imagination and are classic examples of important folk sculpture.

COLLECTING TIPS We have seen work attributed to Ashby that was not his, even in a small museum. His sculptures are for the most part closely held in private collections, and the provenance of a particular piece should be carefully checked whenever a purchase is made. However, once you have located an Ashby, you can bring home a work of art (if you can afford it) that will give you pleasure for years.

WHERE TO SEE ART Since the 1970s, and especially since his inclusion in the 1982 Corcoran show, "Black Folk Art in America, 1930–1980," Ashby's carvings have been included in almost every museum show that includes black folk art. Illustrations of his work can be found in most books and catalogs on this subject.

Ashby's sculpture is in the permanent collections of various museums, including the Museum of American Folk Art, New York City; the Smithsonian Institution's National Museum of American Art, Washington, D.C.; and the Milwaukee Art Museum.

WHERE TO BUY ART Major works by Ashby come on the market only infrequently. Make your desire to purchase known to galleries and auction houses so that you will be alerted when one does surface—and above all be patient!

24
LINVEL AND
LILLIAN BARKER

Linvel was born January 10, 1929, Crockett, Kentucky; Lillian was born August 26, 1930, Roscoe, Kentucky. Now reside Isonville, Kentucky.

Linvel and Lillian Barker could have invented the slogan "less is more." Their deceptively simple unpainted carvings of domestic and farm animals are the Brancusis and Arps of folk art. The Barkers came to their art in 1983 from the boredom of the retirement couch, but they are bored no more. "The cats made us famous," Lillian explains. "We've got orders for more animals now than we can fill in five years."

"If you can see what's in the wood, you can carve it out," says Linvel. "There ain't no paint in wood, and you don't need none."

The Barkers work collaboratively; Lillian roughs out the pieces with a band saw, Linvel then carves them, and Lillian does most of the sanding. In addition to her wood work, Lillian also paints religious scenes.

Linvel and Lillian Barker

COLLECTING TIPS Although all the Barkers' animals are collectible, their cats, sitting majestically with their tails high in the air or curled around them, are their signature works and particularly interesting. The Barkers sign their pieces "L. Barker" for Linvel and Lillian.

A local dealer once insisted that the Barkers paint the eyes on his orders. These animals would be the least desirable from a collector's standpoint in that they do not conform to the artists' sensibility. The earlier the piece, the better the investment.

WHERE TO SEE ART The Barkers' carvings are in the permanent collection of the Huntington Museum of Art, Huntington, West Virginia, and Morehead State University, Morehead, Kentucky. Work by the Barkers was included in "Passionate Visions of the American South," New Orleans Museum of Art, Louisiana (1993). Earlier the Barkers were in the traveling exhibition "Local Visions," sponsored by the Folk Art Collection of Morehead State University (1990), as well as other shows of Kentucky art.

WHERE TO BUY ART The Barkers take orders, but there may be a long wait. The sales gallery at the Kentucky Folk Art Center, Morehead State University, sometimes has carvings available. Barker animals also turn up in galleries such as the Robert Cargo Folk Art Gallery in Tuscaloosa, Alabama, and the Folk Art Gallery (formerly Cognoscenti) in Baltimore. Dealer Larry Hackley, North Middletown, Kentucky, also handles the Barkers' work.

**25
PATSY BILLUPS**

Born December 6, 1910, Deltaville, Virginia. Now resides Saluda, Virginia.

Patsy Billups, a highly original artist, drew gaily decorated autobiographical works on paper and board. They recorded a Joycean journey through a life held together by church, prayer, and remembrances of good times on holidays. At one time she made and decorated her own monthly calendars so that she could place special emphasis on the holidays.

Billups lives on the Eastern Shore of Virginia, where her husband used to find work on the oyster boats and she worked

in the homes of the affluent. "I did drawings," she explained, "just to have something else to do when my husband was away."

The Billups' home was destroyed by fire in 1991, and the drawings then decorating her walls were burned. At the present time she is in poor health and does not feel the urge to draw.

COLLECTING TIPS Billups was all but forgotten until she was included in the exhibition "Virginia Originals," at the Virginia Beach Center for the Arts in 1994. Collectors are currently scouring the Eastern Shore of Virginia trying to find her still-existing drawings.

WHERE TO SEE ART A wooden chest decorated by Billups was included in the Smithsonian Institution's Renwick Gallery installation "Paint on Wood" in Washington, D.C. (1977), and one of her drawings is illustrated in the catalog for "Virginia Originals" (see above).

Her work is included in the permanent collections of the Meadow Farm Museum, Richmond, Virginia, and the James Collection of Southern Folk Art, Saint James Place, Robersonville, North Carolina.

WHERE TO BUY ART From time to time drawings by Billups turn up at flea markets and galleries or at auction.

26
GEORGIA
BLIZZARD

Born May 17, 1919, Saltville, Virginia. Now resides outside Glade Springs, Virginia.

Known for her innovative effigylike pottery and bas-relief ceramic plaques, Georgia Blizzard brings out the natural color of the clay by firing it first in an electric kiln to harden its delicate surfaces and then in a open pit in a manner similar to that used by American Indians. (Blizzard's paternal grandfather is said to have been adopted from one of the western American Indian reservations, but it is not clear whether this had any influence on her firing methods.) Blizzard's method of firing her work may be related to folk traditions, but no other potter working today has shown more ability to capture moods and express such a sharp personal vision through this medium.

Blizzard's face pots should not be confused with traditional southern grotesque face jugs; her images are self-portraits or portraits of people she has known. The themes of her bas-reliefs, which depict both people and animals, represent the artist's view of the struggle between good and evil and the possibility of damnation or salvation. Her pottery often also expresses her own personal mood, and happiness or sorrow may shine through the clay.

COLLECTING TIPS Georgia Blizzard is not very prolific, but her work represents one-of-a-kind pieces that demand—and receive—higher prices than the traditional effigy jugs. Collectors of pottery, particularly southern or Native American pottery, seek out her unique work despite its price.

WHERE TO SEE ART In 1994 Blizzard was featured in a traveling exhibition, "Georgia Blizzard: Southern Visionary," sponsored by the Mountain Lake Workshop of the Virginia Tech Foundation.

Blizzard's effigy pottery is in the permanent collections of several museums, including the High Museum in Atlanta and the North Carolina State University in Raleigh.

Where to Buy Art Mary Blizzard, Georgia Blizzard's daughter, sells her mother's work at a small shop she runs alongside Route 609. Several other dealers also carry her pottery, including Lynne Ingram, Milford, New Jersey; Rising Fawn Folk Art, Chattanooga, Tennessee; and Creative Heart Gallery (formerly Urban Artware), Winston-Salem, North Carolina.

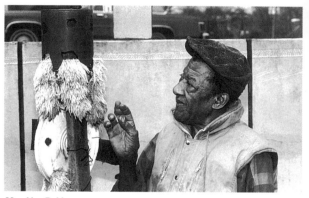

Hawkins Bolden

27

HAWKINS BOLDEN

Born September 10, 1914, Bailey's Bottom (now Memphis), Tennessee. Resides Memphis, Tennessee.

Hawkins Bolden's small urban home is squeezed between a car wash and a tall brick privacy wall; shadowed by the wall is a room-size garden that Bolden loves and protects from harm by "scarecrows" that he makes from found objects. His scarecrows are attached to posts; their faces are made from punctured pans, washtubs, and coffeepots that are alleyway finds, and old rags hang from them to blow in the wind. Yet when his assemblages are spotlighted in white-walled rooms, they bear a clear resemblance to modern abstract sculpture.

Bolden, who is part Creole and part American Indian, was blinded in a baseball accident when he was eight years old and has never seen his amazing creations. "I been gardening since I was nine—it's all I can do," he claims. "My little nephew told me that if you make eyes in a bucket with a screwdriver, that'll keep the birds away."

Collecting Tips Bolden's scarecrows are intended to be placed outside, but many buyers prefer to display them indoors as sculpture. Collectors who come to folk art from a modern or fine art perspective believe in Bolden's sculpture as art; each collector will have to make his or her own decision as to where his work best fits.

Where to See Art Bolden's constructions have been exhibited in "Another Face of the Diamond: Pathways through the Black Atlantic South," INTAR Latin American Gallery, New York City (1989); "Ashe:

Improvisation and Recycling in African-American Visionary Art," Winston-Salem State University, Winston-Salem, North Carolina (1993); and "Passionate Visions of the American South," New Orleans Museum of Art (1993). His work is illustrated in the catalogs accompanying those exhibitions. Bolden is also one of the artists included in "Recycle, Reuse, Recreate," a 1995 exhibition sponsored by the U.S. Information Agency, which is traveling to fourteen African countries.

The work of Hawkins Bolden is in the permanent collection of the Newark Museum, Newark, New Jersey. His art can also be seen at his home in Memphis, Tennessee.

WHERE TO BUY ART Bolden's sculptures are carried by two New York City galleries: American Primitive and Ricco/Maresca. Bolden may also be convinced to part with a piece if you visit him.

2 8
RAYMOND
COINS

Born January 28, 1904,
Stuart, Virginia. Now resides
Westfield (near Pilot Mountain),
North Carolina.

Raymond Coins has emerged as one of the finest folk carvers of this century. His large wooden figures and stone "doll babies"—busts and angels with round, staring eyes and round toothless mouths—have found their way into virtually every important private collection of twentieth-century folk art. "Usually," Coins explains, "the faces look like me; bald on the top." He also has carved stone bas-reliefs, often with religious themes.

Coins spent his life doing farm work and working as a "floor man" in a tobacco warehouse. It wasn't until he retired that he started carving the animals and people that only he could see in his raw materials of wood and river stone.

COLLECTING TIPS Coins's cherubic-faced stone doll babies are his best-known and most popular works, but his religious bas-reliefs in stone and his large cedar carvings of people, even family groups, are currently gaining favor. His stone carvings are well suited for outdoor display; if the larger pieces are too expensive for an individual collector, Coins made a series of smaller stone animals that are also very collectible.

Coins has not been carving since about 1990 because of his advanced age, so no new pieces will be available. In acknowledgment of his work however, this artist received a North Carolina Folk Heritage Award in 1995.

WHERE TO SEE ART Coins's carvings have been widely included in museum exhibitions, for example: "Baking in the Sun: Visionary Images from the South," University Art Museum, University of Southwestern Louisiana, Lafayette (1987); "Signs and Wonders: Outsider Art inside North Carolina," North Carolina Museum of Art, Raleigh (1989); "The Cutting Edge," Museum of American Folk Art, New York City (1990); "Passionate Visions of the American South," New Orleans Museum of Art (1993); and "The Tree of Life," American Visionary Art Museum, Baltimore (1995).

Where to Buy Art	Coins's work is available at the American Primitive Gallery in New York City; Gilley's Gallery in Baton Rouge, Louisiana; Lynne Ingram, Milford, New Jersey; and, from time to time, at other galleries that carry the best in twentieth-century folk art.

HAROLD CROWELL

Born June 26, 1952, Salisbury, North Carolina. Now resides Morganton, North Carolina.

Harold Crowell's large expressionistic canvases combine bold and unusual combinations of unmixed color and form. His inspiration comes from his family life, from religion, from people he has met, from magazine illustrations, and from places he has visited.

Crowell is developmentally disabled, and he paints, as he explains it, "because I am an artist." He works at his art at the Western Carolina Center in Morganton, North Carolina.

Collecting Tips Crowell's colorful paintings are regularly exhibited without mention of his disability and collected as art in their own right, but those collectors who specialize in the art of the disabled will be particularly interested in his work.

Where to See Art Crowell's canvases were included in "Signs and Wonders: Outsider Art inside North Carolina," North Carolina Museum of Art, Raleigh (1989), and "Passionate Visions of the American South," New Orleans Museum of Art (1993). His work is in the Governor's Collection, Raleigh, North Carolina.

Where to Buy Art The Western Carolina Center in Morganton, North Carolina, sells Crowell's paintings.

**29
GERALD
"CREATIVE"
DEPRIE**

Born May 6, 1935, Huntington, West Virginia. Now resides Huntington, West Virginia.

Gerald DePrie's most well known works are his repetitious drawings of a tall, thin, tassel-haired woman who is sometimes clothed, sometimes not, and engaged in everyday activities such as walking her dog or arranging flowers. He also frequently depicts gun-toting, bandit-chasing tough guys or other male figures engaged in unusual activities. All these imaginary characters—outlined heavily in pencil and crayon to stand out starkly on white paper backgrounds—seem to have a sense of urgency about them. Recognizable household pets are also included in his work; these are cute and friendly critters, sometimes dressed in outdoor garb, but who are more expressionistic than realistic in appearance.

DePrie calls himself "Gifted" or "Creative," names, he says, "that came from eternal space. God named me, and now I can create forever."

Collecting Tips DePrie's characterizations of people are spirited and bold. They are instantly recognizable from across a large gallery space. Although the artist is not yet well known, his work is being purchased by a number of collectors, particularly those who visit the region.

The artist signs each drawing "Creative G.E. DePrie."

(continued on page 93)

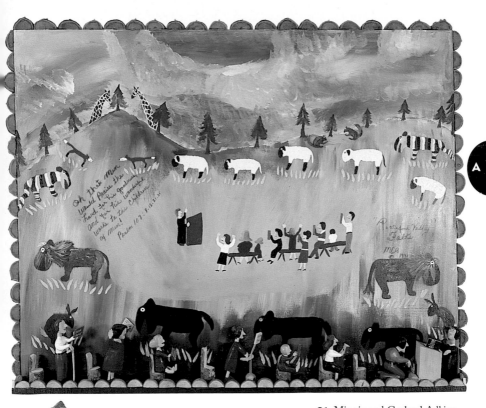

21 Minnie and Garland Adkins
Peaceful Valley Folks, 1990.
Paint on linen shade, carved and
painted wood figures; 50½ ×
59¾ in. (128.3 × 151.8 cm).
Baron and Ellin Gordon.
Photo: Fred Miller

22 John Anderson
Mice, 1994.
Welded metal; 10 × 36 × 8 in.
(25.4 × 91.4 × 20.3 cm) each.
William and Ann Oppenhimer.

23 Steve Ashby
Girl in Bikini, c. 1973.
Carved and painted wood,
found objects; 9½ × 6¾ × 1 in.
(24.1 × 17.1 × 2.5 cm),
CHUCK AND JAN ROSENAK.
PHOTO: LYNN LOWN

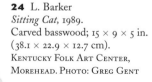

24 L. Barker
Sitting Cat, 1989.
Carved basswood; 15 × 9 × 5 in.
(38.1 × 22.9 × 12.7 cm).
KENTUCKY FOLK ART CENTER,
MOREHEAD. PHOTO: GREG GENT

25 Patsy Billups
*Hex with Flag, Horses,
and Man*, 1974.
Painted wood panel; 14⅛ ×
30¼ in. (35.9 × 76.8 cm).
HERBERT WAIDE HEMPHILL, JR.
PHOTO: GARY SCHUSS

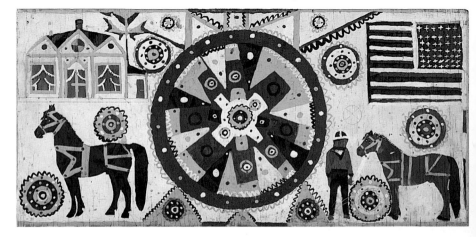

26 Georgia Blizzard
Diulia (Seated Female Pot), 1992.
Low-fired clay; 8 × 12½ × 5 in.
(20.3 × 31.8 × 12.7 cm).
BRIAN SIEVEKING. PHOTO: SARAH
HAZELGROVE

27 Hawkins Bolden
Untitled, late 1980s.
Mixed media, including enamel-
ware metal pan, carpeting, and
wire; 13½ in. (34.3 cm) diameter,
4 in. (10.2 cm) deep, mounted on
30 in. (76.2 cm) metal stand.
BARBARA AND RUSSELL BOWMAN.

28 Raymond Coins
Cabbage Patch Doll, 1983.
Stone; 19 × 13½ × 3 in.
(48.3 × 34.3 × 7.6 cm).
BARRY AND ALLEN HUFFMAN.

29 Gerald "Creative" DePrie
Untitled (Hold-Up Scene), 1993.
Graphite and colored
pencil on paper; 35 × 23 in.
(88.9 × 58.4 cm).
ROBERT AND RUTH VOGELE.

30 John William
"Uncle Jack" Dey
*Accupuncture Spear Style—
Manhunter's,* undated.
Enamel and aluminum paint
on board; 24¼ × 30⅛ in.
(61.5 × 76.5 cm).
AKRON ART MUSEUM.

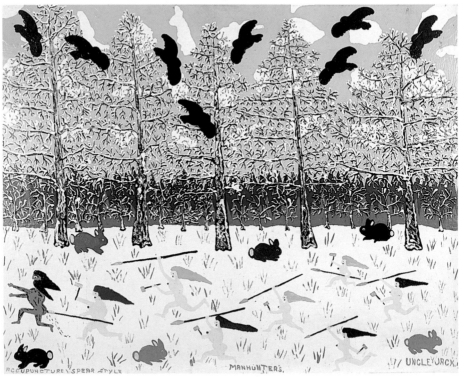

31 William Edmondson
The Crucifix, c. 1932–1937.
Carved limestone; 47½ × 17 ×
4¾ in. (120.7 × 43.2 × 12.1 cm).
ABBY ALDRICH ROCKEFELLER FOLK
ART CENTER, WILLIAMSBURG.

32 Minnie Evans
Untitled, 1960, 1963, 1966
(artist used all three dates on
painting). Oil, crayon, graphite,
ink, and collage on paper board;
16 × 20 in. (40.6 × 50.8 cm).
PRIVATE COLLECTION.
PHOTO: COURTESY LUISE ROSS
GALLERY, NEW YORK

33 Bessie Harvey
*A Thousand Tongues Can
Never Tell*, 1993.
Mixed media; 59 × 39 × 27 in.
(149.9 × 99.1 × 68.6 cm).
Anne Hill Blanchard and
Edward V. Blanchard.
Photo: Courtesy Cavin-Morris

34 Robert Howell
Catfish, 1993.
Wood, metal, paint, feathers,
bottle caps, paper; 24 × 38½ ×
19 in. (61 × 97.8 × 48.3 cm).
William and Ann Oppenhimer.
Photo: Katherine Wetzel

35 Billy Ray Hussey
Lion, 1994.
Fired clay and paint, various
glazes, including uranium
oxide; 7 × 8½ × 2½ in.
(17.8 × 21.6 × 6.4 cm).
COLLECTION OF THE ARTIST.

A

36 Anderson Johnson
Woman with Flag, 1992.
Paint on wood panel; 48 × 39 in.
(121.9 × 99.1 cm).
MERYL AND JOSEPH VIENER.

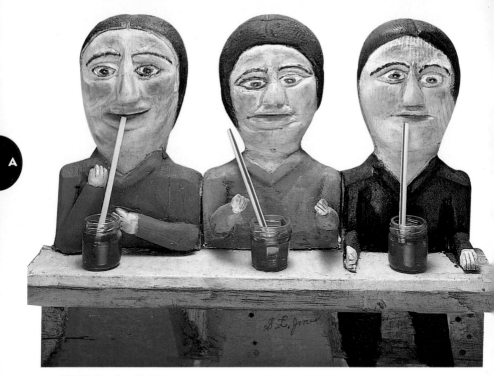

A

37 Shields Landon "S. L." Jones
Soda Fountain, 1980s.
Wood, paint, and glass;
16 × 20 × 6 in. (40.6 ×
50.8 × 15.2 cm).
JOHN AND DIANE BALSLEY.
PHOTO: COURTESY HAGGERTY
MUSEUM OF ART, MARQUETTE
UNIVERSITY, MILWAUKEE

38 Charley Kinney
Old Hanted House, 1988.
Tempera and charcoal on paper;
22 × 28 in. (55.9 × 71.1 cm).
ARIENT FAMILY COLLECTION.

39 Tim Lewis
Man in Chair, 1991.
Carved limestone; 30 × 12 ×
10 in. (76.2 × 30.5 × 25.4 cm).
SUE AND GEORGE VIENER.

40 Laura Craig McNellis
Untitled (Silver Fish Dish),
c. 1980.
Mixed media on newsprint;
20 × 28 in. (50.8 × 71.1 cm).
RICCO/MARESCA GALLERY.

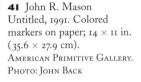

41 John R. Mason
Untitled, 1991. Colored
markers on paper; 14 × 11 in.
(35.6 × 27.9 cm).
AMERICAN PRIMITIVE GALLERY.
PHOTO: JOHN BACK

42 Mark Casey Milestone
Person with a Horn, c. 1990.
Wood and metal; 11 × 18 × 6 in.
(27.9 × 45.7 × 15.2 cm).
G. FAYE AHL.
PHOTO: JOE LECHLEIDER

▲ **43** Mark Anthony Mulligan
Mean Cat Industrial Park, 1994.
Acrylic and pen on panel;
36 × 56 in. (91.4 × 142.2 cm).
SWANSON CRALLE GALLERY.
PHOTO: GEOFFREY CARR

▼ **44** Carl Piwinski
Martian Worlds, undated
(c. 1992).
Ink on paper; 20 × 24 in.
(50.8 × 61 cm). CHUCK AND JAN
ROSENAK. PHOTO: LYNN LOWN

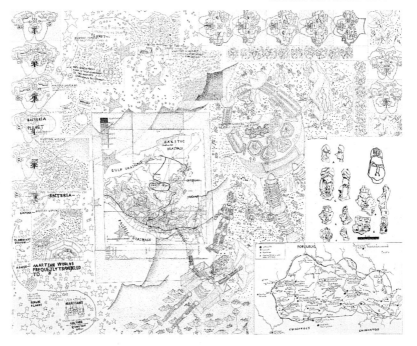

45 Melissa Polhamus
Krasno Wall, 1991.
Watercolor and ink on paper;
10¾ × 13¾ in. (27.3 × 34.9 cm).
BARON AND ELLIN GORDON.
PHOTO: FRED MILLER

46 Edgar Tolson
Paradise, 1969.
Poplar, paint, pencil, glue, and
pen; 12⅛ × 6⅛ × 17⅜ in.
(30.8 × 15.6 × 44.1 cm).
MILWAUKEE ART MUSEUM,
THE MICHAEL AND JULIE HALL
COLLECTION.

47 Hubert Walters
Sailboat, c. 1990. Wood, string,
plastic, metal; 21 × 23 × 3 in.
(53.3 × 58.4 × 7.6 cm).
BARRY AND ALLEN HUFFMAN.

(continued from page 80)

WHERE TO SEE ART DePrie's drawings are in the permanent collections of the Huntington Museum, West Virginia, and the New York State Historical Association, Cooperstown. He was included in a 1992 show of contemporary American folk art at Marquette University's Haggerty Museum of Art, Milwaukee.

WHERE TO BUY ART Creative DePrie's drawings may be purchased directly from the artist. They are also carried by the Dean Jensen Gallery in Milwaukee and the Leslie Muth Gallery in Santa Fe. In addition, folk art dealer Larry Hackley, North Middletown, Kentucky, often has some of DePrie's work on hand.

"Creative" DePrie

30
JOHN WILLIAM
"UNCLE JACK"
DEY

Born November 11, 1912, Hampton, Virginia. Died October 10, 1978, Richmond, Virginia.

John William Dey's paintings tell stories from his life as well as imagined adventures and fanciful daydreams. Many of his story/paintings are full of friendly animals and people he admired—and sometimes people he disliked, shown in uncomfortable positions. His paintings often use birds (usually crows) to form strong and repetitive geometric patterns that enhance the composition; rabbits also appear in almost all his works and, in Dey's words, "anchor the painting."

Dey spent thirteen years on the Richmond City Police Force, where he earned the affectionate moniker of Uncle Jack from neighborhood children whose toys and bikes he fixed. Shortly after leaving the police force, Uncle Jack started to paint. In his paintings, he told story after story—some true, some fables—from his memory, enhancing them with a tongue-in-cheek sense of humor. These paintings have withstood the test of time and earned him a reputation as an outstanding folk painter.

COLLECTING TIPS Most collections built in the 1970s contain examples of work by this artist. Collectors who started more recently are trying hard to find works available for sale.

Dey signed his work "Uncle Jack" and originally attached a handwritten letter to the back of each painting. These letters, when they still exist, should be carefully preserved.

Using frames that he found, Dey framed his paintings, sometimes gilding them in outlandish colors. Some of these frames have been destroyed, but paintings in his original frames are considered more valuable because the artist created the pieces as a whole.

WHERE TO SEE ART The paintings of Uncle Jack Dey are in many museums, including the Smithsonian Institution's National Museum of American Art, Washington, D.C.; the New Orleans Museum of Art; and the Museum of International Folk Art, Santa Fe.

WHERE TO BUY ART Most of Dey's work is widely scattered in a large number of private collections. His paintings occasionally show up in the marketplace, and dealers and auction houses should be consulted for information about the potential availability of his work. The Frank J. Miele Gallery in New York City has had several of his works for sale.

3 1
**WILLIAM
EDMONDSON**

*Born between 1865 and 1883
(probably 1870), near
Nashville, Tennessee. Died
February 8, 1951, Nashville.*

William Edmondson is one of the most important stone carvers this country has ever produced and the most acclaimed black sculptor of this century. He carved numerous memorials and tombstones for use in the local black cemetery, but his masterpieces are limestone figurative sculptures—from cartoon characters such as Orphan Annie to celebrities (a regal Eleanor Roosevelt) and from simple everyday people (a bride and groom and a preacher) to such biblical subjects as Adam and Eve and wonderfully serene angels. Edmondson claimed that the Lord told him to become a stone carver, and he only followed God's directions; whenever this outstanding artist touched hammer and chisel to stone, his fundamental religious beliefs, his simple straightforward style, and his inner vision were added to the stone.

The child of freed slaves, Edmondson was honored by the first individual show ever given to a black artist at the Museum of Modern Art in New York City (1937).

COLLECTING TIPS The artist's reputation is currently international in scope, and if a collector can afford one of his sculptures—any one of his pieces—and an opportunity arises to do so, he or she should acquire it.

WHERE TO SEE ART William Edmondson's work has been extensively exhibited and documented in major books and catalogs on twentieth-century folk art. Most of the artist's sculptures are in museum collections, including those of the Abby Aldrich Rockefeller Folk Art Center in Williamsburg, Virginia; the Birmingham Museum of Art; the High Museum of Art, Atlanta; the Newark Museum, Newark, New Jersey; the Smithsonian Institution's Hirshhorn Museum and Sculpture Garden, Washington, D.C.; and the Museum of the University of Tennessee, Knoxville.

Edmondson's sculpture is rarely on the market; auction sales should be watched. Occasionally pieces may be found at the Janet Fleisher Gallery, Philadelphia; the Carl Hammer Gallery, Chicago; and Ricco/Maresca, New York City.

3 2
MINNIE EVANS

Born December 12, 1892, Long Creek, North Carolina. Died December 17, 1987, Wilmington, North Carolina.

Minnie Evans filled her drawings and paintings with the subject matter of her dreams and visions—floral fantasies and heavenly and mythological subjects—which she captured in drawings of exceptional beauty that blaze with color. She said, "We talk of heaven, we think everything is going to be white. But I believe that we're going to have the beautiful rainbow colors"; she managed to capture and reflect this imaginary rainbow of rich and beautiful colors in her work.

A

Many of Evans's paintings contain a recurring image of a mystical face. It peers out from—and sometimes is almost hidden by—the brilliant flowers and fantastic vegetation that overflow her work.

COLLECTING TIPS Even the smallest works by Minnie Evans, whether watercolors or pencil drawings, are prized possessions today. Her most important works are considered to be a series of collages that she made in the late 1960s and early 1970s; she formed the collages by cutting several earlier drawings into pieces and then recombining them with glue on composition board.

WHERE TO SEE ART In 1986 the North Carolina Museum of Art, Raleigh, presented the work of Minnie Evans in "Heavenly Visions: The Art of Minnie Evans." More recently a retrospective, "Minnie Evans: Artist," was organized by the Wellington B. Gray Gallery, East Carolina University, Greenville, North Carolina (1993); that exhibition traveled to several different venues.

Minnie Evans's work is in the permanent collections of many museums, including the Collection de l'Art Brut, Lausanne, Switzerland; the Whitney Museum of American Art and the Museum of American Folk Art, both in New York City; the Arkansas Arts Center, Little Rock; the Newark Museum, Newark, New Jersey; and the St. John's Museum of Art, Wilmington, North Carolina.

WHERE TO BUY ART The estate of Minnie Evans is represented by the Luise Ross Gallery in New York City. Modern Primitive in Atlanta has examples of Evans's work, as do several other galleries—the Berman Gallery, also in Atlanta; Gasperi in New Orleans; Anton Haardt in Montgomery, Alabama; and Janet Fleisher in Philadelphia.

HOMER GREEN

Born July 10, 1910, Doug Holler, Tennessee. Now resides Beech Grove, Tennessee.

On a rutted dirt road, high above the "holler" in which he was born, Homer Green has constructed a garden of visual delights—totem poles (some twenty feet high) of speckled penguins, owls, and other assorted creatures painted in bright, traffic-stopping polka dots of color. "Every durn animal that can be made of wood!" Green brags, is included.

"A man can't just sit down and do nothin,' and so I just started cutting away," Green explains. "At first I didn't paint 'em much and nobody bothered with my animals. Then my wife [now deceased] said 'paint some color on them and they'll stop traffic' and when I done started spottin', then I had my business going."

One of Green's first pieces is *Yellow Buffalo,* a sparsely painted carving with real horns. A buffalo actually wandered onto Green's farm, and before it could be reclaimed by its owner, it was "dressed out" and its horns affixed to the sculpture!

COLLECTING TIPS Homer Green's early work is simply marvelous, but the repetitive polka-dotted "critters," which come in all sizes, may be too decorative for some collectors. Whether or not you want to take home a "critter," be sure to admire them in their own environment.

WHERE TO SEE ART Green's farmyard facing the road is worth a detour, and afterward there is the scenic blue-highway detour to Bell Buckle and the Bell Buckle Café for lunch.

Homer Green is included in "Passionate Visions of the American South," New Orleans Museum of Art (1993). His "critters" are in the collection of the Sheldon Memorial Art Gallery, University of Nebraska, Lincoln.

WHERE TO BUY ART Homer Green will sell his work and take orders. Anne White-Scruggs, proprietor of Bell Buckle Crafts, buys the best of his sculpture, and she might be able to find a unique early piece for a serious collector. Green's sculpture also shows up in many galleries specializing in folk art, for example: Rising Fawn, Chattanooga, and Bruce Shelton, Nashville, Tennessee; Ames Gallery, Berkeley, California; Vanity Novelty Garden, Miami Beach, and Lucky Street Gallery, Key West, Florida; and Gilley's Gallery, Baton Rouge, Louisiana.

3 3
B E S S I E H A R V E Y

Born October 11, 1929, Dallas, Georgia. Died August 12, 1994, Alcoa, Tennessee.

Bessie Harvey portrayed the souls she saw in branches and roots. "I frees them!" she explained of her root sculptures, to which she often added putty, beads for teeth, turkey bones, trinkets, and other found objects in order to highlight the individual characteristics of the "souls" she found in the wood. She often painted her pieces black because, she declared, "Evil is beautiful because the devil would disguise himself as good. I paint 'em black for evil." The "souls" Harvey depicted ranged from the faces of the tormented to African kings and queens to such religious figures as a black Moses or Christ to just plain ordinary people.

Harvey worked in the homes of others and as a housekeeper's aide at a hospital until she discovered (around 1974) that she had a vision or "gift" that led her into a new profession—making sculpture out of tree roots and branches.

She also did some magic-marker drawings on paper and a few clay pieces.

COLLECTING TIPS Bessie Harvey has achieved star status with collectors of black folk art for her powerful and mysterious sculptures. Some scholars in the field of black studies believe that her style of root sculpture has African and/or voodoo origins.

Since Harvey's death in 1994 and her inclusion in the 1995 Biennial of the Whitney Museum in New York City, the large sculptures by this artist have rapidly escalated in price.

WHERE TO SEE ART Bessie Harvey was the first self-taught artist to be included in the prestigious Biennial of the Whitney Museum, New York City (1995), since Edgar Tolson was selected for the show in 1973. Her sculpture has also been included in most African-American shows of the 1990s, exhibitions such as "Ashe: Improvisation and Recycling in African-American Visionary Art," Winston-Salem State University, Winston-Salem, North Carolina (1993). She has participated in numerous other museum shows, including "Passionate Visions of the American South," New Orleans Museum of Art, Louisiana (1993); "Unsigned, Unsung," Florida State University, Tallahassee (1993); and "Works of Art . . . Worlds Apart," the New York State Historical Association, Cooperstown (1992).

Harvey's work is in the permanent collection of the Dallas Museum of Art, the African American Museum in Dallas, and the Milwaukee Art Museum, as well as the Knoxville Museum of Art, located not far from her former home in Alcoa, Tennessee.

WHERE TO BUY ART Harvey maintained a studio/gallery in Alcoa, Tennessee, where she welcomed visitors and was delighted to show and sell her art. Since her death, however, collectors have to search for her sculptures in galleries, but a number handle her work, among them Cavin-Morris, New York City; Blue Spiral I, Asheville, North Carolina; Berman Gallery, Atlanta; Rising Fawn, Chattanooga, Tennessee; Gasperi Gallery, New Orleans; and the MIA Gallery in Seattle.

34
ROBERT HOWELL

Born May 15, 1934, Powhatan,
near Richmond, Virginia.
Now resides Powhatan.

Robert Howell has fashioned a unique personal environment based on whirligigs of all shapes and sizes. He builds them and, as time and weather destroy them, rebuilds them—stuffed figures on horseback, rocket ships, airplanes, and animal-shaped creatures—all of which move in the wind. To Howell, his creations look real. "I just like making them," he explains. "I'm working all the time to get stuff in my head [new ideas]."

Howell lives in a former roadside country grocery store that was built by one of his brothers; he has surrounded his home with his wind-driven creations. "People come by just to look," he says, "and that's ok. But if they bother my stuff, I'll go after them with this here shotgun."

Howell's marvelous moving creations are made of wood, cloth, and assorted materials that may not last long if kept outdoors as they are currently displayed. The giant wind machines and animals attract the most attention, but the smaller whirligigs are more collectible and can be kept indoors for preservation.

WHERE TO SEE ART The best way to experience Howell's magical world is by visiting Powhatan, Virginia. Examples of his work were included in the exhibition "Diving in the Spirit," Wake Forest University, Wake Forest, Virginia (1992), and are illustrated in the catalog for that show.

WHERE TO BUY ART Although most pieces are not for sale, the artist occasionally makes some whirligigs and assorted objects to sell to the visitors that find their way to his weathered home.

Billy Ray Hussey

3 5
BILLY RAY
HUSSEY

Born August 3, 1955, Robbins, near Seagrove, North Carolina. Now resides Robbins.

Billy Ray Hussey is by far the most innovative of the non-academic North Carolina potters working today, creating a contemporary art form from what traditionally was utilitarian ware. Hussey creates imaginary animals, face jugs depicting Alice in Wonderland–like characters, and even teapots with snake spouts. His ware is thrown on a wheel, fired in a wood-burning kiln, and then covered with traditional glazes, but his pots are sculptural presentations and not meant for table use.

Hussey started working for the Owens pottery when he was ten years old. "My great uncle, M. L. Owens, wrote out his formula for the glazes, and that started me out," Hussey remembers. Hussey is now president of the six-hundred-member Southern Folk Pottery Collectors Society, and he maintains a display area/museum.

COLLECTING TIPS Interest in contemporary folk pottery has increased dramatically during the last two decades, and the work of this artist has steadily appreciated. If you join the Southern Folk Pottery Collectors Society, you are entitled to bid at their auctions, and

some collectors are lucky enough to own a pot signed "B. H." with a Roman numeral that indicates the kiln opening number on the bottom.

Billy Ray Hussey's ware is in the Smithsonian Institution, Washington, D.C.; the Chrysler Museum, Norfolk, Virginia; and in most other institutions where North Carolina folk pottery is displayed.

Hussey has approximately two kiln openings a year. Collectors contact him for dates and arrive in Robbins before early-morning light to draw numbers; however, there are generally more collectors than available pieces. Sometimes dealers like Mike Smith (At Home Gallery, Greensboro, North Carolina) and Lynne Ingram (Milford, New Jersey) will be able to buy a piece at a kiln opening and resell it.

Anderson Johnson

36
ANDERSON
JOHNSON

Born August 1, 1915, Lunenberg County, Virginia. Now resides Newport News, Virginia.

When he was eight years old, Anderson Johnson received a call from God telling him to become an evangelistic preacher; he also became an extraordinary self-taught artist. He draws pictures of women because the Lord said to him "draw what you do best." The woman he paints repeatedly (often on found cardboard) is light-skinned, oval-faced, and dressed to the nines in a Sunday outfit for church, usually topped off with a large, brimmed hat. Johnson also has painted images of his heroes—Christ, Martin Luther King, and Abraham Lincoln.

Johnson refers to himself as Elder, and sometimes Bishop. He is the founder of Faith Mission, a very unusual church. Johnson has turned it into a major folk art environment, decorating it inside and out with his paintings and signs of reminders to the faithful. At Sunday services Johnson plays the guitar, harmonica, and organ, and dances and preaches amid his floor-to-ceiling paintings.

Johnson's compulsive image of the light-faced woman, sometimes accompanied by a cat, is particularly strong, although his other paintings are also of interest.

WHERE TO SEE ART Recently, as part of an urban renovation project, the artist moved to a new house not far from Faith Mission; he is rapidly transforming this fresh setting into another folk environment and welcomes visitors. At the same time, the Committee for the Preservation of the Anderson Johnson Faith Mission is making every effort to save the original mission. Funds have already been raised to preserve several of Johnson's murals.

Johnson was included in "Passionate Visions of the American South," New Orleans Museum of Art (1993) and other shows such as "Virginia Originals," Virginia Beach Center for the Arts (1994). Anderson Johnson's paintings are in several museum collections, including that of the Meadow Farm Museum, Richmond, Virginia, and the Carl Van Vechten Gallery of Fine Arts, Fisk University, Nashville.

WHERE TO BUY ART Johnson says that an angel sat in a corner of the church and told him that the Lord did not want him to be in the business of selling art. Johnson interpreted this to mean that he should not take orders for his art. If one attends a service, he is happy to accept an offering "to help do the work of the Lord."

Occasionally paintings by Johnson turn up in galleries or with dealers (Jim Linderman in New York handles some), but Johnson won't enter into any formal arrangement concerning his art.

CLYDE JONES

Born April 1, 1938, Pittsboro, North Carolina. Now resides Bynum, North Carolina.

Clyde Jones manufactures "critters" with the aid of a chain saw and found objects such as plastic flowers, metal pipes, reflectors, and Styrofoam—anything and everything that he thinks will look interesting. Hundreds of critters fill his yard, wander under fences onto neighboring properties, and even roam out into the street. Jones calls his environment, appropriately enough, "Haw River Critter Crossing"; it has become a tourist attraction for this small town.

COLLECTING TIPS As individual works of art, many collectors feel that Jones's critters (often with plastic eyelashes and artificial flowers) are a bit too kitsch, although they work well within Jones's environment. Jones also makes flat, repetitious paintings of animals that are sometimes interesting, especially in larger sizes.

WHERE TO SEE ART The environment of Clyde Jones in Bynum, North Carolina, is well worth a visit. His work has been included in several shows, including "Passionate Visions of the American South," New Orleans Museum of Art (1993). Several of Jones's critters are in the collection of Saint John's Museum of Art in Wilmington, North Carolina, and the New Orleans Museum also has some of his pieces in its collection.

WHERE TO BUY ART There is a false "folk legend" that Jones will not sell his sculpture, that he even turned down thousands of dollars for a piece from Mikhail Baryshnikov on the occasion of the famous dancer's visit to Critter Crossing. Jones does, however, sell his

Clyde Jones

work occasionally, and some pieces appear from time to time at such galleries as Mike Smith's At Home Gallery, Greensboro, North Carolina, and Main Street Gallery, Clayton, Georgia. A few pieces (usually drawings) are generally available at Tuck's Country Store near Jones's home in Bynum.

**37
SHIELDS
LANDON
"S. L." JONES**

Born October 17, 1901, Indian Mills, West Virginia. Now resides Pine Hill (near Hinton), West Virginia.

S. L. Jones has been described as a single-image artist. His portraits, whether carved or drawn, male or female, all depict an instantly recognizable person, often smiling. "The heads look like I feel," he says, "happy or sad—they aren't of anyone in particular but they come from me." Jones, however, has a far-ranging vision, and though his faces may be similar, his work encompasses carvings of a range of full-figured men and women, busts, heads, animals, and birds. In addition to his carving, Jones also does drawings; these drawings, often of heads, are frequently related to his sculptures.

Jones worked for the Chesapeake and Ohio Railroad for almost forty years. Soon after he retired, he returned to the hobby he had learned as a boy—carving. He still draws at age ninety-three and is fond of saying, "A person has got to have some work to do, don't they?"

COLLECTING TIPS

Jones's most valuable works are his standing full-figured men and women. More recently, his drawings have gained the attention of many collectors; the drawings contain many of the familiar elements that have attracted national attention to his larger pieces, but they are considerably less expensive.

The pieces Jones made after about 1981, when he was already eighty years of age, are not carved quite as well as his earlier work. They lack the definition and some of the inventiveness of the prior carvings. His drawings, however, are as good as ever.

WHERE TO SEE ART

Jones's carvings appeared in "The Cutting Edge" at the Museum of American Folk Art in New York City (1990) and in "O, Appalachia: Artists of the Southern Mountains," spon-

sored by the Huntington Museum of Art, Huntington, West Virginia (1989). He was also included in "Contemporary American Folk Art" at the Haggerty Museum of Art, Marquette University, Milwaukee (1992), and in a recent show at the Huntington Museum, "By the People: American Nineteenth and Twentieth Century Art of the Folk and Self-Taught" (1994).

The work of S. L. Jones is represented in many public museum collections, including the Huntington Museum of Art, Huntington, West Virginia; the Milwaukee Art Museum; the Museum of International Folk Art, Santa Fe; the Arkansas Arts Center, Little Rock; and the Smithsonian Institution's National Museum of American Art, Washington, D.C.

WHERE TO BUY ART Jones has little faith in the normal artist-dealer relationship. He likes to meet the people who buy his art and has always sold his carvings and drawings from his home. However, his work, especially the early carvings, does show up in dealer showrooms from time to time, for example, Epstein/Powell, New York City; the Dean Jensen Gallery, Milwaukee; Carl Hammer, Chicago; and the Robert Cargo Folk Art Gallery, Tuscaloosa, Alabama.

**38
CHARLEY
KINNEY**

Born May 30, 1906, Vanceburg, Kentucky. Died April 7, 1991, Vanceburg, Kentucky.

The tall tales and legends of Appalachia are preserved in the lyrical narrative pictures of Charley Kinney. The stories Kinney told through his art include tales of devils, religion, and "haints" —these latter his most famous. The "haint" that appears in many of his paintings is a dominant image, dark colored and grotesquely shaped, part human and part animal—everything a threatening spirit should be.

Part mountain man, part small-farm tobacco farmer, Kinney and his brother Noah (a folk carver of some note who also died in 1991) belonged to a disappearing culture within the region. According to local lore, Kinney shared his two-room log cabin in Toller Holler (a small mountain valley) with the "haint" that appears in his watercolors. He claimed it rattled its chains in the night from the darkness of the cabin's interior and from the rafters of his decaying tobacco barn nearby.

COLLECTING TIPS As the culture of Appalachia changes and becomes more akin to that of the mainstream United States, its regional stories, songs, and art have become recognized as important contributions to American folk history. Kinney was at his best when spinning these stories of local lore, and his paintings of "haints" stand out as prime examples of this genre.

WHERE TO SEE ART The work of Charley Kinney was included in the traveling exhibition "Local Visions: Folk Art from Northeast Kentucky," sponsored by the Folk Art Collection of Morehead State University, Morehead, Kentucky (1990), as well as "Passionate Visions of the American South," New Orleans Museum of Art (1993); it is illustrated in the catalogs of these exhibitions. Kin-

ney's work was also included in "Slow Time: Art by Charley, Noah, and Hazel Kinney," an exhibition at Morehead in 1995, as well as other shows of Kentucky and Appalachian art, such as "O, Appalachia: Artists of the Southern Mountains," Huntington Museum of Art, Huntington, West Virginia (1989).

Kinney's storytelling paintings are in the permanent collections of Morehead and the Owensboro Museum of Fine Art in Kentucky; the New Orleans Museum of Art, Louisiana; the Huntington Museum of Art, Huntington, West Virginia; and the Birmingham Museum of Art.

WHERE TO BUY ART — Charley Kinney's work is sold at the Museum Shop of the Kentucky Folk Art Center at Morehead State University and at galleries that feature Appalachian art—Anton Gallery in Washington, D.C., for example. The new Archer-Locke Gallery in Atlanta also has Kinney drawings.

HAZEL KINNEY

Born December 1, 1929, Sardis, Kentucky. Now resides Flemingsburg, Kentucky.

The last living artist member of the "Toller Holler" Kinneys, Hazel Kinney has a lot of time on her hands these days and "paints a lot of Bible pictures." Charley Kinney, her brother-in-law, who died April 8, 1991, was the creator of the now well-known Kentucky "haint" paintings, and Noah Kinney, her husband, who also died in 1991, was famous for his spirited carvings of animals.

Hazel Kinney began drawing seriously after the death of the other family members. "I didn't tell nobody at first," she told us, "I was too backward."

COLLECTING TIPS — Hazel Kinney's drawings are an attempt at realism and are not as imaginative as, say, Charley Kinney's "haints." However, collectors may want to round out their collections and include pieces by all three Kinneys.

Hazel Kinney also makes a few clay figures, but her drawings are her best work.

WHERE TO SEE ART — Hazel Kinney's drawings are in the Kentucky Folk Art Center at Morehead State University and the Southern Ohio Museum, Portsmouth. In 1995 her work was included in an exhibition at Morehead, "Slow Time: Art by Charley, Noah, and Hazel Kinney."

WHERE TO BUY ART — The Museum Shop at Morehead State University sells Kinney's art. Occasionally, her work shows up in galleries in Lexington or Louisville, Kentucky.

39
TIM LEWIS

Born October 28, 1952, Eddrich, Kentucky. Now resides Isonville, Kentucky.

Tim Lewis's fanciful carved canes are so widely known that they have become part of the folklore of Kentucky, but what brought us to his hill-hugging cabin were the occasional simple but elegant stone carvings that the artist chisels from the chimney rocks of abandoned coal miners' cabins. "No one was carving stone," the artist explained, "so I just started doing it [around 1988]."

There is a large market for Kentucky canes, and Tim Lewis is one of the most resourceful and best known of the cane carvers in the region. The more fanciful the cane, the better—devils, all kinds of animals, and strange people in unusual poses often appear on the handles and decorate the staffs. "However," the artist says, "Bible stories—Noah and the Ark, angels and such—have always interested me, and they come out best in stone. The more I do, the better I get."

COLLECTING TIPS Tim Lewis sells all the canes he can make to cane collectors and folk art collectors. His stone carvings are much rarer, more expensive, harder to find, and in many ways more desirable.

WHERE TO SEE ART Lewis has been exhibited in numerous shows in the region, such as "Local Visions: Folk Art from Northeast Kentucky," a traveling exhibition sponsored by the Folk Art Collection (now the Kentucky Folk Art Center) of Morehead State University (1990), and his canes are illustrated in *American Folk Canes: Personal Sculpture* (1992) and other books. Tim Lewis's work is included in the permanent collection of Morehead State University and the Owensboro Museum of Fine Art, Kentucky.

WHERE TO BUY ART Larry Hackley, North Middletown, Kentucky, handles most of Lewis's stone sculptures. His canes can be purchased at Morehead's Kentucky Folk Art Center as well as many galleries and museum shops throughout the country: the Anton Gallery, Washington, D.C.; the Kentucky Art and Craft Gallery, Louisville (this gallery sometimes also has Lewis's stone pieces); and Sailor's Valentine Gallery, Nantucket, Massachusetts, among others.

SAM McMILLAN

Born June 22, 1926, Furnam, North Carolina. Now resides Winston-Salem, North Carolina.

Sam McMillan covers everything he can get his hands on—used furniture, furniture he builds, clothing, you name it—with patriotic red, white, and blue polka dots. In between painting polka dots, he manages to find time to do a few portraits and paintings of animals and birds. "I'll paint anything you can put out there," he brags. "I even went to Carnegie Hall and painted the folks' tuxedos during intermission."

COLLECTING TIPS McMillan's colorfully decorated furniture, paintings, and clothing items are inexpensive and fun to own. The artist does some small furniture pieces that are popular items; collectors often buy them for children.

WHERE TO SEE ART When in New York in 1994, McMillan participated in the Outsider Art Fair and did a successful business painting polka dots on collectors' ties. McMillan is the proprietor of Sam's Handcraft and Art Shop in Winston-Salem, North Carolina; this is the preferred place to see the artist's work.

Sam McMillan

WHERE TO BUY ART At Sam's Handcraft and Art Shop, a polka-dotted extravaganza of painted objects signed "SAM" are offered for sale. McMillan's painted furniture is also sold through various galleries such as Creative Heart (formerly Urban Artware) in Winston Salem and Knoke Galleries in Atlanta.

40
LAURA CRAIG McNELLIS

Born September 8, 1957, Nashville, Tennessee. Now resides Nashville.

Laura McNellis's drawings contain bold areas of pure color, abstracted shapes from landscapes, and expressionistic interpretations of events in her life. Her work appears to be that of a contemporary trained painter, perhaps from California, but McNellis is not a trained artist. She is a severely retarded young woman who spends four to five hours each night drawing things that she loves—farms, bowling alleys, birthday cakes—and that are related to her limited environment.

After McNellis finishes a drawing, she trims all four edges with scissors, folds it in quarters, prints her name in bold block letters along the bottom edge, and promptly forgets about it. However, her sister, Pat McNellis, saves and documents the drawings; it is she who arranged for exhibitions of Laura's work.

COLLECTING TIPS McNellis's drawings are extremely popular with two groups of collectors: those who have crossed over to folk art from so-called modern art, and folk art collectors who are looking for outsider art. Her semiabstract drawings, with somewhat recognizable subject matter, are particularly interesting. Her dealer informs us that all the drawings are the same price, so buy what you like best.

Some of McNellis's early drawings are on newsprint; this material may need special attention. Because of the way she works, the fold creases and cut corners become part of the compositions and do not detract from the work.

WHERE TO SEE ART McNellis had a one-person exhibition at the Galerie Karsten Greve, Cologne, Germany (1993). In 1995 the artist was included in a show, "A World of Their Own: Twentieth Century

American Folk Art," organized by the Newark Museum, Newark, New Jersey. Eleven of her drawings are in the prestigious collection of the Collection de l'Art Brut, Lausanne, Switzerland.

WHERE TO BUY ART Laura McNellis is represented by Ricco/Maresca in New York City.

4 1
JOHN R. MASON

Born February 23, 1900, Dinwiddle County, Virginia. Now resides Suffolk, Virginia.

John Mason "draws pictures of jay birds that jump on my pecan tree." His small but colorful magic marker and felt-tip pen drawings of birds, with an occasional smiling male face in the foreground ("I can't draw no women," he claims) as well as bicycles, moons, and sunsets, are extremely popular. Mason, who retired after fifty years of sweeping up shells at the Planters Peanuts plant, says that he started drawing because he just has to have something to do.

"When I went to school [for four years] I'd steal other kids' drawings for the teacher," he explains. "Now I paints 'em and gives 'em to schoolchildren to make it right." And that's why Mason sits in a back booth at a Hardee's fast food restaurant every day but Sunday, drawing his pictures of birds and giving them to the schoolchildren that frequent the place. He has become such a tourist attraction that Hardee's has awarded the artist a certificate granting him free breakfast for life.

COLLECTING TIPS Mason is a new discovery, and his work is being snapped up by collectors in the region. If you can't visit the area, take a look at what's available in New York City.

Each of the artist's drawings is signed "John R. Mason," in a distinctive script, across the top. Some of the drawings bear food stains, and the magic marker ink he uses will fade in direct sunlight.

WHERE TO SEE ART Mason was included in the exhibition "Virginia Originals" at the Virginia Beach Center for the Arts, Virginia Beach (1994).

WHERE TO BUY ART John Mason is represented by American Primitive Gallery in New York City.

4 2
MARK CASEY MILESTONE

Born January 28, 1958, Jacksonville, Florida. Now resides Winston-Salem, North Carolina.

Mark Casey Milestone's paintings and whirligig assemblages reveal a sophisticated and intensely mystical artist on one level and a man who retains a childlike simplicity about the world and world affairs on another. He repeatedly draws a Picasso-style woman in silhouette blowing a trumpet; she is placed among personal symbols that are naive and raw. This duality of creation intrigues and delights the eye.

Milestone represents an emerging generation of folk artists—one that is untrained in art but aware of art movements, including folk art and folk artists, through books and magazine articles. "I quit school in tenth grade to go to work," he

explained. "I got a job in a restaurant rolling millions of potatoes into aluminum foil; then I dreamed of making art."

In 1991 Milestone received an Arts Council of Winston-Salem Emerging Artist Fellowship.

COLLECTING TIPS We prefer Milestone's whirligigs to his paintings. He makes the whirligigs for himself and keeps them outdoors, allowing them to rust in the weather. Many of the pieces are amusing, some are even bizarre, but they are all worth owning. In contrast, his paintings appear a bit deliberate.

WHERE TO SEE ART Mark Casey Milestone has been exhibited at art fairs in New York City and Atlanta.

WHERE TO BUY ART Milestone is represented by Mike Smith's At Home Gallery in Greensboro, North Carolina, and Lynne Ingram, Milford, New Jersey.

43
MARK ANTHONY
MULLIGAN

Born May 20, 1967, Louisville, Kentucky (Chickasaw neighborhood adjacent to Rubbertown, the home of oil refineries). Now resides Louisville.

The city is a beautiful place to Mark Anthony Mulligan; he paints the urban sprawl and commercial logos that most of us try not to see. "Ashland Refinery stunk up my neighborhood," he says, "but I love that smell! To me, Ashland means 'Ask Him Love and Never Doubt.'"

Mulligan is a three-hundred-pound black man who spends his days riding city buses and looking for cityscapes polluted by signs, decaying neighborhoods, and crooked streets; he spends his evenings painting the scenes he finds. Mulligan paints with bright, unmixed acrylic colors on paper and irregular-shaped boards that he finds. His urban landscapes are filled with the joy of discovering the beauty of the city. Mulligan makes up acronyms for the signs that abound in the streets of the city. "I love signs," he cheerfully relates. "Gulf is 'God's Unique Love Forever.'"

COLLECTING TIPS Mulligan signs each work of art with his name and the time spent working on the painting. Selecting a painting is a matter of availability and personal choice. In most instances, his paintings are stronger than his small drawings.

WHERE TO SEE ART Mark Anthony Mulligan has been exhibited at the Kentucky Folk Art Center at Morehead State University ("Signs and Logos: The World According to Mark Anthony Mulligan," 1993), and his work was shown at Bellarmine College, Louisville, Kentucky, in 1995. His work is in Morehead's permanent collection and is also represented in the permanent collection of the New Orleans Museum of Art.

WHERE TO BUY ART Mulligan is represented by the Swanson Cralle gallery in Louisville, Kentucky. Robert Cargo Folk Art Gallery in Tuscaloosa, Alabama, also carries the artist's work.

44
CARL BRUNO PIWINSKI

Born March 25, 1958, Lexington, Kentucky. Now resides Lexington.

Carl Piwinski's carefully detailed studies made with graphite and ink include printed chronicles of Martian adventures. As he explains, "When I stir up my mental processes, I see them [for example, Martians living in Mexico]." Piwinski draws what he sees—the adventures of Martians who are inhabiting prehistoric Mexico after their journey from a "happy world."

Although Piwinski studied art at the University of Kentucky, the faculty there considered him to be a savant and left him alone to quietly do his own thing. Piwinski takes occasional trips to the public library to copy drawings from books on Mexican anthropology. Pre-Columbian objects and maps copied from these books will appear in his work.

COLLECTING TIPS

Piwinski's work is painstaking, and it may take him months to complete a drawing; thus they are comparatively rare. When we visited him in 1994, he had completed only twenty drawings. Many collectors cherish works on paper; most will be interested in owning one of Piwinski's remarkable drawings. Piwinski's larger works are probably his strongest.

WHERE TO SEE ART

Carl Piwinski was included in "Exhibition 280: Works on Walls," at the Huntington Museum of Art, Huntington, West Virginia (1988). He also participates in local shows from time to time.

WHERE TO BUY ART

Piwinski is represented by the Heike Pickett Gallery, Lexington, Kentucky.

45
MELISSA POLHAMUS

Born August 23, 1957, Ludwigsburg, Germany (came to America eighteen months later). Now resides Virginia Beach, Virginia.

Melissa Polhamus's linear drawings are densely packed with colorful images. Unflattering self-portraits and eerie, dreamlike animals inhabit her highly detailed surfaces. "I look at wooden floors and crumpled paper," she explains, "and see threatening faces, which I copy."

After Polhamus was laid off from her defense-related job as an information analyst, she decided to become an artist. "It is a compulsion, all I have going for me right now," she says. "I have trouble paying my rent, but I can't stop doing them [the drawings]."

COLLECTING TIPS

Polhamus started with pen-and-ink drawings; today she uses crayon, colored ink, and watercolor on high-quality paper. Her recent works are even more patterned and densely packed than her earlier pieces; these are considered the most valuable. Polhamus's drawings are not pretty—they expose her subconscious fears to the light of day—but they will not disappoint those folk art connoisseurs who are willing to be bolder in their acquisitions.

WHERE TO SEE ART

Polhamus's drawings were exhibited at the Virginia Beach Center for the Arts and reproduced in the catalog *Melissa Polhamus: Virginia Beach Original* (1994). The artist also had a

one-person exhibition at Virginia's Danville Museum of Fine Art, Danville. She occasionally exhibits at boardwalk shows in Virginia Beach.

WHERE TO BUY ART Mike Smith's At Home Gallery, Greensboro, North Carolina, acts as the artist's exclusive representative.

QUINTON "Q. J." STEPHENSON

Born November 5, 1920, Garysburg, North Carolina. Now resides Garysburg, North Carolina.

Q. J. Stephenson's Earth Museum is a small, heavily decorated concrete-block building that looks like a stage setting for "Hansel and Gretel." Inside and outside it is covered with shells, Civil War relics, petrified wood, and dinosaur fossils. Stephenson makes prehistoric animals, fish, and various personages out of concrete; the objects are then encrusted with a multitude of found objects. "I make creatures that no man has seen," Stephenson boasts.

A retired trapper/dragline operator, Stephenson has spent a lifetime collecting his "finds" and the last twenty years constructing his Earth Museum.

COLLECTING TIPS Many of Stephenson's sculptures are collectible and fun to own, but the main attraction is their unbelievable environment—his unique Earth Museum.

WHERE TO SEE ART Stephenson's work was exhibited in "Outside the Main Stream" at the High Museum of Art in Atlanta (1988), and his work is illustrated in the catalog *Signs and Wonders: Outsider Art inside North Carolina*, North Carolina Museum of Art, Raleigh (1989). His work is in the permanent collections of North Carolina Wesleyan College in Rocky Mount and the Smithsonian Institution's National Museum of American Art in Washington, D.C. His work has also been shown at the James Collection of Southern Folk Art, Saint James Place, Robersonville, North Carolina.

WHERE TO BUY ART Individual works are available at the Earth Museum and from such dealers as Mike Smith (At Home Gallery, Greensboro, North Carolina), Lynne Ingram (Milford, New Jersey), and Dave Knoke (Knoke Galleries, Atlanta).

Q. J. Stephenson

46
EDGAR TOLSON

Born June 24, 1904, Lee City, Kentucky. Died September 7, 1984, Campton, Kentucky.

Kentucky is well known for its wood carvers, but Edgar Tolson stands head and shoulders above all them all. He originated what is now called the "Campton style" by using a simple pocket knife to carve men, women, and animals that he then left unpainted, or occasionally to which he applied only a sparse amount of paint. Ostensibly Tolson carved biblical scenes and representations of common mountain people, but his work was really about the relationship of men to women and people to their God.

The legend of Edgar Tolson, the preacher who blew his church off its foundation (no one was hurt) because his parishioners "couldn't live it" (his version of the word of the Lord) is now part of the folklore of the Kentucky hills, and Tolson's creations in art are now part of our American heritage.

COLLECTING TIPS

Tolson's tableaux (many of which are set in the Garden of Eden) consisting of two or more figures are his most valuable—and the earlier the piece, the better. Even his small animal carvings, however, are now considered of museum quality.

Tolson rarely signed his work, and there are many present-day followers of this artist working in what is now called the Campton style. If you are not sure that a particular carving is by Edgar Tolson, consult an expert.

WHERE TO SEE ART

The carvings of Edgar Tolson have been illustrated in almost every book, catalog, and general survey on twentieth-century folk art since the 1970s. He is represented by many pieces in the permanent collection of the Milwaukee Art Museum; his work is also in a number of other public collections, such as the Kentucky Folk Art Center, Morehead State University; the Museum of American Folk Art, New York City; the Huntington Museum of Art, Huntington, West Virginia; and the Smithsonian Institution's National Museum of American Art, Washington, D.C.

WHERE TO BUY ART

From time to time Edgar Tolson's carvings come on the market; check major folk art galleries and auction houses regularly. Good galleries to try are the Heike Pickett Gallery, Lexington, Kentucky; the Hill Gallery, Birmingham, Michigan; and the Janet Fleisher Gallery, Philadelphia.

47
HUBERT WALTERS

Born August 4, 1931, Kingston, Jamaica. Immigrated to New York, 1971. Now resides Troutman, North Carolina.

Even though Hubert Walters is no longer near the ocean, he remembers the boats that he used to go fishing on. "So now," he says, "I put things I made and things I find together and make folk art boats." These boats are fanciful versions of the fishing boats Walters worked on in Jamaica, and flashlights, clocks, working music boxes, and more all become intrinsic parts of their superstructures. The boats Walters puts together could never survive on the open seas, however; they are made of Bondo, wood, tin, and string. "Not real, man!" he explains, "just trying out ideas."

Hubert Walters

Walters's yard and studio—filled and decorated with boats and large cement animals such as donkeys, mules, and horses—have a carnival-like atmosphere and are a delight to visitors of all ages. The inside of his studio is kept stocked with what Walters calls "half people"; half people (people from the waist up) are made of Bondo, look a bit like highly decorated tenpins, and have painted faces that remind the artist of Jamaicans he used to see in his neighborhood and the marketplace. "The ladies buy the half people," he explains, "the men buy the boats."

A

COLLECTING TIPS Many collectors prefer Walters's "half people"; they are less expensive than the boats, and a carefully arranged grouping makes an amusing display. The boats, especially the large ones, and the concrete animals are for more serious collectors, but boats, animals, or half people, this is art that is fun.

WHERE TO SEE ART Hubert Walters's work was included in "Passionate Visions of the American South," New Orleans Museum of Art (1993). He is included in the permanent collection of the African American Museum in Dallas and the Birmingham Museum of Art, Alabama.

WHERE TO BUY ART Walters sells his art from his home. His pieces may also be found from time to time at Mike Smith's At Home Gallery in Greensboro, North Carolina; the Dean Jensen Gallery in Milwaukee; Knoke Galleries in Atlanta; and the Leslie Muth Gallery in Santa Fe.

M *museum* **G** *gallery* **O** *other*
** denotes profiled artists*

MUSEUM AND GALLERY GUIDE

KENTUCKY

Berea College **M**
Berea, KY 40404
(606) 986-9341

Berea College does not have a large folk art collection, but it does have temporary exhibitions from time to time. In 1994 its Doris Ullman Gallery mounted an exhibition, "Twentieth-Century, Self-Taught, Kentucky Primitive Art," which included work by Charley*, Noah, and Hazel Kinney*, among others. Berea owns most of the known works by Carlos Coyle. The town of Berea is known for its many stores and galleries showing Kentucky crafts.

**Kentucky Museum/
Western Kentucky Museum** **M**
Bowling Green, KY 42101
(502) 745-4878

The museum's emphasis is on traditional crafts such as baskets and duck decoys, but it does have a few folk artists in its permanent collection. Among these are Unto Jarvi and Helen La France. Appointments can be made to view art or artifacts not on display.

Heike Pickett Gallery ◪
522 West Short Street
Lexington, KY 40507
(606) 233-1263

An interesting gallery that carries fine art and folk art, the Heike Pickett Gallery usually has works on hand by Minnie* and Garland Adkins*, Junior Lewis and Carl Bruno Piwinski*. Sculptures by Edgar Tolson* and other well-known folk artists occasionally turn up at the gallery for resale.

Kentucky Art and Craft Gallery ◪
609 West Main Street
Louisville, KY 40202
(502) 589-0102

A nonprofit gallery run by the Kentucky Art and Craft Foundation, the Kentucky Gallery carries work by folk artists Minnie* and Garland Adkins*, together with work by Kentucky craftsmen such as woodturner Rude Osolnik. Only Kentucky artists are represented by the gallery.

Swanson Cralle Gallery ◪
1377 Bardstown Road
Louisville, KY 40204
(502) 452-2904

Swanson Cralle shows contemporary art as well as contemporary folk art. Its folk art centers on Kentucky; Ronald and Jessie Cooper and Mark Anthony Mulligan* are handled on a regular basis. Worth a visit.

Kentucky Folk Art Center Ⓜ
Morehead State University
119 West University Boulevard
Morehead, KY 40351
(606) 783-2204

Morehead has the foremost collection of Kentucky folk art in the country. The collection, formerly the Folk Art Collection of Morehead State University, includes such artists as Edgar Tolson*, Hugo Sperger, Charley* and Noah Kinney, and Minnie* and Garland Adkins*. A museum store is operated in conjunction with the Folk Art Center; it usually has works on hand by about thirty area artists, including Minnie Adkins*, Denzil Goodpaster, and Ronald and Jessie Cooper. In the spring of 1996 the center will be moving into new quarters, a renovated wholesale building on historic First Street in Morehead.

BlueGrassRoots ◪
Larry Hackley
P.O. Box 88
North Middletown, KY 40357
(606) 362-7084

Larry Hackley handles a wide variety of folk art, much of it from Appalachia. Since Hackley is often on the road, he advises that it is "best to write." The gallery usually has works by Charley* and Noah Kinney, Donny Tolson, Carl McKenzie, Tim Lewis*, Linvel* and Lillian Barker*, Minnie* and Garland Adkins*, and Minnie Black. Canes, Afro-American quilts, and face jugs can also be found here.

Owensboro Museum of Fine Art Ⓜ
901 Frederica Street
Owensboro, KY 42301
(502) 685-3181

Opened in 1977 in the renovated Carnegie Library Building, the Owensboro Museum has become a major cultural and educational force in Kentucky. An expansion program presently underway will include a Kentucky wing, which will showcase the cultural history of Kentucky from the eighteenth century to the present. In the interim, the museum is devoting one floor of its existing building to exhibitions of folk art. It has assembled a sizeable collection of contemporary Kentucky folk art, including the Coopers, Junior Lewis, Tim Lewis*, Earnest Patton, and Charley* and Hazel Kinney*, as well as a small collection of folk art from other parts of the country (Charlie Lucas*, James Harold Jennings, and Jimmie Lee Sudduth* for example). The museum's collection was exhibited in "Kentucky Spirit: The Naive Tradition," a 1991 exhibition. Additional exhibitions are planned.

Blue Spiral 1 **G**
38 Biltmore Avenue
Asheville, NC 28801
(704) 251-0884

Blue Spiral has a number of works by the late Bessie Harvey*; the gallery also represents Parks Townsend and Jill Carnes and has works by such artists as Jimmy Lee Sudduth* and Lonnie Holley. Also on hand are southeastern craft objects of wood, clay, and fiber.

Ginger Young Gallery **G**
Southern Self-Taught Art
5802 Brisbane Drive
Chapel Hill, NC 27514
(919) 932-6003

Formerly a dealer in Washington, D.C., Ginger Young has moved to Chapel Hill and is continuing her representation of more than four dozen artists. Since moving to North Carolina, Young reports that she is concentrating on artists such as Rudy Bostic*, Yahrah Dahvah*, Henry Ray Clark*, and Myrtice West*. She will supply a video catalog or complete price list upon request. Open by appointment.

A

Mint Museum **M**
2730 Randolph Road
Charlotte, NC 28207
(704) 337-2000

The Mint Museum has the most comprehensive collection of historic North Carolina pottery. The museum has a few other pieces of folk art, such as a portrait by Ammi Phillips and several works by William Matthew Prior.

At Home Gallery **G**
2304 Sherwood Street
Greensboro, NC 27403
(910) 294-2297

Mike and Lisa Smith's At Home Gallery carries both well-established folk artists (James Harold Jennings, S. L. Jones*, Raymond Coins*) and newer discoveries (Melissa Polhamus* and Mark Casey Milestone*). The gallery usually has an assortment of pottery on hand by B. B. Craig, Billy Ray Hussey*, and others. Open by appointment.

Wind-Powered
Sculptural Environment
of Vollis Simpson **O**
Lucama, NC

Vollis Simpson has created an incredible environment in Lucama, a colorful wind-powered display that is in constant motion. Airplanes, a horse-drawn buggy, and a man riding a bicycle all whirl merrily, high above the ground. The display is covered with aluminum reflectors, so Simpson's environment can also be seen at night. Although the large constructions are not for sale, Vollis Simpson makes a few small airplanes and other pieces to sell to visitors.

Visual Arts Center **M**
North Carolina State University
3302 University Student Center
Raleigh, NC 27695-7306
(919) 515-7473

The Visual Arts Center has a collection of pottery, textiles, porcelains, sculpture, and painting. It owns works by self-taught artists Georgia Blizzard*, Vernon Burwell, James Harold Jennings, and several others.

Saint James Place
Folk Art Museum **M**
Robersonville, NC
(919) 795-4719

Saint James Place, a restored 1910 Primitive Baptist church located on U.S. Highway 64 in Robersonville, serves as a museum for folk art, decoys, and art pottery. Opened in 1993, the first exhibition was the James Collection of Southern Folk Art, an interesting collection that includes many new discoveries. Open by appointment.

Southern Folk Pottery Collectors Society Shop and Museum ◙
1828 North Howard Mill Road
Robbins, NC 27325
(910) 464-3961

Susan and Billy Ray Hussey* have established a museum and shop carrying the very best of contemporary pottery as well as some older pieces—a real delight to visit and an opportunity to observe a folk potter at work. Once or twice a year the Society sponsors an absentee auction sale of southern pottery.

Robert Lynch Collection of Outsider Art ◙
North Carolina
Wesleyan College
3400 North Wesleyan Boulevard
Rocky Mount, NC 27804
(919) 985-5100

The Wesleyan College collection comprises 420 objects, almost all of which are from the Lynch Collection. At present only about ten percent of the collection is on view, but in 1996 the Thorp Gallery will be the formal venue for the collection. The college is known for its extensive holdings of works by Leroy Person (several hundred in number). Other artists in the collection include Herman Bridgers, Vernon Burwell, and Q. J. Stephenson*. The present collection and future acquisitions are drawn from the greater Eastern Carolina region.

North Carolina Pottery Center Ⓜ
Seagrove, NC
(P.O. Box 3304)
Asheboro, NC 27204-3304
(910) 879-5700

An exciting new facility now being built and tentatively scheduled to open in 1997, the center will be located in the heart of the largest community of working potters in the nation. The exhibition space has been designed to provide visitors with an orientation to the history of pottery and the process of making it. Call for more information.

Southeastern Center for Contemporary Art (SECCA) Ⓜ
750 Marguerite Drive
Winston-Salem, NC 27106
(910) 722-6059

The Southeastern Center does not have a permanent collection, but it frequently includes contemporary folk art in its changing exhibitions. For example, SECCA's 1995 traveling exhibition, "Civil Rights Now," included such folk artists as Thornton Dial*, Lonnie Holley, and Herbert Singleton*.

Creative Heart Gallery Ⓖ
207 West 6th Street
(P.O. Box 1133)
Winston-Salem, NC 27102-1133
(910) 722-2345

Formerly Urban Artware, Creative Heart has early pieces by Howard Finster* and Mary T. Smith*. The gallery also has works by Georgia Blizzard* and local artists such as Mark Casey Milestone*, Frank Holder, and Sam McMillan*.

TENNESSEE

Bell Buckle Crafts Ⓖ
Railroad Square
Bell Buckle, TN 37020
(615) 389-9371

Located in the center of the interesting town of Bell Buckle, this gallery-antique store has a number of works by Homer Green*; sometimes, early Green works are available here. Furniture and local craft items are also carried.

Rising Fawn Folk Art Ⓖ
714 Lindsay Street
Chattanooga, TN 37402
(615) 265-2760

Rising Fawn has a wide-ranging selection of folk art. The gallery has works by the "Rhinestone Cowboy" (Bowlin)*, Burgess Dulaney*, Homer Green*, Joe Light, Hubert Walters*, and Myrtice West*, as well as pieces by such well-established artists as Clementine Hunter* and Justin McCarthy*.

Dan Prince G
5539 Big East Fork Road
Franklin, TN 37064
(615) 791-5191

Folk art dealer Dan Prince, who has works by about eighty-five artists, including Larry Armistead and David Secon, is now operating out of Franklin, Tennessee. Prince also shows in other places like Santa Monica, California, and Atlanta; check with him as to scheduling. Open by appointment.

Kurts Bingham Gallery G
766 South White Station Road
Memphis, TN 38117
(901) 683-6200

Kurts Bingham represents trained artists (Walter Anderson and Manuel Neri) as well as folk artists (William Edmondson*, Theora Hamblett, and Clementine Hunter*). It has held one-person exhibitions for the Tennessee self-taught artist Bob Short, who began painting in 1991.

Cheekwood Museum of Art M
1200 Forrest Park Drive
Nashville, TN 37205-4242
(615) 353-2140

Cheekwood is known for its collection of ten works by Tennessee master sculptor William Edmondson*, all of which are on permanent display.

A

**Carl Van Vechten
Gallery of Fine Arts** M
Fisk University
Nashville, TN 37208
(615) 329-8720

The Fisk University Collection was donated by Dr. A. Everette James in 1991. The artists represented in the collection, most still active, include Anderson Johnson*, Sam Doyle*, Mose Tolliver*, Z. B. Armstrong, and Wesley Stewart*, among others.

Lyzon Fine Art G
411 Thompson Lane
Nashville, TN 37211
(615) 256-7538

A well-established gallery in Nashville, Lyzon carries contemporary fine and folk art. It has long represented Sterling and Dorothy Strauser, and Clarence Stringfield worked as a framer here. Justin McCarthy*, Sybil Gibson, and "Old Ironsides" Pry* are among the contemporary folk artists to be found at the Lyzon Gallery.

Bruce Shelton Folk Art G
101 LaSalle Court
Nashville, TN 37205
(615) 352-1970

Bruce Shelton, who has also opened a gallery in Palm Beach, Florida (see page 184), always has an eye open for new discoveries. In addition to artists like Jimmy Lee Sudduth*, Dow Pugh, and Mose Tolliver*, Shelton represents Priscilla Cassidy, the Close family, Homer Green*, Alvin Jarrett, Helen La France, and Wesley Willis* regularly. Open by appointment.

Museum of Appalachia M
P.O. Box 0318
Norris, TN 37828
(615) 494-7680

Located sixteen miles north of Knoxville, off I-75, the Museum of Appalachia exit is well marked. There are now some twenty-five buildings in the Museum Village, which encompasses a working farm and gardens and a Museum Craft and Antique Shop. Most of the folk art can be seen in the museum's Hall of Fame; the main display building contains a diverse collection of pioneer-frontier relics and memorabilia. "Cedar Creek" Charlie Fields and Minnie Black are among the better-known folk artists in the collection. Carvings by coal miner Troy Webb and his family are also on display and for sale in the museum shop. The museum sponsors various special programs, including an Annual October Homecoming.

Meadow Farm Museum M
3400 Mountain Road
Glen Allen, VA 23060
(804) 672-9496

A part of the Recreations and Parks Program of the County of Henrico, the Meadow Farm Museum includes a restored farm with separate exhibition galleries. This complex is located in a large park in Glen Allen, twelve miles northwest of Richmond. In addition to nineteenth-century works, the museum has a good-sized collection of twentieth-century folk art by such artists as Patsy Billups*, Georgia Blizzard*, Abe Criss, Anderson Johnson*, and Jimmy Lee Sudduth*. As is evident from the collection, the emphasis is on the work of Virginia folk artists.

Anderson Gallery M
Virginia Commonwealth
University
907½ West Franklin Street
Richmond, VA 23284-2514
(804) 257-1622

The Anderson Gallery occasionally exhibits folk art. It has had one-person shows of Ned Cartledge (1994) and Leslie J. Payne, for example.

Whitehall Gallery M
Virginia Union University
1500 North Lombardy Street
Richmond, VA 23220
(804) 257-5607

Virginia Union University has a permanent collection of contemporary folk art that includes Thornton Dial*, Mose Tolliver*, Mary T. Smith*, Hawkins Bolden*, and others. It is not always on display due to space limitations, however, so check first.

Hurrah! G
1311 East Cary Street
Richmond, VA 23219
(804) 649-0127

A relatively new gallery that opened in 1993, Hurrah! represents Nellie Mae Rowe*, Luster Willis, Charley Kinney*, and Minnie Adkins*, as well as local artists.

Folk Art Society of America O
P.O. Box 17041
Richmond, VA 23226-7041
(804) 285-4532

The Folk Art Society of America has its national office in Richmond. Its president, Ann Oppenhimer, reports that the office and its extensive library are open to collectors by appointment.

**Art Museum of
Western Virginia** M
1 Market Square
Roanoke, VA 24011
(703) 342-5760

The Roanoke museum has a small but growing collection of contemporary folk art; it includes Leroy Almon, Howard Finster*, Mose Tolliver*, and James Harold Jennings, among others. The museum also exhibits folk art; in 1994, for example, it showed "James Harold Jennings Art World."

**Miles B. Carpenter
Folk Art Museum** M
201 Hunter Street
Waverly, VA 23890
(804) 834-2897

Established as a showcase for the works of Virginia artist Miles Carpenter, the museum setting is Carpenter's former home in Waverly. The museum also has changing exhibitions. Open afternoons, 2–5 P.M.

**Abby Aldrich Rockefeller
Folk Art Center (AARFAC)** M
307 South England Street
(P.O. Box 1776)

The Abby Aldrich Rockefeller Folk Art Center has long been known for its outstanding collection of American folk art, including masterpieces from the late nineteenth and the early twentieth centuries. In recent years, the Folk Art Center has

Williamsburg, VA 23187-1776
(804) 220-7670

also been collecting contemporary folk art, starting with its acquisition of a Miles Carpenter watermelon carving in 1973. With the addition of a new wing in 1992, selections of twentieth-century art are on display together with earlier material; Eddie Arning*, Ulysses Davis, Martin Ramirez*, Edgar Tolson*, and Bill Traylor* are among the contemporary artists represented. In 1997 the museum plans an exhibition of contemporary folk art from the collection of Baron and Ellin Gordon.

WASHINGTON, D.C.

National Museum of American Art **M**
Smithsonian Institution
8th and G Streets, NW
Washington, D.C. 20560
(202) 357-1300

The National Museum of American Art has one of the foremost collections of twentieth-century works in the country. James Hampton's *Throne of the Nations Millennium* is on permanent exhibit; folk art from the collection is on display in several galleries; and the museum also has changing exhibitions. In 1986, through gift and purchase, the National Museum acquired the Herbert Hemphill, Jr., Collection, thus substantially enlarging its folk art holdings. The museum is continuing to acquire contemporary pieces.

Anton Gallery **G**
2108 R Street, NW
Washington, D.C. 20008
(202) 328-0828

Primarily a fine arts gallery, Anton nevertheless usually has some folk art on hand. In the past, the gallery has represented Donny Tolson and other artists from Appalachia. From time to time it brings new discoveries to light. Presently, Anton has works by Tim Lewis* and Carl McKenzie.

Tartt Gallery **G**
2017 Q Street, NW
Washington, D.C. 20009
(202) 332-5652

Jo Tartt, the gallery owner, is from Alabama and has long had an interest in southern folk art. Although the gallery specializes in photography, it has a substantial inventory of folk art, including Jimmy Lee Sudduth*, R. A. Miller*, and Raymond Coins*.

Very Special Arts Gallery **G**
1331 F Street, NW
Washington, D.C. 20004
(202) 628-0800

A nonprofit gallery, Very Special Arts is an international organization that seeks to promote greater awareness of the educational and cultural benefits of the arts. It primarily represents artists with disabilities from the United States and abroad. Works in all media—crafts, folk art, jewelry, painting, and sculpture—are shown in rotating exhibitions. At the beginning of every summer, the gallery sponsors a curated show of folk art. Proceeds from gallery sales benefit the national and international programs of Very Special Arts.

WEST VIRGINIA

Huntington Museum of Art **M**
2033 McCoy Road
Huntington, WV 25701-4999
(304) 529-2701

The Huntington Museum has an expanding collection of American folk art; the collection is particularly strong in work by artists from the region such as Evan Decker, S. L. Jones*, "Creative" DePrie*, and Charley* and Noah Kinney. The museum has acquired Noah Kinney's three-person band and Charley Kinney's* puppets, as well as his paintings. Huntington also exhibits folk art on a fairly regular basis. Recent shows include "O, Appalachia" and "By the People: American 19th and 20th Century Art of the Folk and Self-Taught."

THE SOUTH

THE FOLK ART OF THE SOUTH IS AS DIVERSE AS the region itself. Styles range from the nostalgic memory painting of Mattie Lou O'Kelley, who transformed the harsh red clay of Georgia into verdant hillocks in her romantic paintings of times that never were, to tell-it-as-it-is urban street fighter Roy Ferdinand, Jr., and every nuance in between. The South is generally thought of—with good reason—as a mecca for folk art, and competition for the best is intense. Museums, collectors, pickers, and dealers are constantly out there visiting artists, and prices for work of the better-known artists have escalated substantially, doubling on an almost-yearly basis over the last five years.

Because of the competition and the escalating price of the art, collectors often limit their acquisitions to subspecialties—black folk art, for example, or pottery, baskets, quilts, or canes—and sometimes to the art of one or more of the subregions within the South. Huge collections have been assembled in, say, just the folk art of Alabama, Georgia, or Louisiana.

In the late 1970s we used to visit New Orleans at fairly regular intervals. Once there, we would rush to Jackson Square to see what "Chief" Philo Willey (an artist who captured the color and vitality of New Orleans in his work) and others had hanging on the fence (Jackson Square, a major tourist site of the city, is surrounded by a cast iron fence that many local artists use as a backdrop for showing their wares), or we would look around to find out what works of Sister Gertrude Morgan and Clementine Hunter were available. Those were fun days, but much of the more personal local contact now has been replaced by a very sophisticated nationwide gallery system. Today the best in southern folk art is found not only in southern galleries but also in galleries in New York City, Chicago, and Philadelphia.

Although today collectors who are looking seriously for southern folk art must now look beyond Baton Rouge, New Orleans, Atlanta, and Miami, the local art scenes remain very lively, and local artists are usually well represented. The New

Orleans scene centers around the courtyard of Barrister's Gallery, a constant meeting place for collectors and artists, and the dealer Richard Gasperi; Gilley's Gallery in Baton Rouge, just a short drive to the northwest, is another excellent showcase for local talent. The New Orleans Museum of Art has a growing collection of contemporary folk art and is a must-visit site if you want to see what is new in that city.

Although things change, they seem to change less in New Orleans, and there are still plenty of good collecting moments to be had in the Crescent City. Collectors can no longer visit Sister Gertrude Morgan's Tabernacle, but they can get their shoes shined by Big Al Taplet and collect his delightful signs made from roofing slate, or they can drive south along the Mississippi River to visit J. P. Scott in the hope that he will have on hand one of his wonderful wood and tin boats made from flotsam and jetsam rescued from the river—and meeting Scott is fun whether or not work is available.

Any discussion of Louisiana and folk art collectors brings instantly to mind the names of Warren and Sylvia Lowe, collectors who have contributed significantly to this field. The Lowes, who center their activities around Lafayette, Louisiana, published two groundbreaking catalogs—*Baking in the*

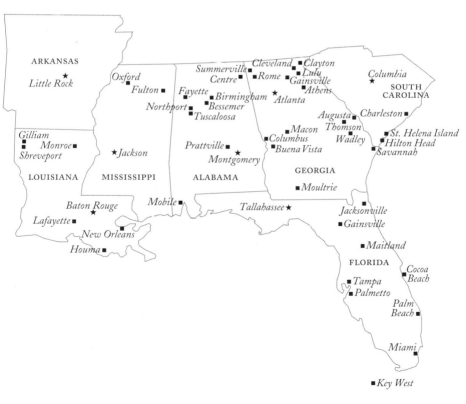

Sun and *It'll Come True*—and have given art generously to many museums in their area; they share our belief in making knowledge in the field available to as wide an audience as possible. The Lowes introduced us to Royal Robertson (a self-proclaimed prophet whose misogynistic images are riveting), the Billiots, "Artist Chuckie" Williams, and Xmeah ShaEla'ReEl. We in turn introduced them to some of our favorite artists, and to Navajo folk art in general.

When we talk about folk art fun, we include our memories of trips into the bayou country of Louisiana, eating Cajun at Pat's in Henderson, Louisiana, with the Lowes, and the time we ran into them by coincidence at the Shonto Trading Post in Arizona and shared a picnic at the Navajo National Monument near Kayenta. Wonderful friendships form and good times roll when you are on the trail of folk art.

Atlanta is the gateway to the South; it is the hub city for several airlines, and the almost obligatory place for a stopover. We used to take advantage of these stopovers to visit Nellie Mae Rowe in Vinings, Howard Finster in Summerville, and Lanier Meaders (a potter who is known for his creatively grotesque face jugs) in Mossy Creek and still get home to Washington, D.C., where we lived at the time, in time for a late dinner. We still stop over in Atlanta on our way to other cities to do the gallery scene (galleries such as Archer-Locke, Berman, Knoke, and Modern Primitive, among others) and to visit artists and dealers nearby.

In August 1994 Atlanta inaugurated a new event—Folk Fest '94—and galleries, dealers, and pickers from all over the country participated; it was so well attended by collectors that it has become an annual affair. Then, from Atlanta, it can be a wonderful escape in August to drive into the cooler hill country to the north of the city to visit innovative potters like the Crockers in Lulu, Georgia, or, a little further afield, Billy Ray Hussey in North Carolina. On the way north there are several folk art galleries, for example, Main Street and Timpson Creek in Clayton, Georgia.

The High Museum of Art in Atlanta is also putting together one of the finest collections of contemporary folk art in America; the material is divided between the main museum building on Peachtree Street and the new annex, known as the High Museum of Art, Folk Art and Photography Galleries. Because Atlanta is the heart of southern folk art country, it is certainly appropriate that the High Museum should collect and exhibit folk art material.

But we soon grow tired of large cities, and we long for time on the dirt tracks. On our last journey to Atlanta we drove to Athens, Georgia, to visit two of our newest discoveries, Alpha Andrews and John Robert Ellis. We spent an hour or two with Alpha Andrews while she told us about her dream-contacts with a deceased daughter, and after a series of calls to welfare agencies and housing authorities, we finally located John Robert Ellis (who sometimes calls himself "Christ

Junior") in his project apartment. Ellis is an expert at karate and a highly excitable artist who admits to bouts of violence, yet his paintings of the black experience, his neighbors in the projects, and celebrities he claims to have known may well be some of the most important contemporary art in the field. It was thrilling to see his work—what he calls his "private collection"—but I also breathed a sigh of relief upon returning to our car with camera equipment intact.

The South as Jan and I knew it in the 1970s is no more; Sam Doyle is dead, as are Luster Willis (whose colorful drawings often served as parables for local events and issues) and James Henry "Son Ford" Thomas (whose clay skulls were striking reminders of the mortality of man); Bessie Harvey died recently, and Howard Finster can no longer take care of his wonderful Paradise Garden unassisted. The dirt roads we once traveled have been for the most part replaced by superhighways, and much of the best of the old dirt-track southern folk art is now in museums or large private collections. Diversity, however, is not dead, and new discoveries abound—Myrtice West in Alabama, for example, Rudy Bostic and Evelyn Gibson in Georgia, Robert Roberg and John Gerdes in Florida—they and others are all there for the finding, so get a move on and come on down.

4 8
L I N D A
A N D E R S O N

Born September 3, 1941, Rome, Georgia. Now resides Clarksville, Georgia.

Linda Anderson believes that an ideal world must exist somewhere beyond her house beneath Yonah Mountain, and the artist paints colorful visions of this world of her imagination. She freely admits to taking ideas from books and magazines—from jungle scenes to a portrait of Frida Kahlo (from a book given to her by her art dealer)—but, she asserts, "I don't copy a picture right off." Instead, she transforms them into her own surrealistic vision of her idealistic and romantic world.

The artist lives in a log house she made without assistance. "The tulip poplars was just growin' here," she explains. "Wasn't nothin' else to make a cabin." Anderson underwent serious surgery in 1992, and when she came out from under the anesthesia, she said, "a voice told me that my art was going to change. I quit my memory paintings, except for commissions. Now I paint about one picture a month in my new style."

COLLECTING TIPS

Linda Anderson's early memory paintings are rather ordinary, but the surrealistic paintings—her current style—are extremely beautiful. The artist is also a talented craftsperson who sometimes makes her own decorated frames. These frames add greatly to the overall impact of the work.

WHERE TO SEE ART

Anderson was included in the exhibition "Georgia Folk Art," Quinlan Art Center, Gainesville, Georgia (1991), and in an exhibition at the Southeastern Center for Contemporary Art, Winston-Salem, North Carolina (1994). She is the recipient of a grant from the Southern Arts Federation (National Endowment for the Arts' Regional Visual Art Fellowship).

Linda Anderson is represented by Judith Alexander, Atlanta. Archer-Locke Gallery, also in Atlanta, and Timpson Creek Gallery, Clayton, Georgia, also handle her work.

49
ALPHA
ANDREWS

Born August 20, 1932, Habersham County, Georgia. Now resides Athens, Georgia.

Known for her visionary paintings, Alpha Andrews has invented a time-saving method for making pointillistic paintings: She uses Tulip Pearl fabric paint and simply drips her pigment from the plastic bottle applicator directly onto canvas board. Her style of using patterns of raised dots of fabric coloring, combined with acrylics and glitter, is truly original.

The subject matter of her visionary paintings includes her dead grandchild in heaven. "In the night, when memories failed me, angels would come to me with messages," Andrews explains. "The family thought my visions strange, and the preacher said I shouldn't be having them, so I wouldn't paint them. After I had a disabling automobile accident [1991], I began to record these visits anyway."

COLLECTING TIPS Alpha Andrews started painting in 1983. Her early work is considered to be run-of-the-mill memory painting, but her pointillistic visionary paintings, which she began doing after about 1991, set her apart as an important new discovery.

WHERE TO SEE ART Andrews made a record cover for an album, "Month of Sundays," by Mosaic (Railroad Records, 1993). Her paintings are in the permanent collections of the Carter Presidential Library, Atlanta, and the New York State Historical Association, Cooperstown.

WHERE TO BUY ART Alpha Andrews is represented by Archer-Locke Gallery in Atlanta.

50
CYRIL BILLIOT

Born October 28, 1945, Houma, Louisiana. Now resides Houma.

Since he was a small boy, Cyril Billiot has whittled out of cypress wood simple, unpainted, realistic crabs, lobsters, crawfish, and the other bayou marine life upon which he depends for a living. Lately he has used tupelo, because cypress has become too expensive. Billiot, a French patois–speaking Houma Indian (a tribe not presently recognized by the federal government), brags that he can make anything out of wood. He even makes his own violins from cigar boxes, and he sings and performs the Cajun music that is currently so popular.

In the last three or four years, since a market developed for Cyril Billiot's carvings, his son, Ivy (born January 28, 1945), also started to carve the marine figures that form the basis of his father's work. The son's unpainted carving is difficult to distinguish from that of the father, and the pieces are not signed. If you meet the family, however, the artists will tell you who made which piece.

COLLECTING TIPS Because the Billiots can "make anything out of wood," collectors, pickers, and dealers have placed orders for "exotics"—anything from Abe Lincoln to Easter bunnies. These objects

are well carved and amusing, but serious collectors usually prefer the marine life pieces that form the basis of the Billiots' reputation. The marine carvings should be treated carefully, however, as they are fragile—claws, legs, and heads can easily become unattached or broken.

WHERE TO SEE ART Carvings by Cyril and Ivy Billiot are in the collections of many southern folk art enthusiasts. The work is also included in the permanent collection of the New Orleans Museum of Art and the University Art Museum, University of Southwestern Louisiana, Lafayette.

WHERE TO BUY ART The Billiots sell their carvings from their house and at busy roadside crossings in and around Houma. Galleries such as Trade Folk Art in New Orleans and the Webb Folk Art Gallery in Waxahachie, Texas, often have examples of their work.

51
RUDOLPH VALENTINO BOSTIC

Born August 16, 1944,
Savannah, Georgia.
Now resides Savannah.

Rudolph Bostic "shakes up" the works of the great masters with the mythology of the movies and then recycles this cocktail of pop and classical through the lens of contemporary black culture. His paintings are to religious art as rap is to music: "I start with Mama's old illustrated Bible," he explains, "and switch 'em around [the illustrations]—shake 'em up—to fit me."

Bostic creates his flamboyant works on rescued cardboard. He visualizes architectural features in the raw material; a barrel top ends up as a stained glass window, for example. He then paints his images on the cardboard with enamel house paint because "it is cheaper" and shellac is added to give what Bostic considers an "old master look to the art."

COLLECTING TIPS Bostic paints a few nudes and other subjects, but most collectors prefer his religious paintings. His paintings are signed "R. V. Bostic."

Although we have been warned that cardboard is unstable, we have paintings on cardboard that have been exposed to

Rudolph Bostic

direct light for as long as twenty years, and they have not shown deterioration. Nevertheless, collectors might want to take this into account in collecting Bostic's work.

WHERE TO SEE ART Rudolph Bostic was exhibited at Armstrong State College in Savannah, Georgia, in 1994. There are ten of his paintings in the Beach Institute Black Heritage Museum's permanent collection in Savannah.

WHERE TO BUY ART The artist is represented by the Knoke Galleries in Atlanta. The Main Street Gallery, Clayton, Georgia, also has examples of his work, as does Ginger Young Gallery/Southern Self-Taught Art, in Chapel Hill, North Carolina.

52
A. J. "SAINTE-JAMES BOUDRÔT" BOUDREAUX

Born September 22, 1948, New Orleans, Louisiana. Now resides New Orleans.

A. J. Boudreaux originated a style of painting that he calls "funerary art." "For years," Boudreaux says, "I cut out the colorful obituaries from the *Times-Picayune* [a New Orleans newspaper], attended black funerals, and visualized the deceased person as he may have been in life." These experiences gave him the inspiration for his memorial paintings, which refer to the person being memorialized by the nickname used in their obituary—"Big Mama," "Can Man," and so forth. The paintings are usually divided into vertical segments and are done on wooden panels (often boards from discarded shipping crates); they are flat and folkish in their presentation. Boudreaux's inventiveness has brought him attention and also embroiled him in an intellectual controversy. Although untrained in art, Boudreaux is a successful (although no longer practicing) lawyer and part owner of the Folk Art Gallery at Barrister's on Royal Street.

COLLECTING TIPS Boudreaux openly admits that his style is influenced by such folk artists as Sam Doyle but argues that he "never studied art" and thus can qualify as a self-taught folk artist. Whether his art is folk or not, it is good art, and many folk art collectors are buying his paintings. Other collectors feel that, because of the artist's obvious sophistication, he should be considered a mainstream artist.

We have spent time trying to pick out the best "funerary painting," but the majority are fairly equal in quality. Boudreaux signs his paintings "Sainte-James Boudrôt" on the back; he also attaches a copy of the funeral notice on the verso.

WHERE TO SEE ART The memorial paintings of "Sainte-James Boudrôt" are in the permanent collection of the New Orleans Museum of Art. The artist was one of four in the X Art exhibition "Sredistuo-Outsiders" (New Orleans, 1992).

WHERE TO BUY ART Barrister's Gallery in New Orleans represents the artist. The Cotton Belt Gallery in Montgomery, Alabama, and the Leslie Muth Gallery in Santa Fe also have his work for sale.

53

LOY A. "RHINESTONE COWBOY" BOWLIN

Born September 16, 1909, Meadville, Mississippi. Died June 14, 1995, McComb, Mississippi.

Loy Bowlin was the personification of the "Rhinestone Cowboy." He decorated his house (both inside and outside), his furniture, his 1966 Cadillac, his cowboy clothes—literally everything he owned—with rhinestones and glitter; he even had rhinestones implanted in his teeth. Bowlin covered the walls and ceilings of his 750-square-foot house with posterboard geometric drawings made from glitter, foil, and a bit of paint here and there. Some of the drawings are entirely abstract; others portray birds and animals, and some contain written messages, such as "Happy Father's Day." Glitter would fall from these drawings to make a rug on the floor, and the glitter-trimmed exterior of the house would shine in sunlight like a house of mirrors on a carnival midway.

Bowlin said that after he retired from his job as a mechanic in 1965, the Lord visited him and told him to decorate his house and person—and that is what he did. Dressed in his rodeolike, glitter-covered country costumes, playing the harmonica, dancing an "old buck dance," telling stories to children, and "flirting with the girls," the Rhinestone Cowboy, as Bowlin became locally known, was for many years a popular attraction in downtown McComb.

COLLECTING TIPS Bowlin sold or gave away as gifts some of his posterboard drawings of collaged foil and glitter. Collectors have now acquired a few of these and are displaying them in their homes. The collages that incorporate sayings, greetings, birds, and other animals are usually preferred to the pure designs. The glitter may wear off if the drawings are not carefully handled; framing helps.

WHERE TO SEE ART Bowlin welcomed visitors to his home until poor health forced him to enter a nursing home, where he lived until his death in 1995. A foundation has been set up to preserve his house and its contents as "The Rhinestone Cowboy Folk Art Museum." Several of Bowlin's collages are in the collection of the State Historical Museum, Jackson, Mississippi.

WHERE TO BUY ART Individual posterboard panels made by Bowlin occasionally show up in galleries such as Gilley's in Baton Rouge, Louisiana, and the Leslie Muth Gallery in Santa Fe.

54

DAVID BUTLER

Born October 2, 1898, Good Hope, Louisiana. Now resides in a nursing home, Morgan City, Louisiana.

David Butler's spectacular environment in his yard was the stuff of which dreams are made—it encompassed everything from nativity scenes to roosters and hens to figures of people in unique poses to such fanciful creatures as flying elephants and fire-breathing dragons. His constructions—some of them with wind-driven moving parts—assemblages, and cutouts were made from roofing tin and painted to create an eye-stopping carnival of color.

Although Butler originally had conceived of his tin creations as part of an overall environment, he had begun to sell individual pieces to museums and collectors by 1982 and so started to lose some interest in the larger idea. His whimsical constructions, however, are regarded as among the finest examples of folk sculpture today.

COLLECTING TIPS Butler's pre-1983 work is highly collectible, but by 1985 family members were helping him by painting individual pieces. Also, with advancing age Butler lost some of his creative energy and began to replicate some of his earlier works. He is now in a nursing home and unable to produce more work.

WHERE TO SEE ART Although Butler's environment no longer exists (his house has been sold), his sculpture is widely exhibited and has been included in exhibitions at, among other places, the New Orleans Museum of Art; the Corcoran Gallery of Art, Washington, D.C.; and the High Museum of Art, Atlanta. His work is also illustrated in many catalogs and books, including *Black Folk Art in America, 1930–1980* (Jane Livingston and John Beardsley, 1982).

Butler's work is included in most museums with major folk art collections such as the Museum of American Folk Art in New York City and the New York State Historical Association in Cooperstown; some smaller museums such as the African American Museum in Dallas and the University Art Museum, University of Southwestern Louisiana, Lafayette, also have examples of his work.

WHERE TO BUY ART Individual works by David Butler show up in almost every major gallery specializing in folk art, but the Gasperi Gallery in New Orleans and Gilley's Gallery in Baton Rouge, Louisiana, usually have some of his best constructions on hand.

5 5
E D W A R D
B U T L E R

Born October 19, 1941, Plaquemines Parish, Louisiana. Now resides Baton Rouge, Louisiana.

Edward Butler talks "black history" to "the brothers" through his bas-reliefs and assembled carvings depicting black heroes. His art is intentionally disquieting, intended to further his often-revolutionary ideas.

Butler started making his collection of carvings while in jail. "At first, they wouldn't give me wood or paint," he remembers. "I had to scrounge for matchsticks and food coloring." Later, he was able to obtain materials more suitable for his work.

"I was locked down [imprisoned for murder]," Butler explains, "but now that I'm out of prison, I want to teach—if I can touch one kid, one mother, I am successful!" He believes that black history should not be taught by whites, and he wants black children to know about black heroes, so he takes "his collection" into the schools and uses his carved reliefs— figures like Malcolm X, Rodney King, and Martin Luther King—to teach his militant version of black history.

COLLECTING TIPS	Butler has yet to sell any work. Collectors, including us, have tried to buy the work of this artist, which he says is for sale "at the right price." We were not successful, but someday someone may be lucky enough to purchase one of his bas-reliefs. Butler's early work may be identified by the fact that it is formed out of matchsticks glued into bundles.
WHERE TO SEE ART	Butler has exhibited at various schools in Baton Rouge, Louisiana, including Southern University (1994). We have visited his house and were welcome. However, the lectures that go with such a visit may not be for everybody.
WHERE TO BUY ART	To date Butler has not sold anything, but he says that his collection is for sale at the right price. "We are talking millions," he repeats over and over again. "I need my collection to teach kids!"

56

ARCHIE BYRON

Born February 2, 1928, Atlanta.
Now resides Atlanta.

Archie Byron makes what he calls "gunstock-sawdust art." His sculptures can be large or small—wall plaques, portraits of people, figures more than six feet tall—but his basic raw material is always painted sawdust mixed with glue. Byron claims to have been the first licensed black private eye in Georgia, and he runs a gun shop. "Rather than throw out the sawdust generated from sanding down gunstocks," he explains, "I sweep it up and make it into art." Byron's boyhood companion was Martin Luther King, Jr. He sang in the choir of "Daddy" King (the father of the civil rights activist), "but," he says, "I wouldn't march with Martin, Jr., unless he'd have let me carry a rifle."

Byron, who served on the Atlanta city council from 1981 to 1989, has made a detailed but not-to-scale replica of the council in session under Mayor Andrew Young. The name of each council member is printed next to the sculpture representing that person.

COLLECTING TIPS	Byron's large standing figures have great presence, and his political plaques and social commentary pieces are historically important.
WHERE TO SEE ART	Archie Byron was included in "Outside the Main Stream," High Museum of Art, Atlanta (1988). In 1989 he was in "Another Face of the Diamond: Pathways through the Black Atlantic South," a show organized by INTAR Latin American Gallery, New York City; his work is illustrated in the catalog of the same name. Byron is also in "Passionate Visions of the American South," New Orleans Museum of Art (1993). In 1994 the artist was invited to Sweden to demonstrate his art and technique.
WHERE TO BUY ART	Byron is not prolific, but the Modern Primitive Gallery in Atlanta usually has some of his works for sale. Another Atlanta gallery, Knoke, also has examples of his art.

Jerry Coker

5 7
J E R R Y C O K E R

Born March 10, 1938,
DeWitt, Arkansas. Now resides
Gainesville, Florida.

Jerry Coker, an artist who makes forceful masks and impos-
ing sculptures representing personages remembered from his
childhood out of rusted roofing tin, considers himself a "rural
Renaissance man" turned professional artist. His striking
masks have a vaguely familiar look—perhaps a cross of the
work of the French artist Jean Dubuffet and some of the insti-
tutionalized artists that Dubuffet collected. Coker, however, is
not institutionalized, although he is fond of saying, "I'm a
screwed-up guy. I traveled as a musician with pop bands, I
graduated from college, but what I really want to be is a classi-
cal sculptor, and what I am is a 'folk-stream Expressionist, a
self-taught Cokerian.'"

Each mask or personage that Coker creates has a name,
and every work is different, yet the style of the artist is easily
recognizable.

COLLECTING TIPS

Coker has painted some expressionistic works that, although
interesting, are not considered as collectible as his tin masks
on wood. His sculpture is very popular with folk art enthu-
siasts and has even been represented as the work of an out-
sider, although he does not fit within the standard definition.
Some collectors might feel that Coker is not a folk artist, even
though his art is self-taught; this question of who is and who
is not a folk artist is becoming blurred as more and more peo-
ple attend universities and our society becomes increasingly
more sophisticated.

WHERE TO SEE ART

Coker's masks and sculptures were shown in a one-person show,
"Face Value: The Identity Masks of Jerry Coker," at the Arkan-
sas Arts Center, Little Rock, in 1995. His work also traveled to
a number of African countries in the 1995 exhibition "Recycle,
Reuse, Recreate," sponsored by the United States Information
Agency. Coker's masks and personages are also generally exhib-
ited at folk art fairs in Atlanta and Chicago, as well as the Out-
sider Art Fair in New York City, where he usually sells out.

(continued on page 149)

48 Linda Anderson
Frida, 1993.
Oil on linen; 30 × 30 in.
(76.2 × 76.2 cm).
Lucinda Bunnen.

49 Alpha Andrews
Dream Castle, 1992.
Oil on canvas; 29 × 22¾ in.
(73.7 × 57.8 cm).
Sue and George Viener.

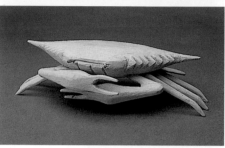

50 Cyril Billiot
Crabs, c. 1989.
Unpainted tupelo wood; 2 × 9 ×
4 in. (5.1 × 22.9 × 10.2 cm).
WARREN AND SYLVIA LOWE.

51 Rudolph Valentino Bostic
Angel of Peace, 1994.
Marker and enamel on
cardboard; 24 × 23¼ in.
(61 × 59.1 cm).
KNOKE GALLERIES OF ATLANTA.

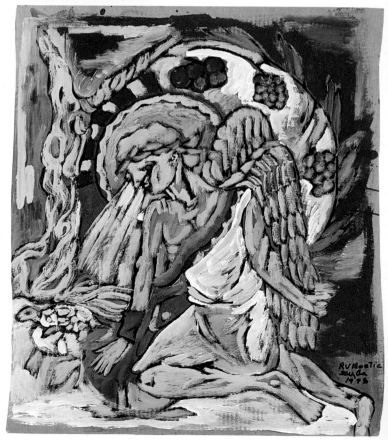

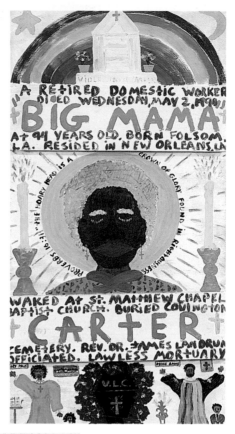

52 A. J. "Sainte-James Boudrôt" Boudreaux
Big Mama, c. 1991.
Pine wood, acrylic paint;
48 × 24 in. (121.9 × 61 cm).
CHUCK AND JAN ROSENAK.

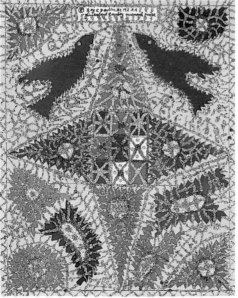

53 Loy A. "Rhinestone Cowboy" Bowlin
Untitled (Two Birds), c. 1990.
Sequins, glitter, foil, papercuts on posterboard; 28 × 22 in.
(71.1 × 55.9 cm).
ROBERT CARGO FOLK ART GALLERY.

▲ **54** David Butler
First Nativity, c. 1965.
Mixed media on tin; 28 × 38 ×
7 in. (71.1 × 96.5 × 17.8 cm).
Richard D. Gasperi.
Photo: Will Drescher

▼ **55** Edward Butler
Thurgood Marshall, c. 1990.
Wood, food coloring, paper,
cotton; 30 × 49 in. (76.2 ×
124.5 cm). Collection of the
artist. Photo: Judy Cooper

56 Archie Byron
Martin Luther King, 1974.
Sawdust and Elmer's glue on
wood panel; 35½ × 36 in.
(90.2 × 91.4 cm).
SUE AND GEORGE VIENER.

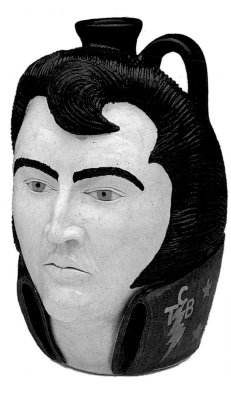

57 Jerry W. Coker
Mrs. McGhee, 1992.
Wood and found tin; 52 in.
(132.1 cm) high.
MARION HARRIS AND
JERRY ROSENFELD.

58 Michael and
Melvin Crocker
Elvis Presley, 1992.
Fired clay, various glazes,
including platinum oxide; 11 to
6½ (27.9 to 16.5 cm) diameter.
ROSEHIPS GALLERY.

59 Thornton "Buck" Dial, Sr.
Heading for the Higher Paying Jobs, 1992.
Enamel, oil, wood, tin, steel, wire screen, cloth, and industrial sealing compound on canvas mounted on wood; 64½ × 90 × 9 in. (163.8 × 228.6 × 22.9 cm).
T. MARSHALL HAHN, JR.

60 Sam "Uncle Sam" Doyle
Ramblin Rose, undated.
House paint on tin with wood; 48½ × 28 in. (123.2 × 71.1 cm).
LOUANNE LAROCHE.

62 John Robert Ellis
"Jesus Christ, Jr."
Gorbachev and Moscom, 1987.
Poster paint, pencil, marker;
14 × 10½ in. (35.6 × 26.7 cm).
CHARLES LOCKE.

61 Burgess Dulaney
Devil, c. 1990.
Unfired clay; 11 × 11 × 10 in.
(27.9 × 27.9 × 25.4 cm).
ROBERT CARGO FOLK ART GALLERY.

63 Roy Ferdinand, Jr.
Mohammed Elijah, undated.
Mixed media on posterboard;
24 × 22 in. (61 × 55.9 cm).
BARRISTER'S GALLERY.

64 Howard Finster
Dog Story of the Bible, c. 1976.
Enamel on panel; 26 × 20 in.
(66 × 50.8 cm).
CHUCK AND JAN ROSENAK.
PHOTO: LYNN LOWN

65 John Gerdes
LED Mill, 1979.
Paint on board, LED lights;
21½ × 32 in. (54.6 × 81.3 cm).
CHUCK AND JAN ROSENAK.
PHOTO: LYNN LOWN

S

66 Evelyn Gibson
Daniel and the Lions, c. 1993.
Acrylic on paper; 22 × 25 in.
(55.9 × 63.5 cm).
CHUCK AND JAN ROSENAK.
PHOTO: LYNN LOWN

67 Clementine Hunter
*"These big vases they is called
Spanish water jars,"* undated.
Oil on paper; 11 × 15 in.
(27.9 × 38.1 cm).
GILLEY'S GALLERY.

68 M. C. "5¢" Jones
Adam and Eve, c. 1989.
Watercolor and ink on
posterboard; 22 × 28 in.
(55.9 × 71.1 cm).
ROBERT CARGO FOLK
ART GALLERY.

69 Eddie Lee Kendrick
God Bles, 1991.
Pencil, colored pencil, ballpoint
pen, and acrylic on paper;
12 × 18 in. (30.5 × 45.7 cm).
JOSEPH AND SUSAN PURVIS.

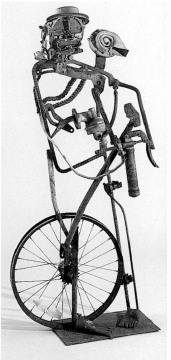

70 Charlie Lucas
*Negative & Positive, But to
Blow the Message Out, It Turn
Me into a Little Mechanic*, 1993.
Metal sculpture; 48 × 22 in.
(121.9 × 55.9 cm).
LYNNE INGRAM.

71 Columbus "Dude" McGriff
B-25 Bomber with Crew, 1988.
Bent and twisted wire and
paint; 16½ × 36½ × 39¼ in.
(41.9 × 92.7 × 99.7 cm).
JIM ROCHE.

72 Reuben "R. A." Miller
Lord Love You, undated. Mixed
media; 51 × 31 in. (129.5 × 78.7
cm). Gilley's Gallery.

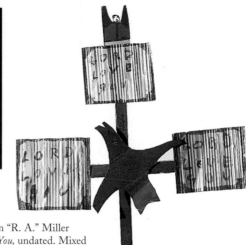

73 Reginald "Reggie" Mitchell
Untitled (Victorian Interior),
1993.
Paint on paper; 17½ × 22½ in.
(44.5 × 57.2 cm).
BILL ROSE.

S

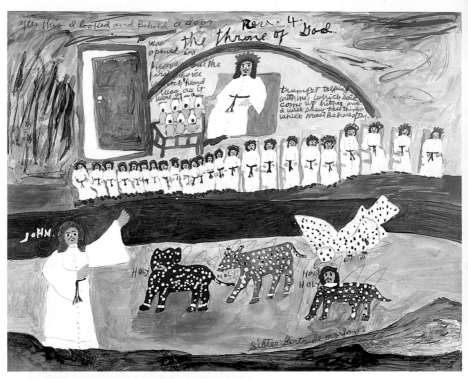

74 Sister Gertrude Morgan
The Throne of God, c. 1970.
Acrylic, ink, pencil on paper;
22 × 28 in. (55.9 × 71.1 cm).
RICHARD D. GASPERI.
PHOTO: WILL DRESCHER

75 Ed "Mr. Eddy" Mumma
Untitled, c. 1980.
Oil on canvas board; 19½ ×
15½ in. (49.5 × 39.4 cm).
CHUCK AND JAN ROSENAK.
PHOTO: LYNN LOWN

76 Roger Rice
Christ Baptised, c. 1987.
Oil on canvas; 50 × 46 in.
(127 × 116.8 cm).
Robert Cargo Folk
Art Gallery.

77 Robert Roberg
Whore of Babylon, c. 1991.
Acrylic on canvas, applied glitter;
24 × 29 in. (61 × 73.7 cm).
Chuck and Jan Rosenak.
Photo: Lynn Lown

78 Nellie Mae Rowe
Nellie, 1982. Crayon and common
pencil; 24 × 19 in. (61 × 48.3 cm).
Judith Alexander.

79 O. L. "Geech" Samuels
Iron Man, 1991.
Carved wood (pine stump),
glass eyes, ink stain; 52 × 17 ×
14 in. (132.1 × 43.2 × 35.6 cm).
Jim Roche.

80 Lorenzo Scott
Jim, Tammy and Jesus, undated.
Oil on canvas; 46¾ × 33½ in.
(118.7 × 85.1 cm).
JANE HUNECKE.

81 Welmon Sharlhorne
Untitled, c. 1990.
Ink on manila envelopes;
11½ × 20 in. (29.2 × 50.8 cm).
WARREN AND SYLVIA LOWE.

S

85 Mose Tolliver
Girl on Tricycle, 1978.
Paint on wood; 17 × 11 in.
(43.2 × 27.9 cm).
MARCIA WEBER/
ART OBJECTS, INC.

86 Annie Tolliver
Running Bull, 1989.
Paint on board; 17 × 28 in.
(43.2 × 71.1 cm).
MARCIA WEBER/
ART OBJECTS, INC.

87 Bill Traylor
Three Figures on Red and Blue Houseboat, c. 1939–1942.
Poster paint and pencil
on cardboard; 15 × 13 in.
(38.1 × 33 cm).
Judy Saslow.

88 Annie Wellborn
Red Ball of Fire, 1993.
Watercolor on tarpaper;
24 × 19 in. (61 × 48.3 cm).
Chuck and Jan Rosenak.
Photo: Lynn Lown

S

89 Myrtice West
Ezekiel Vision, Ch. 1–3, 1993.
Oil on canvas; 42 × 48 in.
(106.7 × 121.9 cm).
Marcia Weber/
Art Objects, Inc.

90 Willie White
Untitled, 1988.
Markers on paper; 22 × 28 in.
(55.9 × 71.1 cm).
Bill Rose.

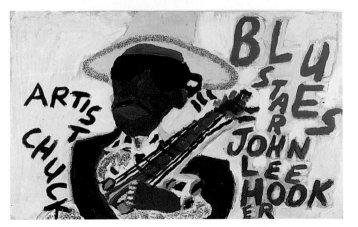

91 Chuck "Artist Chuckie"
Williams
John Lee Hooker, 1990.
Paint, ink, pencil, glitter
on wood; 30 × 48 in.
(76.2 × 121.9 cm).
WARREN AND SYLVIA LOWE.

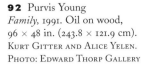

92 Purvis Young
Family, 1991. Oil on wood,
96 × 48 in. (243.8 × 121.9 cm).
KURT GITTER AND ALICE YELEN.
PHOTO: EDWARD THORP GALLERY

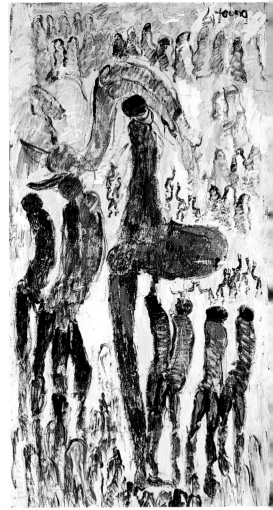

(continued from page 128)

WHERE TO BUY ART Coker is represented by the Marion Harris Gallery, Simsbury, Connecticut.

58
MICHAEL AND MELVIN CROCKER

Michael Crocker, born August 15, 1956; Melvin Crocker, born July 5, 1959; both born Lulu, Georgia. The brothers now reside Lulu.

Michael and Melvin Crocker have turned traditional Georgia pottery into a new art form—cooking vessels and whiskey and water jugs become sculpture in their hands. The brothers saw the utilitarian pottery of northern Georgia just "slipping away," as they said; "So," Michael explains, "we took the old decorative forms and whimsy ideas and pushed them to the limit." A snake, for example, may appear as a decorative element on an antique jug, but the Crocker brothers sculpt a rattlesnake as a freestanding object.

The Crockers make pottery from the brownish gray clay native to their area, hand-turn it on a wheel, fire their kilns with pine slabs, and use the old glazes "handed down from mouth to ear." Although the Crockers are in these ways continuing the hundred-year-old tradition in which they were raised, they also do not hesitate to experiment with new glazes; they may even use such precious metals as platinum.

COLLECTING TIPS Collectors who specialize in southern pottery, as well as those who pick up an occasional piece, will find the Crockers' work worthwhile additions to their collections. Their more innovative work, like the special small editions (ten or fewer pieces) that the brothers occasionally make, is the most valuable.

Michael Crocker has a large private collection of pottery that includes pieces by early Georgia potters. If time permits, he will sometimes share it with visitors.

WHERE TO SEE ART *Foxfire Magazine* has featured the Crockers (Spring 1990 and Summer 1991); their pottery has been included in shows in Atlanta at the History Museum (their stoneware snake is illustrated in the catalog *Handed On*, 1993) and the High Museum of Art (1994).

WHERE TO BUY ART The Crockers sell from their studio in Lulu, Georgia. Their ware is also available from many galleries and dealers specializing in southern folk art, such as Lynne Ingram, Milford, New Jersey, and Rosehips Gallery, Cleveland, Georgia.

YAHRAH DAHVAH

Born Horace Lee Durham, July 23, 1953, Cochran, Georgia. Now resides Cochran.

If you notice signs, paintings, and messages posted throughout the town of Cochran to "help people solve problems and to give them solutions," they are probably the work of Yahrah Dahvah. "I'm a prophet, like Daniel," Dahvah says. "He called me before birth to paint my visions and dreams." Dahvah believes himself to be a Hebrew (Sumerian) prophet, and his messages, whether political (he was opposed to the Gulf War) or spiritual (he preaches conversion to Islamic Judaism), are not popular. The paintings contain evangelistic messages, symbols, and geometric designs that, although not always translatable, add color and interest to the work.

Although his intentions are altruistic, Dahvah is not always understood by the local townspeople. For example, he cleared a lot near the courthouse, built picnic tables, and now maintains it as a park. However, he gave the park a Hebrew name and placed a Star of David sign at its entrance, and the park was largely unused until recently.

COLLECTING TIPS Dahvah has done only forty or fifty works since he started in 1978, and so it is too early to know which are his best. At this time it appears that his paintings are stronger than his largely undecorated message boards. In those cases in which he has combined images with his message, the works are especially interesting.

WHERE TO SEE ART The best place to see Dahvah's art is on a visit to the town of Cochran, Georgia. His work is also shown at art fairs, such as the ones in New York City and Atlanta.

A one-person exhibition for the artist at the Harriet Tubman Museum in Macon, Georgia, is now in the planning stages.

WHERE TO BUY ART Yahrah Dahvah is represented by Ginger Young Gallery/Southern Self-Taught Art in Chapel Hill, North Carolina.

**59
THORNTON
"BUCK"
DIAL, SR.**

*Born September 10, 1928,
Emmel, Alabama. Now resides
near Bessemer, Alabama.*

Thornton Dial uses a variety of materials to create powerful textured assemblages. Dial makes up fables in which he uses animals—tigers and bears, for example—to express his personal ideas and convictions concerning the relationships between the races and between men and women, and sometimes he includes such television personalities as Oprah Winfrey in his assemblages. His works depict individuals in conflict and in harmony with nature and community; one of his underlying and recurring themes is the struggle of blacks—both men and women—in society; another is God's concern for mankind. His drawings emphasize many of the same themes.

Thornton Dial's often provocative work has attracted a great deal of attention in the art world. Dial is the patriarch of an extended three-generation family of self-taught artists that includes his sons, Thornton "Little Buck," Jr., also a painter, and Richard, who creates metaphorical chair sculptures.

COLLECTING TIPS During the last five or six years, many collectors who formerly collected mainstream contemporary art have started to collect contemporary folk art. Thornton Dial is one of the artists that particularly appeals to this group.

Many collectors of contemporary folk art are ambivalent in their feelings about Dial and the high prices that galleries now command for his work. Some experts believe that these prices have not been adequately tested in the secondary marketplace.

WHERE TO SEE ART In 1993 the Museum of American Folk Art in New York City sponsored a traveling exhibition of Dial's work, "Thornton

Dial: Image of the Tiger," accompanied by a monograph of the same title.

Dial's assemblages and drawings are in the permanent collection of various museums, including the Birmingham Museum of Art, Alabama; the High Museum of Art, Atlanta; the Milwaukee Art Museum; the Museum of American Folk Art, New York; the New Orleans Museum of Art; and the Smithsonian Institution's National Museum of American Art, Washington, D.C.

WHERE TO BUY ART Thornton Dial is represented by the Ricco/Maresca and Louise Ross galleries in New York City. The Berman, Fay Gold, and Archer-Locke galleries in Atlanta also handle Dial's work.

BRIAN DOWDALL

Born February 12, 1948, Anaconda, Montana. Now resides Cocoa Beach, Florida.

Brian Dowdall makes paintings and large sculptures out of found objects, but he is best known for what he calls "backyard sand paintings"—paintings of mysterious animals that are a combination of creatures known and imagined. His animals—painted mostly in browns and blacks and silhouetted against the natural color of his paper—are usually shown in motion, and they posture as though they were performing a ballet for the benefit of the artist.

"I find animals to be my most honest and comfortable companions," Dowdall declares. He paints on rumpled paper bags that he has rescued from the supermarket trash bin.

COLLECTING TIPS The artist's mysterious spirit drawings of animals are his best work, and collectors on the East Coast of Florida are particularly attracted to his sand paintings.

WHERE TO SEE ART Dowdall was included in "The Passionate Eye," Orlando City Hall, Orlando, Florida (1994). His work is in the permanent collection of the Kentuck Museum, Northport, Alabama.

WHERE TO BUY ART The artist's work is sold through galleries such as the Vanity Novelty Gallery, Miami Beach; the Timpson Creek Gallery, Clayton, Georgia; Galerie Bonheur, Saint Louis; and America Oh Yes, Hilton Head and Saint Helena Island, South Carolina.

60 SAM "UNCLE SAM" DOYLE

Born March 23, 1906, Saint Helena Island, South Carolina. Died September 24, 1985, Saint Helena Island.

Sam Doyle's remarkable paintings on roofing tin, plywood, and even window shades capture a facet of the Gullah tradition, including the practice of voodoo, a tradition that is slowly disappearing from South Carolina's offshore islands. (For many years, until a bridge was built, Saint Helena Island, Doyle's home, was virtually isolated from the mainland of South Carolina. The residents spoke a local dialect called Gullah, which includes words and pronunciations from several African languages.) Doyle painted the local "root doctors" (traditional healers) such as Doctor Buz (for buzzard) and Halk (for hawk), as well as black sports heroes such as Joe Louis and basketball player Larry Rivers. But he also captured the likenesses of relatives—for example, James Doyle, the first black

truck driver on Saint Helena—and other important members of the local population, such as the first black midwife on the island and Le Bit, the smallest girl in town.

Doyle's paintings are expressive, colorful, and flat. They were hung from a clothesline in front of his house, intended to attract the attention of local passersby.

COLLECTING TIPS As the price of the panels painted by Sam Doyle has risen, his watercolors and occasional small painted works on paper have begun to appreciate as well. Doyle also made a few wooden animals that he covered with tar; these are quite rare.

Doyle's best paintings date from the 1970s and early 1980s, and these works attract much higher prices than his later paintings. Because Doyle repeated themes, the later works have somewhat less spontaneity; they are, however, also desirable.

WHERE TO SEE ART Doyle's paintings on roofing tin have been exhibited in almost every major show of folk art since the Corcoran Gallery in Washington mounted "Black Folk Art in America, 1930–1980" (1982). In 1993 Doyle was included in the New Orleans Museum's "Passionate Visions of the American South" and "Made in USA" at the Collection de l'Art Brut in Switzerland. His work is in such public collections as the High Museum of Art, Atlanta; the Craft and Folk Art Museum of Los Angeles; and the Museum of American Folk Art, New York City.

WHERE TO BUY ART Louanne LaRoche in Hilton Head, South Carolina, specializes in the work of Sam Doyle. Red Piano Too on Saint Helena's also has Doyle's paintings on hand, and they show up from time to time at other galleries, including Anton Gallery, Washington, D.C.; Gilley's Gallery, Baton Rouge, Louisiana; and the Ann Nathan Gallery, Chicago.

6 1
BURGESS
DULANEY

Born December 16, 1914, Fulton, Mississippi. Now resides Fulton.

Burgess Dulaney may be fond of saying that he just "piddles here and there," but he is quickly becoming recognized as one of the most important and innovative southern sculptors working with clay today. Dulaney's "piddlings" with Mississippi mud have produced a remarkable collection of elfin figures with green marble eyes and fantasy animals in which he blends real and imaginary elements.

For many years Dulaney farmed thirty acres of cotton and corn, retiring in 1991 to make his art full-time. "I get my red mud from the farm, the yellow mud from the driveway, and the gray modeling clay, I buy over at the school," he explains. Dulaney's unpainted clay figures are dried slowly outdoors or, in winter, on a table near a stove in his home—just across the yard from the 130-year-old log farmhouse where he was born.

COLLECTING TIPS Sometimes Burgess Dulaney lets his imagination go on flights of fantasy; the resulting mud sculptures—men riding frogs, fish with humanoid heads—are the pieces we particularly seek

out. Collectors should, however, be warned that unfired clay and mud is very fragile.

WHERE TO SEE ART Dulaney's work was included in "Baking in the Sun: Visionary Images from the South" (1987), a traveling exhibition sponsored by the University Art Museum, Lafayette, Louisiana, and also illustrated in that exhibition's catalog. His work is in the permanent collection of the State Historical Museum, Jackson, Mississippi.

WHERE TO BUY ART Gilley's Gallery in Baton Rouge, Louisiana, and the Webb Folk Art Gallery in Waxahachie, Texas, represent the artist. The Ann Nathan Gallery in Chicago also carries his clay sculptures.

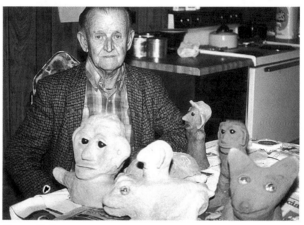

Burgess Dulaney

62
JOHN ROBERT ELLIS

Born April 13, 1939, Athens, Georgia. Now resides Athens.

Known for his street savvy and prisonwise drawings, John Ellis looks and acts the tough-guy part. "No one fools with me—I do karate—and I did time for beating a cop," he states, underscoring his statement with a karate chop. He thinks of himself as more than one person in a thin and muscular black body, and he refers to himself by three names: "Christ Junior," "The Sinner," and "Mr. Teach." Ellis says he knows the people he draws—Gorbachev, Nancy Reagan, and Oprah Winfrey— and he captures their likenesses in ink and crayon without the usual glamour associated with celebrities, just as though they were indeed neighbors and friends in the project in which he lives.

The true story of Ellis's prison incarceration is unknown, but it was apparently a lengthy stay. "While I was in prison," he said, "I had a lot of free time and my lawyer sent me paper, so I made drawings [mostly with crayon and pencil]. Now I got a lot of things to do, man, so I ain't making no drawings!"

COLLECTING TIPS Ellis has probably done fewer than one hundred drawings, and he doesn't have many left. A few of his drawings are known to

be in the hands of private collectors, and a dealer is trying to encourage him to create more. If he doesn't intend to draw again, as he claims, his art will be hard to find and accordingly more valuable.

WHERE TO SEE ART Locating Ellis and seeing his art was a rare experience. His apartment is decorated with what he calls his "collection," and he made us feel that we were in the presence of a great talent. Ellis was included in "Unsigned, Unsung," an exhibition at Florida State University, Tallahassee (1993), and his drawings are illustrated in the catalog for that show.

WHERE TO BUY ART We know of no works by Ellis that are for sale at this time, but Archer-Locke in Atlanta is one place to try if you are interested in finding one of his drawings.

63
ROY
FERDINAND, JR.

Born May 15, 1959, New Orleans (area known as "The Flats"). Now resides New Orleans.

Roy Ferdinand is a gun-carrying, street-tough Creole (a self-proclaimed "street gorilla") who paints recognizable New Orleans neighborhoods peopled with uncompromising images of the people who have shared his life on the street—pimps, whores, drug dealers, junkies, and gamblers. "I see people with faces that say they haven't got out of life what they expected," he explains.

"Man!" Ferdinand says. "I got straight F's in grade school art." The artist may have flunked sixth-grade art, but he has made quite an impression on folk art collectors who are not afraid to buy works that are tough and realistic. Ferdinand works with ink, colored pencils, and tempera on posterboard. He is a practitioner of an African form of voodoo, and several of his earliest works are displayed in the House of Voodoo in New Orleans, where he worked at one time.

COLLECTING TIPS Some of Ferdinand's work is sexually explicit and some is full of brutality—if you have a problem with this type of art, look for something else that is easier to live with.

WHERE TO SEE ART Ferdinand has had a number of gallery shows, and his work was included in "It'll Come True," Artists' Alliance, Lafayette, Louisiana (1992). The artist is in the permanent collection of the African American Museum, Dallas, and the University Art Museum, University of Southwestern Louisiana, Lafayette. Examples of Ferdinand's paintings can also be seen at Doug's Steak House in New Orleans.

WHERE TO BUY ART Barrister's Gallery in New Orleans is the principal representative of Roy Ferdinand. Robert Cargo Folk Art Gallery, Tuscaloosa, Alabama, and the Leslie Muth Gallery, Santa Fe, also handle his work. As the price of Ferdinand's work has risen rapidly during the last few years, other galleries are also acquiring his paintings for resale.

Born December 2, 1916, Valley Head, Alabama. Now resides Summerville, Georgia.

Howard Finster

Howard Finster, the founding father, pastor, and builder of "The World's Folk Art Church," began to create expressive and often apocalyptic sermons in paint in response to a directive from the Lord; his paintings are eclectic, expressing a deep-rooted and unique interpretation of the Bible. He depicts angels and saints as well as earthly characters and popular heroes; many are interspersed with printed quotations and original, often witty, sayings—or "Finsterisms," as they have come to be called. He has now completed (according to his unique numbering system) more than thirty-eight thousand works of art since 1976.

In addition to his prodigious output in paint, Finster also spent years building his now-famous Paradise Garden and Folk Art Church (the Georgia Bureau of Tourism counts it as one of the state's attractions) from, in his words, "other people's junk." He dedicated his labors to the Lord in the belief that the Lord would in return protect and save his works, even the paintings he left outdoors in Georgia's steamy and damp weather. Today Finster and the garden are showing the effects of age, and even though he still labors night and day—with the help of his children and grandchildren—keeping up Paradise Garden, he now realizes that it will be reclaimed by the swamp on which it was built unless some sort of worldly help is forthcoming.

Howard Finster not only created a religious visionary tradition in northern Georgia, he also founded an artistic dynasty. He and his wife, Pauline, have five descendants who are artists: two children, Roy (born September 3, 1941) and Beverly (born May 5, 1956), and three grandchildren, Allen Wilson (born September 30, 1959), Michael Finster (born June 20, 1969), and Chuck "Chuckie" Cox (born May 28, 1977), all born in Summerville, Georgia. Being a member of the Finster clan is not always easy, however; no matter how original their art, it is always compared to that of the family patriarch. Roy acknowledges his indebtedness to his father in his art style, but Allen and Michael are working to create idiosyncratic styles of their own. Beverly paints only occasionally, and then more or less in the mode of her father. Chuck "doesn't like working all the time on art," but he helps his ailing grandfather at Paradise Garden in addition to being an artist.

COLLECTING TIPS In the latter part of 1976 or early 1977, Finster began to number his paintings. His extraordinary output has actually increased with the passing of years, but in general his earlier pieces (those unnumbered or numbered below two thousand) are considered to be his most valuable creations. Finster still preaches every Sunday in Paradise Garden, and collectors come from all over the country to hear his sermons and buy mementos of their trips.

Because Finster's offspring were born and grew up in Paradise Garden, they are part of the folk art establishment by

right of birth, and tourists, collectors, and dealers now also seek them out. Outside of Howard, Beverly may be the best painter in the family, but she has completed fewer than twenty works; Roy, Michael, and Allen, however, are prolific. Chuck has mastered his grandfather's style of handwriting; he does few things under his own name, but his writings may appear on Howard Finster's more recent works.

Each Finster swears that he or she signs his or her own art, but some pieces appear to be collaborative efforts. Allen now plans to recreate some of his grandfather's works that were sold out of the garden.

WHERE TO SEE ART Howard Finster, folk art's first "superstar," has been honored by the art world and has also become a TV personality. His work has been reproduced in almost every book and general catalog on contemporary American folk art, and his art is included in the permanent collections of most museums with folk art collections.

Lehigh University, Bethlehem, Pennsylvania, which has exhibited the work of Finster and his family on several occasions (including a 1986 exhibition, "The World's Folk Art Church: Reverend Howard Finster and Family") has collected works by Howard Finster as well as by other Finsters. Since 1976 Howard Finster's work has been included in well over one hundred exhibitions, a number of which were one-person shows ("The Road to Heaven Is Paved by Good Works: The Art of Reverend Howard Finster," a traveling exhibition organized by the Museum of American Folk Art in New York City, for example). He was one of the artists selected to represent the United States in the Venice Biennale in Italy in 1984.

Paradise Garden has a display and sales shop, and the family also participates in the Finster Festival held in Summerville every May.

WHERE TO BUY ART Howard Finster has always sold his art at the Paradise Garden shop; at present Beverly is handling a large portion of the sales, and there is a toll-free number for the shop. Finster was represented by the Phyllis Kind Gallery for a number of years, but his paintings currently may be found in many galleries throughout the country; possible sources include the Phyllis Kind Gallery, New York City and Chicago; the Janet Fleisher Gallery, Philadelphia; and the Carl Hammer Gallery, Chicago. Several Georgia dealers (John Denton in Hiawassee and Archer-Locke in Atlanta, for example) are also possibilities, and his work may sometimes be found at auction.

The display shop at Paradise Garden also sells the work of Finster's offspring, as do several galleries. Michael's work is handled by Knoke Galleries of Atlanta, Gilley's Gallery in Baton Rouge, Louisiana, and HMS Folk Art in New York City. HMS also has Roy's work, as does the Southside Gallery in Oxford, Mississippi. Red Piano Too, Saint Helena Island, South Carolina, sells the work of Allen and Roy.

6 5
JOHN GERDES

Born March 18, 1913, Bremen, Germany; came to America in 1913. Now resides Maitland, Florida.

John Gerdes makes "op art" paintings by combining the two trade skills acquired during his working years—woodgraining and electronics. "When there wasn't any demand for woodgrainers no more, I fixed televisions and electronics," he explains. Gerdes painstakingly imitates the natural grains of both common and rare woods and startles the eye with an infusion of color and a blinking rainbow of artificial electric light.

Gerdes buys secondhand computer parts, transistors, and the like, then combines them on boards that are often painted in blocks that look like samples advertising a woodgrainer's product. When these assemblages are switched on, gears appear to be grinding mysteriously and preprogrammed lights flash, sometimes with sound accompaniment. Gerdes has also created several life-size robots, figures that, with their moving parts and flashing lights, look as if they could inhabit a *Star Wars* adventure.

COLLECTING TIPS

All of Gerdes's paintings are interesting, but the pieces that combine his woodgraining technique with electronics represent his best work. His large robot sculptures are major attention-getters wherever they are displayed.

WHERE TO SEE ART

Gerdes has been included in "A Separate Reality: Florida Eccentrics," Museum of Art, Fort Lauderdale, Florida (1987), and "Unsigned, Unsung," Florida State University, Tallahassee (1993); both shows were accompanied by illustrated catalogs in which his work appears. In 1995 the artist's work was shown in "Contemporary Folk Art: A View from the Outside" (also a catalog show), Nathan D. Rosen Museum Gallery, Boca Raton, Florida.

WHERE TO BUY ART

Gerdes's house is a museum of his art, with flashing lights and turning gears, and many collectors have found his home display fascinating. Gerdes is not looking for customers, but he occasionally sells works to interested visitors.

6 6
EVELYN GIBSON

Born January 11, 1944, Augusta, Georgia. Now resides Augusta.

Evelyn Gibson, a black visionary artist to watch, illustrates biblical scenes in an art moderne style, with her figures often posed as though they were models for a fashion magazine. In one painting costumes are emphasized and faces are hidden; in another Daniel wears a beautiful red cardinal's robe and a bow tie—he looks pleased with himself, satisfied with his appearance and stature in life, even though he is being circled by lions—albeit friendly ones—right out of the Wizard of Oz.

Gibson, a stenographer, scrimped for five years in order to take a trip to the Holy Land in 1985. In 1992 she started to paint recalled visualizations of her trip. "It all came together for me over there," she says. "Christians, Jewish, and Islams—they all looked beautiful together."

COLLECTING TIPS

Evelyn Gibson has been painting for only two years. Since it is early in the artist's career, collectors should make their own

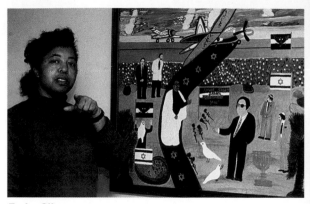

Evelyn Gibson

evaluations of Gibson's art. We believe, however, that we may have happened on a fresh new talent in an out-of-the-way place, and we wanted to share this discovery with others.

WHERE TO SEE ART One of Gibson's paintings hangs in her church, the Church of the Lord Jesus Christ, in Augusta, Georgia.

WHERE TO BUY ART Gibson is represented by the Spotted Cow Gallery, Augusta, Georgia, and by Weathervane Antiques, Thomson, Georgia.

SYLVANUS HUDSON

Born July 18, 1914, Athens, Georgia. Now resides Augusta, Georgia.

Through clever use of an unusual collage technique, Sylvanus Hudson takes what would otherwise be trite sayings or familiar religious passages and gives them new life and meaning. He collects printed religious messages—the kind that are frequently given away by churches, leaflets or message cards with flowery borders and common sayings such as "A watch that won't run is right twice a day"—then turns them into message pictures intended to affirm our belief in the saying or message.

Hudson's message collages are made of unusual materials; he takes broken glass, shells, pebbles, old watches, and other found objects and glues them to wooden panels covered with black velvet. The artist is fond of saying, "The Riverside Glass Company will sell me an awful lot of broken glass for five dollars. I'm also a rockhound and buy unwanted tires." He paints the tires white, fills them with dirt, and in summer maintains a beautiful tire-planter garden (tires, rocks, driftwood sculpture).

COLLECTING TIPS Hudson's output increased in the early 1980s after his retirement and the death of his wife. He gave away his message collages to friends until about 1985, when he began selling his art.

WHERE TO SEE ART One of Hudson's message collages was used as a record cover for the Human Rights album *Our Faith* (Railroad Records, 1992).

WHERE TO BUY ART Sylvanus Hudson is represented by Weathervane Antiques, Thomson, Georgia, and Archer-Locke, Atlanta.

67
CLEMENTINE HUNTER

Born late December 1886 or early January 1887, Cloutierville, Louisiana. Died January 1, 1988, near Melrose Plantation, Louisiana.

Clementine Hunter, a descendant of slaves, was inspired by plantation life, portraying plantation hands at work, at church, and at play in her paintings. She recorded a bygone era of American life with humor, simplicity, and a marvelous sense of color. Her paintings reverberate with authenticity, and for good reason. She was one of the women picking cotton and wearing a bright hat to shade her from the harsh summer sun. She participated in the Saturday nights at the honky-tonk, and she was there at the Sunday-morning baptisms in the nearby Cane River.

It is true that Hunter's paintings are overlaid by a somewhat romantic vision of plantation life, but it is equally true that the attractiveness and historical importance of the paintings has earned her recognition as one of the most important artists of her generation.

COLLECTING TIPS
The quality of Clementine Hunter's paintings is somewhat uneven, and especially during the later years of her life, she tended to repeat the subject matter of the earlier works. For this reason her earlier works are the most valuable. Experts can approximate the date of a Hunter painting through an examination of her signature, which changed over the years.

Hunter made a few quilts, and these are now extremely expensive. She also painted on tinware, bottles, gourds, and other items; these works are less expensive but very desirable.

WHERE TO SEE ART
Clementine Hunter's paintings may be seen at the Melrose Plantation, now a historical site, where she lived and worked for many years. Her work is in many public collections, such as the New Orleans Museum of Art; the Birmingham Museum of Art and the Montgomery Museum of Fine Arts, both in Alabama; the High Museum of Art, Atlanta; the Milwaukee Art Museum; and the Museum of International Folk Art, Santa Fe. Her work may also be seen in a well-illustrated biography of the artist, *Clementine Hunter: American Folk Artist,* by James L. Wilson (1988).

WHERE TO BUY ART
Hunter was extremely prolific, and her work might appear in almost any gallery. Gasperi Gallery in New Orleans and Gilley's Gallery in Baton Rouge, Louisiana, both specialize in Clementine Hunter's works.

68
M. C. "5¢" JONES

Born November 4, 1917, Eagle Shute (near Gilliam), Louisiana. Now resides Gilliam, Louisiana.

M. C. "5¢" Jones is a living reminder of a rural southern cotton-dependent culture that is almost gone. His watercolor and oil portraits of southern blacks, rural farm life, and Sunday church meetings are without parallel, but do not confuse them with romantic memory paintings. His strongest paintings show the not-so-pretty everyday side of the rural South in which he lives, and Jones knows of what he paints. He lived most of his life on the Lynn Plantation, where he picked cotton and did yard work until old age caught up with

him. He is called "5¢" Jones because he is only about five feet tall.

COLLECTING TIPS Jones sometimes repeats his most popular paintings, such as Adam and Eve in the Garden of Eden or country baptisms. These are often made to order and not what serious collectors should be looking for. Try to find one-of-a-kind portraits or unusual, seldom-repeated scenes.

Jones includes an upside-down "5¢" below his signature.

WHERE TO SEE ART One of Jones's paintings hangs in the Justice Baptist Church in Gilliam. He participates in the annual Gilliam fair (a county crossroads festival) and has been exhibited in a number of local art shows in Louisiana.

WHERE TO BUY ART The work of M. C. "5¢" Jones is shown at a number of galleries in Louisiana and Alabama, including Gasperi Gallery, New Orleans; Gilley's Gallery, Baton Rouge, Louisiana; Robert Cargo, Tuscaloosa, Alabama; and Marcia Weber, Montgomery, Alabama. Several galleries in other parts of the country also carry his work; Webb Folk Art Gallery in Waxahachie, Texas, is one of them.

6 9
EDDIE LEE KENDRICK

Born September 20, 1928, Stephens, Arkansas.
Died November 23, 1992, Little Rock, Arkansas.

Eddie Lee Kendrick took imaginary celestial journeys that he recorded in a series of extraordinary drawings that are now attracting posthumous interest in this artist. By day he worked as custodian at the Parham Elementary School in Little Rock, Arkansas, but in his dreams he traveled in space—"heaven bound," he would say, by train and "plain."

Kendrick had his worktable in the basement of the school where he was employed, and school children would often visit his workspace, listen to his stories, and admire his drawings. Sometimes he would give his drawings to the children. Kendrick was also a deacon of the Woods Temple Church of God and sang in a gospel group.

COLLECTING TIPS Kendrick's drawings include landscapes, cityscapes, and portraits, but his visionary drawings depicting his journey into the heavens are by far his most sought after work.

The artist signed his name "E. Kendrick," or sometimes just plain "Eddie."

WHERE TO SEE ART Eddie Kendrick's work was brought to the attention of the art world when he was included in the traveling exhibition "Passionate Visions of the American South," organized by the New Orleans Museum of Art (1993). The Arkansas Arts Center in Little Rock has Kendrick's work in its collection.

WHERE TO BUY ART Kendrick's drawings might be discovered by exploring the Little Rock area. At this time, however, we are not aware of any gallery that carries his work.

Born October 12, 1951,
Birmingham, Alabama.
Now resides Pink Lily, near
Prattville, Alabama.

The larger-than-life metal assemblages that populate the fields of the hilly rural community of Pink Lily, Alabama, are the creations of "Tin Man" Charlie Lucas—his self-styled "Garden of Delights." Lucas, a sculptor and painter, feels that he is "recycling himself" as well as his sculptures, which are made from rusted scrap metal and machine parts, the flotsam and jetsam of American industrial waste. Lucas also intends his sculpture—some abstract, others that resemble people and animals—to deliver a message concerning black history, compassion for mankind, and a desire for social unity. Thus his work can be enjoyed and understood on many levels.

Lucas also creates semiabstract paintings on board and canvas that are usually intended to deliver messages similar to those of his sculpture. These are displayed on the inside of his house and barn/studio. Lucas's wife, Annie, a religious person, is also a painter; her subject matter is biblical.

COLLECTING TIPS

Lucas's large sculpture is his most important work, but if a collector has neither the money nor the appropriate space for it, his paintings are worth consideration.

Charlie Lucas is one of a group of southern black self-taught artists who are consciously trying to make a place for themselves in the art world. He has attracted a large following who believe that this style of art is one of the directions that folk art will take in the coming years.

WHERE TO SEE ART

Lucas's work has been included in many exhibitions; for example, "Another Face of the Diamond: Pathways through the Black Atlantic South," INTAR Latin American Gallery, New York City (1988), "Passionate Visions of the American South," New Orleans Museum of Art (1993), and "Recycled, Re-Seen: Folk Art from the Global Scrap Heap," Museum of International Folk Art, Santa Fe (1996). Several museums, including the Birmingham Museum of Art, Alabama, and the New Orleans Museum of Art, have work by Charlie Lucas in their collections.

WHERE TO BUY ART

Lucas has been known to sell work from his home. His work is featured in several Alabama galleries: Cotton Belt and Marcia Weber in Montgomery, and Robert Cargo Folk Art Gallery in Tuscaloosa. Other galleries that show Charlie Lucas include Rising Fawn Folk Art, Chattanooga, Tennessee; Art Adventure, Boulder, Colorado; and Sailor's Valentine Gallery, Nantucket, Massachusetts.

Although there are other sculptors who have made objects from wire, Columbus McGriff excelled in his handling of this medium. He created airplanes, an eight-foot dinosaur, trucks, alligators, and more—all made with baling machine wire. By using different colors of wire, he could add color and highlight

Born December 8, 1931,
Grady County, Georgia.
Died December 31, 1991,
Cairo, Georgia.

the features (red for eyes, silver for teeth, for example) of his assemblages. Children loved to play with his entertaining baling-wire creations, but they can also be looked at as serious works of art that contain elements of surprise—his B-24 bomber, for instance, allows the viewer to look into it and observe the crew at work.

McGriff worked for a while as a shoe shiner in New York City, but when his eyesight began to fail, he gave that up and returned to Georgia, where he began to create his wire fantasies. Although almost blind, he had great strength in his hands and was able to shape the wire without the aid of tools. He worked on his sculpture until he died.

COLLECTING TIPS Some of McGriff's smaller pieces have a toylike appearance, but his larger work has a strong sculptural presence.

WHERE TO SEE ART Columbus McGriff was included in "Unsigned, Unsung," at Florida State University, Tallahassee (1993), and illustrated in the catalog for that show. He was also included in "African-American Folk Art" at Fisk University, Nashville, Tennessee (1991). McGriff is in the James Collection, Saint James Place, Robersonville, North Carolina.

WHERE TO BUY ART McGriff's wire sculptures can often be found at galleries such as the Modern Primitive Gallery in Atlanta and Robert Cargo Folk Art Gallery in Tuscaloosa, Alabama.

72
REUBEN "R. A."
MILLER

Born July 22, 1912, Gainesville,
Georgia. Now resides Gainesville.

R. A. Miller has built a forest of whirligigs on an otherwise almost barren hill near his house. Representations of Uncle Sam, strange flat animals, angels, devils, and a colorful character called "Blow Oscar" turn, dip, dive, and swoop in the wind on the hilly site that overlooks a two-lane paved road. "Blow Oscar," Miller explains, "is a big ol' boy who blows his horn every time he goes past."

"I was just an old man trying to get by," Miller declares. "My guardian angel told me to build all this and people will pass by and buy 'em." Miller's guardian angel was right; folk art collectors from all over the country come to see this environment and to buy his whirligigs, some with messages like "Lord Love You." Besides being a patriot, Miller was a preacher at the Free Will Baptist Church.

Miller also draws with magic markers. In this medium, he has produced a series of animal drawings that reminds one of the petroglyphs seen at ancient sites.

COLLECTING TIPS Miller's early whirligigs, from the mid-1980s, and his rarer cavelike drawings of animals are his best. He is presently making multiple copies of Blow Oscar and Uncle Sam—still fun to own and display, they have largely lost their original spontaneity.

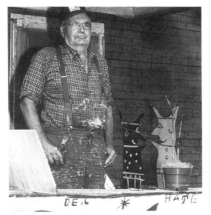

R. A. Miller

WHERE TO SEE ART R. A. Miller's work was included in "Georgia Folk Art," Quinlan Art Center, Gainesville, Georgia (1991), and "Passionate Visions of the American South," New Orleans Museum of Art (1993). He frequently participates in the art festivals held in Gainesville.

WHERE TO BUY ART R. A. Miller will sell from his home, and many folk art galleries offer a selection of his recent work (for example, Robert Cargo, Tuscaloosa, Alabama; Modern Primitive, Atlanta; Vanity Novelty Garden, Miami Beach; the Tartt Gallery, Washington, D.C.; and the Ames Gallery, Berkeley, California). American Primitive Gallery in New York City carries some of Miller's older drawings and whirligigs, but they are more expensive than his more recent work.

**73
REGINALD
"REGGIE"
MITCHELL**

Born July 28, 1959, New Orleans, Louisiana. Now resides New Orleans.

Reginald Mitchell has the soul of a poet and the frail body of a severely physically handicapped man. He filters reality through his own unique perspective, shaped by his physical limitations, and the resulting paintings are glorious expressionistic abstractions of New Orleans—its colorful street life, its buildings, and its gardens. He also paints people who sometimes appear to tower over the buildings in the paintings.

When he was young, the artist stuttered so badly that the public schools gave up on him, but he is not retarded. His neighbors in the projects where he lives taunted him as a cripple, mugged him, and made fun of his art. But he has now found a home away from home—every day he takes public transportation to Barrister's Gallery on Royal Street and spends the day there painting in the courtyard or attic, depending on the weather conditions—and he has also found success. Reggie Mitchell loves his occupation as a folk artist: "I'm gonna paint, never stop. Gonna paint and paint and paint."

COLLECTING TIPS Many collectors buy more than one of Mitchell's paintings because they are relatively small and tend to show off better in groupings on a wall.

WHERE TO SEE ART	Reggie Mitchell's art can be seen at Barrister's Galle New Orleans.
WHERE TO BUY ART	Barrister's Gallery in New Orleans represents Reggie Mitche

7 4
SISTER
GERTRUDE
MORGAN

Born April 7, 1900, Lafayette, Alabama. Died July 8, 1980, New Orleans.

Sister Gertrude Morgan preached a colorful, personal, and often apocalyptic vision of biblical events through her art. Her pictures are occupied by religious figures, angels, children, and often a portrait of herself in white robes shown as the bride of Christ (from 1957 on she always dressed in white). Many of her angels and other biblical characters are black. Throughout her work, Morgan interspersed religious messages done in a childlike script; without being conscious of it, she was also a calligrapher.

Sister Gertrude Morgan believed that her art, her ministry, and her marriage to Christ were due to the intervention of the Lord and spoke often of the directives he gave her. She ran an orphanage and a small gospel mission in New Orleans, preached in the streets, and of course painted her sermons and thus preserved her unique religious philosophy for all of us to share.

COLLECTING TIPS

There is not a collector or museum interested in black folk art that is unfamiliar with the visionary works of Sister Gertrude Morgan. Toward the end of her life Morgan lost some of her motor control, making her later works less consistent and not as valuable as the earlier ones. Paintings larger than 12 × 20 in. (30.5 × 50.8 cm) are rare, and would be particularly valuable.

WHERE TO SEE ART

Sister Gertrude Morgan is widely represented in public institutions, including the New Orleans Museum of Art; the African American Museum, Dallas; the Akron Museum, Ohio; the Museum of American Folk Art, New York City; the Milwaukee Art Museum; and the Smithsonian Institution's National Museum of American Art, Washington, D.C. Illustrations of Morgan's work are to be found in most books and catalogs that include black or religious folk art of the second half of the twentieth century.

Morgan was included in "Passionate Visions of the American South," New Orleans Museum of Art, and "Made in USA," Collection de l'Art Brut, Lausanne, Switzerland (both in 1993). Her work was also widely exhibited during her lifetime.

WHERE TO BUY ART

Sister Gertrude Morgan's drawings are mostly held in public and private collections, but occasional pieces do turn up in the marketplace. Gilley's Gallery in Baton Rouge, Louisiana, and the Gasperi Gallery in New Orleans are good places to start a search for her work.

75
ED
"MR. EDDY"
MUMMA

Born 1908, Milton, Ohio.
Died October 7, 1986,
Gainesville, Florida.

Ed Mumma, who called himself "Mr. Eddy," repeatedly painted an abstract version of the bust of a round-faced man with his hands held in front of his chest. The artist was a colorist; the face might be red or green and the background any color, but the work is instantly recognizable as Mumma's because of his often-repeated image. Sometimes the image was painted on both sides of the plywood or Masonite Mumma used.

Mumma suffered from diabetes, which eventually led to the loss of both his legs. Sick and housebound, Mumma began to paint his compulsive images (possibly self-portraits) to decorate the walls of his home. "They belong here, where I can see them," he frequently proclaimed. As a result of Mr. Eddy's need to have the paintings close to him, he did not sell or exhibit his work during his lifetime.

COLLECTING TIPS

Mr. Eddy occasionally framed his work with found objects and even bits of glued wood; these pieces are very desirable. He also made a few paintings of multiple figures and even nudes; these are rare and hard to find.

Some of Mumma's paintings are in bad condition, and condition is always factored into the price of a work of art.

WHERE TO SEE ART

Mumma was included in museum exhibitions such as "A Separate Reality: Florida Eccentrics," Museum of Art, Fort Lauderdale (1987), "Made in USA," Collection de l'Art Brut, Lausanne, Switzerland (1993), and "Unsigned, Unsung," Florida State University, Tallahassee (1993). His work is illustrated in the catalogs for those exhibitions.

WHERE TO BUY ART

The Luise Ross Gallery in New York City carries Mr. Eddy's work, as does Tyson's Trading Company in Micanopy, Florida.

76
ROGER RICE

Born June 14, 1958,
Crawford, Mississippi. Now
resides Parchman, Mississippi.

An obsessive believer in the evil nature of mankind, Roger Rice has illustrated his religious fervor, frustrations, and a snake-pit hell of sexual violence in a series of remarkable oil paintings on canvas. He uses two palettes to separate his principle themes—dark, brooding, and ominous colors represent his erotic paintings, and lighter, quieter pastels are used for the religious works. But even in the religious paintings, which can capture the excitement of a historic moment (for example, a black Christ being baptized in the River Jordan by a black John the Baptist), there is the sense of the bloody trials ahead for Christianity.

As in the paintings, there is a contradictory duality in the life of the artist. Roger Rice is an ordained fundamentalist minister; he is also a "lifer" serving time in Mississippi's infamous Parchman Prison. Prior to his incarceration he had painted some forty oils, about equally divided between religious scenes and erotic themes; since his imprisonment in 1992, however, he has produced less than twenty black-and-white drawings (Parchman does not allow him to use color).

COLLECTING TIPS Rice's paintings of a sexual hell may well be his most popular and important works. We, however, prefer his quieter religious paintings.

WHERE TO SEE ART Roger Rice had a one-person exhibition at the University of Alabama (1992) and was included in "Unsigned, Unsung," Florida State University, Tallahassee (1993) and illustrated in the catalog for the show.

WHERE TO BUY ART Rice is represented exclusively by the Robert Cargo Folk Art Gallery, Tuscaloosa, Alabama.

77
ROBERT ROBERG

Born November 13, 1943, Spokane, Washington. Now resides Palmetto, Florida.

"In 1977, I was lifted off the earth by a blinding light and there was Jesus. He said: 'Work for me!'" Robert Roberg relates. Roberg's work for Jesus led him to art, and at the Lord's command, he began to sermonize in paint. His religious experience was similar to that of Howard Finster, and his paintings glorifying the word of the Lord and preaching against the work of Satan on earth are capturing the imagination of the folk art world.

The artist uses Day-Glo paint, tempera, house paint, fingernail polish, and "just about anything I can get my hands on," he says. He often attaches glitter and found objects to his work to help the viewer focus on the message, which is sometimes spelled out in bold block letters.

COLLECTING TIPS Roberg's paintings are uniformly good, although some may prefer the religious work (particularly his interpretation of Revelations) and others the scenes preaching against evil on earth (drugs, alcohol, prostitution, and poverty). He has framed some paintings with bits of colored glass that he glues to store-bought frames; these frames, although fragile, add color and excitement to the paintings.

WHERE TO SEE ART Roberg's home in Palmetto is a must-see museum, filled with his paintings and furniture he has painted himself, and he welcomes visitors. The artist also takes his art into the streets as visual aids when he preaches to the down-and-out. If you are lucky, you may catch one of his sermons.

Roberg was exhibited at the Museums of Abilene, Texas (1992), and his paintings were included in "Contemporary Folk Art: A View from the Outside," Nathan D. Rosen Museum Gallery, Boca Raton, Florida (1995). His work is in the James Collection of Southern Folk Art, Saint James Place, Robersonville, North Carolina.

WHERE TO BUY ART Collectors may purchase work directly from the artist. G. H. Vander Elst in Franklin, Tennessee; Timpson Creek Gallery, Clayton, Georgia; and the Leslie Muth Gallery in Santa Fe also show Robert Roberg's paintings on a regular basis.

**NELLIE MAE
ROWE**

*Born July 4, 1900,
Fayetteville, Georgia. Died
October 18, 1982, Atlanta.*

Nellie Mae Rowe told imaginative stories in paint about her childhood, her friends and family, and other people around her. Her colorful paintings have an unreal, almost surreal, look about them—partly because she didn't care if a face or an animal was red or blue or whatever color, as long as it looked right to her. "I don't care," she also said, "if the color is ink, watercolor, crayon, or pencil." Rowe never forgot the Lord in her work, and she painted for his pleasure. "Call Him up," she was fond of saying, "He'll hear you."

Rowe lived in a pleasant house near the Chattahoochee River. RealLemon and RealLime yellow and green plastic containers hung in the shade tree above the terrace on which she would sit and sew. Rowe made beautiful quilts in the style of her paintings as well as a few assemblages and some stuffed dolls; she also created small but unusual painted sculptures out of chewing gum.

COLLECTING TIPS

Rowe's lively and colorful visionary drawings must be considered her legacy, and they are her most collectible work. The few quilts, dolls, gum sculpture, and assemblages are closely held in either private or public collections, and it is hard to estimate what they might bring in the marketplace.

WHERE TO SEE ART

Rowe's first artistic recognition occurred when she was included in "Missing Pieces," a show of Georgia folk art put together by the Georgia Council for the Arts and Humanities (1977), and she was later included in the 1982 Corcoran Gallery show "Black Folk Art in America, 1930–1980." Since then Nellie Mae Rowe has been included in virtually every important exhibition of black folk art, and her work is illustrated in numerous catalogs and books on self-taught artists.

Rowe is in the permanent collection of such museums as the High Museum of Art, Atlanta; the Museum of American Folk Art, New York City; and the Museum of International Folk Art, Santa Fe.

WHERE TO BUY ART

Rowe is represented by Judith Alexander in Atlanta and New York City. From time to time her work turns up in other galleries, especially in galleries in Georgia, such as the Berman Gallery, Atlanta, and John Denton, Hiawassee (northeast of Atlanta, near the North Carolina border).

79

**O. L. "GEECH"
SAMUELS**

*Born November 18, 1931, "way
out in the country," Wilcox
County, Georgia. Now resides
Moultrie, Georgia.*

O. L. Samuels finds unusual figures in pieces of wood—sometimes a bit scary, sometimes a bit surreal—and carves them out. His carvings are made even more surreal by the pigment he applies to the wood—a secret mixture of paint, sawdust, glitter, and glue, and the artist always has pots of this mixture warming on his wood-burning stove. "I carved unicorns, killer bees, my cousin James Brown, and Jesse Jackson with wings, because he needed to be built for speed to run for president," Samuels explains with a sly laugh. "There's

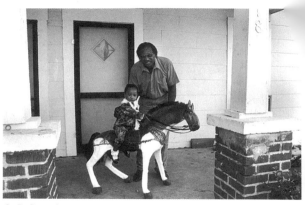

O. L. Samuels

a story to go with everything, and the stories just keep popping out."

Samuels is called "Geech" or "Geechie" because of the accent he acquired from his West Indian father. He once fought as a professional boxer, "but I had to quit because I wouldn't take no dives," he brags. Later Samuels worked as a tree surgeon until he was injured. At present he is retired and spends his time carving out the figures and stories he finds in wood.

COLLECTING TIPS Samuels has turned out some small potboiler doll-like figures, but his best works are the large storytelling figures and his unique animals. Georgia collectors know about Samuels and visit him regularly; they often have his more unusual pieces.

WHERE TO SEE ART O. L. Samuels was included in "Unsigned, Unsung" at Florida State University, Tallahassee, and illustrated in the catalog (1993) for that exhibition. He had a one-person show at the Harriet Tubman Museum, Macon, Georgia (1994).

WHERE TO BUY ART Samuels will take orders, but because of his lack of schooling, he finds it difficult to correspond with collectors. Representatives of the Modern Primitive Gallery in Atlanta visit the artist from time to time, and sometimes his work is available through that gallery. Other Georgia galleries, such as Knoke (Atlanta) and Main Street (Clayton), frequently have his carvings.

80
LORENZO
SCOTT

Born July 23, 1934, Westpoint, Georgia. Now resides Atlanta.

Lorenzo Scott, a fervent and enthusiastic Baptist, paints classical religious subject matter—a little Giotto, a little Leonardo, and a few pop images such as Tammy Faye and Jim Bakker (he is looking angelic and innocent in handcuffs) for good measure. Scott spends many solitary hours in the High Museum of Art in Atlanta looking at religious art, and then, he says, "I go home and paint 'em again, only a little better." Scott also builds his own frames, fashioning them from wood and rosettes of Bondo. After his frames are gilded, they closely resemble the baroque frames that he sees in the High Museum.

According to Scott, the Lord is always with him. "I got mugged," he remembers, "and the Lord brought 'em [his assailants] right into the police station. Now nobody fools with me!"

COLLECTING TIPS We prefer Scott's pop imagery to his more serious copies of classical paintings, but some collectors may prefer the latter. The baroque frames that Scott makes to go with his paintings are works of art in themselves; they should not be removed.

WHERE TO SEE ART Lorenzo Scott had a one-person exhibition at the Springfield Museum of Art, Springfield, Ohio, in 1993.

WHERE TO BUY ART Scott is represented by the Modern Primitive and Knoke galleries, both in Atlanta.

8 1
WELMON
SHARLHORNE

Born August 17, 1952, Houma, Louisiana. Last known residence, the streets of New Orleans.

Welmon Sharlhorne is known to have made fewer than fifty drawings while in prison, but those drawings have attracted a lot of attention in this country as well as Europe. His work depicts crisply drawn imaginary structures, people—some of whom have vague animal-like characteristics—buses, and night skyscapes.

Sharlhorne said that he "used to hustle grass" (do yard work) but he also "hustled" outside of the law. Over half of his adult life has been spent inside prisons, and it is from behind those walls that he made most of his drawings. "I'd tell 'em I needed manila envelopes," he confided, "to write my lawyer. They'd give me envelopes and Bic pens. Then I'd go to the nurse and get a thing for under tongues [tongue depressors] and make paintings with them." Sharlhorne glued manila envelopes together in order to get the rectangular shape he wanted for some of the drawings. He would cut the envelopes with the edge of a ruler (scissors and knives are not allowed in prison).

COLLECTING TIPS In some of Sharlhorne's works, the paper has been torn by his heavy hand with a thin-tipped Bic pen. The artist signs his drawings "W. Sharlhorne" in a bold script.

Sharlhorne has completed some drawings during the periods of time that he has been out of jail, but to date these have not been his best work.

WHERE TO SEE ART Welmon Sharlhorne's drawings were exhibited at the Collection de l'Art Brut in Lausanne, Switzerland (1993); they were also included in "Drawing outside the Lines: Works on Paper by Outsider Artists," an exhibition at the Noyes Museum, Oceanville, New Jersey (1995).

WHERE TO BUY ART Most of the prison drawings by Sharlhorne are in several private collections, although Barrister's Gallery in New Orleans has had some of Sharlhorne's work in the past. The American Primitive Gallery in New York City has some of the artist's later work.

**HERBERT
SINGLETON**

*Born May 31, 1945,
New Orleans, Louisiana. Now
resides Algiers (a suburb of
New Orleans), Louisiana.*

Herbert Singleton's work is the finest of the current generation of southern black carvers; his powerful images can shock an audience, but they can also bring about further understanding of the world as seen through the eyes of an urban black. During the last few years he has become recognized as the most important black carver since Elijah Pierce and Josephus Farmer. His storytelling pieces narrate his philosophy—"This is the way we was, take us as we are, Uncle Tom is dead." In Singleton's capable hands, bas-reliefs made of cypress, driftwood, and paint turn into intense visual commentaries on religious themes, political history, and New Orleans life.

Singleton's roots go deep into the drug culture, voodoo, and street crime, but he has personally rejected this subculture and embraced life as an emissary of his "black brothers."

COLLECTING TIPS

Singleton's works appeal to collectors who are looking for the best in carving and for art that makes a strong visual statement. The growing demand for his work has been driving up Singleton's prices, and his large doors are now among the more expensive pieces in this field.

WHERE TO SEE ART

Herbert Singleton has been included in such exhibitions as "Passionate Visions of the American South," organized by the New Orleans Museum of Art (1993); "Diving in the Spirit," organized by Wake Forest University, Wake Forest, Illinois (1992); "Civil Rights Now," organized by the Southeastern Center for Contemporary Art, Winston-Salem, North Carolina (1995); and "The Tree of Life," American Visionary Art

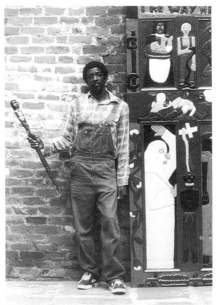

Herbert Singleton

Museum, Baltimore (1995). His carvings are in the permanent collections of the New Orleans Museum of Art and the African American Museum, Dallas.

Singleton's large bas-reliefs are illustrated in *Elijah Pierce: Woodcarver* (1992).

WHERE TO BUY ART Barrister's Gallery in New Orleans is the exclusive representative of the artist.

8 3
M A R Y
"M A R Y T."
S M I T H

Born November 4, 1904,
Brookhaven, Mississippi.
Died June 19, 1995,
Hazelhurst, Mississippi.

Mary T. Smith painted figures of men and women with large brushstrokes of pure color (red, yellow, and black) in a bold, expressionistic style; she painted without any attempt at detail or perspective and filled in the empty spaces between the lines later. Her paintings often include written legends proclaiming the faith of the artist in God and giving names to some of her figures, like "Mr. Big."

Smith originally fenced in her yard with paintings that she did on panels of corrugated roofing tin "to brighten the place up, and please the Lord," she said. Her yard soon attracted the attention of collectors of southern folk art, who purchased Smith's panels almost as fast as she could make them, and earned her status as a legend in this part of the country. Her compulsive desire to "brighten up" her hillside home did not abate, however, and she continued to paint, even after suffering a stroke in 1985. Unfortunately, her health deteriorated, and the artist could no longer make "her pictures" for several years prior to her death in 1995.

COLLECTING TIPS The early work of Mary T. on panels of roofing tin are by far her most valuable pieces. By the late 1980s collectors were bringing the artist plywood panels to paint; these made-to-order works are not nearly as desirable.

WHERE TO SEE ART Smith was included in "It'll Come True," Artists' Alliance, Lafayette, Louisiana (1992); "Give Me a Louder Word Up," Metropolitan State College of Denver, Colorado (1992); and "Passionate Visions of the American South," New Orleans Museum of Art (1993).

The work of Mary T. is in various southern museums, among them the Birmingham Museum of Art, Alabama; the New Orleans Museum of Art; and the Mississippi State Historical Museum, Jackson.

WHERE TO BUY ART Mary T. Smith's colorful paintings are carried by many galleries in the South (for example, the Berman Gallery and Knoke Galleries, Atlanta; the Robert Cargo Folk Art Gallery, Tuscaloosa, Alabama; Gilley's, Baton Rouge, Louisiana; and the Gasperi Gallery, New Orleans), as well as by galleries in other parts of the country (Ames Gallery, Berkeley, California; Leslie Muth Gallery, Santa Fe; Creative Heart, Winston-Salem, North Carolina; and Ricco/Maresca, New York City, among others).

WESLEY "TOOTHPICK KING" STEWART

Born August 21, 1916, Columbia, South Carolina. Now resides Jacksonville, Florida.

Wesley Stewart is known as the "Toothpick King" for a very good reason; he bundles toothpicks together and uses them to make everything from sailing ships to tennis rackets (the tennis rackets are close to actual size). For many years Stewart was a messenger for a radio station (now TV Channel 4) in Jacksonville, Florida. One day while he was listening to Ma Perkins, he says, the Lord appeared to him and gave him a specific command: "Buy forty-five boxes of toothpicks and you'll make something of yourself."

Stewart's most famous sculpture is a miniature toothpick piano that he gave to Liberace during his appearance on a Channel 4 program. The piano is carefully crafted and covered with shellac.

COLLECTING TIPS Stewart's pieces are skillfully made and inexpensive. His miniatures are particularly interesting.

WHERE TO SEE ART Wesley Stewart will show you examples of his work at his home. His sculptures can also be seen in the collection of the Carl Van Vechten Gallery of Fine Arts, Fisk University, Nashville, Tennessee (the James Collection).

WHERE TO BUY ART Tom Wells' Weathervane Antiques in Thomson, Georgia, as well as America Oh Yes and Louanne LaRoche, both in Hilton Head, South Carolina, carry the artist's toothpick sculptures.

**84
JIMMY LEE SUDDUTH**

Born March 10, 1910, Caines Ridge, Alabama. Now resides Fayette, Alabama.

Fanciful renditions in mud that are colored with rubbed-on vegetable material such as weeds and berries are the hallmark of Jimmy Lee Sudduth. The residents and buildings of turn-of-the-century Fayette are among his favorite subjects. This artist has a singular imagination, and he lets his fancy run wild; the Fayette courthouse is transformed into a medieval castle, the neighborhood mutt becomes a wild jungle animal, and fish are ferocious scavengers.

Sudduth keeps a galvanized washtub at hand in which he stores his mud, mixed with sugar water. The sweetened water, he explains, makes the mud permanent. However, since fame has come his way (and at the insistence of collectors fearing the impermanence of mud), Sudduth has added house paint to his repertoire.

Jimmy Lee Sudduth may be the founding father of a new tradition to be known as Alabama mud painting. He has taken on an apprentice, Bernard Wright, who works with Sudduth but also does his own independent painting.

COLLECTING TIPS We have owned a heavily built-up mud painting of Sudduth's since the mid-1970s, and the work has remained stable. The early mud paintings are rare, but they are also the most sought after. By the mid-1980s Sudduth was filling orders from collectors and repeating images. These are not as valuable.

While the use of house paint alone does not necessarily diminish the value of his paintings, Sudduth's later works, which are often done in series of similar subjects, are generally not as interesting to collectors. Nevertheless, some of his recent work is noteworthy and fresh.

WHERE TO SEE ART In 1993 Jimmy Lee Sudduth was included in "Passionate Visions of the American South," New Orleans Museum of Art, and "Made In USA" at the Collection de l'Art Brut in Lausanne, Switzerland. Sudduth and his work are featured in a 1994 book on Alabama artists, *Revelations: Alabama's Visionary Folk Artists.*

Sudduth is in the permanent collection of the Fayette Art Museum, Fayette, Alabama, which was the first to exhibit his work. He is also in the collection of the Birmingham Museum of Art, Alabama; the New Orleans Museum of Art; and the Museum of American Folk Art, New York City, as well as others.

WHERE TO BUY ART Although collectors like to buy directly from Jimmy Lee Sudduth, if you are looking for a unique early piece, you are more likely to obtain it from galleries. Most major folk art galleries have Sudduths on hand; we suggest, for example, the Gasperi Gallery in New Orleans; the Robert Cargo Folk Art Gallery in Tuscaloosa, Alabama; and Cotton Belt and Marcia Weber/Art Objects, Inc., in Montgomery, Alabama.

ALFRED "BIG AL" TAPLET

Born July 19, 1934, New Orleans, Louisiana. Now resides New Orleans.

Big Al Taplet paints sparkling signs on used slate shingles as advertisements for his roving bicycle-powered shoe-shine stand. His graffiti-like calligraphy is eye-catching, and, although advertising was what Taplet had in mind, his signs soon became as popular as his shoe shines.

Al Taplet is a cigar-smoking, five-and-a-half-foot-tall huckster. "I named myself 'Big Al,'" he explains, "because it is better for business than 'Little Al.' I love to paint and I love to shine shoes; I'm a happy man." Taplet finds or buys irregular broken roofing slates and paints them, applying glitter and bright colors. His slates usually include pictures of stylized boots, shoes, or sneakers with slogans like "Shoes or Sneakers Any Style" or "Get a Shine on Your Soul." Wherever he sets up his shoe-shine stand, he takes his finished works and hangs them on trees or attaches them to fences.

COLLECTING TIPS Slate is heavy and brittle, and glitter can rub off easily, but selecting a work is generally a matter of personal choice. Taplet is beginning to paint figures and animals, but his shoe art remains the most popular.

WHERE TO SEE ART Big Al usually sets up his shoe-shine stand on Decatur Street in New Orleans. Besides getting a shine, visiting Big Al can be a social occasion—there will often be other collectors standing in line and plenty of friendly banter passes the time.

After complaints from other New Orleans artists who pay the city a fee in order to exhibit and sell their work in Jackson Square, a major tourist site of the city, Taplet stopped selling his art from his shoe-shine stand. He is now represented by Peligro Folk Art on Royal Street in New Orleans and occasionally can be found shining shoes on the patio of the shop.

WILLIE TARVER

Born May 23, 1932, Wadley, Georgia. Now resides Wadley.

Willie Tarver decorated his yard with what he called "foolin's around with cement." His "foolin's around"—statues of blacks, cowboys, and mermaids, and even nursing women, further enlivened with house paint—were soon discovered by museum curators in Savannah and Atlanta. When Tarver learned that others considered him to be an artist, he added small iron-welded sculpture to his repertoire because it was lighter in weight and could be transported to art fairs and the like. Tarver's wife, Mae, is now also making iron sculptures.

Tarver's first cement carving was a gravestone for his brother, who died in 1972. "I could afford no other stone," he explained. When the artist retired from his job as a mechanic in 1993, he took up art as a full-time career.

COLLECTING TIPS Tarver's early concrete sculptures are what serious collectors are looking for—they came out of his unique and imaginative vision of the people around him—but these pieces are hard to ship. His welded work resembles touristlike roadside art; although collectible, it is not his best work.

WHERE TO SEE ART Willie Tarver has been exhibited at Armstrong State College (1994), and at the Telfair Academy of Arts and Sciences (1993), both in Savannah, Georgia.

WHERE TO BUY ART Tarver welcomes visitors and also exhibits at Riverside Walk art fairs in Savannah. Tarver's early cement pieces are carried by Weathervane Antiques in Thomson, Georgia.

85
MOSE TOLLIVER

Born July 4, 1919, near Montgomery, Alabama. Now resides Montgomery.

Mose Tolliver paints flat and colorful images of fantastic animals and exotic figures, some with explicit sexual content. He has become the most widely exhibited and collected of the living black southern folk artists.

Unable to walk without crutches, Tolliver finds standing somewhat difficult and has taught his large family to paint in his style. They bring him their finished work, he signs it "Mose T.," with his characteristic backward *S,* and then he sells it to visitors.

COLLECTING TIPS Family members joined Mose in his art endeavors after about 1982. His children, Johnny, Charles, and Annie Tolliver, work on the paintings, and Victorine Tolliver, wife of Johnny Tolliver, paints most of the recent decorated furniture. A few experts can differentiate between the work of Mose Tolliver and that of family members, but it is often difficult.

A painting completed by the hand of the master, Mose

Tolliver, is worth more than one by a family member. His early paintings (pre-1983) are generally more valuable than the later work, which might be composite family pieces.

WHERE TO SEE ART Mose Tolliver has been included in almost every major museum show of folk art from the Corcoran's "Black Folk Art in America, 1930–1980," in Washington, D.C. (1982) to the New Orleans Museum of Art's "Passionate Visions of the American South" (1993).

Tolliver's paintings appear in the permanent collections of museums with large holdings of folk art; these include the Museum of American Folk Art in New York City, the Milwaukee Art Museum, and the Smithsonian's National Museum of American Art. Other museums with growing collections of work by self-taught artists, such as the Akron Art Museum in Ohio, the African-American Museum in Dallas, and the Birmingham Museum of Art in Alabama, also have paintings by Tolliver.

WHERE TO BUY ART Paintings by Mose Tolliver can be found in Alabama galleries and folk art galleries from coast to coast (for example, Marcia Weber/Art Objects, Inc. and the Anton Haardt Gallery, both in Montgomery, Alabama; Robert Cargo Folk Art Gallery, Tuscaloosa, Alabama; American Primitive and Epstein/Powell in New York City; and MIA Gallery in Seattle, Washington).

8 6
A N N I E
T O L L I V E R

Born March 20, 1950, Montgomery, Alabama. Now resides Montgomery.

A talented artist, Annie Tolliver is the first member of the family of the famous folk artist Mose Tolliver to, as she puts it, "strike out on my own" and sign her paintings (1990). Her work is amusing, colorful, and decorative; it is also, unfortunately, quite reminiscent of her father's. "At first, I tried to draw just like him [Mose], but I couldn't do it," she explains. "Mine's got more bodies and I do the details better. Most of my painting is from my family, about my family, and when I was coming up."

For many years Mose Tolliver's children and even his in-laws have been painting in his style and allowing the patriarch to sign their work with his well-known signature, "Mose [with a backward S] T." Recently, however, Johnny and Charlie Tolliver, Mose's sons, have also begun to sign their own work.

COLLECTING TIPS We had high hopes that Annie Tolliver would create a distinct style of her own, but this has not happened to date. After Mose Tolliver achieved his meteoric success in the Corcoran exhibition in Washington, D.C., "Black Folk Art in America, 1930–1980" (1982), "I started painting for him," Annie Tolliver admits. Some collectors will want to reevaluate their collections; others won't care, because family enterprise falls within the traditional definition of folk art.

WHERE TO SEE ART Annie Tolliver has been included in "New Outsiders," Southeastern Center for Contemporary Art, Winston-Salem, North

Carolina (1992), and "Outsider Artists in Alabama," Alabama State Council on the Arts, Montgomery (1991).

WHERE TO BUY ART Annie Tolliver's paintings are handled by the Cotton Belt Gallery, the Anton Haardt Gallery, and Marcia Weber/Art Objects, Inc., all in Montgomery, Alabama; the Lucky Street Gallery in Key West, Florida; and Barrister's Gallery in New Orleans; they might also appear almost anywhere southern folk art is sold.

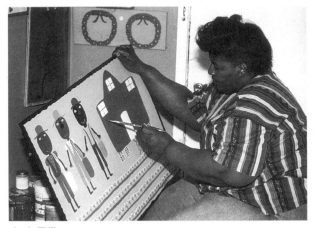

Annie Tolliver

87

BILL TRAYLOR

Born April 12, 1856, near Benton, Alabama. Died October 23, 1949, Montgomery, Alabama.

Through his stark and simple drawings on whatever paper was at hand, Bill Traylor spun yarns about plantation life, street life, and the black experience in the South; he also drew familiar farm and domestic animals. Traylor could not draw three-dimensionally, so he developed devices, such as a two-eyed profile, that he sometimes used to give a sense of depth.

Traylor was born into slavery, and when emancipated, chose to stay and work on the plantation where he grew up. When he was eighty-four, he moved to Montgomery, but illness soon prevented him from working; he then spent his days sitting on a box near the street in downtown Montgomery and making his imaginative narrative drawings of the life around him and his remembrances of days gone by.

Today Bill Traylor is recognized as one of the most important black artists of this century, and his reputation is equal to that of such artists as Horace Pippin (1988–1946).

COLLECTING TIPS Traylor's imaginative narrative drawings are a significant contribution to the art of this century, and his work should be included in every serious collection. The price for his work varies depending on condition, size, and image, but the best that budget permits should be obtained.

WHERE TO SEE ART Although Traylor had a one-person exhibit in Montgomery many years earlier, his work first attracted widespread public

attention in the landmark Corcoran exhibition, "Black Folk Art' in America, 1930–1980," in Washington, D.C. (1982). Since then, Traylor has been widely exhibited in the United States and abroad.

Traylor's work is in the permanent collections of many museums, including the Abby Aldrich Rockefeller Folk Art Center, Williamsburg, Virginia; the High Museum of Art, Atlanta; the Menil Collection, Houston; the Milwaukee Art Museum; the Montgomery Museum of Fine Arts, Montgomery, Alabama; and the Newark Museum, Newark, New Jersey.

A monograph on Traylor, *Bill Traylor: His Art—His Life*, includes many of his drawings.

WHERE TO BUY ART A number of galleries will occasionally have one of Traylor's drawings, but his principal representatives include the Janet Fleisher Gallery, Philadelphia; the Carl Hammer Gallery, Chicago; and the Luise Ross Gallery and Ricco/Maresca in New York City.

8 8
ANNIE G.
WELLBORN

Born May 22, 1927,
Lexington, Georgia.
Now resides Bishop, Georgia.

Annie Wellborn is a woman of legend. She has the vision to see a terrifying red ball of fire descending on the home of a loved one, and this vision portends an imminent death. Twenty times this dreaded apparition has appeared to her, and twenty times she has lost loved ones within days of its sighting. Other family members have been with her when the ball of fire has appeared and attest to its authenticity; however, no family member has seen the ball of fire except when Wellborn is present. Wellborn's paintings of "the red ball of fire" document her visions; she prints the legend and date of each visitation on the surface of her paintings.

"I never had a wedding band, nor a silver spoon, but I was a good wife and mother," she relates. "The angels float over my head—flutter their wings—and wake me up at night to tell me what to paint. They [the angels] left me here to paint the truth about the red ball of fire. It's a blessing [the red ball] because it prepares me for the death."

COLLECTING TIPS Wellborn prints her signature, "Annie Wellborn," on the bottom right-hand corner of each picture. We have singled Wellborn out for her unusual "ball of fire" paintings because we believe that the artists' visions and their lives are an important part of their work; however, this artist is also known for her memory paintings, which some collectors find interesting and which are included in several museum collections.

WHERE TO SEE ART Wellborn's work is in the permanent collections of the New York State Historical Association, Cooperstown, and the University of Georgia, Athens.

WHERE TO BUY ART Annie Wellborn is represented by Archer-Locke in Atlanta and the Timpson Creek Gallery in Clayton, Georgia.

*Born September 14, 1923, rural
Cherokee County, Alabama.
Now resides Centre, Alabama.*

Myrtice West began a series of visionary paintings based on the Book of Revelations when her beloved daughter, Martha Jane, followed her abusive husband to Japan and West feared her daughter and grandchildren would never return. The family did return, but Martha Jane was later murdered by her husband. "I saw Revelations in flashes," West explains. "It was the hand of God that directed me to put it down." Since she did this series of fourteen paintings (completed in late 1984 or early 1985, about seven years after she started them), West has gone on to paint other books of the Bible, including Ezekiel and Daniel; her painted stories are told in subtle colors that suggest an early-morning dream.

Although West is a student of the Bible, her paintings are much more than literal translations of biblical stories. She often depicts biblical events as though they were occurring simultaneously, giving her work a somewhat surreal quality.

COLLECTING TIPS West's visionary paintings have taken the folk art market by storm, and the paintings started after her daughter left for Japan are her signature works. The artist's pre-1977 endeavors—painted gourds, cutout angels, and genre paintings—had a local market, but they are unexceptional. West has copied some of her Revelations series—she originally intended to keep the originals and sell the copies—but the copies generally have less value than the fourteen original paintings. West still makes gourds and cutout angels from time to time, but her visionary works are the reason for her fame.

WHERE TO SEE ART Myrtice West's work was included in "Outsider Artists in Alabama," Alabama State Council on the Arts, Montgomery (1991).

West's Revelations series is the subject of a book in process by Mustang Publishing. Her work is also illustrated in Kathy Kemp's *Revelations: Alabama's Visionary Folk Artists* (1994).

WHERE TO BUY ART Myrtice West's visionary paintings and other works may be purchased directly from the artist. She is also represented by Marcia Weber/Art Objects, Inc. in Montgomery, Alabama. West's work is also offered for sale at art fairs in New York and Atlanta.

*Born February 20, 1908,
Natchez, Mississippi. Now resides
New Orleans, Louisiana.*

Willie White sees life on earth "as it were seven million years ago. There weren't no people," he explains, "so I don't paint people—just dinosaurs." Using permanent markers and pens on posterboard, White draws the earth, with strange animals, moons, and suns, sometimes in dark and ominous tones, almost as though he were also predicting its destruction by fire.

White looks at images on television and filters them through his mind. He learned to draw from a sign painter who often frequented a bar where White was working. The sign painter made large, bold images so that they would be recognizable

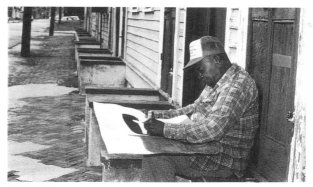

Willie White

from a distance, and that gave White the idea of hanging his art on his porch to attract passersby.

COLLECTING TIPS White's depictions of strange worlds inhabited by prehistoric animals, fantastic birds, and sometimes even 1920s-type airplanes are his best work. His recent work and his paintings of fruit such as watermelons and cherries are not as strong.

White's work is not always signed, but once seen, it is quite recognizable. White's signature is upside down on all his work.

WHERE TO SEE ART White has been ill in recent years, but on nice days he may still be found drawing on the stoop in front of his house in New Orleans. His work was in "Passionate Visions of the American South," New Orleans Museum of Art (1993), as well as in earlier Louisiana shows, including a 1991 exhibition at the Louisiana Arts and Science Center in Baton Rouge.

WHERE TO BUY ART Most galleries in Louisiana—such as Gilley's in Baton Rouge and the Barrister's and Gasperi galleries in New Orleans—carry drawings by White. The American Primitive Gallery in New York City carries some of his early drawings.

91 CHUCK "ARTIST CHUCKIE" WILLIAMS

Born June 12, 1957, Shreveport, Louisiana. Now resides Shreveport.

Chuck Williams, who refers to himself as "Artist Chuckie," captures the color, motion, and vibrancy of rock music videos in his paintings. "I don't go to movies—make my own in my head—I'm too busy doing the artistic stuff," he explains. Williams casts celebrities such as Michael Jackson, Natalie Cole, and Ray Charles in the movies in his mind and then paints the performances on board, paper, or cardboard. These paintings, sometimes covered with glitter, fill his small frame house from wall to wall and spill out to the porch and yard.

Williams is personally influenced by the stars he imagines in his "movies"—he has taken on a bit of the persona of Michael Jackson, wearing dark glasses and braided hair with glitter in it.

COLLECTING TIPS Size makes very little difference in Williams's work; the small paintings are as important as the large ones, which can range

upward to six feet in height. In fact, in many instances his recent small works are stronger than the larger paintings. The material used by Williams is often old and imperfect, but to date there have been no conservation problems.

Williams signs his paintings "Artist Chuckie."

WHERE TO SEE ART Williams's work was exhibited in "It'll Come True" at the Artists' Alliance, Lafayette, Louisiana, an exhibition that also traveled to the Contemporary Arts Center in New Orleans (1992). He is widely collected, and most collections of contemporary southern folk art include paintings by Artist Chuckie.

WHERE TO BUY ART Williams welcomes collectors and sells from his home. Pickers and dealers also travel to Shreveport and compete for the paintings by this prolific artist; these works then turn up in galleries all over the country, including Gilley's Gallery in Baton Rouge, Louisiana, and Marcia Weber/Art Objects, Inc., and Anton Haardt Gallery, both in Montgomery, Alabama.

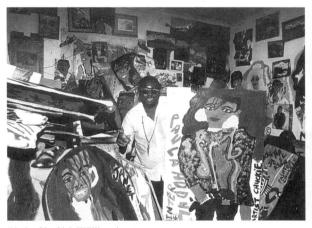

"Artist Chuckie" (Williams)

9 2
PURVIS YOUNG

Born February 4, 1943,
Liberty City, Miami.
Resides Overtown, Miami.

Purvis Young has seen it all—the inside of a jail, the riots that raged through Overtown, the drug culture—and he paints it as he sees and feels it. Young is a black visionary "street" artist who paints "peoples who are knocking each other trying to get over the blue eye." A cherubic blue-eyed "angel face" (which represents the white establishment) watching over a mean street is one of the symbols that Young uses in his work; others include a silhouetted black horse and a pregnant African woman who appears to be engaged in a ritual dance. In his paintings, heads and faces that rise above the crowd stand for the "good people" and "angels."

Young uses very little color to get his message across—black is predominant. He often paints on flat boards that he finds in the street; splinters, nails, and other defects are left untouched. Young does most of his painting on a strip of road beneath the Interstate overpass in Overtown.

COLLECTING TIPS	The artist's large paintings, which are very powerful, are considered his best work; they are also easier to display than the books. Both types of work, however, are interesting.

COLLECTING TIPS The artist's large paintings, which are very powerful, are considered his best work; they are also easier to display than the books. Both types of work, however, are interesting.

Young's paintings are filled with angst, and collectors who have trained their eyes on the work of contemporary German expressionists, for example, will relate strongly to them. Others fear Young may be a passing fad and are frightened off by the public relations hyperbole that has accompanied his rapid rise to national attention.

WHERE TO SEE ART Purvis Young's work was shown by the Miami Museum of Modern Art in the 1970s, but he first gained national attention in 1987 when he was included in "A Separate Reality: Florida Eccentrics," Museum of Art, Fort Lauderdale, Florida. Since that time he has been included in numerous museum exhibitions and gallery shows in this country and abroad. Young's work is in many public collections, such as the Newark Museum, Newark, New Jersey; the New Orleans Museum of Art; the Studio Museum of Harlem, New York City; and the University of Miami.

WHERE TO BUY ART The artist is represented by the Janet Fleisher Gallery in Philadelphia, and his work is also available from the Joy Moos Gallery, Miami; the Ann Nathan Gallery, Chicago; and Ricco/Maresca, New York City.

S

M *museum* G *gallery* O *other*
denotes profiled artists

MUSEUM AND GALLERY GUIDE

ALABAMA

Birmingham Museum of Art M
2000 8th Avenue North
Birmingham, AL 35203
(205) 254-2565 or 2566

The Birmingham Museum is in the process of establishing a major folk art collection. The museum presently owns work by such artists as Lonnie Holley, Sister Gertrude Morgan*, Jimmy Lee Sudduth*, and Clementine Hunter*. A large exhibition of contemporary self-taught art is scheduled for 1996.

Fayette Art Museum M
530 North Temple Avenue
Fayette, AL 35555
(205) 932-8727

The Fayette Museum has works by three Fayette natives: Jimmy Lee Sudduth*, Benjamin F. Perkins, and Fred Webster. In addition, the collection includes the late Sybil Gibson, an artist who formerly lived in neighboring Walker County.

Mobile Museum of Art M
4850 Museum Drive
Langan Park
(P.O. Box 8426)
Mobile, AL 36689
(205) 343-2667

The Mobile Museum, formerly the Fine Arts Museum of the South, has most of the known works by Robert Marino, several of which are usually on display. The museum has a few other pieces of folk art, including several works by Mose Tolliver* and a face jug by Lanier Meaders. It has organized exhibitions such as "Enisled Visions: The Southern Non-Traditional Folk Artist." In 1994 the museum showed "Southern Outsider, Visionary and Folk Art from the Collection of Dr. J. Everette James, Jr." In the catalog for that show the museum expressed its commitment to exhibiting this type of work.

Montgomery Museum of Fine Arts M
1 Museum Drive
Montgomery, AL 36123
(334) 244-5700

Housed in an attractive new building in Wynton M. Blount Cultural Park, the Montgomery Museum has a small but growing collection of folk art. Although the collection is not large, visitors will usually find works by Bill Traylor* and Mose Tolliver* on display.

Cotton Belt G
225 South Decatur Street
Montgomery, AL 36104
(334) 834-5544

Cotton Belt emphasizes Alabama folk and outsider art. The gallery handles more than twenty artists on a regular basis; Bernice Sims and Fred Webster are particular favorites, and a number of their works are available there. Among the other artists regularly shown are Charlie Lucas*, Benjamin F. Perkins, Mose* and Annie Tolliver*, Thornton Dial*, R. A. Miller*, and Juanita Rogers. Open by appointment.

Anton Haardt Gallery G
1220 South Hull Street
Montgomery, AL 36104
(334) 263-5494

Long known for its representation of such artists as Juanita Rogers and Mose Tolliver*, the Anton Haardt Gallery has an impressive selection of folk art by many other artists as well; David Butler*, Thornton Dial*, Minnie Evans*, Charlie Lucas*, Annie Tolliver*, and "Artist Chuckie" Williams* are examples. Although Anton Haardt spends part of her time at her New Orleans annex (see page 188), the gallery remains open throughout the year.

Marcia Weber/ Art Objects, Inc. G
3218 Lexington Road
Montgomery, AL 36106
(334) 262-5349

Marcia Weber is considered an expert on works by Mose Tolliver* and other Tolliver family members. The gallery has a selection by Mose*, Annie*, and Charlie Tolliver, Anne and Charlie Lucas*, Woodie Long, and others, and it is one of the few galleries showing paintings by Myrtice West*. A particularly good source for Alabama self-taught art.

Kentuck Museum M
503 Main Avenue
Northport, AL 35476
(205) 758-1257

The Kentuck Museum, now in a new location, has changing exhibitions of folk art. Each October, the museum sponsors a festival.

Robert Cargo Folk Art Gallery G
2314 6th Street
Tuscaloosa, AL 35401
(205) 758-8884

A gallery with an extensive collection of folk art, Robert Cargo has pieces on hand by about seventy artists. It has carefully selected works by such artists as Burgess Dulaney*, Joseph Hardin, Jimmy Lee Sudduth*, and "Son Ford" Thomas. Other gallery artists include Sybil Gibson, M. C. "5¢" Jones*, Roger Rice*, Charley* and Hazel Kinney*, and Sulton Rogers*. The gallery also carries antique quilts and a large group of contemporary African-American quilts and Haitian voodoo flags. Open weekends and by appointment.

ARKANSAS

Arkansas Arts Center M
MacArthur Park
(P.O. Box 2137)
Little Rock, AR 72202
(501) 372-4000

The Arkansas Arts Center has a surprisingly extensive collection, including many works on paper. Bill Traylor*, Inez Nathaniel Walker*, Lee Godie*, Ted Gordon*, and Eddie Lee Kendrick* are among the artists in the center's collection.

Leslie J. Neumann G
P.O. Box 61
Aripeka, FL 34679
(904) 686-2422

Leslie J. Neumann represents Florida artist "Mr. B." Other gallery artists are Jerry Coker*, Lonnie Holley, and Jimmy Lee Sudduth*. Open by appointment.

East Martello Gallery and Museum M
Key West Art and Historical Society
3501 South Roosevelt
Key West, FL 33040
(305) 296-1702

The East Martello Gallery and Museum has a large collection of works by Florida artist Mario Sanchez, many of which are usually on display. The historical society has also acquired a number of scrap metal pieces from the environment of Stanley Papio; they are also on display.

Lucky Street Gallery G
919 Duval Street
Key West, FL 33040
(305) 294-3973

The only gallery in Key West regularly showing self-taught artists, Lucky Street usually has pieces by Mose* and Annie Tolliver*, R. A. Miller*, Homer Green*, Jake McCord, and Jimmy Lee Sudduth*. It also has older Finster* cutouts and paintings.

Lowe Art Museum M
University of Miami
1301 Stanford Drive
Coral Gables, FL 33124
(305) 284-3535

Known for its large collection of traditional American Indian art, the Lowe also has some later works—pottery by Maria Martinez and a totem pole by Calvin Hunt, for example.

Joy Moos Gallery G
355 NE 59th Terrace
Miami, FL 33137
(305) 754-9373

The Joy Moos Gallery features twentieth-century self-taught artists, including an in-depth selection of work by Jamie Nathenson*, Gene Beecher, Sybil Gibson, Purvis Young*, and others.

Vanity Novelty Garden G
919 4th Street
Miami Beach, FL 33139
(305) 534-6115

A fun gallery to visit, Vanity Novelty Garden has hats by Joseph Abrams and rugs by blind artist William Eaglin. The gallery also has works by Brian Dowdall*, Eric Holmes, and Purvis Young*.

Zak Gallery G
P.O. Box 546662
Surfside, FL 33154
(305) 866-8200

The gallery lists a number of American folk artists, among them Minnie* and Garland Adkins*, Michael Finster*, S. L. Jones*, Mose* and Annie Tolliver*. The gallery also carries works by self-taught artists from England, Russia, and Brazil. Open by appointment.

Tyson Trading Company G
P.O. Box 369
Micanopy, FL 32667
(904) 466-3410

Located just south of Gainesville in a town with numerous antique stores, Tyson Trading Company handles work by several self-taught artists in addition to an assortment of American Indian objects and antiques. Tyson represents Jesse Aaron, Jerry Coker*, Brian Dowdall*, Alyne Harris, and Mr. Eddy (Mumma)*. Open by appointment only.

Wanda's Quilts G
P.O. Box 1764
Oldsmar, FL 34677
(813) 855-1521

Wanda's Quilts in Oldsmar represents "The Beaver" (Robyn Beverland).

Shelton Gallery G
323 Worth Avenue
Palm Beach, FL 33480
(407) 832-8874

Nashville dealer Bruce Shelton has recently opened a gallery in Palm Beach. The artists represented in Florida are the same as those handled in Tennessee (see page 115).

Florida State University Museum of Fine Arts M
Copeland and West Call Streets
Fine Arts Building
Tallahassee, FL 32306
(904) 644-6836

Although it does not at present have a collection of folk art, Florida State University is interested in the material, an interest expressed through folk art exhibitions such as "Unsigned, Unsung" (1993) and inclusion of contemporary folk art together with fine art in changing exhibitions.

Rena Minar G
Tallahassee, FL
(904) 997-4100

Rena Minar was formerly the proprietor of a Houston gallery specializing in southwestern folk art. As a private dealer, she will carry southwest and Texas artists as well as self-taught artists from the southeast. Open by appointment.

Tampa Museum of Art M
600 North Ashley Drive
Tampa, FL 33602
(813) 274-8130

The Tampa Museum frequently has exhibitions of folk art. In 1995, it featured the traveling exhibition, "Driven to Create." Check scheduling if you are in the area.

GEORGIA

High Museum of Art M
1280 Peachtree Street, NE
Atlanta, GA 30309
(404) 733-4200

A museum very active in the field of contemporary folk art, the High and its new branch in the Georgia-Pacific Center, the High Museum of Art, Folk Art and Photography Galleries (30 John Wesley Dobbs Avenue), have a large permanent collection that includes Vernon Burwell, Sam Doyle*, Thornton Dial*, Minnie Evans*, Howard Finster*, Nellie Mae Rowe*, Bill Traylor*, Lizzie Wilkerson, and a number of others. Increasingly, the museum is a venue for folk art exhibitions. The 1995 exhibition "Discovering Ellis Ruley*," for example, opened at the High Museum. Look for great things to come from the High and its new satellite.

Archer-Locke Gallery G
3157 Peachtree Road
Atlanta, GA 30625
(404) 623-8477

The well-known dealer Charles Locke opened an art gallery with former curator Barbara Archer in late 1995. The gallery has a large selection of paintings by Jimmy Lee Sudduth*, as well as works by Alpha Andrews*, Charley Kinney*, Willie Massey, Nellie Mae Rowe*, Annie Wellborn*, Ab the Flagman, and others. An important addition to the field.

Berman Gallery G
3261 Roswell Road, NE
Atlanta, GA 30305
(404) 261-3858

Potter Rick Berman opened his gallery in 1981, in the days when work by artists like Howard Finster* and Nellie Mae Rowe* was readily available. Today, the Berman Gallery handles a variety of people, such as Thornton Dial*, Sam Doyle*, J. B. Murry, Willie Massie, and Nellie Mae Rowe*.

Jane Connell Gallery ◩
333 Buckhead Avenue
Atlanta, GA 30305
(404) 261-1712

The Connell Gallery has all the works of Eddie Owens Martin (St. EOM) that have been released for sale. The remainder are at Pasaquan (see below) or at the Columbus Museum in Columbus, Georgia (see page 186).

Judith Alexander ◩
3060 Pharr Court
Atlanta, GA 30305

Judith Alexander befriended Nellie Mae Rowe* and collected her drawings. She now sells Rowe's work as well as work by other artists, including Linda Anderson* and Mose Tolliver's* early paintings.

Knoke Galleries of Atlanta ◩
5325 Roswell Road, NE
Atlanta, GA 30342
(404) 252-0485

Established in 1973, the Knoke Galleries feature works by contemporary southern folk artists and traditional southern folk potters. The gallery list exceeds forty; Steve Ashby*, Rudy Bostic*, Howard Finster*, Lanier Meaders, Ned Cartledge, Nellie Mae Rowe*, O. L. Samuels*, and Hubert Walters* are among those represented by Knoke. A good place to find contemporary self-taught art.

Modern Primitive Gallery ◩
1402-4 North Highland Avenue
Atlanta, GA 30306
(404) 892-0556

Modern Primitive advertises "the finest from the self-taught South." The gallery has a considerable variety of works on hand; Archie Byron*, Bruce Burris, Minnie Evans*, Lorenzo Scott*, O. L. Samuels*, Terry Turrell*, Purvis Young*, and about twenty others are regularly represented by Modern Primitive. An up-and-coming contemporary folk art gallery.

Robert Reeves American Art ◩
1656 Executive Park Lane
Atlanta, GA 30329
(404) 634-9791

Robert Reeves has paintings and sculptures by such well-known artists as Raymond Coins*, Sam Doyle*, and Howard Finster*. He also has works by Herman Bridgers and others. Reeves is particularly interested in African-American material. Open by appointment only.

Spotted Cow ◩
1411 Monte Sano Avenue
Augusta, GA 30904
(706) 736-7622

The Spotted Cow shows folk art from time to time and usually has paintings on hand by Augusta artist Evelyn Gibson*.

The Land of Pasaquan ◎
Buena Vista, GA
(912) 649-2842

The environment of Eddie Owens Martin (St. EOM), just outside Buena Vista, has been preserved. The brightly-colored temples and pagodas, as well as Martin's paintings, are being maintained by the Marion County Historic Society. The grounds have been open for some time; the house, which has been undergoing restoration, opened in 1995 and may be visited on weekends or by special arrangement at other times.

Main Street Gallery ◩
P.O. Box 30525
Clayton, GA 30525
(706) 782-2440

One of two galleries located in the north Georgia town of Clayton, Main Street numbers over twenty artists on its regular gallery list. It carries works by Rudy Bostic*, James Harold Jennings, Charlie Lucas*, O. L. Samuels*, and others.

Timpson Creek Gallery G
Route 2
(P.O. Box 2117)
Clayton, GA 30525
(706) 782-5164

Timpson Creek handles about twenty artists on a regular basis. Many are from the South—Linda Anderson*, Cyril* and Ivy Billiot, Robert Roberg*, Roy Minshew, and (a gallery find) Indian Joe Williams. In addition, there are works by Kentucky artist Helen La France and Navajo artists Delbert Buck* and Mamie Deschillie*. An interesting selection.

Rosehips G
1611 Highway 129 South
Cleveland, GA 30528
(706) 865-6345

Rosehips Gallery is only a few miles from Lanier Meader's home. The gallery has pottery by Lanier and the Meaders family, Michael* and Melvin Crocker*, Marie Rogers, Burlon (B. B.) Craig, and the Hewell family. It also has folk art by James Harold Jennings, R. A. Miller*, Annie Wellborn*, and Leroy Almon.

Columbus Museum M
1251 Wynnton Road
Columbus, GA 31906
(706) 649-0713

The Columbus Museum has a small collection of twentieth-century folk art. Among the artists represented are Eddie Owens Martin (St. EOM), Minnie Evans*, and Thomas Jefferson Flanagan. A 1996 folk exhibition is planned: "In Our Own Backyard: Folk Art and Traditional Expressions from the Chattahoochee Valley" (artists from west Georgia and east Alabama).

John Denton G
102 North Main Street
Hiawasse, GA 30546
(706) 896-4863

Hundreds of Howard Finster* pieces have gone through the hands of collector-dealer John Denton, and he still has some Finsters around. He also has works by J. B. Murry, Nellie Mae Rowe*, and several other artists.

Crocker Pottery G
P.O. Box 505
Lula, GA 30554
(404) 869-3160

Visitors are welcome at the Crocker Pottery. Michael* and Melvin Crocker* make innovative pottery—face jugs, snake jugs, and Indian Princess jugs—some in small limited editions. The Pottery Shop also carries some utilitarian wares, plates, and other objects. All pieces are hand-made. Worth a detour.

Harriet Tubman Museum M
340 Walnut Street
(P.O. Box 6671)
Macon, GA 31208
(912) 743-8544

The Harriet Tubman Museum has had one-person exhibitions for contemporary folk artists such as O. L. Samuels* and Jimmy Lee Sudduth*. It also has a permanent collection that includes those artists and others. The museum hopes to expand its quarters in the next several years.

King-Tisdell Cottage Foundation (Beech Institute) M
502 East Harris Street
Savannah, GA 31401
(912) 234-8000

The King-Tisdell Cottage Foundation has 234 works by Ulysses Davis, an artist known for his carvings of busts of the Presidents, who was included in the Corcoran's 1982 "Black Folk Art" show. At present, his works are displayed on a rotating basis. By 1996, however, the Foundation hopes to have all of the Davis pieces on display. Open afternoons, Tuesday–Saturday.

Weathervane Antiques G
324 Main Street
Thomson, GA 30824
(706) 595-1998

At Weathervane Antiques you can find almost anything, including contemporary folk art. Z. B. Armstrong, Wesley Stewart*, Evelyn Gibson*, Sylvanus Hudson*, Willie Tarver*, and Ernest Lee are among the artists whose work is usually available through this gallery.

Gilley's Gallery 🅖
8750 Florida Boulevard
Baton Rouge, LA 70815
(504) 922-9225

Gilley's Gallery specializes in southern and Louisiana folk art. There you can find wonderful pieces by artists like Clementine Hunter*, Sister Gertrude Morgan*, David Butler*, and Jimmy Lee Sudduth*. Gilley's also handles artists who are not as well known, for example, the "Rhinestone Cowboy" (Bowlin)*, "Artist Chuckie" Williams*, M. C. "5¢" Jones*, and Woodie Long. The works on hand are generally of high quality.

University Art Museum 🅜
University of
Southwestern Louisiana
101 Girard Park Drive
Lafayette, LA 70504
(318) 482-5326

The University Art Museum schedules changing exhibitions on a regular basis. For that reason, its substantial permanent collection of folk art is not always on display. The collection includes such artists as Cyril Billiot*, David Butler*, Roy Ferdinand*, M. C. "5¢" Jones*, Welmon Sharlhorne*, Herbert Singleton*, and "Artist Chuckie" Williams*.

Debbie and Mike Luster 🅞
1800 Riverside Drive
Monroe, LA 71203

Photographers and private dealers, the Lusters have a considerable body of work by John Stoss*.

**New Orleans
Museum of Art** 🅜
City Park
(P.O. Box 19123)
New Orleans, LA 70179-0123
(504) 488-2631

The New Orleans Museum has a folk art collection that includes nineteenth- and twentieth-century works. Its twentieth-century collection has expanded rapidly in the last several years, and more than fifty contemporary folk artists are represented; among them are Sister Gertrude Morgan*, Clementine Hunter*, Charles W. Hutson, David Butler*, Jimmy Lee Sudduth*, Sainte-James Boudrôt (A. J. Boudreaux)*, Sybil Gibson, Howard Finster*, Herbert Singleton*, Philo "Chief" Willey, Willie White*, and Purvis Young*. The museum also has sponsored major folk art shows, such as "Passionate Visions of the American South," a traveling exhibition organized by the museum that opened in New Orleans in 1993.

Barrister's Gallery 🅖
526 Royal Street
New Orleans, LA 70130
(504) 525-2767

A New Orleans gallery with a broad selection of folk art, as well as tribal art, Barrister's has become well known to collectors as the exclusive representative of carver Herbert Singleton*. The gallery has an in-depth selection of works by Louisiana artists Roy Ferdinand, Jr.*, Reggie Mitchell*, and, of course, Sainte-James Boudrôt (A. J. Boudreaux)*. The gallery also carries, among others, Henry Speller. It is a meeting place for collectors.

Gasperi Gallery 🅖
1808 North Rampart Street
New Orleans, LA 70116
(504) 943-8656

Gasperi Gallery is now open at a new location on North Rampart Street. Gasperi has works by many important southern artists—David Butler*, Clementine Hunter*, Sister Gertrude Morgan*, and O. W. "Pappy" Kitchens, among them.

Anton Haardt Gallery (annex) G
2714 Coliseum Street
New Orleans, LA 70130
(504) 897-1172

Known for her in-depth representation of artists like Mose Tolliver*, Anton Haardt has opened an annex in New Orleans. In addition to the artists carried in her gallery in Montgomery, Alabama (see page 182), the New Orleans gallery also features several Louisiana artists, including "Big Al" Taplet* and Willie White*.

House of Blues G
225 Decatur Street
New Orleans, LA 70130
(504) 529-2583

The House of Blues, which opened in 1994, is a restaurant featuring mostly blues-based music. The walls are covered with contemporary folk art, most of which is not for sale but on permanent display. Artists Jimmie Lee Sudduth*, R. A. Miller*, B. F. Perkins, Mose Tolliver*, and Herbert Singleton* are among those whose works can be found in the restaurant. There are similar restaurants—all of which display folk art—in Cambridge, Massachusetts (the original House of Blues, see page 65), and in Los Angeles (see page 300). Additional restaurants are planned for New York, Orlando, and Chicago.

Peligro Folk Art G
900 Royal Street
New Orleans, LA 70116
(504) 581-1706

Peligro Folk Art, located in the French Quarter, has "Big Al" Taplet's* slates on a regular basis. The gallery represents Jimmy Lee Sudduth*, Mose Tolliver*, and others.

Trade Folk Art G
828 Chartes Street
New Orleans, LA 70116
(504) 596-6827

Trade Folk Art handles both American and Mexican folk art. Among the contemporary American artists represented are Jessie Mitchell, R. A. Miller*, Mose Tolliver*, and Willie White*. The gallery also carries face jugs by various potters, including Michael* and Melvin Crocker* of Georgia.

Meadows Museum of Art M
Centenary College
P.O. Box 41188
Shreveport, LA 71134-1188
(318) 869-5169

Shreveport's Centenary College has paintings and sculptures by folk artists in its permanent collection. Among those represented are Clementine Hunter*, M. C. "5¢" Jones*, and Doris Parse-Sroka. The museum usually has some folk art on display.

Southern Tangent Gallery G
6482 Highway 22
(Highway 22 at Highway 70)
Sorrento, LA 70778
(504) 675-6815

Southern Tangent Gallery, located in The Cajun Village just off I-10 between New Orleans and Baton Rouge, represents 160 artists. As owner Linda Black explains, "We opened the gallery to provide a vehicle for the self-taught artist who is not readily invited to show in urban or fine arts galleries." Alvin Batiste, Joan Bridges, and Tony Ellison are a few of the artists who show at Southern Tangent.

MISSISSIPPI

Mississippi Department of Archives and History M
State Historical Museum
P.O. Box 571
Jackson, MS 39205-0571
(601) 359-6920

The museum has a large collection of objects by Mississippi folk artists, many of which are anonymous. There are, however, quite a few contemporary works, including seventeen "Son Ford" Thomas sculptures, twenty-six Sulton Rogers* carvings, a number of Luster Willis canes and paintings, paintings by Mary T. Smith*, wood carvings by George Williams, Burgess Dulaney* sculptures, and collages by the "Rhinestone Cowboy" (Bowlin)*. The museum's quilt collec-

tion is also very extensive. Although some folk art is included in temporary exhibitions, an appointment with the curator is suggested in order to view specific objects in the collection.

University Museums Ⓜ
University of Mississippi
University (Oxford), MS 38677
(601) 232-7073

The University Museums in Oxford have a good-sized collection of works by self-taught artists. Of particular note, artist Theora Hamblett willed her house and artwork to the museums (over 300 oil paintings and other pieces). Sulton Rogers*, Luster Willis, Howard Finster*, Willie Massey, Jimmy Lee Sudduth*, and Mary T. Smith* are among the other artists in the collection. Several quilters—Pecolia Warner and Minnie Watson, for example—are also included. The University collects Caribbean as well as American folk art.

Southside Gallery Ⓖ
150 Courthouse Square
Oxford, MS 38655
(601) 234-9090

A gallery that frequently exhibits folk art, Southside carries Mississippi artists such as Sulton Rogers*, Sarah Mary Taylor (drawings), and Burgess Dulaney*, as well as lesser-known artists from the state. It also has on hand works by self-taught artists Sam McMillan*, Mose Tolliver*, and Willie White*, among others.

SOUTH CAROLINA

Erich Christopher and Dorn Gallery Ⓖ
428 King Street
Charleston, SC 29403
(803) 722-3845

Opened in 1994 Erich Christopher and Dorn Gallery has work by Howard Finster*, Mose Tolliver*, and the Catfish Man (Michael Suter).

America Oh Yes Ⓖ
4 Towne Center
(P.O. Box 3075)
Hilton Head, SC 29928
(803) 785-7100

Among the forty or more artists to be found at America Oh Yes are established artists like Sam Doyle*, Clementine Hunter*, Gerald Hawkes, Bessie Harvey*, and the Finster family*, along with emerging artists like Mark Casey Milestone*, Brian Dowdall*, and M. C. "5¢" Jones*. The list also includes other artists, such as Jake McCord and Wesley Stewart*. America Oh Yes also has a space on Saint Helena Island, the Rising Star, next to Red Piano Too.

Louanne LaRoche Ⓖ
51 Pineview Road
Bluffton, SC 29910
(803) 757-5826

Louanne LaRoche (formerly Red Piano Gallery) is now a private dealer; the gallery has been sold and will no longer handle folk art. LaRoche has collected the works of Sam Doyle* in depth; she is one of the best sources for the work of this artist. Another artist represented by a large selection is Z. B. Armstrong, and LaRoche carries work by Jimmy Lee Sudduth* as well.

Red Piano Too Art Gallery Ⓖ
751 Sea Island Parkway
Saint Helena Island, SC 29920
(803) 838-2241

Not far from where Sam Doyle* lived is Red Piano Too Art Gallery, which, in fact, has a few pieces by that artist, as well as a number of others—Roy Finster*, Allen Wilson*, Robyn Beverland, and R. A. Miller*. Between the two galleries on Saint Helena, Red Piano Too and Rising Star (see entry for America Oh Yes in Hilton Head), the selection of folk art is wide-ranging.

THE MIDWEST

AT HEART IT SEEMS WE ARE STILL MIDWESTERNERS. For us the big city has always been Chicago, and it was in Chicago that we discovered art and began collecting. In 1959 the Art Institute of Chicago had a show of Spanish art; we loved it and went to Spain looking for the artists, and it's been like that ever since. It has been a long journey from Manuel Millares and Luis Feito to Steve Ashby and Leon Kennedy, but the aesthetic visions of the four artists are not that different. All four were revolutionaries in their own right, and all four sang their own song despite—or maybe because of—the social pressures in their very different environments. The lure of discovering the next facet of the universal diamond of art is a part of what keeps us going, looking for the next set of dirt tracks.

In the late 1960s and early 1970s, we collected the work of Chicago Imagists such as Roger Brown, Ed Paschke, and Karl Wirsum. Their paintings were, in turn, influenced by folk artists such as Lee Godie, Martin Ramirez, and Joseph Yoakum. After a while we began to think that perhaps we should be collecting the work of the folk artists themselves rather than the art that was partially derived from it.

Chicago is a restless city that unveils new talent constantly. Lee Godie is dead, but Wesley Willis is out on the streets selling his work, and artists such as Mr. Imagination and Jamie Nathenson are available in galleries. Chicago galleries—Carl Hammer, Ann Nathan, and Phyllis Kind, for example—do not hesitate to show these new artists (in fact many of the artists in this book are represented by these galleries), and the scene is easier on the feet and wallet than that in New York.

Chicago is also always a city of promise. Patrons of the Art Institute of Chicago and the Museum of Contemporary Art have been building collections of contemporary folk art for years, and there is always the hope that these collections will soon find their way into significant positions within these institutions. But Chicago is also a city of constant growth; if those two institutions don't satisfy their patrons, a new institution will rise up and take over—Intuit, for example, is growing and

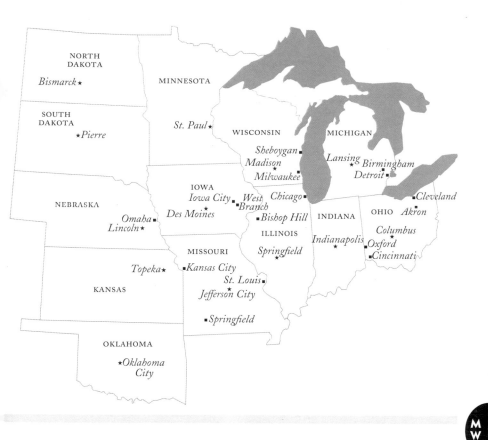

looking for space, and a promising new museum, the Chicago Center for Self-Taught Art, has opened in Marshall Field's State Street Store. Just recently the once-staid Terra Museum, which usually shows nineteenth-century American art, put on a wonderful exhibition, "Reclamation and Transformation: Three Self-Taught Chicago Artists" (1994)—Mr. Imagination and David Philpot were included in that show.

And then there's folk art fun in Chicago's out-of-the-ordinary places. Weeds, a neighborhood hangout where Sergio Mayora tends bar, is the kind of place where the audience gets excited over folk poetry—they even let me read a poem (not my own) to mild applause.

Yet Chicago is far from being the only source of contemporary folk art in the Midwest. Columbus, Ohio, for example, has established a unique support system for its folk artists. In the late 1970s the city realized that it had a major asset in one of its residents, Elijah Pierce, now recognized as one of the great American folk artists of this century. Pierce was a gentle, humble, and quiet man who always welcomed us into his museum/barbershop. Just as he had stories to tell and stories to carve, so do we have stories to tell of our times with him. For example, the night of the opening of the Corcoran's black

folk art show in 1982 in Washington, D.C., there was a terrible snowstorm, and Pierce was ill. After the opening dinner at the museum, as I prepared to take Pierce to his hotel, a collector rudely pushed his way into the car to be near Pierce—leaving Mrs. Pierce, Jan, and Lynda Hartigan (now a curator at the Smithsonian Institution's National Museum of American Art) out in the cold, to walk alone at night down Pennsylvania Avenue and past the White House through accumulated snowdrifts. I came back for them, but memories of moments like this with Pierce are still very much a part of our lives and affect the way we look at his art.

Today a major part of Pierce's work is in the Columbus Museum of Art; that museum is also acquiring the work of other local folk artists and actively supporting their endeavors. The artists now working in the Columbus area know each other and help each other out—Smoky Brown, Mary Merrill, Levent Isik, and Ricky Barnes, for example. After Pierce died, the artists rallied around William Hawkins and Smoky Brown. "Grandpa" Smoky Brown is one of our favorite artists, but he doesn't finish many works, and he has very little use for galleries. The best way to collect his art is to climb his staircase, enter his room—chock-full of objects intended to be, someday, transformed into art—and make a deal with his wife, LaVerne.

An important part of the folk art support system in Columbus is Ohio State University. The university has made space available for folk art exhibitions, collected the art, and given advanced degrees based on this subject. Barbara Vogel, a photographer/teacher at the university, has photographed and documented most of the local artists; her good friend Leslie Constable wrote a master's thesis on Smoky Brown and worked for the *Columbus Post Dispatch* during the early 1990s, writing articles and reviews on folk art. Yes, Columbus, Ohio, realizes that folk art is a precious asset, and its institutions are willing, even eager, to support the artists. There is also support for folk art at Miami University, north of Cincinnati in Oxford, Ohio; there, the university's art museum includes contemporary folk art in its collection and sponsors various folk art exhibits.

Another place to see contemporary folk art in the Midwest is Milwaukee, Wisconsin. Russell Bowman, director of the Milwaukee Art Museum, has been instrumental in assembling a large collection (which includes both the Michael and Julie Hall Collection of American Folk Art and the Flagg Collection of Haitian Art) for the museum. This museum is one of the few "all-purpose" museums in this country where there is always contemporary American folk art on display. Bowman, who was trained in Chicago and has written about the Chicago Imagists (as well as about contemporary American folk art), has the aesthetic eye of a great collector.

There is also more than a gallery or two to visit when in Milwaukee—Dean Jensen handles the work of "Creative"

(continued on page 201)

93 Clyde Angel
Freewill, 1994.
Scrap steel and tin cans;
30 × 19 in. (76.2 × 48.3 cm).
SHERRY PARDEE COLLECTION.

94 Thomas King Baker
Untitled, 1958.
Oil on zinc; 17½ × 14 in.
(44.5 × 35.6 cm).
THOMAS AND JANIS McCORMICK.

95 Ricky Barnes
Johnny Bench, 1993.
Paint on wood; 23½ × 14½ in.
(59.7 × 36.8 cm).
ANN NATHAN GALLERY.

96 Ralph Bell
Untitled, date unknown.
Acrylic on wood; 21½ × 47¾ in.
(54.6 × 121.3 cm).
COLUMBUS MUSEUM OF ART.

97 Russell "Smoky" Brown
Flowers for the Living, 1992.
Mixed media collage;
27 × 31 in. (68.6 × 78.7 cm).
CHUCK AND JAN ROSENAK.
PHOTO: LYNN LOWN

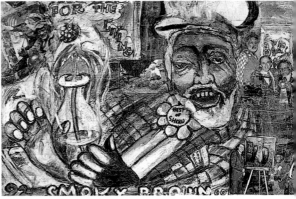

98 Henry J. Darger
Detail, *Vivian Girls (No Two
from the Other Side)*, n.d.
Mixed media on paper;
31½ × 126 in. (80 × 320 cm).
COLLECTION DE L'ART BRUT,
LAUSANNE, SWITZERLAND.
PHOTO: CLAUDE BORNAND

99 William Dawson
Billy Davis, Jr. and Marilyn Me Coo (of the 5th Dimension), 1986.
Painted wood; *Davis*, 13¼ × 3 × 2¼ in. (33.7 × 7.6 × 5.7 cm); *Me Coo*, 13¾ × 3 × 2 in. (34.9 × 7.6 × 5.1 cm).
ARIENT FAMILY COLLECTION.

100 Eileen Doman
Marlene's Web, 1993.
Acrylic on canvas; 20 × 16 in. (50.8 × 40.6 cm).
LIZ BLACKMAN GALLERY.

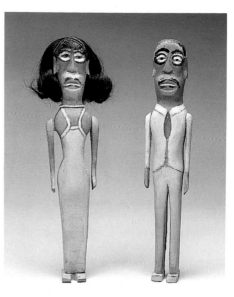

101 Josephus Farmer
Seven Wonders of the Ancient World, 1970–1975.
Carved wood, paint; 30 × 50 in. (76.2 × 127 cm).
MUSEUM OF AMERICAN FOLK ART, NEW YORK; GIFT OF HERBERT WAIDE HEMPHILL, JR.
PHOTO: GAVIN ASHWORTH

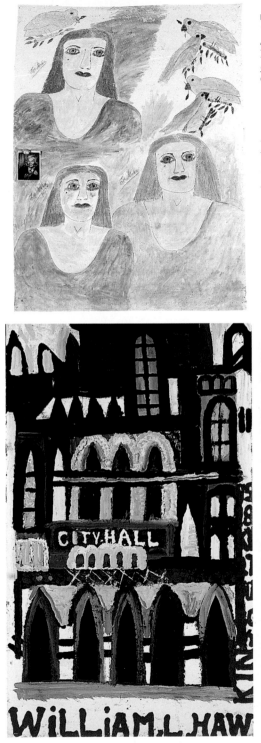

102 Lee Godie
Three Self-Portraits with Photo and Locket, undated.
Pen, watercolor on canvas; 52 × 37 in. (132.1 × 94 cm).
CHUCK AND JAN ROSENAK.

▼◁ **103** William Hawkins
Untitled (City Hall), 1984.
Enamel on Masonite; 21½ × 37½ in. (54.6 × 95.3 cm).
LEE AND ED KOGAN.
PHOTO: GAVIN ASHWORTH

▼ **104** "Mr. Imagination"
Gregory Warmack
Totem with Five Broomheads, c. 1994.
Mixed media; 79 × 20 × 12 in. (200.7 × 50.8 × 30.5 cm).
CARL HAMMER GALLERY.

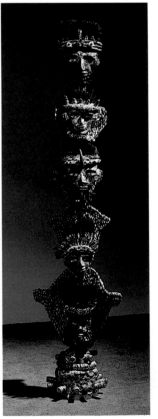

105 Levent Isik
Adam and Eve with Snake, 1992.
Housepaint, water putty, and
mirror molding on wood;
26 × 16 in. (66 × 40.6 cm).
Sue and George Viener.

106 Mary Francis Merrill
Harlin N.Y. Homecomeing,
undated.
Watercolor, yarn, tin cans;
15½ × 18½ in. (39.4 × 47 cm).
Chuck and Jan Rosenak.
Photo: Lynn Lown

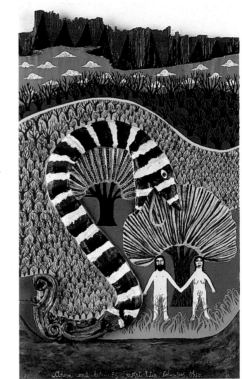

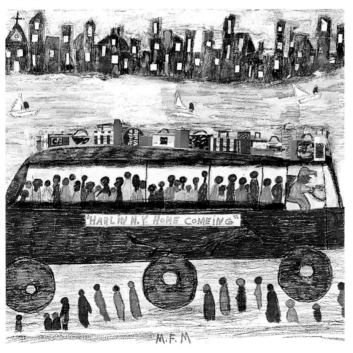

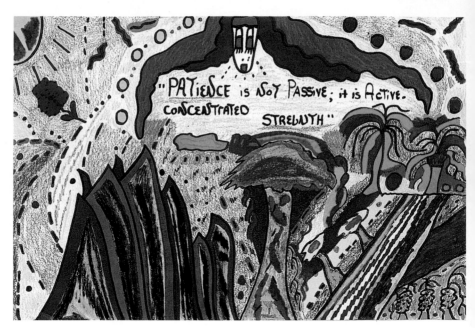

▲ **107** Jamie Nathenson
*Patience is Not Passive; it is
Active,* c. 1993. Colored
marker on paper; 12 × 18 in.
(30.5 × 45.7 cm).
CHUCK AND JAN ROSENAK.
PHOTO: LYNN LOWN

▼◁ **108** David Philpot
Assorted staffs, various dates,
1986–1990.
Carved wood, 71–76 in.
(180.3–193 cm).
CARL HAMMER GALLERY.

▼▷ **109** Elijah Pierce
*Pearl Harbor and the
African Queen,* c. 1941.
Carved and painted wood
with glitter; 23¼ × 27 × 1½ in.
(59.1 × 68.6 × 3.8 cm).
MILWAUKEE ART MUSEUM,
THE MICHAEL AND JULIE
HALL COLLECTION.

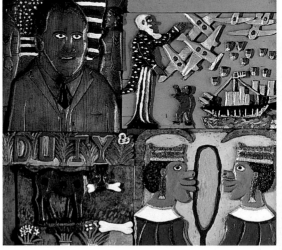

110 Richard Saholt
War and the Beginning of Madness, 1976.
Collage, mixed media, photos, and magazine words; 44¼ × 28¼ in. (112.4 × 71.8 cm).
AMERICAN VISIONARY ART MUSEUM. PHOTO: RON SOLOMON

111 Carter Todd
Untitled, 1989.
Colored pencil and graphite on paper; 14 × 17 in (35.6 × 43.2 cm).
DEAN JENSEN GALLERY.

112 Wesley Willis
The Chicago Skyline, 1992.
Crayon and colored pencil on posterboard; 28 × 40 in. (71.1 × 101.6 cm).
PATRICK DRISCOLL.

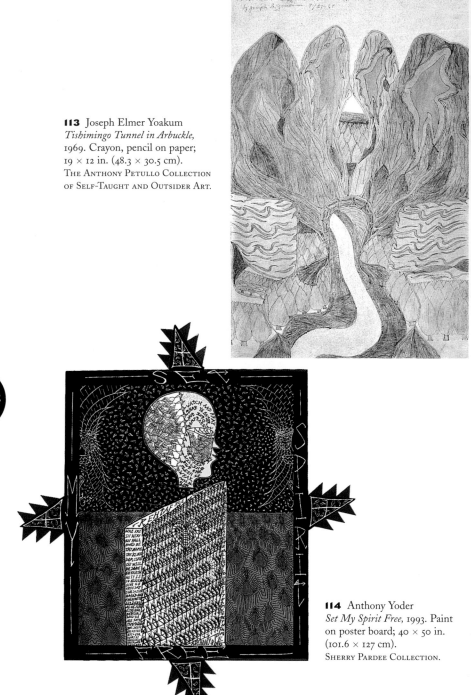

113 Joseph Elmer Yoakum
Tishimingo Tunnel in Arbuckle,
1969. Crayon, pencil on paper;
19 × 12 in. (48.3 × 30.5 cm).
THE ANTHONY PETULLO COLLECTION
OF SELF-TAUGHT AND OUTSIDER ART.

114 Anthony Yoder
Set My Spirit Free, 1993. Paint
on poster board; 40 × 50 in.
(101.6 × 127 cm).
SHERRY PARDEE COLLECTION.

(continued from page 192)
DePrie, Jamie Nathenson, and others, and Instinct, a new gallery devoted solely to folk art, has a wide selection from the region as well as from other parts of the country. There is also Prophet Blackmon's "Revival Center and Shoe Repair Shop." Blackmon, a black preacher, fills his colorful paintings with messages about the difficulties encountered on the road to heaven. Because Blackmon's flock is small, he must support himself by repairing shoes, selling used clothing, and making sermons in art. A visit is a not-to-be-forgotten event.

In addition to folk art, there are several fine German restaurants in Milwaukee (all have been there since our youth)—Mader's, Karl Ratzsch's, and the John Ernst Cafe, for example. After a morning viewing folk art, a private booth at the Ernst Cafe is a good place for lunch (it's near the museum)—their bratwurst and red cabbage is still the way we remember it from high-school days!

While we were growing up in Milwaukee, we knew nothing about folk art; indeed, we had never heard the term. It was not until 1982, long after we moved to Washington, that we met our first Milwaukee folk artist—at that time, Russell Bowman introduced us to Reverend Josephus Farmer, and now Farmer is considered one of the great black visionary carvers of the century. We know now that we may have missed some golden opportunities to discover folk art in those days of growing up in Milwaukee, and that is one of the reasons we continue to go back to our midwestern roots, looking for the wonderful art that we may once have passed by.

M W

93
CLYDE ANGEL

Born August 31, 1957,
Beaver Island (in the Mississippi
River), Iowa. Lives in Iowa,
no permanent address.

Known as the "Iowa highway wanderer," Clyde Angel gathers up the rich harvest of materials to be found along the shoulder of America's roads and from it assembles animated personages as he moves from place to place. Most hobos are anonymous, but Angel leaves behind welded scrap-metal sculptures containing poetic blowtorched messages—"moon to my west, sun to the east, moving to the north in the early light"—to remind us of his existence. The assemblages of this artist are slightly reminiscent of the welded "junk art" popular in mainstream art circles during the 1960s and 1970s; the sensibility and motivation of this artist, however, is uniquely different.

Clyde Angel says he "runs free on the blacktop" with no interest in settling down, creating a family, or accumulating social obligations and wealth. "If you want to see me," he writes on a paper bag, "see my art."

COLLECTING TIPS

Angel makes some wall sculpture from flattened tin cans and assemblages on paper and newsprint, but his large collages (often life-size) made from highway litter, with their cutout messages, are his most significant legacy.

WHERE TO SEE ART

Clyde Angel's work is illustrated in the *Iowan* (Summer 1994). He has been exhibited at art fairs in New York.

Angel's art is available from Sherry Pardee, the Pardee Collection, Iowa City, and the American Primitive Gallery in New York City.

94
THOMAS KING BAKER

Born September 18, 1911,
Pittsburgh, Pennsylvania.
Died September 8, 1972,
Kansas City, Missouri.

Thomas King Baker filled sketchbooks and tablets with watercolors, drawings, pasted cutouts, jokes, and written observations of his many adventures during his extensive travels. In his art Baker "exhibited the rawness of a punster and societal critic" (as quoted in the catalog on Baker noted below). He invented a German composer that he named Buscht, and he is known to have written a complete illustrated biography of this imaginary character, although the present whereabouts of this work is now unknown.

Baker was a shy man who did not go to college because of his parents' fear of the smoking and drinking that might occur there. He had an ordinary job with an insurance company, but he married a woman with a bit of money, which gave him access to travel, art, music, and the social and worldly pleasures of his day. In the solitude of his basement, however, over a period of twenty-five years, the shyness vanished, the ordinariness of his existence dissolved, and the quiet businessman blossomed into an artist—but one who never shared his work with the outside world.

Collecting Tips The work of Thomas King Baker provides an opportunity to purchase a previously ignored artist at what may prove to be a good price. Some scholars may feel that Baker's drawings and social commentary are too sophisticated to be properly classified as folk art, and they do in fact embrace some of the qualities of high art. But many recognized folk artists of the early twentieth century also painted in a manner that related to high art (John Kane and Joseph Pickett are two, among others, who come to mind), so it would be illogical to ignore Baker for this reason.

Where to See Art Thomas McCormick, a Chicago dealer, has published an illustrated catalog, *Thomas King Baker, an Eccentric Original* (1993), on Baker's art, and a museum exhibition of his work is in the planning stages.

Where to Buy Art The estate of Thomas King Baker is represented by Thomas McCormick Works of Art in Chicago. The Liz Blackman Gallery in Los Angeles has also shown Baker's work.

95
RICKY BARNES

Born November 26, 1959,
Columbus, Ohio.
Now resides Columbus.

Ricky Barnes carves bas-reliefs of his heroes, the "boys of summer." "Life," he philosophizes, "imitates baseball—life is baseball!" He captures all the greats—Henry Aaron, Eric Davis, and Joe Morgan, among others—in action, with special emphasis on the world champions who played for the "Big Red Machine" (the Cincinnati Reds). Barnes carves the players in uniform and highlights great moments in their careers;

he also prints legends on the front and back of the carvings, attesting to the greatness of the subject or in some instances to their abuse or mistreatment by management or fans.

Barnes is a busy young man; in addition to his carving he runs a "new American-style café" (the Galaxy, in Powell, Ohio), sings and plays the guitar in an old-style cowboy band (Ricky Barnes and the Hoot Owls), and has recorded four albums under the Okra label. Barnes is also aware of the regional interest in folk artists of the Columbus area and of their success in the marketplace. "I bought a painting by William Hawkins in 1983 for fifty dollars," he brags, "and sold it in 1994 for many times its original value."

COLLECTING TIPS Barnes is an interesting new talent. His bas-reliefs of ballplayers, painted with enamel, are well carved and fun to own. For those collectors who are not as familiar with baseball as the artist, the carvings with printed legends may be preferable. For baseball fans—take your pick!

Recently Barnes has been making castings from his original bas-reliefs. These multiple copies are very inexpensive, but of course they do not have the value of the original reliefs.

WHERE TO SEE ART Barnes has had many local shows and displays some of his work at the Galaxy Café.

WHERE TO BUY ART Ricky Barnes's bas-reliefs are handled by the Ann Nathan Gallery in Chicago and by Toad Hall in Cooperstown, New York.

9 6
R A L P H B E L L

Born November 17, 1913,
Columbus, Ohio.
Died June 24, 1995, Columbus.

Ralph Bell's complex compositions portray dreamlike images that appear suspended in brightly colored gardens. He used cheerful hues to paint animals and children at play, but if the viewer looks closely, it will be apparent that the children have no arms and that the animals, too, are deformed in strange ways.

Part Cherokee and part black, the artist overcame disabling cerebral palsy to paint award-winning canvases, albeit with a great deal of labor and effort. From about 1983 until shortly before his death, Bell painted in a cerebral-palsy workshop under the direction of Dean Campbell. It was Campbell who fitted Bell with a stylus that could be strapped to his head (the artist had been paraplegic since birth), and Campbell who first recognized that Bell "was an artist in the real sense of the word" in spite of his unorthodox method of producing art.

COLLECTING TIPS Bell's work fits under the broad category of "workshop art." A lot of workshop art seems to have a sameness to it—bright colors and cheerful childlike subject matter—and it is often intentionally decorative, but a very few workshop artists, such as Bell, manage to transcend the label (see also Dwight Mackintosh). Bell's art will not appeal to every collector, but it deserves to be given consideration.

The artist was very prolific, and his larger works, depicting armless people and strange animals, are often the strongest. His recent death may affect the prices for his work.

WHERE TO SEE ART Ralph Bell has been widely shown (more than twenty exhibitions since 1983 in Columbus alone). He was included in "A Show of Independents: Ohio Artists" at Ohio State University (1993), Columbus, and his work is in the permanent collections of that university and of the Columbus Museum of Art, Ohio. In 1995 the artist had a retrospective exhibition at the Elijah Pierce Gallery, King Arts Complex, Columbus, Ohio.

WHERE TO BUY ART Bell's paintings, signed "Ralph," may be purchased through Dean Campbell, now a dealer and Bell's representative, and several galleries in Columbus, Ohio. The Ann Nathan Gallery in Chicago and the Leslie Muth Gallery in Santa Fe also show Ralph Bell's work.

**97
RUSSELL
"SMOKY"
BROWN**

Born November 28, 1919, Dayton, Ohio. Now resides Columbus, Ohio.

Russell "Smoky" Brown is a black thespian, a showman; there is wit and satire in his work, and he does not hesitate to comment on himself, his friends, and the political and social issues of the day. Brown's art, like the man himself, is bigger than life—humorous, idiosyncratic, and engaging. He likes to make collages; he claims it is easier for him to accumulate and store in his bedroom bits and pieces of newsprint, plastic, and other flotsam and jetsam of back-alley Columbus and then assemble them into collages than it is for him to "draw them out." Sometimes, however, he'll do just that—paint an oil on canvas.

Brown lost his left eye in a barroom fight, and the accompanying loss of depth perception may partially account for the buildup of his paintings—he applies layer after layer of accumulated found materials to the surface of his work, until the final piece is almost sculptural in its elements. Smoky Brown is also known for his papier maché and painted "monsters," which, he says, "talk to him."

Brown thoroughly enjoys the notoriety that has come with his local folk hero status in Columbus. A gregarious storyteller, he was a friend and painting companion of the late William Hawkins. He has had to overcome bouts with alcohol to achieve artistic success.

COLLECTING TIPS Brown is not prolific—he starts many more works than he finishes. His best works are the occasional large collage-paintings, often including self-portraits, that he completes. If one of these is not available, his papier maché monsters can be appealing.

WHERE TO SEE ART Brown has been included in numerous Ohio exhibitions, including "A Show of Independents: Ohio Artists" at Ohio State University, Columbus (1993) and a show at the Columbus Cultural Arts Center (1990). His work is in the permanent collection of the Columbus Museum of Art.

Brown's art is carried by It's An Art Gallery in Columbus. His wife, LaVerne (Ace Gallery), also acts as his agent.

REECE CRAWFORD

Born July 20, 1955, Springfield, Massachusetts. Now resides Omaha, Nebraska.

Reece Crawford sculpts innovative and sometimes unflattering depictions of family, friends, and various black celebrities —"the 'hood I know so well," she says. Crawford is awakened frequently in the night by apparitions, some of whom have faces she knows and others with faces she doesn't quite recognize. Then, in the early light of morning, she turns these apparitions into sculpture. "My work is a contribution to the people in the 'hood," she volunteers.

Crawford's media are as unusual as her subject matter. She collects the remains of top secret government documents that are shredded at her workplace, combines the shredded paper with Elmer's glue and a bleach mixture to "take the smell out," and molds what she calls her "glop mixture" into sculpture. When the work dries, she applies some paint.

Reece Crawford received an arts fellowship from the Mid-American Art Alliance, National Endowment for the Arts, in 1994.

COLLECTING TIPS Crawford is making a name for herself in her hometown. Her depictions of people in the "hood" may be unsettling to some viewers, but others will find them to be important statements about black ghetto life. The artist's work is continuing to evolve, and her newer works are the most intriguing.

WHERE TO SEE ART Reece Crawford was given a one-person exhibition, accompanied by an illustrated catalog, by the Metropolitan Arts Council, Omaha (1992). Her work is in the permanent collection of the Black Americana Museum in Omaha.

WHERE TO BUY ART Crawford's sculpture can be purchased from the White Crane Gallery in Omaha, and from the Ann Nathan Gallery in Chicago.

98 HENRY J. DARGER

Born April 12, 1892, probably Chicago, Illinois. Died April 13, 1973, Chicago.

Henry Darger was a reclusive man who created a world of astounding fantasy in his ambitious illustrated books and journals. In his vivid drawings and watercolors, good (represented by the Vivian girls, seven doll-like and very properly dressed little girls) battles the forces of evil (often represented by thuglike soldiers) and always emerges unscathed. There are sexual references to be found in his work, as well as illustrated passages of extremely violent acts involving children.

Henry Darger was placed in a boy's home at the age of eight and spent his early life shunted from orphanage to orphanage and school to school—and running away whenever he was able. Darger's institutional background, which isolated him from society, and his strong religious beliefs, perhaps the most stable factor in his life, undoubtedly influenced his art.

Darger drew on both sides of his paper, and some of his draw-ings are in need of restoration. Before purchasing a work, an examination by an expert paper restorer is recommended.

WHERE TO SEE ART Henry Darger's work was exhibited in "The Cutting Edge" at the Museum of American Folk Art (1990), in "Parallel Vi-sions: Modern Artists and Outsider Art" at the Los Angeles County Museum of Art (1992), and "Made in USA" (1993) at the Collection de l'Art Brut, Lausanne, Switzerland. In 1995 Darger was included in a show organized by the Newark Mu-seum, Newark, New Jersey, "A World of Their Own: Twenti-eth Century American Folk Art."

Darger's drawings are in many public collections, including L'Aracine, Neuilly-sur-Marne near Paris; the Collection de l'Art Brut, Lausanne, Switzerland; the Chicago Art Institute; and the Smithsonian's National Museum of American Art, Washington, D.C. Darger's drawings are also now in almost all of the great private collections of outsider art.

WHERE TO BUY ART The Carl Hammer Gallery in Chicago and the Phyllis Kind Gallery in New York City and Chicago sometimes have Darger's drawings and watercolors for sale. The Janet Fleisher Gallery in Philadelphia and the Gasperi Gallery in New Orleans also carry Darger's work. Major auctions of folk art may also occasionally contain works by this artist.

9 9
WILLIAM
DAWSON

Born October 20, 1901, near
Huntsville, Alabama.
Died Chicago, July 1, 1990.

Now recognized as one of the country's most important black carvers, William Dawson carved obsessive personal images. His figures, both male and female, have blocklike bodies with large, primitive faces and prominently outlined facial features. Sometimes the figures are based on television characters such as Chicken George (seen in Alex Haley's *Roots*) or political despots such as Idi Amin; at other times Dawson drew his subjects from folk tales and the Bible, as well as from just plain folk. The artist also arranges faces one atop another to form totem poles. Sometimes he attaches real hair and other objects to these images, and occasionally the bases for the totems are carved likenesses of his birthplace in Alabama.

Dawson left the South when he was in his early twenties. He worked for many years in Chicago's South Water Street Market. He began carving after retiring from his job at the produce market, and his memories of the South, dreams of the future, and hopes for a more perfect life were mirrored in his art.

COLLECTING TIPS Dawson's carvings from the mid-1970s to the early 1980s are generally thought to be his strongest. The reputation of this artist is so well established, however, that most collectors of folk art, especially of black folk art, will want work from a variety of periods. His totem poles are also very popular.

By the 1990s Dawson's watercolors and drawings, which were originally felt to be less important than his carvings, had

become recognized and exhibited in their own right. These are still less expensive than his carvings.

Dawson's art has been included in most of the major folk art exhibitions from "Black Folk Art in America 1930–1980" (1982) to "Passionate Visions of the American South" (1993); it is illustrated in the catalogs from these and other exhibitions. He was given a one-person retrospective at the Chicago Cultural Center (1990).

 William Dawson's work is in the permanent collections of most museums that collect folk art.

Sometimes dealers, particularly those in Chicago such as Carl Hammer, Phyllis Kind, and Ann Nathan, will have Dawson's carvings and drawings on hand. His work is also carried by such galleries as the Ames Gallery, Berkeley, California; Robert Cargo, Tuscaloosa, Alabama; and Epstein/Powell, New York City.

100
EILEEN DOMAN

Born January 14, 1954, Chicago, Illinois. Now resides Genoa, Illinois.

The frozen smiles of friends and family captured forever in black-and-white photographs that crowd the pages of family albums are the inspiration for the paintings that catapulted Eileen Doman from the ranks of the unknown into art world celebrity status. "As long as there are people in this world," the artist declares, "I can go on and on." She paints a larger version of the original photograph, adds color and sometimes a family pet or a familiar gesture, and the result is self-taught photorealism. Madison Avenue, always craving something new, has found a star performer living in a small farming community in Illinois.

 Doman started to paint some twenty years ago, "Modigliani style," as she says; she copied the Modigliani works in the Art Institute of Chicago, but added her own touches here and there. In 1992 she joined the Art League in Wheaton, Illinois,

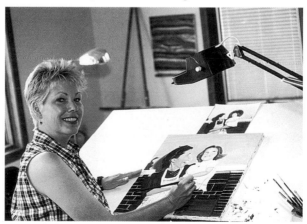

Eileen Doman

and began making her own version of photorealistic paintings. "It's a gift," she explained. "It's caused me to go to church every Sunday in thanksgiving."

COLLECTING TIPS Liz Blackman, a dealer from Los Angeles, California, discovered Doman and brought her work to the New York Outsider Art Fair in January, 1994. Priced at five hundred dollars a painting, they sold out. By spring of that year Eileen Doman had a one-person show in New York, and her work had escalated to three to four thousand dollars a painting. Her price has continued to rise, and collectors will have to make up their own minds—and check their budget—in deciding whether or not they can live without a Doman.

WHERE TO SEE ART Doman exhibits at the annual art fair in New York City.

WHERE TO BUY ART Eileen Doman is represented by the Liz Blackman Gallery in Los Angeles and by Ricco/Maresca Gallery in New York City.

1 0 1
JOSEPHUS
FARMER

Born August 1, 1894,
near Trenton, Tennessee.
Died November 15, 1989,
Joliet, Illinois.

From the early 1960s into the early 1980s Josephus Farmer created a series of relief carvings that are now considered to be some of the best examples of twentieth-century folk sculpture. When he was at his best, Farmer carved deep into his wood—at times, even through the wood—to make his figures three-dimensional. The carved and painted reliefs depict Farmer's version of both biblical and historical subject matter as well as such political heroes as Abraham Lincoln and John F. Kennedy.

Farmer was ordained as a Pentecostal minister in 1922 after hearing the voice of God. He took his ministry into the streets, attracting attention by the use of large, colorful canvas banners that he made himself, with their formats derived from standard theological texts and charts. The artist also combined carvings, bits of cloth, plastic, and other assorted objects into dioramas that documented his memories of rural life in Tennessee in addition to biblical and political events.

COLLECTING TIPS Farmer made fewer than forty of his deeply carved reliefs, and they are by far his best works. The banners are very rare—he made less than ten of them—and are also of great value; the dioramas are for the most part of historical interest only. His later pieces, carved after about 1983, tended to be repeats of earlier works and are of less interest to serious collectors.

WHERE TO SEE ART Josephus Farmer was given an individual show at the University of Wisconsin, Milwaukee, "The Gift of Josephus Farmer" (1982); many of his best works are illustrated in the accompanying catalog.

There are several examples of Farmer's carvings in the permanent collection of the Milwaukee Art Museum, and he is included in the Smithsonian Institution's National Museum of American Art, Washington, D.C.

Farmer's seminal work is closely held and comes on the market only very rarely—it pays to check major auction catalogs and galleries in the Midwest regularly. Another possible source is the Dean Jensen Gallery in Milwaukee.

102
LEE GODIE

Born September 2, 1908,
Chicago, Illinois.
Died March 2, 1994, Chicago.

Lee Godie was a "bag lady" who made her home on the streets of Chicago by choice rather than necessity, as she could easily sell two or three paintings in a single day and earn the price of a hotel room whenever she wanted. Among her favorite subjects were a blond Prince Charming (she referred to him as "a friend of Picasso's") and "the girl in the mirror"—dramatic self-portraits that sometimes included cameos or photo-booth photographs of Godie that she attached to the drawings. Sometimes both Prince Charming and Godie herself are present in the same painting. Chicago landmarks can often be recognized in the backgrounds.

Godie called herself a French Impressionist and claimed that her financial success was due to the advice of Renoir to "paint beauty." She was one of the best-known figures on Chicago's art scene for over twenty years, and her work is included in more collections in that metropolitan area than any other single artist, folk or otherwise.

COLLECTING TIPS Godie is widely considered Chicago's most collected artist. Her best work includes the self-portraits and the depictions of Prince Charming. Her art is so popular among folk art collectors (and others) that it is hard to imagine a major collection of this genre that doesn't include at least one Godie. However, her materials were not always the best, and some of her paintings will fade in direct sunlight, so buyers should be careful of how the work is displayed, and conservation measures may need to be taken.

WHERE TO SEE ART Godie was given a major retrospective, "Artist Lee Godie," at the Chicago Cultural Center in 1993; an illustrated catalog accompanied the exhibition.

Among the major museums that include Godie's work in their permanent collections are the Museum of American Folk Art in New York City; the Milwaukee Art Museum; and the Museum of Contemporary Art in Chicago. In response to our inquiry, the Art Institute of Chicago indicated that, while Lee Godie was not represented in the institute's collection, most of the museum staff had collected Godie's work over the years.

WHERE TO BUY ART The estate of Lee Godie is represented by the Carl Hammer Gallery in Chicago. Other galleries, such as the Gasperi Gallery in New Orleans, also carry her work.

103
WILLIAM HAWKINS

Born July 27, 1895,
Union City, Kentucky.
Died January 23, 1990,
Columbus, Ohio.

The cityscapes and houses that William Hawkins painted in a bold and expressionistic style are endowed with his personal sense of reality. He had no particular concern for perspective or detail, concentrating instead on the colorful and dramatic. His paintings all have a great sense of motion; his city streets, public buildings, and houses all seem to have a life of their own, and he would give his painted animals human qualities.

An energetic man, Hawkins often held several jobs at a time—driving trucks, doing demolition (he was a one-man wrecking crew), and running numbers—but after he retired, he became part of the folk art scene in Columbus, Ohio. He was a friend of self-taught artist Smoky Brown, and in turn Hawkins befriended younger artists like Levent Isik. The folk art community in Columbus was proud of his success and referred to him fondly as "Grandpa Hawkins."

COLLECTING TIPS

By the time of his death William Hawkins had become one of the most widely exhibited and sought after black American folk artists. He painted on used Masonite and board, and there are scratches and irregularities in his work; these defects do not detract from the value of the piece, however. His earlier paintings, created before fame came his way in the late 1970s to mid-1980s, are for the most part Hawkins's strongest and most original work.

Hawkins always signed his paintings. Along with his signature, he usually included the date of, and sometimes the place of, his birth.

WHERE TO SEE ART

William Hawkins's expressionistic paintings are in a number of public collections, including several Ohio museums (the Akron Art Museum, the Columbus Museum of Art, and the Miami University Art Museum in Oxford), the Museum of American Folk Art in New York City, and the Smithsonian Institution's National Museum of American Art in Washington, D.C.

WHERE TO BUY ART

The estate of William Hawkins is represented by the Ricco/Maresca Gallery in New York City. Other galleries that carry his paintings include the Janet Fleisher Gallery in Philadelphia and the Gasperi Gallery in New Orleans.

104
"MR. IMAGINATION" OR "MR. I" (GREGORY WARMACK)

Born March 30, 1948, Chicago,
Illinois. Now resides Chicago.

"I like to make my art out of things I've found because they're there and they're free," Mr. Imagination (as the artist refers to himself) says. The artist beats the Chicago Sanitation Department to back-alley waste and assembles what most of us would consider trash into sculptures of great power. He creates dramatic personages from used paintbrushes, sandstone carvings from industrial waste, totems from brooms and paintbrushes, and large, collagelike sculptures of African royalty from bottle caps.

"Mr. Imagination" (Warmack)

Warmack's work is beautiful, but it has another level as well—it is about the black experience and Warmack's search for his African roots. In 1978 he was shot while being mugged; "While I was in a coma," he remembers, "I went back in time and saw myself as an African king. I was reborn as Mr. Imagination, and I began to make art that reflects my ancient tribal position in life."

Warmack's apartment is dominated by a bottle-cap-encrusted throne from which he holds court. He walks the streets of Chicago carrying a royal staff, dressed in a royal jacket covered with about thirty pounds of bottle caps. Just as he was "reborn," Mr. Imagination believes that the objects he collects "deserve to be reborn too."

COLLECTING TIPS In art world parlance, Mr. Imagination is "hot." Buy what you can afford—the larger and more complicated the work, the more valuable it will be.

WHERE TO SEE ART Mr. Imagination has been included in about twenty shows in the Chicago area since the early 1980s, including "Reclamation and Transformation: Three Self-Taught Chicago Artists" at the Terra Museum of American Art in Chicago, which was accompanied by a fully illustrated catalog (1994); and "Black Art—Ancestral Legacy: The African Impulse in African-American Art," a traveling exhibition that originated at the Dallas Museum of Art in 1989.

WHERE TO BUY ART Mr. Imagination is represented by the Carl Hammer Gallery, Chicago.

Levent Isik

Born Istanbul, Turkey, August 1, 1961. Moved to Canada in 1966; has resided in Columbus, Ohio, since 1981.

Levent Isik, an up-and-coming artist, delights his audience with fanciful renditions of subjects that are both decorative and quite serious. His paintings sometimes have a dreamlike quality, because he paints his subconscious thoughts and dreams as well as those of his girlfriend. Although paint is Isik's medium, he will sometimes incorporate pieces of furniture molding or other objects to give extra character to his work.

Isik, a Canadian citizen and a green-card holder here, began to paint while in this country and has gained a strong following in the Columbus area, where he is very much a part of the support system for untrained artists. The work of Elijah Pierce has been an inspiration to Isik, and he has befriended (and been befriended by) and exhibited with other local artists such as William Hawkins and Smoky Brown.

COLLECTING TIPS

Levent Isik is a colorist and romanticist. While this should not be confused with memory painting, his work may have greater appeal to collectors who are not looking for "tougher" art. Nevertheless, Isik is a talented artist whose work is witty and fun; in reviewing his work in 1992, the *Columbus Dispatch* wrote, "Levent Isik's visual lexicon adds up to a playful, warmly humanistic vision filled with homey wisdom and more than a dash of bawdy humor."

WHERE TO SEE ART

Isik illustrated a Columbus columnist's tale, "Slack Hollow," for *Ohio Magazine* (January 1994). He was included in "A Show of Independents: Ohio Artists" at Ohio State University, Columbus (1993), as well as other local exhibitions. Northern Kentucky University also showed Isik's work in 1993.

WHERE TO BUY ART

Isik welcomes visitors to his Columbus studio. His work can also be found in various galleries in the area and at the Frank J. Miele Gallery in New York City and the Leslie Muth Gallery in Santa Fe. Other galleries that have recently shown Isik's work include the Ann Nathan Gallery in Chicago and America Oh Yes in Hilton Head, South Carolina.

SERGIO MAYORA

Born July 14, 1953, Chicago, Illinois. Now resides Chicago.

Sergio Mayora's beautifully crafted boxes, which open one box into another like traditional Russian wooden doll figures, contain personal messages intended for himself and his friends. His brightly painted and lacquered boxes are highly decorative and have glass linings; sometimes they have kitschy items affixed to the lids.

Mayora is a Chicago personality. His interests and activities range wide and far; he is a folk poet, runs a family neighborhood bar called Weeds (which has weekly folk poetry readings), and got seven hundred votes when he ran for mayor of Chicago.

COLLECTING TIPS

Mayora is a new talent on the folk art stage who deserves to be watched. All of his boxes—and the messages they contain—are interesting.

WHERE TO SEE ART

Tony Fitzpatrick's World Tattoo Gallery (now closed) in Chicago gave Mayora a one-person show in 1993.

WHERE TO BUY ART

The best way to see and buy Mayora's boxes is to stop in at his bar, Weeds. Many of the boxes he has made belong to his friends and thus are not for sale.

**106
MARY FRANCIS MERRILL**

Born March 11, 1920, Flushing, Ohio. Now resides Columbus, Ohio.

Mary Merrill, a master of collage, once suffered from agoraphobia and made rag dolls to keep her company. "Everybody had little white babies to play with, so I made black doll babies," she said. The doll babies, stuffed with rags and dressed in hand-sewn, brightly colored, cast-off clothing, are what first brought us to her apartment, but once there we discovered that the artist also made wonderful painted collages of scenes and events she could not participate in because of her phobia. These collages, made from product labels, paper cutouts, and other objects, are her tour de force.

Merrill has, in her words, "always made things." In the early 1980s she made small head sculptures, using chunks of coal for the heads; she has also done a series of paintings on discarded linoleum. Although she lives in a project, she comments that "I had everything right here to work with because I was a collector and used to run an antique shop. The Lord gave me a time to rest [during her phobic period], and the Lord told me to make these beautiful things."

Mary Merrill

COLLECTING TIPS

Mary Merrill suffered two strokes during the past year, and her work is becoming hard to find. Doll collectors will prefer the colorful hand-sewn "black baby dolls," but we prefer her paintings and, particularly, the rarer and more complex collages. The artist signs her collages "M.F.M."

Where to See Art Merrill's collages were included in "A Show of Independents: Ohio Artists" at Ohio State University, Columbus (1993). Her work has also been exhibited in a number of other Ohio shows, including a 1990 show at the Miami University Art Museum, Oxford, which has acquired a Merrill painting for its permanent collection. In 1985 Mary Merrill was awarded an Ohio Arts Council artist's grant.

Where to Buy Art If the artist is feeling well enough, she receives visitors. Many collectors in Columbus have been buying Merrill's "doll babies," paintings, and collages for years, and some examples turn up in local galleries. It's An Art Gallery in Columbus is one that often carries her work.

107
JAMIE
NATHENSON

Born August 10, 1955, Chicago, Illinois. Now resides near Chicago.

Jamie Nathenson fills every inch of her paper with compulsive designs and drawings (*horror vacui*, or fear of empty spaces, is the phrase sometimes used for this compulsion)—faces and designs that come from the visions of a soul tormented by manic depression. The world as seen through this artist's eyes is intensified with the "colors of brightness" and the energy that is generated by her illness. The elongated, cartoonlike face found in almost all her work is her face, with her tongue extended into space, her birthmark evident on the cheek, and the printed sayings—such as "I did my time" or "pray for me"—representing her prayer for relief from depression.

Nathenson started transforming her visions into art when she was nineteen years old, the same year her illness was diagnosed. "It [manic depression] comes and goes," she explains, "but I know I was meant to be an artist, and I will always work at my art. My images explore my joys and despairs as well as hopes for the realization of my dreams."

Collecting Tips Some believe that this type of work is better understood in Europe by collectors of *art brut* than it is by collectors in the United States; nevertheless, as Nathenson's artistic reputation grows—and as more is learned about such art in this country—her drawings are beginning to attract more attention here as well.

Where to See Art Jamie Nathenson has been included in five European shows during the past four years, including one at the Collection de l'Art Brut in Lausanne, Switzerland (1991). Her work is in the permanent collection of this latter museum as well as in other museums in France and the Netherlands.

In 1994 Nathenson was included in an exhibition at the University of Miami, Coral Gables, Florida. Her work was also shown in "Contemporary Folk Art: A View from the Outside," Boca Raton, Florida (1995). Earlier, in 1990, she was in "Uncommonly Naive," a show at Beloit College, Beloit, Wisconsin.

Nathenson is represented by the Joy Moos Gallery in Miami, Florida, and by the Dean Jensen Gallery in Milwaukee.

108
DAVID PHILPOT

Born November 21, 1940, Chicago, Illinois. Now resides Chicago.

David Philpot

David Philpot carves elegant decorative staffs from the wood of the ailanthus tree. Although reminiscent of ritual emblems carried by African potentates, Philpot's staffs are unique. When he began carving, around 1971, he was unfamiliar with African art, yet as he now explains his carvings, "My African ancestors are with me, talking to me—guiding me." Philpot also believes that the plentiful ailanthus—a weed-like tree that grows along city streets and refuses to be eradicated—talks to him, helping him to develop his "God-given talent."

Philpot's large staffs (many over six feet tall) contain recognizable elements—birds, snakes, faces—and abstract ones. Although the meaning of each design is known only to the artist, the intricately carved pieces can stand on their own as sculpture.

After carving the staffs, Philpot applies lacquer and paint as well as decorative elements such as shells, glass, mirrors, and beads. He says that it may take him many months to finish a staff because when the wood says "it's 'pissed off. Don't bother me,' I'll put it aside until it's ready for me to work again."

COLLECTING TIPS Prices for Philpot's work may vary according to the artist's fondness for particular staffs. However, since the quality is uniformly high, selection should be made on the basis of individual taste.

WHERE TO SEE ART Philpot has participated in several shows in and around Chicago, including a 1984 exhibit at the DuSable Museum of African-American History; that museum has also acquired his work for its permanent collection. In 1989 the artist's staffs were featured in "Black Art—Ancestral Legacy: The African Impulse in African-American Art" at the Dallas Museum of Art. Most recently Philpot was included in "Reclamation and Transformation: Three Self-Taught Chicago Artists" at the city's Terra Museum of American Art (1994); an illustrated catalog from the exhibition is available.

WHERE TO BUY ART David Philpot is represented by the Carl Hammer Gallery in Chicago.

109
ELIJAH PIERCE

Born March 5, 1892, Baldwyn, Mississippi. Died May 7, 1984, Columbus, Ohio.

The bas-reliefs of Elijah Pierce are considered to be among the most important American folk carvings of this century. Pierce was a sculptural storyteller, and the subject matter for his work was far ranging—everything from black sports heroes to biblical and political events provided possibilities for his carving knife. Although he is perhaps best known for his

religious carvings—his Book of Wood, a series of thirty-three large reliefs representing Christ's thirty-three years on earth, and *Crucifixion* are generally regarded as Pierce's masterworks—his pieces representing political and social commentary are equally important.

Pierce started carving as a young boy and never stopped. In the 1920s he settled in Columbus, Ohio, and opened his own barbershop with two rooms—one for barbering, the other for displaying his carvings.

COLLECTING TIPS
In addition to the bas-reliefs, Pierce also made some free-standing carvings of figures and animals. Anything by this artist is now considered worth owning; collectors and museums, however, are particularly interested in the early pieces, especially those before about 1975. Although Pierce never lost his vision of the world around him, as he aged he did lose some motor coordination, and that affected his ability to carve with the precision of his youth. The later carvings, though somewhat less defined, are often brighter in color, and their content remains extremely interesting.

WHERE TO SEE ART
The Columbus Museum of Art, which contains the largest and best collection of Pierce's work (including the *Crucifixion* and Book of Wood series), mounted a major retrospective, "Elijah Pierce, Woodcarver," in 1993. The exhibition, which contained more than 170 pieces and traveled to a number of venues, was accompanied by a comprehensive catalog. Examples of his carvings may also be found in the Miami University Art Museum, Oxford, Ohio; the Museum of International Folk Art, Santa Fe; the Milwaukee Art Museum; and the Ohio State University Museum, Columbus.

WHERE TO BUY ART
Pierce's carvings are sometimes for sale in prominent folk art galleries such as the Janet Fleisher Gallery in Philadelphia. Major auction houses also occasionally may have pieces available.

110
RICHARD
SAHOLT

Born February 22, 1924, Minneapolis, Minnesota. Now resides Minneapolis.

Richard Saholt creates collages to address his grievances against the federal government, grievances that include war, crime, and intolerance. In getting his message across, Saholt makes what doctors call "psychotic art" and he calls "graphics." Whatever they are called, his works are intentionally disturbing, and sometimes even frightening. The collages are composed of cut-out pictures from magazines and other printed material that are then glued to posterboard to form messages concerning the failure of government and the carnage present in America. "The government keeps me on a merry-go-round, but I keep fighting my case," he explains.

Saholt says that, after years during which he did not know what was wrong following frontline service in World War II, he has now been diagnosed as having chronic paranoid schizophrenia. "In 1964," he relates, "the government sent me a batch of forms, so I made collages of my grievances, photocopied

them, and sent the copies back. They laughed in my face but I kept doing it." But the government officials don't always laugh. In 1981 Saholt sent a graphic of the Kennedy assassination to the Reagan White House, which disturbed the authorities.

COLLECTING TIPS The artist has sold colored photocopies of his collages in reduced sizes. Although interesting, these are of little monetary value compared to the collages themselves. A collector fortunate enough to obtain a collage will possess a rare work.

WHERE TO SEE ART After many years of struggle, recognition has at last—and deservedly—come to Richard Saholt, a true "outsider" artist. A number of his collages have been included in psychology textbooks, and his work was featured in an article in *Raw Visions, International Journal of Intuitive and Visionary Art*, No. 9, Summer 1994.

A major work by Saholt is in the permanent collection of the American Visionary Art Museum, Baltimore.

WHERE TO BUY ART Saholt says that someday he will sell his collages, but at present he has only sold one. He occasionally gives them away or, as noted above, sells photocopies.

▌▌▌
CARTER TODD

Born April 2, 1947, Indianapolis, Indiana. Now resides Madison, Wisconsin.

Small, tight, and fanciful drawings, Carter Todd's trademark, depict in detail the buildings and churches with which he is familiar in Madison; occasionally he will also render buildings he has seen on television. These painstakingly drawn but not totally realistically colored pencil-and-pen renditions of architectural subjects give the feeling that the maker is desperate to escape from his environment but doesn't know where to go or how to proceed.

In fact, Carter Todd has had a difficult life. "I never bothered to learn to read. When I was sixteen they said, 'You graduated,'" he says. He started to draw while in a center for alcohol treatment in the early 1980s. Later, at an AA meeting, "people said 'your art is good,' and told someone at the Civic Center about me. Now, at least, I got something to do every day."

COLLECTING TIPS Todd's drawings are small, generally on letter-size paper or cardboard. They will not appeal to collectors who believe that bigger is better, but collectors who specialize in works on paper will be intrigued by these unusual drawings, and a number of major folk art collectors from all regions of the country are quietly buying them up.

Sometimes a drawing will show a mark where a coffee cup has been carelessly placed, and there will be tack holes in those that have been hung on Todd's walls to keep him company, but that's just par for this kind of folk art.

WHERE TO SEE ART We saw Todd's drawings for the first time in the home of Baron and Ellin Gordon in Williamsburg, Virginia, and other major collectors also hold his work.

Carter Todd's drawings have been exhibited at the Madison Art Center, Madison, Wisconsin, and the Haggerty Museum of Art, Marquette University, Milwaukee.

WHERE TO BUY ART Carter Todd is represented exclusively by the Dean Jensen Gallery in Milwaukee.

112
WESLEY WILLIS

Born May 31, 1963, Chicago, Illinois. Now resides Chicago.

Wesley Willis captures a bus rider's perspective of the Windy City; the landscape is elongated and sometimes blurred as though it were seen through the window of a moving vehicle. He says that he makes "city art," and where could there be a better place to make it than the streets of Chicago, with its ballparks, the navy pier, the lakeshore, the skyline dominated by the famous John Hancock Building? "I take the bus around and around," he says. "I love the buildings and music."

At night Willis does make music. He plays a synthesizer in Chicago's country rock and roll clubs, but, he muses, "I got no daytime work, so I go out on the streets and make and sell art, that's my job. The police all know me and leave me alone."

COLLECTING TIPS Pick your favorite Chicago landmark, and it is almost certain that Willis has drawn it. Trains and architecture are his specialties.

Willis's drawings are done with crayons on large pieces of posterboard; he prints his name and the identity of the landmark or the roadscape he has drawn on each work.

WHERE TO SEE ART Wesley Willis can often be found drawing in Chicago's Loop area or on Michigan Avenue. His work was included in "Eureka!" a 1993 show organized by Intuit in Chicago.

WHERE TO BUY ART Willis will sell his work to those who can find him on Chicago's streets. Some galleries carry his work, including Bruce Shelton Folk Art in Nashville, and HMS Gallery in New York City.

Wesley Willis

113

JOSEPH ELMER YOAKUM

Born February 20, 1886 or 1888, place unknown (perhaps Arizona). Died December 25, 1972, Chicago, Illinois.

Joseph Yoakum's unique pastel-colored drawings show fluid dreamscape visions of places visited or claimed to have been visited by the artist. Yoakum was a storyteller who felt that "mystery" increased the value of his art. Mystery does, indeed, pervade his work and lend a sense of unreality to the drawings, even though the places the artist so neatly and precisely labeled in his flowing script are real. But did he visit them, as he claimed, or was it make-believe? We may never know for sure, but, as Whitney Halstead, a teacher at the Art Institute of Chicago for many years who befriended this artist, has said, it is clear that Yoakum's imagination "extended the geography of his experience further still."

Mystery pervades the life of Joseph Yoakum just as it pervades his work. He sometimes referred to himself as an "old black man" but at other times claimed to have been a Navajo ("a full-blooded Nava-joe Indian," as he said), born on the reservation in Window Rock, Arizona; there are, however, no records to substantiate his Navajo heritage. What we do know is that after years of a peripatetic life Yoakum settled in Chicago probably during the late 1950s, that he began drawing in the early 1960s at a command from God, and that his drawings have had a lasting impact on a number of now well known contemporary artists who met him in the 1960s and 1970s while they were students at the Art Institute of Chicago.

COLLECTING TIPS

Joseph Yoakum's work is held in high esteem by the art world in general. He did a few portraits, mostly of popular personalities, and historical figure studies, but in general his reputation rests upon his pastel dreamscape drawings.

Most of his works carry an identification of the scene depicted, his signature, his address and a handwritten or stamped date, and occasionally a copyright notice. Those drawings with such descriptive material are the most valuable, but any Yoakum is worth having.

WHERE TO SEE ART

In 1972 the Whitney Museum of American Art in New York City had a show, "Joseph E. Yoakum," of this artist's work. Yoakum's drawings have been included in many exhibitions and illustrated in numerous catalogs, including *Transmitters: The Isolate Artist in America* (1981); Jane Livingston and John Beardsley, *Black Folk Art in America, 1930–1980* (1982); and *Made in USA: Collection of Chuck and Jan Rosenak,* Collection de l'Art Brut, Lausanne, Switzerland (1993).

The Art Institute of Chicago has more than one hundred Yoakums in its collection and in 1995 mounted a show from its holdings, "Force of a Dream: The Drawings of Joseph E. Yoakum." Yoakum's work is also in collections of the Milwaukee Art Museum and the Smithsonian Institution's National Museum of American Art, Washington, D.C.

Yoakum's drawings may be found at galleries such as Janet Fleisher in Philadelphia, Carl Hammer in Chicago, and Phyllis Kind in New York City and Chicago. Some of his work also occasionally shows up at auction.

114
ANTHONY
YODER

Born March 1, 1952,
Washington, Iowa. Now resides
Jo Town, Iowa.

The drawings of Anthony Yoder recall stop-action pictures taken through the lens of a child's kaleidoscope or early-morning dreams remembered after waking. His drawings are, however, intended as scriptural messages from God. According to Yoder, "God is like a rocket that explodes inside your head creating beautiful forms and patterns. All I have to do is copy these patterns, adding occasional quotations, to unfold my scriptural paintings." Visions come to Yoder as he reads the Bible late at night, sometimes during the solitude of his night job as a security guard, and he labors slowly to "put them down" and thus preserve their beauty.

Yoder, a member of a full-gospel charismatic Christian church, intends that his work be known for its religious content. "Whether I plan them or not," he writes, "my pictures are my freedom and my partners in prayer."

COLLECTING TIPS Yoder's drawings that incorporate printed matter or spiritual messages (in an angular left-leaning script) are particularly interesting for collectors.

WHERE TO SEE ART In 1995 Yoder's work was included in "Drawing outside the Lines: Work on Paper by Outsider Artists," Noyes Museum, Oceanville, New Jersey. He has also had several gallery exhibitions and is often shown at art fairs. His work is reproduced in the *Iowan* (Summer 1994).

WHERE TO BUY ART Yoder is represented by Sherry Pardee, the Pardee Collection, Iowa City, Iowa, and American Primitive Gallery in New York City.

Ⓜ *museum* Ⓖ *gallery* Ⓞ *other*
**denotes profiled artists*

MUSEUM AND GALLERY GUIDE

ILLINOIS

Art Institute of Chicago Ⓜ
111 South Michigan Avenue
Chicago, IL 60603
(312) 443-3600

A world-class museum with frequently changing exhibitions, the Art Institute of Chicago is a must-visit site for collectors. Although its holdings of contemporary folk art are small in number, the institute does own the work of Henry Darger* and more than one hundred Yoakums* (in 1995 the museum mounted a Yoakum show from its holdings). A few contemporary pieces are often on display in American Decorative Arts.

Chicago Cultural Center Ⓜ
78 East Washington Street
Chicago, IL 60602
(312) 744-6630

Formerly the Chicago Public Library, the Cultural Center, known for its Tiffany dome, has important exhibits of contemporary folk art from time to time, with particular emphasis on Chicago artists such as William Dawson* and Lee Godie*.

Museum of Contemporary Art 🅜
237 East Ontario Street
Chicago, IL 60611
(312) 280-2660

One of the first public institutions to show the work of Chicago artist Lee Godie*, the museum occasionally exhibits contemporary folk art. Its permanent collection includes the work of Henry Darger*, Lee Godie*, Aldobrando Piacenza, Pauline Simon, and Joseph Yoakum*.

Terra Museum of American Art 🅜
664 North Michigan Avenue
Chicago, IL 60611
(312) 664-3939

The Terra Museum, which opened in 1987, has changing exhibitions as well as a display of its permanent collection. In 1994 the museum organized the exhibition "Reclamation and Transformation: Three Self-Taught Chicago Artists," a show that included works by "Mr. Imagination" (Warmack)*, Kevin Orth, and David Philpot*. The museum's future plans include additional folk art exhibitions.

Chicago Center for Self-Taught Art 🅜
The Museum for Folk, Naive & Outsider Artists
Marshall Field's State Street
9th Floor
Chicago, IL 60602
(312) 781 4845

A new museum that opened in November 1994, the non-profit Chicago Center shows regional, national, and international folk art. Among the American self-taught artists included in early exhibitions were William Dawson*, Jamie Nathenson*, and Wesley Willis*. A recent exhibition focused on artists from NIAD (National Institute of Art and Disabilities, Richmond, California), including Sam Gant*.

Carl Hammer Gallery 🅖
200 West Superior Street
Chicago, IL 60610
(312) 266-8512

The Carl Hammer Gallery specializes in high-quality self-taught art. Among the artists represented are Lee Godie*, Dwight Mackintosh*, David Philpot*, Simon Sparrow, Bill Traylor*, Eugene Von Bruenchenhein, "Mr. Imagination" (Warmack)*, and Joseph Yoakum*. The gallery also carries anonymous works from the early part of the century.

Phyllis Kind Gallery 🅖
313 West Superior Street
Chicago, IL 60610
(312) 642-6302

One of the first galleries to specialize in contemporary folk art, the Phyllis Kind Gallery has works by, among others, Stephen Anderson, Howard Finster*, J. B. Murry, Martin Ramirez*, and Joseph Yoakum*. The gallery also has *art brut* works by such European artists as Adolph Wolfli and Carlo (Zinelli). The gallery also has a New York location (see page 67).

Plum Line Gallery 🅖
1511 Chicago Avenue
Evanston, IL 60201
(708) 328-7586

The Plum Line Gallery carries several Appalachian artists: Minnie Adkins*, Charley Kinney*, Tim Lewis*, and Carl McKenzie.

Thomas McCormick Works of Art 🅖
2055 North Winchester
Chicago, IL 60614
(312) 227-0440

Thomas McCormick carries a full range of contemporary art, including folk art. His gallery regularly carries works by Thomas King Baker* and Lee Godie*; he usually has other contemporary folk art on hand, but the artists vary. The gallery often handles estate sales that involve folk art.

Ann Nathan Gallery 🅖
212 Superior Street
Chicago, IL 60610
(312) 664-6622

Ann Nathan represents well-known artists such as William Hawkins*, Mary T. Smith*, and Purvis Young*. In addition she shows newer talents such as Ricky Barnes* and Bart Powers. For that reason interesting work can usually be found in varying price ranges.

Judy Saslow Gallery 🅖
212 West Superior Street
Suite 208
Chicago, IL 60610
(312) 943-0530

A new Chicago gallery, Judy Saslow has works by such contemporary American folk and outsider artists as Howard Finster*, Lee Godie*, and Mose Tolliver*. The gallery also shows Eskimo and African art.

Intuit: The Center for Intuitive and Outsider Art 🅞
P.O. Box 10040
Chicago, IL 60610
(312) 759-1406

Intuit organizes several shows and educational events a year; it also publishes a newsletter. Long-range plans include a permanent facility, but exhibitions are presently held in various gallery spaces, depending on availability.

Bishop Hill State Historic Site Museum 🅞
Bishop Hill, IL 61419
(309) 927-3899

The Bishop Hill State Historic Site Museum, located about two-and-a-half hours southwest of Chicago, displays the work of Olof Krans (1838–1916), an artist known for his portraits and landscapes. The Village of Bishop Hill, originally a colony of Swedish immigrants, includes several other museums, restaurants, working artisans, and gift shops.

IOWA

The Pardee Collection 🅖
Midwestern Folk &
Outsider Art, P.O. Box 2926
Iowa City, IA 52244
(319) 337-2500

The Pardee Collection contains a number of works by Midwestern artists, some relatively unknown and many of whom were discovered by Sherry Pardee. Among the artists in the collection are Clyde Angel*, Emitte Hych, Rollin Knapp, and Anthony Yoder*.

Main Street Antiques and Art 🅞
110 West Main Street, Box 340
West Branch, IA 52358
(319) 643-2065

Primarily an antique shop, Main Street carries some contemporary folk art as well as country Americana. The owner, Louis Picek, is an artist himself and is always on the lookout for new finds.

KANSAS

The Grassroots Art Center 🅜
213 Main Street
Lucas, KS 67648
(913) 525-6118

Newly opened in 1994, the center features, among others, the work of Inez Marshall; the center has about seventy-five of her large sculptures. In addition, the Kansas Grassroots Art Association (KGAA) is loaning the center, on a long-term basis, Ed Root's sculptures. Dinsmoor's fantastic concrete "Garden of Eden" environment is also located in Lucas, and the center will assist visitors in finding other local environments, such as the concrete and rock garden of 95-year-old Florence Deeble. Open seven days a week in summer; in winter, weekends and by appointment.

Kansas Grassroots Art Association (KGAA) ⊙
P.O. Box 221
Lawrence, KS 66044

KGAA no longer operates as a museum; instead, it is concentrating on preserving environments, such as Ed Galloway's totem pole in Foyil, Oklahoma (KGAA is assisting the Rogers County Historical Society in this endeavor). The association is also striving to increase the awareness of grassroots art and its importance.

MICHIGAN

Hill Gallery ⓖ
163 Townsend Street
Birmingham, MI 48009
(810) 540-9288

A gallery that carries contemporary art and twentieth-century folk art, Hill shows the work of Eddie Arning*, Ralph Fasanella, Willie LeRoy Elliot, and Bill Traylor*.

MISSOURI

Galerie Bonheur ⓖ
9243 Clayton Road
Saint Louis, MO 63124
(314) 993-9851

Galerie Bonheur represents about twenty American self-taught artists, including Sylvia Alberts, Reginald Mitchell*, and Lorenzo Scott*. Bonheur also carries Eastern European art and art from Central America.

NEBRASKA

Sheldon Memorial Art Gallery Ⓜ
University of Nebraska at Lincoln
12th & R Streets
Lincoln, NE 68588-0300
(402) 472-2463

The Sheldon Memorial Art Gallery is acquiring a twentieth-century collection of self-taught art. At present, the collection includes works by such artists as Homer Green*, Reggie Mitchell*, Mose Tolliver*, Willie White*, and others.

White Crane Gallery ⓖ
1032 Howard Street
Omaha, NE 68102
(402) 345-1066

White Crane specializes in American crafts; however, the gallery has represented Omaha artist Reece Crawford* since her first show and continues to represent her today.

OHIO

Akron Art Museum Ⓜ
70 East Market Street
Akron, OH 44308-2084
(216) 376-9185

One of the museums presently expanding its holdings of contemporary American folk art, the Akron Art Museum has a fine twentieth-century collection with works by Elijah Pierce*, Minnie Evans*, Anthony Joseph Salvatore, and Ernest "Popeye" Reed, among others. To commemorate Ohio artist Joseph Salvatore's death in 1994, the museum mounted an exhibition of self-taught artists from Ohio in 1995 and dedicated it to Salvatore's memory.

Bingham and Vance Galleries ⓖ
12801 Larchmere Boulevard
Shaker Heights, OH 44120
(216) 721-1711

Bingham and Vance shows work by Okey John Canfield, Ernest "Popeye" Reed, Howard Finster*, and others. The gallery also features ethnographic art and military and Civil War objects.

J. E. Porcelli, American Folk Art and Americana Ⓖ
P.O. Box 200453
Shaker Heights, OH 44120
(216) 932-9087

Porcelli Gallery has works by Albert Wagner, Silvio Zoratti, and several other twentieth-century artists. The gallery also has nineteenth-century works, tramp art, and walking sticks. Open by appointment only.

Columbus Museum of Art Ⓜ
480 East Broad Street
Columbus, OH 43215-3886
(614) 221-4848

The Columbus Museum, known for its outstanding collection of Elijah Pierce* works (which number more than one hundred), mounted a major retrospective of the artist's work in 1993, "Elijah Pierce Woodcarver." The museum is actively collecting twentieth-century material, particularly works by Ohio artists. Other self-taught artists in the collection include William Hawkins*, Ralph Bell*, Ernest "Popeye" Reed, and Smoky Brown*.

Grace Kindig Adult Center Ⓖ
Cerebral Palsy of Columbus
and Franklin County
440 Industrial Mile Road
Columbus, OH 43228-2411
(614) 279-0109

The Grace Kindig Center sponsors an active art program. Formerly the representative of artist Ralph Bell*, works of other program participants, including Tony Hoover and Betty Angel, may be purchased at the center.

Elijah Pierce Gallery Ⓖ
King Arts Complex
867 Mount Vernon Avenue
Columbus, OH 43203
(614) 252-5464

The Elijah Pierce Gallery frequently exhibits folk art and has had shows for Ralph Bell* and Smoky Brown*, as well as its namesake, Elijah Pierce*. The art is sometimes for sale.

It's An Art Gallery Ⓖ
4516 Kenny Road, Suite 119
Columbus, OH 43220

It's An Art Gallery makes a point of carrying local artists. The gallery often has on hand works by such Columbus folk artists as Smoky Brown*, Levent Isik*, and Mary Merrill*. Open by appointment.

William H. Thomas Art Gallery Ⓖ
The Gallery in the Hood
1270 Bryden Road
Columbus, OH 43205
(614) 252-7525

This non-profit gallery, incorporated as the Urban Cultural Arts Foundation, shows trained and untrained artists. Smoky Brown* and Mary Merrill* are among the self-taught artists regularly exhibited. Open Saturdays (1–7 P.M.) and by appointment.

Miami University Art Museum Ⓜ
Patterson Avenue
Oxford, OH 45056
(513) 529-2232

The Miami University Art Museum, housed in a contemporary building, has an extensive collection that ranges from ancient glass to twentieth-century painting and sculpture. It includes works by a number of folk artists—William Hawkins*, S. L. Jones*, Mary Merrill*, Elijah Pierce*, and Anthony Joseph Salvatore, for example. The museum has also sponsored several important exhibitions of contemporary folk art.

Milwaukee Art Museum ⓜ
750 North Lincoln
Memorial Drive
Milwaukee, WI 53202
(414) 224-3200

The Milwaukee Art Museum has an outstanding collection of twentieth-century American folk art. Although portions of the collection date back many years, the museum increased its commitment to contemporary material with its 1989 acquisition of more than 270 objects from the collection of Michael and Julie Hall. Also on display is a strong collection of Haitian folk art.

UWM Art Museum ⓜ
University of Wisconsin
at Milwaukee
3253 North Downer Avenue
Milwaukee, WI 53211
(414) 229-5070

The UWM Art Museum has a growing collection of twentieth-century material, more than 100 pieces at present. Among the artists represented in the permanent collection are Josephus Farmer*, William Dawson*, and "Prophet" William Blackmon. The museum often shows contemporary folk art; in 1994 it organized a one-person show of the work of Carl McKenzie.

Instinct ⓖ
725 North Milwaukee Street
Milwaukee, WI 53202
(414) 276-6363

Instinct, opened in late 1994, is the only gallery in Milwaukee devoted solely to folk art. Among the artists regularly exhibited are Milwaukee's "Prophet" William Blackmon, Rudy Rotter (carvings, assemblages, and drawings), Purvis Young*, and Charley Kinney*. Worth a visit.

Dean Jensen Gallery ⓖ
165 North Broadway
Milwaukee, WI 53202
(414) 278-7100

Dean Jensen handles the work of both fine and self-taught artists. The latter includes such artists as "Creative" DePrie*, Josephus Farmer*, S. L. Jones*, Jamie Nathenson*, and Carter Todd*. Jensen also carries folk art by anonymous artists (sideshow banners, fishing decoys, canes) and a few European *art brut* artists.

Whistling Moon ⓖ
Diane Balsley
8325 Cedarburg Road
Brown Deer, WI 53209
(414) 355-9779

This gallery has a number of southern artists such as Jimmy Lee Sudduth*, Howard Finster*, and R. A. Miller*, as well as S. L. Jones* and "Creative" DePrie*. Various anonymous works, early to mid-twentieth-century, are also for sale. Open by appointment only.

**John Michael Kohler
Arts Center** ⓜ
608 New York Avenue
Sheboygan, WI 53082-0489
(414) 458-6144

Active in the field of self-taught art, the Kohler Arts Center offers changing exhibitions; it also has a growing collection of twentieth-century folk art. Mary Le Ravin* and Eugene Von Bruenchenhein are among the artists represented in depth in the collection.

M
W

THE SOUTHWEST

THE SOUTHWEST—COMPRISING ARIZONA, Colorado, New Mexico, and Texas—is a large geographical area where, for the most part (and particularly in Texas), collectors used to slumber under the mistaken belief that folk art is an eastern or southern phenomenon. But today the *Dallas Morning News*, the African American Museum in Dallas, the Dallas Museum of Art, the Art Museum of Southeast Texas in Beaumont, the Museums of Abilene, the Museum of the Southwest in Midland, and a great legion of collectors are at last waking up the art scene. Folk art is no longer a secret in Texas, and Texans collect and exhibit their local artists with passion.

Recently, when I went through security in the Dallas airport, the security guard exclaimed, "That's a painting by 'The Texas Kid' [Willard Watson] under your arm!" There had been a series of articles in the *Dallas Morning News* about this artist, and the guard was right—I was leaving the state with a bit of Texas as part of my luggage.

Texans have also realized the importance of their folk art environments and have been leading advocates for the preservation of these assets. As a result, many environments in Texas have been well cared for and are open to the public. Jeff McKissack's Orange Show in Houston is a notable example, and the staff at the Orange Show can direct you to other nearby environments, such as the Beer Can House, the Flower Man, and the Sand Man. And in Beaumont, about an hour east of Houston, the Art Museum of Southeast Texas has on display environmental works by Felix "Fox" Harris. That museum also has a noteworthy number of pieces of folk art in its collection, as well as changing exhibitions that often include folk art.

Leslie Muth, a pioneer folk art dealer originally from Houston, who now has a gallery in Santa Fe, New Mexico, shows a variety of work by new folk artists, including a number of those from Texas. She introduced the work of such well-known Texan folk artists as Johnnie Swearingen, Naomi Polk, and more recently, Carl Dixon and David Strickland.

The Webb Folk Art Gallery in Waxahachie, south of Dallas, also exhibits many Texan folk artists, such as the Reverend J. L. Hunter and Xmeah ShaEla'ReEl, among others.

Compared to that in Texas, the folk art scene in Arizona, except for American Indian art, is pale. Arizona institutions as a whole are not collecting contemporary folk art, although several museums have started to include contemporary Navajo work in their collections. For example, the Heard Museum in Phoenix now has a few contemporary Navajo weavings, the Museum of Arizona State University in Tucson has the best collection of Navajo pottery to be found in any public institution, and the Museum of Northern Arizona in Flagstaff has the beginnings of a contemporary Navajo folk art collection.

Arizona as a source of folk art, however, has been an eye-opening adventure for us, and it is ripe for further exploration. We rediscovered two artists there—Frank Bruno and Andrea Badami—and there are others to be found. We had seen Paul Richard's review of Frank Bruno's work in the *Washington Post* in 1968, but we had forgotten about the artist until we got a call from Rebecca Hoffburger, president of the American Visionary Art Museum in Baltimore. "Chuck, Jan," she said excitedly, "Frank Bruno is a neighbor of yours!"

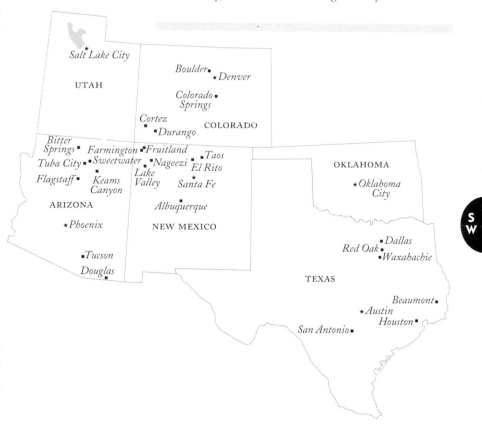

Well, she was a little wrong about the neighbor bit—Bruno lives in Douglas, Arizona, an out-of-the-way and seldom-visited town that is a long, hot drive from our home near Santa Fe—but she was right about the artist. We called him to arrange a visit, and we arrived to find that he had our names emblazoned on the marquee of his Avenue Hotel. Having the opportunity to meet the artist and to see his art in the hotel was well worth the long drive.

The second artist we rediscovered in Arizona was Andrea Badami. He originally lived in Omaha, Nebraska, but had disappeared from our view for many years. Then one Christmas we got a card, saying, "Hi folks, I moved to Tucson. The vegetables they don't grow so good here, but all else fine." It is our pleasure to keep in touch with as many artists as possible, and we had a joyful reunion with the Badamis in Tucson that Christmas; we were able to sample Lena Badami's cookies and buy some of Andrea's paintings.

In New Mexico (also known as the Land of Enchantment), the folk art scene represents three cultures—American Indian, Hispanic, and Anglo. Some of the art is more traditional, but often the work represents a blending of cultures, often with quite dazzling results. Also, in the exhibition of contemporary American Indian and Hispanic folk art, most museums in other parts of the country, in fact, are far behind the museums of New Mexico.

At one time most collectors of American Indian art did not think of the innovative pottery being produced by the Pueblo Indians, the Hopi, and the Navajo as folk art. Today, however, most experts in the field concur that the nonfunctional, nonceremonial art of American Indians comes within the general umbrella of folk art. Helen Cordero of Cochiti, acclaimed for her pottery storytellers, potter Louis Naranjo, also of Cochiti, and Manuel and Arthur Vigil, figurative pueblo potters from Tesuque, for example, are names now well known in this area; they led the way for the many pueblo artists who are just beginning to emerge on the folk art scene. You don't have to leave Santa Fe or the Old Town area of Albuquerque to find work by such renowned artists—all you have to do is stroll through the shops and galleries or spend a little time in the museums—but if you want dirt-track adventures and the thrill of finding new artists, the pueblos along the Rio Grande and the Navajo, Apache, and Hopi reservations are nearby, spread through New Mexico, Arizona, and Utah. And, of course, there is Indian Market every August in Santa Fe, where more than one thousand Indian artists from all over the country exhibit and over 100,000 collectors are usually in attendance.

Collectors of Hispanic folk art usually visit another Santa Fe event, Spanish Market, held each July. The emphasis here is on traditional work, but every year an exciting innovator or two shows up.

The *santero* tradition of carving saints and making *bultos* is

alive and flourishing in New Mexico. The saints made by such early carvers as José Benito Ortega and José Dolores Lopez may be seen in many museums—the Museum of International Folk Art's Hispanic Wing, for one—and are sometimes available in Santa Fe galleries (the William Channing and Dewey galleries, for example), often for a high price. We, however, prefer to collect the work of contemporary carvers, such as the El Rito *santero* Nicholas Herrera.

The animal-carving tradition founded by the great Felipe Archuleta is also alive and well. Leroy Archuleta of Tesuque, New Mexico, is the leading exponent of this genre, but there are many others—such as Ron Rodriguez, Mike Rodriguez, and Jimbo Davila.

The third tradition in New Mexico, Anglo folk art, is not as well represented as the other two, although several artists in or near Santa Fe—Joel Lage, Betty Hutt, and Marcia Muth—are well known and represented by such galleries as Leslie Muth. Pop Shaffer worked in the Mountainair area southeast of Albuquerque, and several figures from the hotel and workshop he built are included in the collection of the Museum of International Folk Art. Tours of Shaffer's environment can often be arranged during the warmer months, and his painted furniture occasionally turns up for sale in Santa Fe.

Colorado is a vacation paradise, but it is worth a visit for folk art, too. We have not as yet discovered many major folk artists working in Colorado; however, there are several important museums in the state, such as the Taylor Museum in Colorado Springs and the Denver Art Museum, as well as galleries in Boulder and Denver. Additional galleries in Cortez and Durango are also excellent sources for contemporary Indian art, jewelry, and pottery.

Thus, although historically folk art was thought to exist mainly in the East and the South, the Southwest clearly is catching up, if not overtaking, these regions. If you want to be there at the right time—now is that time.

I I 5
CONSUELO
"CHELO"
GONZALEZ
AMEZCUA

Born June 13, 1903, Piedras Negras, Mexico. Moved to Del Rio, Texas, 1913. Died June 23, 1975, Del Rio, Texas.

The open spaces in Chelo Amezcua's passionate and mystical designs and the brilliance of her colors reminds the viewer of exotic filigree, but ballpoint pens and paper rather than silver, gold, and lace were her means of expression. The artist herself used the term "Texas filigree art" to describe her narrative drawings of Aztec poets and rulers, muses and mythological figures, many of which were taken from the Bible and other written sources dealing with such exotic places as ancient Mexico, Persia, Spain, and Egypt. Amezcua often also depicted birds and gardens in her art.

Chelo Amezcua was a poet and composer as well as a visual artist. She sometimes included poems and musical scores within the body of a drawing, and messages, poems, and scores are also often to be found on the verso. The artist was more concerned with communicating her spiritual messages to a viewer than with the "proper" way of doing things.

The drawings that contain recognizable central figures (often a Spanish or Mexican female figure, possibly a self-portrait) are generally preferred to Amezcua's abstract work. However, the patterns and filigree designs in all the drawings are extraordinarily beautiful.

WHERE TO SEE ART Chelo Amezcua has had four one-person museum exhibitions, and she has been included in more than sixteen group shows. In 1993 she was included in "Driven to Create," an exhibition organized by the Milwaukee Art Museum. Her work is illustrated in "Filigree Drawings," Marion Koogler McNay Art Institute, San Antonio (1968), and "Mystical Elements/Lyrical Imagery," Del Rio Council for the Arts, Del Rio, Texas (1993).

Amezcua is in the permanent collection of the Smithsonian Institution's National Museum of American Art, Washington, D.C.; the Marion Koogler McNay Art Institute, San Antonio; and the Whitehead Memorial Museum, Del Rio, Texas.

WHERE TO BUY ART Consuelo Amezcua is represented by Cavin-Morris, New York City.

116
JOHNSON
ANTONIO

Born April 15, 1931, Lake Valley, the Navajo Nation, New Mexico. Now resides Lake Valley.

Johnson Antonio is the most celebrated woodcarver on the Navajo Nation, as well as one of the most celebrated in the entire Southwest. He has broken the Navajo taboo against carving likenesses of people and has become the founding father of a new tribal tradition of wood carving. His "dolls" (the name he uses to refer to his sculpture), representations of Navajos carrying out familiar tasks, are dressed for the climate in jeans, trade blankets, and velvet; the harshness of survival in the high, arid region—the Bisti—in which Antonio lives is etched into their faces and mirrored in their posture.

Antonio carves for personal pleasure but also, as he puts it, "I need the money. Unfortunately, the cash will soon be gone, but the dolls will live forever."

COLLECTING TIPS Antonio's early cottonwood carvings, painted with watercolors and *dleesh* (a white clay used by the Navajo to paint their bodies during ceremonies), are probably his best work. *Dleesh* is, however, a very fragile pigment—it is easily rubbed off or dissolved by water—and this must be taken into account in collecting his work.

WHERE TO SEE ART Antonio's carvings have been widely exhibited, and a group of them recently toured the country in "Contemporary Art of the Navajo Nation," an exhibition organized by the Cedar Rapids Museum of Art, Cedar Rapids, Iowa (1994).

The artist is included in the permanent collections of the Museum of American Folk Art, New York City; the Smithsonian Institution's National Museum of American Art, Washington; and the Wheelwright Museum of the American Indian, Santa Fe, New Mexico.

Johnson Antonio's carvings show up in many galleries in the Southwest, but his work can usually be found at the Beasley Trading Company in Farmington, New Mexico, and at the Leslie Muth Gallery in Santa Fe.

117, 118
FELIPE BENITO ARCHULETA AND LEROY RAMON ARCHULETA

Felipe Archuleta was born August 23, 1910, Santa Cruz, New Mexico; died January 1, 1991, Tesuque, New Mexico. Leroy Archuleta was born January 9, 1949, Tesuque. Now resides Tesuque.

Felipe Archuleta is considered to be the founding father of the non-*santero* wood-carving tradition in New Mexico. He claimed that he began carving in response to a command from God, but he chose to carve animals instead of saints because, he said, he "was not worthy to be a *santero*." His ferocious yet delightful animals sometimes are ones that may be seen in New Mexico, and sometimes come from the pages of magazines such as *National Geographic*. Leroy Archuleta has followed in the footsteps of his famous father, but he has added his own personal touches and more refined vision to his lively animal carvings.

Each one of the Archuletas' animals—by father or son—has unique and distinct personality traits. They smile, scowl, bluster, and pose as though they are in the wild, but in spite of their often-aggressive stances, they have the inherent appeal of domestic pets. The carvings range from as small as four inches in height to some that are life-size.

COLLECTING TIPS

Felipe Archuleta sometimes made small black-and-white sketches of his carvings, but in the several years before his death (from around 1987 to 1990), when he could no longer carve because of ill health, he made about two dozen complete drawings of animals in which he used color for the first time. These drawings, which have the same intense quality as his sculptures, are currently popular among collectors who can no longer afford the large sculptures. If you are fortunate enough to obtain one of Felipe Archuleta's carvings, try to obtain a drawing to accompany it.

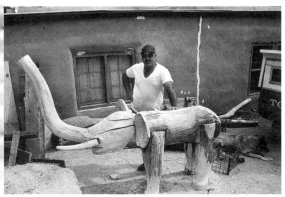

Leroy Archuleta

Felipe Archuleta's rough, fierce carvings and Leroy Archuleta's one-of-a-kind pieces are truly folk art masterpieces. However, some of the animals bearing Felipe's signature, "F.B.A." (particularly those dating from the mid-1970s), were made with the assistance of other carvers who were serving as apprentices to the artist, and this work should be closely examined by experts before purchase. Leroy Archuleta always signs his own work.

WHERE TO SEE ART

The art of the Archuletas is in many museum collections, including those of the Museum of American Folk Art, New York City; the Milwaukee Art Museum; and the Museum of International Folk Art, Santa Fe.

Leroy Archuleta sells his work from his home in Tesuque, New Mexico. The animal carvings of both Archuletas show up in such Santa Fe galleries as the Dewey Gallery, the Leslie Muth Gallery, Davis Mather, and the Rainbow Man. Other galleries (John Hill in Scottsdale, Arizona, and Janet Fleisher in Philadelphia, for example) sometimes have works by Felipe. Leroy's carvings can also be found in several galleries specializing in southwestern art.

119
EDDIE ARNING

Born January 3, 1898, Germania, Texas. Died October 15, 1993, McGregor, Texas.

Eddie Arning's drawings are flights of fancy into a dream world. His paper is filled with bold colors and geometric designs (some of which are representational, while others are highly abstract); these designs, inspired by ordinary objects and illustrated scenes from popular magazines, are transformed by an extremely personal iconography that he invented.

Arning showed symptoms of mental illness (ultimately diagnosed as schizophrenia) at an early age and spent most of his life in institutions. Despite his almost total withdrawal from society, he produced a large body of drawings that are currently considered to be among the best work produced by folk artists in this century.

COLLECTING TIPS Arning often attached copies of the original illustrations that inspired him to the back of his work. If such an illustration is present, even though yellowed and brittle with age, it is extremely important and adds value to the particular drawing.

The artist also numbered his works on the verso, and, by consulting the catalog *Eddie Arning: Selected Drawings, 1964–1973,* approximate dates can be given to his drawings. His peak period is generally considered to be between 1968 and 1972.

WHERE TO SEE ART Arning's drawings are in the foremost museum collections of this type of art. Of particular significance is the collection of his work held by the Abby Aldrich Rockefeller Folk Art Center in Williamsburg, Virginia. The Museum of American Folk Art in New York City also has a number of Arning's drawings.

WHERE TO BUY ART The Hill Gallery in Birmingham, Michigan, the Janet Fleisher Gallery in Philadelphia, and the Leslie Muth Gallery in Santa Fe are especially good sources for the work of this artist.

120
ANDREA BADAMI

Born October 27, 1913, Omaha, Nebraska. Now resides Tucson, Arizona.

Andrea Badami expresses his pent-up emotions concerning religion, politics, and life in general through allegorical and often complex paintings. His lively and colorful oils on unstretched canvas are touched with humor, a love of God, and a recognition of the frailties of the world.

Badami, who was American-born, lived and worked in Italy for a number of years when he was a young man, and in 1940 he was drafted (protesting) into the Italian army, ending up as a British prisoner of war during World War II. After the war he returned to America with his family and worked for the Union

Pacific Railroad until 1978, when he earned his "golden spike" and retired. Today Badami, who began painting in 1960, continues to paint the many stories he has to tell about life for all of us to enjoy.

COLLECTING TIPS Badami's goal is "to paint a masterpiece before I die," and some consider many of his paintings to be masterpieces already. His large canvases are skyrocketing in price, especially his paintings of a fat, unsmiling child. If you cannot afford the larger works, look for a good smaller painting similar in feeling to the larger ones.

Shortly after moving to Arizona (about 1980), Badami painted a series of about twenty western scenes—stagecoaches, cowboys, and the like. These pieces are not his best work.

WHERE TO SEE ART Andrea Badami's paintings are in the permanent collection of the Museum of American Folk Art in New York City and the Smithsonian Institution's National Museum of American Art in Washington.

WHERE TO BUY ART Badami welcomes visitors and will sometimes sell his paintings from his home, depending on limitations that may occasionally be imposed by dealer contracts. His work appears in such galleries as Cavin-Morris and Frank J. Miele in New York City and the Leslie Muth Gallery in Santa Fe.

I 2 I
WILLIAM ALVIN BLAYNEY

Born December 21, 1918, Claysville, Pennsylvania. Died October 19, 1985, Thomas, Oklahoma.

William Blayney, an ordained Pentecostal minister, called on the symbols of popular evangelism—plus his imagination—to fulfill his vocation as a preacher, using his colorful and dramatic paintings as his sermons. Heaven and hell, sometimes puzzling spiritual messages and worldly thoughts, fantastic multiheaded animals, and tormented souls populate his paintings. Blayney also often included numerical notations and biblical quotes in his works.

Blayney was a religious visionary who abandoned his wife and family, moving from Pittsburgh to Thomas, Oklahoma, to pursue his evangelical ministry. There he lived in a small house trailer, using another for a studio where he created the paintings that expressed his concern with the spiritual and moral decay of the world.

COLLECTING TIPS Blayney worked on Masonite and canvas, and some of his paintings are in bad condition, with paint worn from their surfaces. Although these problems are not unexpected and may not substantially lessen the value of an individual work, collectors should try, if possible, to find a Blayney that is in reasonably good condition.

Blayney is known to have painted some diptychs and even triptychs. The paintings, however, have become separated with the passage of time, and an intact diptych or triptych would be a rare find.

William Blayney's paintings are well known, mainly through reproductions. They were recently exhibited in "Made in USA," Collection de l'Art Brut, Lausanne, Switzerland (1993), and "Contemporary American Folk Art" at the Haggerty Museum of Art, Marquette University, Milwaukee (1992); they were also illustrated in the catalogs accompanying the exhibitions. His work has been featured in several other books and catalogs, including *Transmitters: The Isolate Artist in America,* Philadelphia College of Art (1981), and *A World of Their Own,* Newark Museum (1995).

WHERE TO BUY ART Most of William Blayney's visionary art is closely held in private collections. Although there is great demand for his paintings, they are difficult to find on the open market. Since the fall of 1994, however, the Phyllis Kind Gallery in New York City and Chicago has been handling those of Blayney's paintings that are available.

122
FRANK BRUNO

Born March 22, 1925, Douglas, Arizona. Now resides Douglas.

Frank Bruno paints in a very detailed style, using an iconography all his own. He believes in the magic of numbers and in the imminent arrival of an Antichrist, whom he portrays as blond and grinning; he also color-codes his works for the dates he predicts for happenings such as Armageddon. There is so much going on in his paintings and so much detail work that he has been able to complete only twenty-three pieces in the thirty-four years that he has been painting. Although Bruno received accolades from the *Washington Post* after his work was included in a show in 1968—"Bruno's paintings are free of faults . . . a wholly private vision; primitive in the sense of primal" (Paul Richard, June 2, 1968)—he never exhibited his paintings again, and in fact all but disappeared from view.

In the 1980s Bruno inherited the Avenue Hotel, a twenty-nine-bedroom hotel that his mother had owned in Douglas, a small dusty Arizona town on the Mexican border. He maintains this hotel exactly as it was when his mother died—with fresh flowers in the dining room each day, for example—but he doesn't take in guests.

COLLECTING TIPS Some of Bruno's paintings are unfinished, and others he keeps in crates, making them difficult to show. He has sold only one painting, but the collector who could persuade him to sell another would be very fortunate indeed.

WHERE TO SEE ART Frank Bruno was exhibited at the Washington Gallery of Modern Art in 1968. One of his paintings is included in the permanent collection of the American Visionary Art Museum, Baltimore.

WHERE TO BUY ART Bruno is not represented in any galleries. He will receive visitors at the Avenue Hotel in Douglas, but according to the artist we are the only collectors who have gone there to view his extraordinary paintings.

Born September 10, 1976, Gallegos Wash, the Navajo Nation (near Farmington), New Mexico. Resides Gallegos Wash.

Delbert Buck, a young Navajo, combines carved and painted figures with found bits of cloth, beads, and fur to create humorous and satirical constructions. His colorful figures are decked out in Navajo finery: cowboy hats, concho belts, and silver jewelry (sometimes painted, sometimes real trinkets are attached). His cartoonlike characterizations—lively portraits of his Navajo neighbors and politicians—might be riding motorcycles, horses, buffalo, or low riders. Topical current events are also central to much of his art.

The Buck family members are shepherds; they raise sheep and goats, and Delbert helps in this enterprise. He also supplements the family income by picking potatoes in Colorado in the summer as well as through the sale of his art.

COLLECTING TIPS

Just as Delbert Buck helps his family, so, too, do they help him. His father, Wilford, does some of the carving; his brothers Philbert and Larry and his sister Emma help with the decoration and painting. But the ideas are Delbert's, and so the work is credited to him.

Buck's early pieces contained more jewelry and other collaged objects and were done with loving attention to detail. As the artist progressed, however, he began to work more rapidly, and some of his more recent work lacks the spontaneity of the earlier carvings.

WHERE TO SEE ART

Delbert Buck's appealing carvings are illustrated in *The People Speak: Navajo Folk Art* (Chuck and Jan Rosenak, 1994), and he is featured in the traveling exhibition "Contemporary Art of the Navajo Nation" (1994), organized by the Cedar Rapids Museum of Art, Cedar Rapids, Iowa.

WHERE TO BUY ART

Delbert Buck is represented by Beasley Trading Company in Farmington, New Mexico. His work also appears in many galleries in the Southwest, including the Leslie Muth Gallery and the Rainbow Man in Santa Fe. Timpson Creek Gallery in Clayton, Georgia, also carries Buck's carvings.

**S
W**

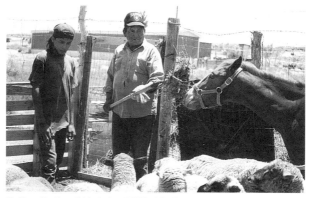

Delbert Buck and his father, Wilford Buck

124
HENRY RAY CLARK

Born October 12, 1936, Bartlett, Texas. Now resides Houston, Texas.

Henry Ray Clark, a compulsive geometric colorist who uses mostly red, black, yellow, and green, fills his paper from edge to edge with his designs. Integrated into the design patterns are the figure and face of a superwoman from another planet whom he calls Robin. Her dark piercing eyes and often scanty costumes are a recognizable trademark of this artist.

Clark, who goes by the street name of Magnificent Pretty Boy, is a "three-time loser"—a term in Texas that translates into many years in prison. At the present time he is not in prison, but neither is he concentrating on his career as an artist. Like so many artists we have met who started their work in prison, Clark did his best drawing while he was behind bars; the one hundred or so drawings that he did in his cell at the Walls Prison in Huntsville, Texas, are considered among the strongest work produced by an imprisoned American artist.

COLLECTING TIPS

Clark's drawings on prison requisition forms, manila envelopes, and whatever else he could get his hands on in prison are his best work. After he was released, he was given higher-quality paper and some of his drawings were larger, but his designs became repetitive, and the work is not considered as collectible as his prison art.

WHERE TO SEE ART

Henry Ray Clark's drawings were included in the exhibitions "It'll Come True" (Artists' Alliance, Lafayette, Louisiana, 1992) and "Passionate Visions of the American South" (New Orleans Museum of Art, 1993); it is also illustrated in the catalogs that accompanied those shows.

Clark's work is in the permanent collection of the Menil Collection, Houston. He recently painted murals on the walls of a space that he opened as a hamburger restaurant (now closed), and additional murals are planned as part of a Department of Housing and Urban Development (HUD) project.

WHERE TO BUY ART

William Steen in Houston sometimes acts as Clark's business agent. At the present time, Clark is not represented by any commercial gallery, although some of his earlier work may be found at the Leslie Muth Gallery, Santa Fe; Cavin-Morris, New York City; and Phyllis Kind, New York City and Chicago.

125
MAMIE DESCHILLIE

Born July 27, 1920, Burnham, the Navajo Nation, New Mexico. Now resides Fruitland area, the Navajo Nation.

Mamie Deschillie is often referred to as a folk art superstar. Her star status came about because she invented or excels in three folk art forms—"mud toys," "cutouts" (sometimes called "cardboards"), and collage paintings of Navajo scenes. Deschillie is known for her innovative use of such raw material as mud, wool, and turquoise as well as discarded long johns. She delights museum audiences the world over with her sense of humor and her theatrical presentations of Navajo life.

Deschillie dresses in the Navajo manner, wears the fine silver and turquoise jewelry for which Navajos are known, and herds sheep and goats. She follows the Navajo Way, and many

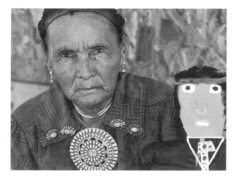

Mamie Deschillie

who meet her find it surprising that all the accolades attached to her work have been earned by a traditional Navajo woman of the older generation.

COLLECTING TIPS We believe that Deschillie's cardboard cutouts are her best work. Some collectors, however, are taken with her recent paintings on board. Her mud toys, though often delightful, are unfired and extremely fragile.

In recent years Deschillie has begun to repeat her more popular subject matter. Thus her later cutouts, while amusing, are not as valuable as her pre-1990 work.

Deschillie does not sign most of her work. When she does add a signature, she generally uses the initials "M.D."

WHERE TO SEE ART Two of Deschillie's large cardboard cutouts were included in an exhibition at the Collection de l'Art Brut in Lausanne, Switzerland (1993), and her cutouts, mud toys, and collage paintings are featured in a traveling exhibition organized by the Cedar Rapids Museum of Art, Cedar Rapids, Iowa, "Contemporary Art of the Navajo Nation" (1994).

Her work has also been included in a number of other museum shows, including ones at the Wheelwright Museum of the American Indian, Santa Fe (1988); the Museum of Northern Arizona, Flagstaff (1990); and the Museums of Abilene, Abilene, Texas (1993).

WHERE TO BUY ART Deschillie is represented by Beasley Trading Company, Farmington, New Mexico, and by the Leslie Muth Gallery and the Rainbow Man, both in Santa Fe. Galerie Bonheur, Saint Louis, and the Timpson Creek Gallery, Clayton, Georgia, also carry her work.

126
CARL DIXON

Born September 29, 1960, Jackson, Mississippi. Now resides Houston, Texas.

Carl Dixon, an African-American, has an unusual and recognizable style; he makes religious paintings—not sculpture—in bas-relief. He prefers not to carve deep into wood, using his knife instead to "sketch out" figures and scenes so they will appear more prominent after oil paint is applied. "I study the Bible," he explains, "and try to share a great thought and catch a great moment."

"Understanding the Bible," Dixon declares, "is a way of life, and I want people to get the complete message. That's why I leave nothing out. My pictures include the frame and a copy of the manuscript."

COLLECTING TIPS Carl Dixon's work fits into the genre of southern visionary painting, and there are a lot of collectors interested in this field. We have found that Dixon's "complete messages" require space and that the smaller paintings are hard to decipher.

WHERE TO SEE ART Carl Dixon was included in "Rambling on my Mind: Black Folk Art of the Southwest," Museum of African-American Life and Culture (now the African American Museum), Dallas, Texas (1987); "Texas Folk Art," Rice University, Houston (1992); and "Works of Art . . . Worlds Apart," New York State Historical Association, Cooperstown, New York (1993).

His paintings are in the permanent collections of the African American Museum, Dallas, and the New York State Historical Association, Cooperstown.

WHERE TO BUY ART Carl Dixon is represented by the Leslie Muth Gallery, Santa Fe.

**1 2 7
WOODY
HERBERT**

Born c. 1926 or 1927, Sweetwater, the Navajo Nation, Arizona. Died August 9, 1994, Sweetwater.

Woody Herbert is a Navajo folk artist known for his carved and painted Brahma bulls as well as other animals that are everyday sights on the Navajo reservation. The bulls proudly bear real goat horns, and goat or sheep wool is used in the genital areas. The bulls stand spindle-legged on thin boards; the larger the bulls or other animals, the stronger their sculptural presence.

Woody Herbert's extended family depend for their livelihood on a small herd of sheep and goats and, to a certain extent, on folk art. Herbert's daughters, Edith Herbert John and Lula Yazzie, as well as his son-in-law, Wilfred Yazzie, have all become artists in the Sweetwater area of Arizona. Each of the Herbert relatives has developed his or her own unique style; their work cannot be mistaken for that of Woody Herbert's.

COLLECTING TIPS Woody Herbert's large carved and painted Brahma bulls are his signature pieces. His other animals—goats, pigs, and horses—have been snapped up since his death and are getting hard to find.

Some of Herbert's animals are painted with *dleesh,* a white clay used by the Navajos to decorate their bodies during ceremonies. While *dleesh* adds interest and authenticity to the sculptures, it is water-soluble, so the object must be handled with care.

WHERE TO SEE ART Woody Herbert is featured and illustrated in *The People Speak: Navajo Folk Art* (Chuck and Jan Rosenak, 1994). His sculpture was included in the touring exhibition "Contemporary Art of the Navajo Nation," sponsored by the Cedar Rapids Museum of Art, Cedar Rapids, Iowa (1994).

Herbert's work is in the permanent collection of the Wheelwright Museum of the American Indian, Santa Fe.

WHERE TO BUY ART Woody Herbert's carved animals can be purchased from Beasley Trading Company, Farmington, New Mexico, and from the Leslie Muth Gallery, Santa Fe.

128
NICHOLAS
HERRERA

Born July 11, 1964,
El Rito, New Mexico.
Now resides El Rito.

One of the best of the current *santeros* (carvers of images of the holy saints), Herrera's carving ability has earned him the title of "El Rito Santero." There is a continuum of religious experience, handed down by generations of *penitente santeros*, in northern New Mexico, and the weight of this tradition now rides upon Nicholas Herrera's shoulders. "I died in a car crash," Herrera explains, "and God brought me back to make saints."

Herrera's creative vision is a contemporary melding of tradition and the changing lifestyle of the region. He creates images that have never been carved before, for example, the figure of death brandishing an automatic weapon (normally, by Hispanic tradition, a woman with bow and arrow) and the fusion of the Trinity into one being.

Herrera has also made some *retablos* (paintings on flat boards) depicting nonreligious subject matter, such as low riders in front of adobe houses.

COLLECTING TIPS The artist recently started making many of his own pigments from local minerals; *santos* painted with these pigments are very desirable.

With his contemporary vision of Hispanic life and culture, Herrera is attracting a large following in the Southwest. His prices are increasing accordingly.

Nicholas Herrera with "Christo"

WHERE TO SEE ART	Herrera's *santos* are hanging in the *moradas* at Abiquiu and El Rito, New Mexico. With special permission, a visit to a *morada* is sometimes possible. Herrera, along with Luis Tapia, another well known *santero* whose work combines contemporary and traditional elements, were featured in the two-person exhibition "*Cruzando Fronteras:* Crossing Boundaries" at the Museum of International Folk Art, Santa Fe (1995). His carvings are also in the permanent collection of the Autry Museum of Western Heritage, Los Angeles, and the Museum of International Folk Art, Santa Fe.
WHERE TO BUY ART	Herrera usually exhibits at Santa Fe's Spanish Market, and his work is carried by the Montez Gallery in Santa Fe. The artist also welcomes visits to his studio in El Rito, where the local restaurant serves an excellent New Mexican meal.

**129
REVEREND
JOHN "J. L."
HUNTER**

Born March 17, 1905, Taylor, Texas. Now resides Dallas, Texas.

The Reverend J. L. Hunter has a Baptist Bible school–patriotic vision of the world, on the one hand idealistic and on the other reminiscent of a South that is no more. His carvings reflect his worldview; he has incorporated a subtle bit of social commentary into many of them, from drunks on a bench to patriotic figures to moon landings, while others—his angels, for example—have religious overtones.

Reverend Hunter is the senior minister of the True Light Baptist Church. His ministry is his true work; his carvings, made from whatever material is at hand, he views as a sideline. All his figures have flat, crude faces highlighted with red paint, and he uses tacks or screws for eyes.

COLLECTING TIPS — Most of the celebrated southern black carvers born at the turn of the century—Elijah Pierce, Josephus Farmer, William Dawson, Steve Ashby—are gone, but Reverend Hunter is still with us, and because of that reason, if for no other (although there are other reasons—the art is charming and fun), we have collected his sculptures.

Hunter will take orders and sometimes repeats popular subjects, such as his Statues of Liberty that he covers with silver glitter. We do not encourage buying his made-to-order objects; try to seek out unique works or the early versions of popular subjects.

Hunter's carvings are usually signed on the base with the printed initials "J.L.H."

WHERE TO SEE ART — Hunter's sculptures have been exhibited at the Art Museum of Southeast Texas, Beaumont (1994), and the Museum of African American Life and Culture (now the African American Museum), Dallas (1993); his work is also included in the permanent collection of the African American Museum.

Hunter's imaginative carvings can be found in most private folk art collections in Texas as well as in numerous other private collections around the country.

(continued on page 253)

115 Consuelo "Chelo"
Gonzalez Amezcua
September, c. 1968. Ink on paper;
16 × 24 in. (40.6 × 61 cm).
MARK MAINWARING AND ROBIN
RUSSELL. COURTESY CAVIN-MORRIS

116 Johnson Antonio
Man Carrying Wood, 1993.
Paint and watercolor on
cottonwood; 16 × 3 × 2 in.
(40.6 × 7.6 × 5.1 cm).
JAY AND DONNA SCHAFF.

117 Felipe Benito Archuleta
Lion, 1977.
Cottonwood, straw, resin,
wire mesh, nails, glue, sawdust,
and paint; 47⅞ × 16 in.
(121.6 × 40.6 cm).
THE MENIL COLLECTION, HOUSTON.
PHOTO: HICKEY-ROBERTSON

118 Leroy Ramon Archuleta
Polka-dotted Camel, 1994.
Wood carving with bristle;
51 × 48 × 12 in. (129.5 ×
121.9 × 30.5 cm).
HENRI AND LESLIE MUTH.

S
W

119 Eddie Arning
We Didn't Need to Talk, 1972–1973.
Oil pastel on wove orange paper;
22 × 32⅛ in. (55.9 × 81.6 cm).
ABBY ALDRICH ROCKEFELLER FOLK
ART CENTER, WILLIAMSBURG.

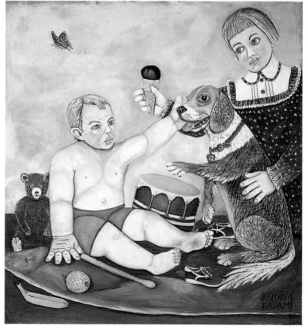

120 Andrea Badami
Untitled, date unknown.
Oil on canvas; 32 × 30 in.
(81.3 × 76.2 cm).
COURTESY LESLIE MUTH GALLERY.

121 William Alvin Blayney
All Rights Reserved, 1969.
House paint on Masonite;
37 × 25 in. (94 × 63.5 cm).
CHUCK AND JAN ROSENAK.
PHOTO: LYNN LOWN

122 Frank Bruno
Behold the White Horse
(triptych), 1970.
Oil on canvas, wood frames
connected by wood sculpture
pieces; 48½ × 83 in.
(123.2 × 210.8 cm).
AMERICAN VISIONARY ART
MUSEUM. PHOTO: RON SOLOMON

123 Delbert Buck
Navajo Couple on Horseback, 1991.
Mixed media (carved and
painted wood, wire glasses,
beadwork, feathers, cloth,
turquoise jewelry, aluminum
foil); man, 26 × 20½ × 7½ in.
(66 × 52.1 × 19.1 cm); woman,
20 × 19 × 7 in. (50.8 × 48.3 ×
17.8 cm).
CHUCK AND JAN ROSENAK.

124 Henry Ray Clark
"The Magnificent Pretty Boy"
*I Am Sabrina from the Planet
Eyeball,* 1992.
Ballpoint pen on manila
envelope; 12 × 15 in.
(30.5 × 38.1 cm).
WILLIAM STEEN.

125 Mamie Deschillie
Giraffe and Rider, 1989.
Cardboard construction;
46 × 25 in. (116.8 × 63.5 cm).
LESLIE MUTH GALLERY.

126 Carl Dixon
Walking on the Sea, 1991.
Carved and painted wood;
9½ × 16 in. (24.1 × 40.6 cm).
ROBERT AND JUDY MACKAY.

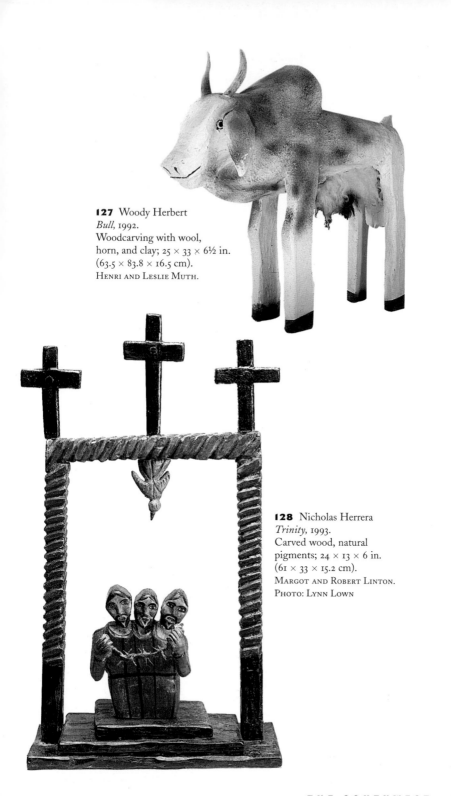

127 Woody Herbert
Bull, 1992.
Woodcarving with wool,
horn, and clay; 25 × 33 × 6½ in.
(63.5 × 83.8 × 16.5 cm).
HENRI AND LESLIE MUTH.

128 Nicholas Herrera
Trinity, 1993.
Carved wood, natural
pigments; 24 × 13 × 6 in.
(61 × 33 × 15.2 cm).
MARGOT AND ROBERT LINTON.
PHOTO: LYNN LOWN

S
W

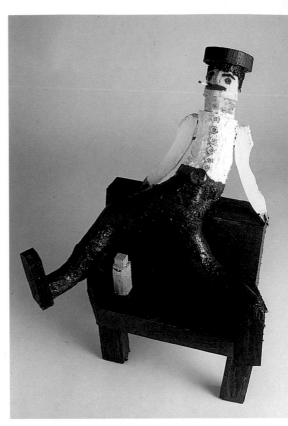

129 Rev. John "J. L." Hunter
Drunk on Bench, 1992.
Mixed media on carved
wood; 18 × 15 × 10 in.
(45.7 × 38.1 × 25.4 cm).
SALLY M. GRIFFITHS.
PHOTO: SALI

130 Christine McHorse
Untitled, 1988.
Fired micaceous clay; 14½ in.
(36.8 cm) diameter.
MR. AND MRS. RICHARD D. BLUM.
PHOTO: LYNN LOWN

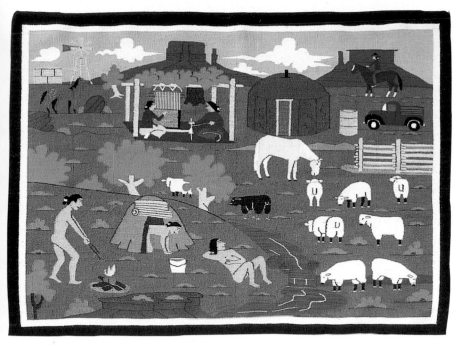

131 Linda Nez
Sweathouse, 1993.
Pictorial rug, commercial yarn;
30½ × 57 in. (77.5 × 144.8 cm).
CHUCK AND JAN ROSENAK.
PHOTO: COURTESY OF CEDAR
RAPIDS MUSEUM OF ART

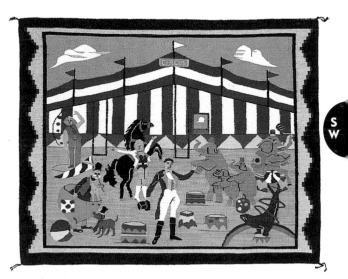

132 Florence Riggs
Circus Scene, 1992.
Pictorial rug, commercial yarn;
34½ × 42 in. (87.6 × 106.7 cm).
THE HEARD MUSEUM.

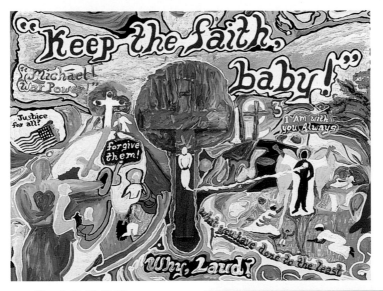

133 Xmeah ShaEla'ReEl
Keep the Faith Baby, 1991.
Enamel paint on wood;
22 × 28 in. (55.9 × 71.1 cm).
WARREN AND SYLVIA LOWE.

134 Isaac Smith
Leopard, 1992.
Carved and painted wood; 17 ×
34 × 13 in. (43.2 × 86.4 × 33 cm).
WEBB FOLK ART GALLERY.

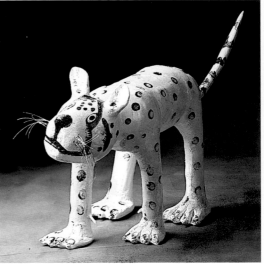

135 David Strickland
Animal, 1993.
Welded metal, auto parts;
39 × 12½ × 11½ in.
(99.1 × 31.8 × 29.2 cm).
CHUCK AND JAN ROSENAK.
PHOTO: LYNN LOWN

136 Rev. L. T.
"Thunderbolt" Thomas
Airplane and Bandito, 1994.
Pencil and crayon on paper;
18 × 12 in. (45.7 × 30.5 cm).
WEBB FOLK ART GALLERY.

137 Willard "Texas Kid"
Watson
Untitled (from Suite of 12 Life
Cycle Drawings), 1985. Colored
marker and pencil; various sizes.
DALLAS MUSEUM OF ART, GIFT OF
THE FRIENDS OF WILLARD WATSON.

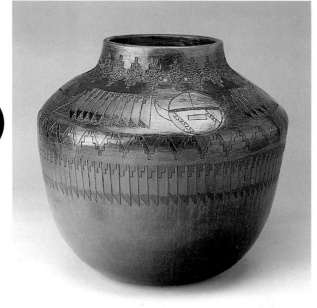

▲◁ **138** Charlie Willeto
Untitled (Figure), c. 1962.
Pine board with house paint,
feathers; 20 × 7 × 3 in.
(50.8 × 17.8 × 7.6 cm).
GREG LACHAPELLE.
PHOTO: LORRAN MEARES

▲▷ **139** Robin Willeto
Three-Headed Skinwalker, 1991.
Carved and painted wood;
36½ × 20 × 9½ in. (92.7 ×
50.8 × 24.1 cm).
HENRI AND LESLIE MUTH.

140 Lorraine Williams
Horned Moons, 1993.
Fired clay with piñon pitch, slip,
incised designs; 10¼ in. (26 cm)
high, 10¾ in. (27.3 cm) diameter.
ROBERT AND DOROTHY WALKER.
PHOTO: LYNN LOWN

(continued from page 240)

WHERE TO BUY ART Hunter welcomes visitors, and he will sell his carvings from his home when he is not conducting a service at his church. Southwestern folk art galleries such as the Leslie Muth Gallery in Santa Fe and the Webb Gallery in Waxahachie, Texas, usually have his work on hand; other galleries include Robert Cargo Folk Art Gallery, Tuscaloosa, Alabama, and the Folk Art Gallery (formerly Cognoscenti) in Baltimore, Maryland.

MYRA TSO KAYE

Born October 4, 1961, Tuba City, the Navajo Nation, Arizona. Now resides Flagstaff, Arizona.

Myra Tso Kaye adds a modern-day vision to the ancient art of Navajo pottery, making a form once dictated by taboos and religious concerns into a contemporary sculptural statement. Kaye was brought up to be a potter; "I learned the Navajo Way from my mother [Faye Tso, a famous potter] and my father [Emmett Tso, a medicine man]—that's the spiritual part," she explains. "When I pot in the Navajo Way, I get a spiritual high, but the art comes from me."

Kaye's pots are both traditional and innovative. She will sculpt a ram's head on the spout of a wedding vase, for example, "but," she says, "the ram is very sacred to the Navajo, so I fill [the vase] with cornmeal so the ram has something to eat."

COLLECTING TIPS Kaye's early work is very similar to that of her mother, Faye Tso, except that the daughter's designs have always been more stylized and modern in appearance. Her recent work, which has evolved into almost pure sculpture, is unlike that of any other Navajo. We prefer her middle period (1987–1991), which is innovative but still shows a family influence. Her early work is signed "Myra Tso," but since her marriage she has signed her pots "Myra Tso Kaye."

WHERE TO SEE ART Kaye's pots are included in "Contemporary Art of the Navajo Nation," a traveling exhibition organized by the Cedar Rapids Museum of Art, Cedar Rapids, Iowa (1994).

WHERE TO BUY ART Myra Tso Kaye exhibits at Indian Market in Santa Fe every August. Her pots are also carried by Keams Canyon Arts and Crafts, Keams Canyon, Arizona, and by the Rainbow Man in Santa Fe.

130 CHRISTINE MCHORSE

Born December 21, 1948, Morenci-Clifton area, Southeastern Arizona. Now resides Santa Fe, New Mexico.

Christine McHorse is a modern Navajo whose work represents a melding of three cultures—Navajo, Pueblo, and Anglo. McHorse states, "I am not bound by Navajo taboo or the demands of the Anglo art/pottery marketplace. I am free to set my own standards. I can explore the beauty and purity of form that can be achieved from micaceous clay [from Taos Pueblo], or I can use elements of Navajo design and legend."

McHorse's work has an elegance and grace of design that sets it far apart from the more traditional Navajo work. Her popularity has risen rapidly in recent years, and it is probably safe to say that she is considered one of the best—if not the best—of the living American Indian potters today.

COLLECTING TIPS	There is no longer any question about this artist—she is one of the truly great potters of her generation. Many dealers prefer McHorse's undecorated kiln-fired, thin-walled, and beautifully shaped vessels. We prefer the pottery pit-fired in the traditional Navajo Way, a method that reveres the almost religious depth of spirit that comes out of the accidental interaction of earth, piñon pitch, and fire.
WHERE TO SEE ART	McHorse's résumé lists four pages of exhibitions, honors, and awards in this country, Germany, and Canada. A pot of hers is currently on display as part of the permanent collection of the Museum of American Indian Arts and Culture in Santa Fe.
	McHorse's pottery is included in "Contemporary Art of the Navajo Nation," a traveling exhibition organized by the Cedar Rapids Museum of Art, Cedar Rapids, Iowa (1994).
WHERE TO BUY ART	In August, come at sunrise to Indian Market in Santa Fe. McHorse has won a blue ribbon every year she has entered the judging, and her work will be sold out by ten o'clock on Saturday morning. Her pottery is also sold at the Case Trading Post, the shop at the Wheelwright Museum of the American Indian, and by Andrea Fisher Fine Pottery, all in Santa Fe.

DEACON EDDIE MOORE

Born January 31, 1913, Longview, Texas. Now resides Dallas, Texas.

Deacon Eddie Moore, a superbly talented carver of wood, works only with knives and chisels, the simplest of hand tools. He can turn almost any flat newspaper photograph of a person or event into an exciting and very decorative three-dimensional sculpture or diorama.

Moore is a deacon at the Greater New Zion Baptist Church. "I used to carve and give away my work to friends and relatives," Moore explains. "After I retired, the Reverend Hunter [John "J. L." Hunter] gave me the connections with collectors and the ideas that set me up in the folk art business." Moore was so grateful that he built a studio for Hunter, whom he had met at a church affair, in his friend's backyard.

COLLECTING TIPS	Collectors bring Moore photographs of political figures, rodeo events, just about anything, and he carves them on commission. Sometimes, if he likes a sculpture—be it a wedding portrait or Bill Clinton with George Bush—he will repeat it. The originals are the most valuable. If the work was not a commissioned piece, the photograph that served as its inspiration sometimes comes with the sculpture; this is an important document to preserve.
	Moore's signature includes "03," the middle digits of his social security number.
WHERE TO SEE ART	Deacon Moore gave a carving of President Clinton to the White House in February 1993. In 1994 he was exhibited at the Art Museum of Southeast Texas in Beaumont. He is included in the permanent collection of the African American Museum in Dallas, Texas.

Deacon Eddie Moore sells most of his sculpture from his home. The Webb Folk Art Gallery in Waxahachie, Texas, carries his work, and other Texas galleries have pieces on hand from time to time.

1 3 1
LINDA NEZ

Artist requested her birth date not be given; born the Navajo Nation, Arizona. Now resides Bitter Springs, the Navajo Nation, south of Page, Arizona.

Linda Nez uses traditional Navajo weaving techniques, but her pictorial rugs are anything but traditional. The artist is not afraid to tackle any subject matter, whether taboo or not; one of her rugs, for example, depicts a Navajo sweathouse, complete with naked Indians in the foreground. Nez likes her weavings to bring out the colors she says she has in her head. "I once saw a traveling carnival from a car window," she relates. "The colors really stuck in my mind, and so I bought the wool and wove my memory."

"[Weaving] is an eight-hour-a-day job—the only job I have, and pictorials are hard work," she says. Because her rugs contain curved lines (in faces, for example) and unusual designs, they take a long time to make; some may take more than six months.

Linda Nez



COLLECTING TIPS The market for Navajo pictorials includes traditional collectors of American Indian art as well as folk art collectors. Linda Nez's unusual pictorials cost many times more than contemporary Navajo rugs in traditional patterns, but the artist is well known and has no trouble selling her colorful rugs.

Nez often weaves her initials, "L. N.," into the lower right-hand corner of her work, "but sometimes I forget," she says. It therefore behooves buyers to be somewhat cautious in selecting a rug if there are no initials.

WHERE TO SEE ART Linda Nez's weavings were included in "The Image Weavers," Wheelwright Museum of the American Indian, Santa Fe (1994), and "Contemporary Art of the Navajo Nation," a traveling exhibition organized by the Cedar Rapids Museum of Art, Cedar Rapids, Iowa (1994). Her rugs are illustrated in the catalogs for those exhibitions.

S W

Nez usually sells her rugs to the Notah Dineh Trading Post in Cortez, Colorado, and they in turn wholesale the rugs to dealers who specialize in innovative weaving, for instance, Cristof's Gallery in Santa Fe.

1 3 2
FLORENCE
RIGGS

Born November 4, 1962, Beryl, Utah. Now resides Tuba City, the Navajo Nation, Arizona.

Florence Riggs is an innovative leader in the new Navajo art movement of pictorial weaving. "I can weave traditionals on order," she explains, "but what I really want to make is pictures that have never been done before." Riggs weaves on an upright loom in the Navajo manner, but her weavings are contemporary in every other aspect. She gets the ideas for her work from magazines and from her own observations of Navajo life and weaves them in colors that can only be obtained from commercially dyed wool. Her subject matter and designs are not limited by tradition or taboo or the marketplace demands of Indian traders. "If one trader doesn't like my rugs, too bad! I'll find another," Riggs says.

COLLECTING TIPS Occasionally in recent years Riggs has put her initials on a rug, but if there are no initials, be somewhat cautious in selecting a rug. Riggs is not the only weaver doing such pictorials, and even traders may not know the name of the weaver because the rug may have been woven by one person and brought in by another.

WHERE TO SEE ART Florence Riggs was included in "The Image Weavers," Wheelwright Museum of the American Indian, Santa Fe (1994), and "Contemporary Art of the Navajo Nation," a traveling exhibition organized by the Cedar Rapids Museum of Art, Cedar Rapids, Iowa (1994).

A weaving by Riggs is in the permanent collection of the Carnegie Museum of Natural History, Pittsburgh, Pennsylvania.

WHERE TO BUY ART The Notah Dineh Trading Post in Cortez, Colorado, buys most of Riggs's rugs, but they also appear at various other trading posts and at galleries in Cortez, Santa Fe, and Chinle, Arizona.

1 3 3
XMEAH
SHAELA'REEL

Born David E. Jones, October 29, 1943, Latania, Louisiana. Now resides Beaumont, Texas.

"I am Xmeah, warrior, divine angel of God," preaches Xmeah ShaEla'ReEl, and his paintings reveal "messages received from God." The paintings are done in bright colors and often use glitter in a manner that is at least superficially reminiscent of the psychedelic 1960s, but this is not the work of a former flower child—it is unique, shamanistic, startling, and moving.

Xmeah and his wife, Cherry, consider themselves shamans; in the late 1970s, under the Lord's direction, they founded a ministry, Children of Christ of America, in their combination home/used clothing store/secondhand shop in Beaumont, Texas. Their flock is growing, and the ShaEla'ReEls publish an illustrated newsletter/calendar, the *Carrium*, that has attracted a wide following among folk art collectors.

COLLECTING TIPS Xmeah ShaEla'ReEl makes many of the frames for his paintings, sometimes applying glitter and paint to decorate them; this adds value to his work. The paintings are not signed: "The signature is in the work," Xmeah declares.

Xmeah's paintings have yet to be shown in the eastern market. When they appear, the price will probably increase.

Cherry paints secondhand Styrofoam wig stands with messages and designs somewhat similar to those of her husband. Her work is also collected, but it is not as valuable as the paintings of her spouse.

WHERE TO SEE ART Xmeah ShaEla'ReEl was included in "It'll Come True," an exhibition with an accompanying catalog sponsored by the Artists' Alliance, Lafayette, Louisiana. His work is included in the collection of the African American Museum in Dallas, Texas, and the Art Museum of Southeast Texas, Beaumont.

There's a sign on the church door of the Children of Christ of America in Beaumont that says, "The door is always open." Frequently Xmeah's paintings are on the walls.

WHERE TO BUY ART Sometimes one of Xmeah's paintings is available in the church. The artist is represented by the Webb Folk Art Gallery in Waxahachie, Texas, and Rena Minar (formerly RM Gallery in Houston, Texas), a private dealer in Tallahassee, Florida. Gasperi Gallery in New Orleans also handles this work. Webb Folk Art Gallery and Rena Minar also have work by Cherry ShaEla'ReEl from time to time.

Xmeah and Cherry ShaEla'ReEl

1 3 4
ISAAC SMITH

Born April 27, 1944,
Winnsboro, Louisiana.
Now resides Dallas, Texas.

Isaac Smith's carved animals, based on ones he has seen in the woods as well as larger ones he knows from books, have a nonrealistic, almost magical quality. Smith says that though his formal education "stopped in the eighth grade," he continued to learn from hunting and walking in the woods. "I trained myself to look at animals—I loved all of them, even the snakes. My animals come alive in my dreams," he explains. And many

of Smith's carvings do, indeed, look like creatures from a nocturnal fantasy; a fierce bulldog might, for example, be a bright purple, while other animals exhibit a benign belligerency that is more appealing than intimidating.

COLLECTING TIPS Isaac Smith's work is highly sought after by collectors for its amusing and decorative qualities, and by museums because his pieces are sure crowd-pleasers.

Although Smith will sculpt animals to order, it is best to try to find his original work; some of his earlier pieces have less of a made-to-order look. The artist has carved several very large animals that are quite remarkable.

WHERE TO SEE ART Since 1988 this artist has been included in many exhibitions in Texas, including "Contemporary American Folk Art," Museums of Abilene (1993); "Texas Black Folk Artists," organized by the Museum of African-American Life and Culture (now the African American Museum), Dallas (1993); and "Outside In," Laguna Gloria Art Museum, Austin (1994).

WHERE TO BUY ART Smith sells his sculpture from his home in Dallas. Galleries and dealers that specialize in Texas art, such as Webb Folk Art Gallery in Waxahachie, Texas, and Rena Minar, a private dealer in Tallahassee, Florida (formerly RM Gallery in Houston), have his works for sale. Epstein/Powell in New York City and Ames Gallery in Berkeley, California, also often carry Isaac Smith's animals.

David Strickland

135
DAVID
STRICKLAND

Born August 26, 1955,
Dallas, Texas. Now resides
Red Oak, Texas.

David Strickland's welded monsters, men from outer space, and big birds—animated by wind power and sometimes illuminated—are made from scrapped farm equipment. They tickle the funny bone and at the same time remind us of technical progress and our throwaway culture. Yesterday's plow once became art in the hands of Picasso; Strickland continues the tradition of making art from all kinds of castoffs that he welds together.

Strickland once earned his living as a welder, but "when times were slow in my area [1989]," he recalls, "I went to the scrap farm yard and made me 'Big Bird' [his first large work]." Today the field next to his house, now filled with scrap iron sculpture, is an intriguing sight. The sculptor often names his creations by the trademark on the piece of equipment that forms the body of his large sculptures. Thus a prehistoric-looking monster made from an Oliver tractor radiator body becomes "Oliver."

COLLECTING TIPS — Strickland's sculpture is perfect for outdoor settings, such as a terrace or garden; he has in fact made a few monsterlike barbecues for patrons. Strickland also welds smaller pieces that can go indoors or outdoors, but the bigger the work, the more attention it draws. The large sculptures are heavy, however, and require careful transportation arrangements.

WHERE TO SEE ART — Strickland's sculpture was included in "Passionate Visions of the American South," New Orleans Museum of Art (1993) and illustrated in the catalog of the same name. His work has also been shown at the Art Museum of Southeast Texas, Beaumont, and the Museums of Abilene, Texas.

Strickland's field of farm equipment art is well worth a detour on the drive between Dallas and Waxahachie, Texas.

WHERE TO BUY ART — Strickland is represented by the Webb Folk Art Gallery in Waxahachie, Texas, and the Leslie Muth Gallery in Santa Fe. These galleries can arrange for large pieces to be made on commission.

136
REVEREND L. T. "THUNDERBOLT" THOMAS

Born October 9, 1904, Calvert, Texas. Now resides in a nursing home in Texas.

Reverend "Thunderbolt" Thomas, a black minister who earned the nickname "Thunderbolt" through his hellfire-preaching sermons, draws pictures of notorious Texas gangsters, the infamous Bonnie and Clyde (Bonnie Parker and Clyde Barrow), Fred Douglas, and Pretty Boy Floyd. In his drawings he depicts these mobsters as though they were paunch-bellied, tin-horn dictators from some banana republic. They ride swayback horses and wear military decorations, while World War I biplanes sometimes pass in review overhead.

Reverend Thomas was pastor of the Mount Pleasant Baptist Church for more than fifty years; he got his education, as he says, "on his knees with the Lord." Reverend Thomas explains his motivation to draw as follows: "All the folks is out gambling, drinking beer, chasing women, and cussing, and so I drawed to keep myself company."

COLLECTING TIPS — To date, Reverend Thomas has been a southwestern secret, but his work may become popular on a larger scale as the artist becomes better known.

Some of Reverend Thomas's crayon drawings have tack holes where they have been tacked to walls; others are wrinkled and torn and even bear fold creases. The quality of his

work is consistent, but the drawings in reasonable condition are preferred. Thomas signs some drawings "L. T. Thomas"; others are unsigned.

As Thomas's drawings are relatively small, it is often more interesting to group several gangsters together on a wall.

Thomas's drawings may be seen at the Webb Folk Art Gallery, Waxahachie, Texas. He was included in "Outside In," Laguna Gloria Art Museum, Austin, Texas (1994).

The Webb Folk Art Gallery is the exclusive representative of Reverend Thomas.

137
WILLARD
"TEXAS KID"
WATSON

Born June 17, 1921, Caddo Parish, Louisiana. Died June 12, 1995, Dallas, Texas.

Until his death in 1995, Willard Watson was perhaps the most famous living folk artist in Texas, and like Texas, he was bigger than life. The legend and stories of the Texas Kid and his days as a cowboy, rounder, and pimp (some true, some not), have been chronicled in his famous Life Cycle Drawings.

Watson's front-yard sculpture garden, an exotic fantasyland of found and transformed objects, often stopped traffic on the road between Love Field (the old Dallas airport) and downtown Dallas. Visitors were both shocked and amused by his root sculptures, suggested by the natural form of found wood, and his conglomeration of discarded mannequins, plaster casts, and animal horns that he transformed into strange and mysterious forms. The Texas Kid is also known for his colorful narrative drawings.

Watson was, however, an enigma; he could be sweet and gentle as well as profane. He claimed to have been married seven times, and he admitted to having been wild in his younger days. Even in his later years, he enjoyed drinking and gambling with his artist friends.

"Texas Kid" (Watson)

Although Watson continued to work until shortly before his death, he had been ill for a number of years, and as a result, his recent production is limited. When he could no longer carve, he would draw when he felt up to it. However, fame has come his way, so if you find something by the Texas Kid, buy it. First choice would be his Life Cycle Drawings.

The Dallas Museum of Art has acquired thirteen drawings from Watson's Life Cycle series; his work is also in the permanent collection of the African American Museum in Dallas and the Museum of International Folk Art in Santa Fe.

The Texas Kid has been included in many exhibitions, including "Rambling on My Mind," Museum of African-American Life and Culture (now the African American Museum, 1987), and "Black History/Black Vision: The Visionary Image in Texas," University of Texas at Austin (1989).

Willard Watson used to sell his work directly from his home, and his friends also sometimes sell Watson objects that they own. The artist generally preferred not to deal with galleries, although the Webb Folk Art Gallery in Waxahachie, Texas, has examples of his work. The Photographic Archives Lab and Gallery in Dallas has had drawings available from time to time.

138
CHARLIE
WILLETO

Born February 20, 1906, Nageezi, the Navajo Nation, New Mexico. Died December 14, 1964, Nageezi.

Navajo folk art has risen to national prominence in the 1990s, and Charlie Willeto was one of the artists who helped pave the way for its broad acceptance. Willeto, the first Navajo known to carve fanciful, idiosyncratic figures of men and women, owls, and other half-imaginary, half-real animals, was a taboo-breaking carver who reasoned his way around the Navajo taboo against making exact likenesses of spirits and people. He did this by making dreamlike, part religious, part spiritual figurative representations with no definitive characteristics attributable to any particular person or spiritual being.

Charlie Willeto lived in a hogan, was a medicine man, herded sheep and goats, and followed the traditional Navajo Way. But his art was neither traditional nor ordinary, and he also instilled the desire to create in his family. His widow, Elizabeth Willeto Ignacio, and three of his sons, Leonard (died 1984), Robin (see below), and Harold, are now also considered groundbreaking Navajo artists.

Although Charlie Willeto did not sign his fanciful carvings, there are many experts who can identify his style and authenticate his work. His animals, especially the owls, are rare, but most collectors, including collectors of American Indian art, are drawn to his three-dimensional figurative pieces.

Charlie Willeto's sculptures are featured in "The Tree of Life," the inaugural exhibition of the American Visionary Art Museum in Baltimore (1995). He is also represented in the

permanent collections of many museums, including the Museum of International Folk Art, Santa Fe; the Denver Art Museum; the Museum of Northern Arizona, Flagstaff; and the Smithsonian Institution's National Museum of American Art, Washington, D.C.

WHERE TO BUY ART The William Channing Gallery in Santa Fe specializes in the work of Charlie Willeto. His carvings also appear at such galleries as Antique Tribal Arts and Owings-Dewey Fine Art, Santa Fe, and the Hill Gallery in Scottsdale, Arizona.

139
ROBIN
WILLETO

Born October 24, 1962, Nageezi, the Navajo Nation, New Mexico. Now resides Nageezi.

Robin Willeto's visionary carving is some of the strongest and most imaginative work being produced today. As with the work of his father, Charlie Willeto, Robin's spirit carvings break Navajo taboos in regard to carved images; they are nontraditional in every sense. "I see witch spirits in my dreams," Robin relates. "They have white faces and glaring eyes; I carve them." He has carved a spirit bear on its hind legs, with its paws raised to strike; a skinwalker (or witch); a catlike person decorated with an owl design; and even a three-headed person.

Willeto lives in the family hogan, and when he isn't carving, he is herding a small flock of sheep and goats.

Robin Willeto

COLLECTING TIPS Robin Willeto is a member of an artistic family; his father's carvings formed a bridge between the traditional and modern art of the Navajo, and his mother Elizabeth and his brothers Leonard (died 1984) and Harold have all also carved. Robin, however, is considered the most innovative of the surviving family members. He and his brother Harold have somewhat similar styles, but they each sign their own work so that identification is not difficult.

Recently, so-called visionary art has been in vogue; Robin Willeto's carvings appeal to collectors of this genre as well as collectors of American Indian art.

WHERE TO SEE ART Robin Willeto's carvings have been included in various museum shows in the Southwest, including exhibitions at the Wheelwright Museum, Santa Fe; the Museum of Northern Arizona, Flagstaff; and the Museums of Abilene, Texas. Willeto is also in "Contemporary Art of the Navajo Nation," a traveling exhibition organized by the Cedar Rapids Museum of Art, Cedar Rapids, Iowa (1994); his work is illustrated in the catalog for that exhibition.

WHERE TO BUY ART Robin Willeto's spirit carvings are carried by the Beasley Trading Company in Farmington, New Mexico, and by the Leslie Muth Gallery in Santa Fe.

140
LORRAINE
WILLIAMS

Born November 1, 1955,
Sweetwater, the Navajo Nation,
Arizona. Now resides
Cortez, Colorado.

The *yei* figures and horned moons usually seen in Navajo sandpaintings are some of the trademark taboo-breaking designs on the pottery made by Lorraine Williams. A traditional Navajo in other ways, Williams experiments with designs and slips (russets and yellows) as well as shapes that are delicate but innovative. On occasion she even abandons the vessel shape entirely, making hollow cylindrical pieces with design elements—like bear claws—that mysteriously break through the surface.

Williams married into the famous family of Navajo potters headed by the clan matriarch, Rose Williams. Her sister-in-law, Alice Cling, is the best-known Navajo potter in Arizona. "I'd stand around watching my mother-in-law," Williams says, "pretending that I wasn't. And then I'd go home and try." Like her in-laws, she makes her pottery in the Navajo way, building up coils of clay, shaping them, then smoothing the finished ware with a Popsicle stick or river stone. The pottery is fired in an open pit—where it comes in contact with ash, bluish black discolorations called "fire clouds" appear—then coated with melted piñon pitch inside and out.

COLLECTING TIPS Navajo pottery has risen in price at a rapid rate since 1990, as it has been discovered by collectors of more traditional Pueblo and Hopi pottery as well as folk art collectors. We believe that this trend will continue for some years. Look for innovation in the work—for example, Lorraine Williams's most valuable pieces are those with unusual designs and shapes.

S W

WHERE TO SEE ART Williams was included in "Contemporary Art of the Navajo Nation," a traveling exhibition organized by the Cedar Rapids Museum of Art, Cedar Rapids, Iowa (1994), and her pottery is illustrated in *The People Speak: Navajo Folk Art* (Chuck and Jan Rosenak, 1994).

WHERE TO BUY ART Lorraine Williams exhibits at the Indian Market in Santa Fe, and her pottery is sold in galleries in Santa Fe—Packard's Indian Trading Company, Trader West, and Cristof's, for example—and as far west as Los Angeles.

MUSEUM AND GALLERY GUIDE

ARIZONA

Museum of Northern Arizona (MNA) M
3001 Fort Valley Road
Flagstaff, AZ 86001
(602) 774-5211

A museum popular with collectors of American Indian art, the MNA collection includes some works by Navajo folk artists Charlie Willeto* and Ronald Malone, as well as other well-known and emerging American Indian artists. Until recently, the museum sponsored three summer shows, Zuni, Hopi, and Navajo, but in 1994 the shows were combined into one event (check scheduling). The museum also has a fine gift shop, frequented by tourists and serious collectors alike.

Sacred Mountain Trading Post G
U.S. Route 89, north of Flagstaff
(HC Box 436)
Flagstaff, AZ 86004
(602) 679-2255

Bill Beaver, the proprietor of Sacred Mountain Trading Post, was an early collector of contemporary Navajo pottery, an activity he continues to this day. This trading post is a wonderful source for the work of folk artists such as Alice Cling, Louise Goodman, and the Manygoats family (Betty and her children).

McGee's Indian Arts G
(formerly Keams Canyon Arts and Crafts Gallery)
State Route 264
Keams Canyon, AZ 86034
(602) 738-2295

The Keams Canyon Trading Post has been run by the McGee family since 1938. Its upstairs art gallery specializes in Hopi and Navajo textiles, sandpaintings, and pottery, including work by Navajo potters Faye Tso, Myra Tso Kaye*, and Ida Sahmie, and Hopi potters such as Iris Nampeyo.

Heard Museum M
22 East Monte Vista Road
Phoenix, AZ 85004-1480
(602) 252-8840

The Heard, a museum of southwest culture, is known for its fine collection of American Indian art, including the Goldwater Kachina Doll Collection. The museum schedules changing exhibitions on a regular basis; it has an extensive pottery collection and a number of contemporary Navajo pictorial rugs by such artists as Linda Nez* and Florence Riggs*. The Heard's permanent collection also includes Hispanic art.

John C. Hill Gallery G
6962 East 1st Avenue
Scottsdale, AZ 85215
(602) 946-2910

The Hill Gallery specializes in early Navajo and Pueblo textiles, historic Pueblo pottery, Southwestern baskets and Kachina dolls. It also carries some contemporary folk art, including the carvings of Navajo artist Charlie Willeto* and Tesuque artist Felipe Archuleta*.

Arizona State Museum M
University of Arizona
Park Avenue and
University Boulevard
Tucson, AZ 85721
(602) 621-6302

Arizona State Museum has a large collection of contemporary Navajo pottery, one of the most important collections of this type of material that is available to the public.

COLORADO

Art Adventure ◧
Folk & Outsider Art
1510 Columbine Avenue
Boulder, CO 80302
(303) 449-1320

Art Adventure handles a wide variety of folk and outsider art. Works by Burgess Dulaney*, Leon Kennedy*, and Dwight Mackintosh* are carried on a regular basis.

Taylor Museum for Southwestern Studies (Colorado Springs Fine Art Center) ◪
30 West Dale Street
Colorado Springs, CO 80903
(719) 634-5581

The Taylor Museum has one of the most definitive collections of *santos* and *bultos* anywhere, ranging from the late seventeenth century to the present. Contemporary *santeros* whose work is represented in the collection include Charles Carillo, Marie Romero Cash, and Felix Lopez.

Notah Dineh ◧
345 West Main Street
Cortez, CO 81321

Notah Dineh is a source for unusual and innovative Navajo pictorial rugs (by weavers Florence Riggs* and Linda Nez*, for example). From time to time the gallery has a few pieces of folk art by artists such as Navajo Delbert Buck*.

Denver Art Museum ◪
100 West 14th Avenue Parkway
Denver, CO 80204
(303) 640-2295

In addition to its contemporary art collection, Denver has an interesting collection of southwestern folk art and a very fine collection of American Indian art. Although the American Indian collection does not include many contemporary pieces, the Denver Art Museum does have on display two carvings by Navajo Charlie Willeto*.

Brigitte Schluger Gallery ◧
265 Detroit Street
Denver, CO 80206
(303) 329-3150

Brigitte Schluger exhibits contemporary art and folk art. In addition to periodic folk art exhibits, she usually carries works by David Alvarez, Mike Rodriguez, and Colorado artist Bill Potts. The gallery also features tramp art.

Toh-Atin Gallery ◧
145 West 9th Street
Durango, CO 81301
(970) 247-8277

An Indian arts gallery, Toh-Atin has a large supply of Navajo rugs, including pictorials. Yazzie animals and sculptures by Lawrence Jacquez can also be found at the gallery.

NEW MEXICO

Albuquerque Museum ◪
2000 Mountain Road, NW
Albuquerque, NM 87103
(505) 243-7255

The Albuquerque Museum has a number of pieces by Hispanic artists, including Felipe* and Leroy Archuleta*, Frank Brito, and Horacio Valdez. The permanent collection includes works by American Indian artists, and it exhibits folk art on a fairly regular basis; it shows art from its own collection and also books traveling exhibitions. In 1995, for example, the museum hosted "Contemporary Art of the Navajo Nation."

Adobe Gallery ◧
413 Romero, NW
Albuquerque, NM 87104
(505) 243-8485

The Adobe Gallery has long been known for its pottery, particularly storytellers by Cochiti artists Helen Cordero and Louis Naranjo. The gallery has a broad selection of Navajo textiles, as well as a collection of Pueblo pottery and other American Indian objects.

Beasley Trading Company ▣
113 East Main Street
Farmington, NM 87401
(505) 327-5580

Indian trader Jack Beasley was an early discoverer of folk artists such as Johnson Antonio* and Mamie Deschillie*. He has promoted Navajo folk art from his Farmington gallery; his son Jason deals privately in Flagstaff, Arizona, and may open a gallery in the near future (602-774-7714). Beasley Trading Company also handles work by other American Indian artists such as Delbert Buck* and the Hathales.

Museum of International Folk Art ▣
706 Camino Lejo
Santa Fe, NM 87505
(505) 827-6350

The Museum of International Folk Art houses a large collection of contemporary American folk art as well as folk art from other countries; the famed Girard Collection is on permanent display. The Spanish Heritage Wing of the museum, opened in 1988, exhibits Spanish Colonial and Hispanic folk art from the museum's collection.

Museum of Indian Arts and Culture/Lab of Anthropology ▣
710 Camino Lejo
Santa Fe, NM 87505
(505) 827-6344

The museum serves as an exhibition facility for the very large collection of the Lab of Anthropology, which includes prehistoric, historic, and contemporary basketry, textiles, pottery, and artifacts by American Indians. Items from the collection are rotated, but a pottery exhibition that includes pieces by contemporary potters such as Navajo Christine McHorse*, has been on display for several years and may become permanent.

Wheelwright Museum of the American Indian ▣
704 Camino Lejo
Santa Fe, NM 87505
(505) 982-4636

Founded in 1937 by Mary Cabot Wheelwright and Navajo medicine man Hastiin Klah, the museum is shaped like a Navajo hogan, or home. The Wheelwright, which features changing exhibits, has a number of contemporary folk artists in its collection, including Johnson Antonio*, Sheila Antonio, and Mamie Deschillie*. The museum also collects contemporary Navajo weavings, including pictorials. Many of Hastiin Klah's sandpainting weavings are a part of the permanent collection. The Case Trading Post, the museum store, always has high-quality objects on hand.

Antique Tribal Arts ▣
536 Old Santa Fe Trail
Santa Fe, NM 87501
(505) 820-2941

Opened in 1995, Antique Tribal Arts specializes in American Indian, African, and Oceanic art. The gallery also has works by the Navajo carver Charlie Willeto*.

Joshua Baer ▣
116½ East Palace Avenue
Santa Fe, NM 87501
(505) 988-8944

A specialist in classic American Indian art, Joshua Baer carries a few pieces of contemporary folk art, such as muslin sandpaintings by Bruce and Dennis Hathale and crows by the Yazzie family.

William E. Channing Gallery ▣
53 Old Santa Fe Trail
Santa Fe, NM 87501
(505) 988-8984

A dealer in American Indian art since 1972, W. E. Channing also has works by Eddie Arning* and Charlie Willeto*, as well as other Hispanic, American Indian, and some anonymous folk art.

Cristof's 🄶
106 West San Francisco
Santa Fe, NM 87501
(505) 988-9881

A gallery specializing in southwestern art, Cristof's has fine textiles, including an excellent selection of pictorial rugs by the best of the Navajo weavers. Rugs by weavers Florence Riggs* and Linda Nez*, among others, can often be found here.

Dewey Galleries and Owings-Dewey Fine Art 🄶
74 East San Francisco Street
2nd Floor
Santa Fe, NM 87501
(505) 982-8632

Dewey and Owings-Dewey exhibit paintings and sculpture, American Indian art and textiles, Spanish colonial furniture and *santos;* the galleries are listed here because Owings-Dewey handles contemporary carvings by Luis Tapia and the drawings of Felipe Archuleta*.

Andrea Fisher Fine Pottery 🄶
221 West San Francisco
Santa Fe, NM 87501
(505) 986-1234

Andrea Fisher carries the best of the Southwestern American Indian potters, including Navajo potters Christine McHorse* and Ida Sahmie.

Davis Mather Folk Art Gallery 🄶
141 Lincoln Avenue
Santa Fe, NM 87501
(505) 983-1660

New Mexico animal woodcarvings, folk, American Indian, Hispanic, and "unpredictable" art are the focus of the Davis Mather Gallery. Mather has personally collected Felipe Archuleta's* work; he handles a number of contemporary animal carvers, such as Ron Rodriguez and Wilfred and Lula Yazzie.

Montez Gallery 🄶
125 East Palace Avenue
Santa Fe, NM 87501
(505) 982-1828

The Montez Gallery shows New Mexican art and furniture. Some of the artists represented by the gallery are the late Horacio Valdez, Nicholas Herrera*, Luisito Lujan, and George Lopez. The gallery has a wide selection of *retablos* and *bultos.*

Leslie Muth Gallery 🄶
225 East de Vargas
Santa Fe, NM 87501
(505) 989-4620

The Leslie Muth Gallery specializes in southwestern folk art, artists from Texas (Henry Ray Clark*, Carl Dixon*, and Ike Morgan) and New Mexico (Felipe* and Leroy Archuleta*, Ron Rodriguez, and Joel Lage), and Navajo folk art (Delbert Buck*, Mamie Deschillie*, Dennis Pioche, and Robin Willeto*, for instance). In addition, the gallery carries folk art from other parts of the country, including work by Levent Isik*, Justin McCarthy*, Greg Pelner*, Rodney Rosebrook*, and Mary T. Smith*. The gallery sponsors a Navajo exhibition on an annual basis. In our opinion, it is the best folk art gallery in the Southwest.

Okun Gallery 🄶
301 North Guadulupe
Santa Fe, NM 87501
(505) 989-4300

Primarily a gallery of contemporary arts and crafts, the Okun Gallery occasionally shows folk art, such as painted cutouts by Mo.

Packard's Indian Trading Company 🄶
61 Old Santa Fe Trail
Santa Fe, NM 87501
(505) 983-9241

One of *the* places to find American Indian material, Packard's has an excellent selection of Pueblo and Navajo pottery. The trading company has storytellers by Louis Naranjo of Cochiti and pottery by Navajo Lorraine Williams*, among others.

**S
W**

Rainbow Man G
107 East Palace Avenue
Santa Fe, NM 87501
(505) 982-8706

A first-class American Indian art gallery, Rainbow Man also has a selection of Navajo and other folk art, including Delbert Buck* and Mamie Deschillie*. The gallery has a few pieces by Tobias Anaya. A place to look for interesting finds.

Millicent Rogers Museum M
1504 Museum Road
(5 miles north of Taos)
Taos, NM 87571
(505) 758-2462

Opened in 1956, the museum collection is largely based on material collected during the 1940s by Millicent Rogers—American Indian textiles, basketry, jewelry, pottery, and paintings. The collection has been expanded to include contemporary American Indian pottery and Hispanic folk art. Among the Hispanic artists in the collection are George Lopez, Luis Tapia, and Horacio Valdez. The museum store has a sizeable collection of folk art, both American Indian and Hispanic.

Taos, NM G

The historic town of Taos has more than 40 art galleries, most of which are located within several blocks of the Plaza. Although no one gallery features contemporary folk art as such, pieces do turn up from time to time. Make inquiries at the galleries on the Plaza.

TEXAS

Art Museum of Southeast Texas M
500 Main Street
Beaumont, TX 77701
(409) 832-3432

The Beaumont Museum has a small collection of folk art, including the work of local artists Xmeah ShaEla'ReEl* and Rosalie Pinto. It also has a collection of works by Felix "Fox" Harris, some of which are on display in an outdoor courtyard.

African American Museum M
3536 Grand Avenue
(P.O. Box 150153)
Dallas, TX 75210
(214) 565-9026

The Billy R. Allen Folk Art Collection at the African American Museum has works by more than fifty artists in its rapidly expanding folk art collection. Housed in a new building that opened in 1993 at Fair Park, the museum's permanent collection of folk art already numbers over 200 pieces. The museum also schedules exhibitions of African American folk art.

Dallas Museum of Art M
1717 North Harwood
Dallas, TX 75201
(214) 922-1200

Although primarily a fine arts museum, Dallas has acquired some folk art, including thirteen drawings from the Life Cycle series of "Texas Kid" Watson* and work by Bessie Harvey*. The Dallas Museum of Art has also organized exhibitions that include folk art, such as "Black Art—Ancestral Legacy: The African Impulse in African-American Art."

Valley House Gallery G
6616 Spring Valley Road
Dallas, TX 75240
(214) 239-2441

Largely a traditional fine arts gallery, Valley House also shows paintings by Velox Ward and Clara McDonald Williamson.

The Menil Collection M
1515 Sul Ross
Houston, TX 77006
(713) 525-9400

The permanent collection of the Menil contains some work by folk artists such as Felipe Archuleta*, Eddie Arning*, Henry Ray Clark*, Frank Jones, and Bill Traylor*.

The Orange Show ◙
2401 Munger Street
(Off I-45, Telephone Road Exit)
Houston, TX 77219
(713) 926-6368

Flags fly, wheels spin, and awnings flap in the breeze in The Orange Show, an environment created by Jeff McKissack, who died in 1980. McKissack, a mailman in downtown Houston, built his environment with concrete block, tiles, wagon wheels (for oranges), and pieces that he scavenged from old Houston structures being torn down, such as fire escapes, roof tiles, and other decorative elements. Various special events are presented at The Orange Show. Open from Memorial Day to Labor Day, 9 A.M.–1 P.M. Wednesday, Thursday, and Friday, and 3–8 P.M. Saturday and Sunday. Between Labor Day and Memorial Day, the environment can be seen on weekends; call for hours.

Webb Folk Art Gallery ◙
209 West Franklin Street
Waxahachie, TX 75165
(214) 938-8085

Only a short drive south of Dallas, the Webb Folk Art Gallery in Waxahachie has the work of most of the emerging Texas artists—Xmeah ShaEla'ReEl*, Isaac Smith*, David Strickland*, Rev. L. T. Thomas*, and a new find, Mark Cole Greene—as well as that of more established Texans like Rev. Johnnie Swearingen and "Texas Kid" Watson*. The gallery also has a wide assortment of folk art from other parts of the country, including the "Rhinestone Cowboy" (Bowlin)*, Burgess Dulaney*, Sulton Rogers*, and "Artist Chuckie" Williams*, to name a few. Worth a detour from Dallas.

THE WEST

ALTHOUGH FOLK ART IS WIDELY KNOWN AND collected in most of the country, the term "folk art" is still relatively new to the West. In Los Angeles and San Francisco, in Seattle and Portland, however, a few adventurous dealers have established footholds, and a few museums have begun to show and collect folk art. Thanks is also owed to the state of California for its farsighted programs that help the mentally and physically disabled to develop their individual potentials in the arts.

We call the art of the mentally and physically handicapped that is created in the organized and controlled environment of an institution "workshop art." Workshop art is folk art, but much of it lacks the qualities that set great folk art apart from the run-of-the-mill, and there is a risk in collecting it; you also need to be an experienced collector and to have a trained eye to find the diamond in the rough. However, there are collectors who specialize in this type of art, and the art of the severely handicapped can teach us much about the human condition.

California is the place to learn about workshop art. At the Creative Growth Art Center in Oakland and the National Institute of Art and Disabilities (NIAD) in Richmond, some of the best of the seriously handicapped artists are working. Dwight Mackintosh, for example, who works at Creative Growth, may be considered one of the most important workshop artists in this country. Nothing and no one can distract him from his task of making art or interfere with the process. He didn't even look up from his work when my camera flashed. We have collected his art in depth and also the work of Donald Paterson, another Creative Growth artist. At NIAD, we found the mysteriously brooding paintings of Sam Gant and the colorful work of Juliet Holmes, among others. We have no hesitancy in recommending the art of these highly creative individuals.

There are some pitfalls to be aware of in workshop art, however, not least of which is its institutionalization. At a minimum, workshops supply basic materials and some instruction

on their use. In some cases (not at Creative Growth or NIAD), institutions go beyond this threshold of merely supplying materials, and instructors may intrude on the process of making art itself. We heard one professional artist/instructor telling a student what color to use next and where to place it on his paper, and another even referred to the art of a seriously autistic patient, which had been well received in New York, as a "collaboration." However, we believe that collectors should be aware of workshop art and visit the artists and sales shops.

In southern California, Liz Blackman is one of the most knowledgeable and adventurous dealers. In Los Angeles, where we thought folk art did not really exist, she discovered Greg Pelner and Raymond Chavoya; she introduced Eileen Doman at the Outsider Art Fair in New York in 1994 and gave Thomas King Baker, Philip Travers, and others their first West Coast exhibitions. It was Liz Blackman who sent us to see Leon Kennedy in Oakland; we were the first collectors to meet this artist in his "studio."

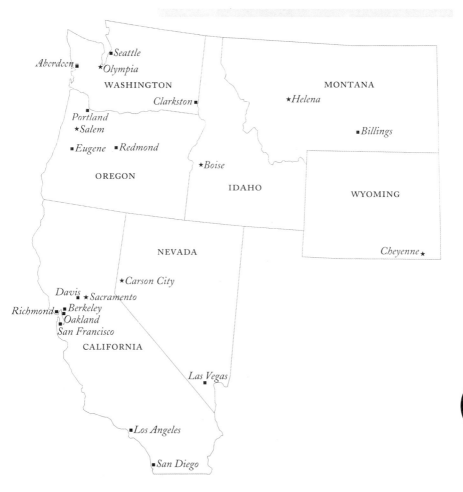

Kennedy lives in two rooms in a tenement-type house, complete with the not-unusual urine-smelling stairwell. But if you persevere and climb those stairs to enter his room, what a treat is in store! The walls, the windows, the floor, and the bed are all covered with stacks of intricately painted bedsheets—large tapestrylike paintings of central-city life taken from the artist's experiences in Houston and daily events around him in Oakland. The fabric of the everyday lives—from domino players in a local bar to children and mothers sitting on stoops or praying in church—of southern blacks who have migrated north and now live in ghettoized inner-city areas comes to life before your eyes in Kennedy's paintings. He is also a preacher and has a sermon to go with every detail depicted in his paintings.

We were also fortunate enough to have visited Rodney Rosebrook at his museum and home in Redmond, Oregon, before his death in 1994. Like much of Kennedy's work, Rosebrook's reflects memories of his youth, but Rosebrook's vision was about as dissimilar from Kennedy's as the high country of Oregon is from Oakland's inner city. Rosebrook's work tells of the simpler life of the buckaroo on the bunchgrass plains, dependent only on his horse and handmade tools. Rosebrook filled the interior of his barn with so many handmade implements that it became a museum dedicated to the western way of life, and he fashioned a fence from more tools and buggy wheels salvaged from the scrap heap. The fence and museum are gone now (they exist only in photographs), but the New Redmond Hotel has decorated its ballroom with remnants of Rosebrook's fence, and some of his individual collage sculptures are available at the local gallery/antique store.

Several other important West Coast galleries and dealers should be mentioned; for example, MIA in Seattle, Washington, and Jamison/Thomas in Portland, Oregon. Both have been at the forefront in showing new and important self-taught artists. MIA introduced the work of Terry Turrell, and Jamison/Thomas was one of the first to exhibit Jon Serl's work. Both galleries presently show the interesting painting-collages of Anne Grgich.

In the San Francisco Bay Area, Bonnie Grossman of the Ames Gallery in Berkeley has long shown the work of self-taught artists such as Alex Maldonado, along with a wide selection of tramp art, quilts, and anonymous works. Ruth Braunstein of the Braunstein/Quay Gallery in San Francisco represents Ted Gordon and several other folk artists.

As is the case in most other regions, there is no such thing as a "western" style of folk art. Although there seems to be somewhat more workshop art to be found in California, the art of the region is as diverse as the region itself—Simon Rodia and Jon Serl worked in the West, as did Martin Ramirez and Rodney Rosebrook. What we can tell you is, if you go West, give it some time, ask a few questions, don't be hesitant to

(continued on page 281)

141 Raymond Chavoya
Untitled, 1994.
Mixed media on cloth; 79 ×
47½ in. (200.7 × 120.7 cm).
LIZ BLACKMAN GALLERY.

142 Larry Clark
I Feel So Sick I Cannot Eat, 1994.
Pastel on paper; 18 × 26 in.
(45.7 × 66 cm).
JOHN NATSOULAS GALLERY.
PHOTO: MARK BULLARD

W

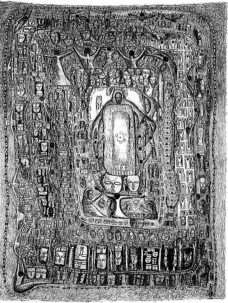

144 Theodore "Ted" Gordon
Royal Anomaly, 1993.
Ink on board; 14 × 14 in.
(35.6 × 35.6 cm).
BRAUNSTEIN/QUAY GALLERY.

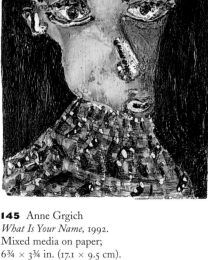

145 Anne Grgich
What Is Your Name, 1992.
Mixed media on paper;
6¾ × 3¾ in. (17.1 × 9.5 cm).
JAMISON/THOMAS GALLERY.

146 Leon Kennedy
*When There Is No Vision,
The People Parish*, 1993.
Mixed media on cloth; 69 ×
53½ in. (175.3 × 135.9 cm).
LIZ BLACKMAN GALLERY.

147 Dwight Mackintosh
Three Figures, 1988.
Mixed media; 20 × 28 in.
(50.8 × 71.1 cm).
CREATIVE GROWTH ART CENTER.

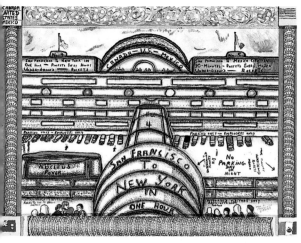

148 Alexander A. Maldonado
San Francisco to New York in One Hour, 1969.
Oil on canvas; 21½ × 27½ in.
(54.6 × 69.9 cm).
NATIONAL MUSEUM OF AMERICAN ART, SMITHSONIAN INSTITUTION, GIFT OF HERBERT WAIDE HEMPHILL, JR., AND MUSEUM PURCHASE MADE POSSIBLE BY RALPH CROSS JOHNSON.

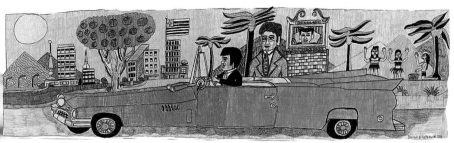

149 Donald Paterson
Elvis, the Artist, and Pink Cadillac, c. 1992.
Paint, pencil, and watercolor on paper; 15 × 49 in.
(38.1 × 124.5 cm).
CHUCK AND JAN ROSENAK.
PHOTO: LYNN LOWN

150 Greg Pelner
Female Nude, c. 1993.
Oil on canvas; 24 × 20 in.
(61 × 50.8 cm).
Collection of Henri and Leslie
Muth. Photo: Lynn Lown

151 Stephen Powers
*Department of Defense Lift
Off Building,* 1992.
Acrylic on canvas; 18 × 24 in.
(45.7 × 61 cm).
MIA Gallery.
Photo: Richard Nicol

152 Martin Ramirez
Courtyard, c. 1953.
Pencil and colored pencil
on paper; 40½ × 36 in.
(102.9 × 91.4 cm).
THE ANTHONY PETULLO
COLLECTION OF SELF-TAUGHT AND
OUTSIDER ART.

153 Raymond "Bad Ray
Komer" Raymond
Birth, c. 1990.
Acrylic on Masonite; 48 × 24 in.
(121.9 × 61 cm).
DOUBLE K GALLERY/KRALJ SPACE.

154 Simon "Sam" Rodia
Watts Towers (Detail),
Los Angeles, 1921–1954.
Mixed media environment
(cement, bottles, dishes,
seashells, mirrors, steel rods,
and other found objects);
as high as 99½ ft. (30.3 m).
Marvin Rand

155 Rodney "Rod" Rosebrook
Untitled, 1978.
Welded and painted steel and
iron; 35 in. (88.9 cm) diameter.
Chuck and Jan Rosenak.
Photo: Lynn Lown

156 Jon Serl
A Windy Day, 1988.
Oil on board; 48 × 32 in.
(121.9 × 81.3 cm).
KURT GITTER AND ALICE YELEN.

157 John Stoss
Everett Maddox on Carrolton,
c. 1990.
Watercolor on paper; 18 ×
24 in. (45.7 × 61 cm).
DEBORAH AND MIKE LUSTER.

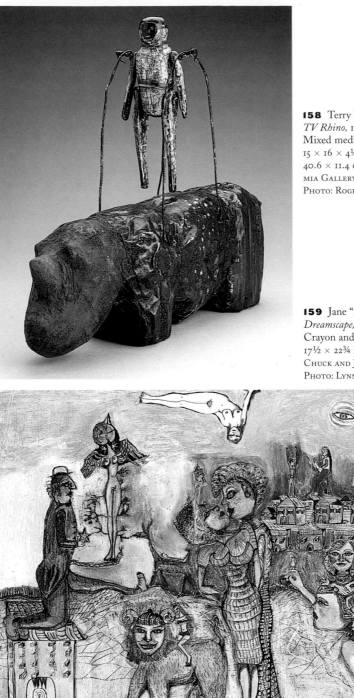

158 Terry N. Turrell
TV Rhino, 1994.
Mixed media sculpture;
15 × 16 × 4½ in. (38.1 ×
40.6 × 11.4 cm).
MIA GALLERY.
PHOTO: ROGER SCHREIBER

159 Jane "in vain" Winkelman
Dreamscape, 1985.
Crayon and ink on posterboard,
17½ × 22¾ in. (44.5 × 57.8 cm).
CHUCK AND JAN ROSENAK.
PHOTO: LYNN LOWN

(continued from page 272)
strike out in new directions—and the risk takers will come home with great art.

JIM BAUER

(see illustration on page 3)

Born April 10, 1954, Portland, Oregon. Now resides Alameda, California.

Jim Bauer

Jim Bauer's robotlike figures suggest a kitchen come to life in a nightmare. The kitchen-utensil personalities he parades before us remind one of friends and family miniaturized and cast in aluminum. They are not, of course, intended to be real people—or are they? Bauer won't let us in on his secret.

Bauer started out as a junk dealer and worked his way up to flea market entrepreneur. He began to collect cast-off aluminum coffeepots, salt shakers, gears, and almost anything he could find made of this durable and shiny metal. In a seemingly natural progression, he began to assemble the bits and pieces of his collection into humanoid objects. Glass and reflectors were added to the works so that they could be illuminated from within and glow in the dark. "I'd just pick up the pieces of aluminum and hardware and something would come to me," he explains of his work.

Initially the kitchenoid figures were sold at the same flea markets that provided the source of Bauer's raw material.

COLLECTING TIPS

Our personal favorites are those of Bauer's sculptures that contain lights, giving the works a feeling of an inner mystical glow.

Bauer is part of a younger generation of folk artists who are more or less dependent on their art for a livelihood. Some purists are not willing to recognize this new group as folk artists, but we think that entrepreneurial folk art is just one of the new/old directions the field is now taking. There is no rule that says that a folk artist must only create art for art's sake and not for profit, and the folk artist as entrepreneur is not a new notion—as any study of eighteenth- and nineteenth-century limners will show!

WHERE TO SEE ART

Jim Bauer's sculpture is included in "Recycle, Reuse and Recreate," an exhibition sponsored by the United States Information Agency, which traveled to fourteen African countries in 1995.

WHERE TO BUY ART

Jim Bauer is represented by the American Primitive Gallery in New York. His figural sculptures often appear at folk and outsider art fairs.

DUKE CAHILL

Born July 30, 1920, Sacramento, California. Now resides Sacramento.

Duke Cahill has built himself a unique midcity hideaway—a place where he can escape from family, business, and the minor annoyances that can plague us all. Cahill's hideaway is, however, not one that would suit everyone's tastes; it is populated with monster-size people and animals—women, dinosaurs, and whales, among others—that he has built out of used storage tanks covered with plaster and coated with fiberglass. Several of these tall statues light up—the breasts of his moon lady (sixty feet tall), for example, shine like stars in the night sky.

Cahill, a former professional prizefighter turned swimming-pool contractor, states that he has always collected things that his wives (he has had two) would not find room for in their houses. "I take whatever I can get hold of," he declares, "barrels, tanks, wagons, and turn them into things from my imagination." His former ranch house now resembles a museum, filled with collectibles and prizefight mementos of all sorts in addition to his fantastic statues.

COLLECTING TIPS The artist has created a fantasyland for his own amusement. The objects are not for sale.

WHERE TO SEE ART Cahill's environment is strictly a personal retreat that he will sometimes share with visitors. However, an appointment is needed to get inside the gate, which is kept locked. A photomural and several smaller pieces from his environment were included in "Cat and Ball on a Waterfall: 200 Years of California Folk Painting and Sculpture," an exhibition put together in 1986 by the Oakland Museum, Oakland, California.

WHERE TO BUY ART Although Cahill does not sell his creations (many of which are, in any event, too heavy to move), a visit to his environment is a memorable event. You can call him directly for an appointment.

1 4 1

R A Y M O N D
C H A V O Y A

Born April 5, 1929,
Oakland, California.
Now resides Los Angeles.

Big fast cars, central-city apartments teeming with spiffy dressers, and the forgotten and lonely living under freeway interchanges—all make up part of the Hispanic cultural scene in Los Angeles that Raymond Chavoya paints. Chavoya himself is part of this scene and dresses and looks like the players he portrays in his paintings, people spilling out of buildings and into the streets in order to take in the brightly colored low riders cruising by and the women dressed to attract attention.

Chavoya is part of the Hispanic scene in Los Angeles, but he is also different. He has been classified as mildly developmentally retarded, and he considers his job to be painting. Each day he takes public transportation from his home to the Art Center run by the Exceptional Children's Foundation (the center has only adults in its program, however), where he spends his time working on art. Chavoya has been in this program since the early 1980s.

Raymond Chavoya

COLLECTING TIPS Chavoya is an exciting new talent, especially for those collectors looking for work that expresses the Hispanic experience; they should follow Chavoya's career. At this time Chavoya's oils on board are stronger than his watercolors on paper.

WHERE TO SEE ART Raymond Chavoya's expressionistic paintings of Hispanic culture have been exhibited at art fairs in New York City and Chicago.

Chavoya is represented exclusively by the Liz Blackman Gallery, Los Angeles.

1 4 2
L A R R Y C L A R K

Born September 18, 1954,
Lafayette, Louisiana.
Now resides San Francisco.

Pain and suffering—the memories of a cruel existence in the rural South—comprise the sometimes hard-to-take subject matter of Larry Clark's brightly colored pastels and gouaches. "I don't do pictures of people having fun," he explains. "I do pictures of the hard times." His paintings can be classified as memory painting or, more properly, as a new form of social realism; the usual romantic remembrances found in memory painting that gloss over discomfort and unhappiness are missing. What Clark remembers are the homeless, the sick and the poor, and discrimination. Clark believes that all black Americans should come to grips with their southern heritage; "It's where their roots live—not in Africa."

The artist got his first break in 1989 when he began participating in the art program of Hospitality House, a Tenderloin community center in San Francisco.

COLLECTING TIPS Some of Clark's art may be shocking and uncomfortable to view, but these paintings, as social commentary, are apt to be the most valuable in the long run.

WHERE TO SEE ART *Time* magazine chose a portrait by Clark, *Homeless in America*, for the December 17, 1990, cover of its international edition; this work is now in the permanent collection of the Smithsonian Institution's National Portrait Gallery, Washington, D.C. Clark was also featured in a well-illustrated article in *Image*, a magazine of the *San Francisco Examiner*, May 23, 1993. The artist has been included in over twenty-five local exhibitions since 1989.

WHERE TO BUY ART Larry Clark is represented by the John Natsoulas Gallery, Davis, California, and the Ames Gallery, Berkeley, California.

1 4 3
S A M U E L G A N T

Born December 9, 1954,
San Francisco, California. Now
resides Richmond, California.

A dark, brooding cacophony of symbols, repeated letters, and numbers, Samuel Gant's paintings have the look of a television screen in need of repair. In fact, many of Gant's images are related to television as well as the artist's private inner world. We try to understand them but, as with other forms of abstract art, are uncertain of their exact meaning; nevertheless we remain intrigued by their brilliance of form.

Gant spends much of his spare time in front of a television set, but he is hard of hearing and has difficulty speaking, so his thoughts can only be communicated to us through the "constant rhythm of his jabbing [brush] strokes which suggest the deep resonance of drum beats." (Quoted in *The Creative Spirit*, the catalog for the show of the same name.)

Samuel Gant began painting about 1988, when he began to work at the National Institute of Art and Disabilities (NIAD) in Richmond, California.

W

COLLECTING TIPS

Although some workshop art appeals only to collectors of the art of the handicapped, Gant's abstracted images have far greater attraction than the therapeutic work of most developmentally disabled persons, and a broad audience should respond to

143 Samuel Gant
Shark, 1990s.
Paint on paper; 23 × 30 in.
(58.4 × 76.2 cm).
AMERICAN PRIMITIVE GALLERY.

them. Gant's paintings can be exhibited as abstract folk art without mention of his disability.

WHERE TO SEE ART

The work of Samuel Gant was included in the exhibition "The Creative Spirit" (Richmond, California, 1990), which has been traveling the country; it is also illustrated in NIAD's catalog for that show. Gant's paintings have been exhibited at the Oakland Museum, Oakland, California; the University of California at Davis; the Very Special Arts Gallery, Washington, D.C.; and in a 1995 exhibition at the Chicago Center for Self-Taught Art. His work was also included in "Visions from the Left Coast: California Self-Taught Artists," Santa Barbara Contemporary Arts Forum, Santa Barbara, California, in 1995.

WHERE TO BUY ART

NIAD has sales centers in San Francisco and Richmond, California. American Primitive in New York City also handles Gant's work.

144
THEODORE
"TED" GORDON

*Born June 23, 1924,
Louisville, Kentucky. Now resides
Laguna Hills, California.*

Ted Gordon is known for his compulsive style and for his singular theme of the human face in infinite variety. Gordon fills his paper or posterboard with obsessive line drawings and spirals in black-and-white and in brilliant color—he calls them "doodles." "When I draw something," he explains, "I am that person, fish, or bird." Although Gordon draws some animals (cats and dogs, birds and fish), the majority of his doodles resolve themselves into a human face—his own. His self-portraits are of a person in torment, never at ease or repose.

COLLECTING TIPS

Throughout his artistic career Ted Gordon's "doodles" have been of consistently high quality, although some consider his early drawings, done on the back of posters advertising the San Francisco opera, as his benchmark work. The Collection de l'Art Brut in Lausanne, Switzerland, has mounted a number of Gordon's obsessive drawings together in large groupings, and the result is spectacular.

Gordon's drawings were initially recognized as belonging within the definition of *art brut* in Europe, and he was collected on the Continent prior to gaining acceptance in America. The French phrase *art brut* roughly equates with what we call "outsider art" in this country, and American collectors of this currently popular genre would want to include Gordon in their collections. He is a personal favorite of ours.

Where to See Art	Ted Gordon had a one-person show at the Collection de l'Art Brut in Lausanne, Switzerland, and he was the only American included in a recent show there, "Les Obsessionnels." His work was also included in "Visions from the Left Coast: California Self-Taught Artists," Santa Barbara Contemporary Arts Forum, Santa Barbara, California, in 1995. Gordon's drawings are in the permanent collections of many museums: L'Aracine, Neuilly-sur-Marne (near Paris); Collection de l'Art Brut, Lausanne, Switzerland; the Museum of American Folk Art, New York City; the Smithsonian Institution's National Museum of American Art, Washington, D.C.; the Milwaukee Art Museum; and the Laguna Museum of Art, Laguna Beach, California. The American Visionary Art Museum, the newly established museum in Baltimore, has several hundred of Gordon's drawings.
Where to Buy Art	Ted Gordon is represented by the Braunstein/Quay Gallery in San Francisco, and the Luise Ross Gallery in New York City.

145
ANNE GRGICH

Born May 18, 1961, Harbor City, California. Now resides Seattle.

"Tortured psychological realism" is the name some have given to Anne Grgich's unique style. However, the artist notes, "I love people." She goes on to explain that she "collects faces in my mind and the faces I have stored up come out, depending on my mood. I couldn't afford paint, so I collected art magazines and incorporated collage images into my work." Grgich builds up her surfaces with a combination of paint and cutout images that give the viewer the feeling of looking through the skin of the portrait into the very soul of the subject. According to the artist, "the layers of surface give each face its mood and setting."

Grgich admits to being influenced by the famous German constructivist Kurt Schwitters (1887–1948). "He'd ride around on a bicycle collecting magazines," she said, "and I do the same thing." Grgich works on her kitchen table, putting together her collage portraits while she functions as a single parent. "I am proud of the fact that I can support us through the sale of art," she declares.

Collecting Tips	Grgich is part of a younger generation of untrained artists who are, nevertheless, aware of academic art. Folk art styles and our understanding of them are constantly changing. It is our belief that collectors should also broaden their horizons and begin to recognize this next generation of artists, or they may fall behind as the field moves ahead.
Where to See Art	Grgich has had more than twenty-five shows in the Seattle-Portland area. In 1987 she was included in a group show at the Whatcom Art Museum, Bellingham, Washington. Her work can also be found in the Outsider Artist Archives in London.
Where to Buy Art	Grgich is represented by MIA Gallery, Seattle, and by the Jamison-Thomas Gallery in Portland.

ALAN KELLER

Born November 26, 1951, Lewiston, Idaho. Now resides Clarkston, Washington.

Alan Keller lives in the dreamlike world of the moderately autistic, communicating primarily through a series of remarkable paintings that he cannot explain. Keller obsessively paints his companions, the imaginary youth of the Snake River Valley in Washington. The world he tells us about is inhabited by what he calls "teenage wrestlers," who face the viewer with frozen smiles or present equally frozen profiles. Shirtless cowboy wrestlers wearing red chaps, bicycle-riding wrestlers, and even bathers are often present in his works. The young men that he paints are given names, and they may play an important role in his dreams, but we cannot quite decipher what their parts might be.

Keller's "teenage wrestlers" play and posture under clear blue western skies and in front of recognizable landmarks of his hometown, Clarkston, on Washington's beautiful Snake River. Although he stores away travel brochures, maps, and advertisements from many places, his paintings always feel like southeastern Washington.

COLLECTING TIPS

Keller's pictures can be enjoyed for what they are—beautiful surreal paintings that take one into another world—or the viewer can attempt to understand the fantasies of an autistic artist. Either way, pleasure may be obtained from these bright works.

WHERE TO SEE ART

Keller was discovered by Victor Moore, a local artist, who was asked to judge an exhibition of the Clarkston Valley Art Association in 1991. Keller was an exhibitor in that show, and he sometimes has exhibited at other regional events.

Keller's work has been exhibited and well received at the Outsider Art Fair in New York City.

WHERE TO BUY ART

Keller is represented by the MIA Gallery in Seattle.

146
LEON KENNEDY

Born September 10, 1945, Houston. Now resides Oakland, California.

Leon Kennedy's paintings—huge murallike works filled with detailed scenes from black inner-city life—are tapestries taken from his youthful memories of life in a Houston ghetto as well as from what he sees around him in his Oakland neighborhood. Although many of the works are memory paintings in a sense—church, family, and everyday activities are depicted—they are not romanticized by the passing of years. "My message," he emphatically states, is "the spirit of God and the spirit of the black community. I am my own church. My hands uplifted, praise the faith, truth, and strength of my church." Kennedy's uplifted hands, in fact, with palms turned toward the viewer, are often present in his paintings and become a focal point for the other images.

Leon Kennedy works on bedsheets that he buys at flea markets ("I ran out of canvas and I had a sheet" is his explanation for the choice of material), and the size of his painting is determined by the size of the sheet—they range from single to

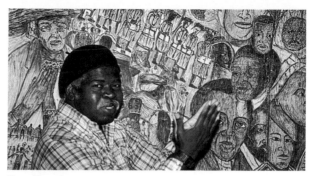

Leon Kennedy

king-size. The artist uses markers, crayon, pencil, and paint to create his images, and when he has finished a mural, he irons it to make sure that the sheet has properly absorbed the color.

COLLECTING TIPS Kennedy makes occasional small drawings that are studies for his full-size works, and a few of his paintings, from sheets that he finds torn, are not as large. Although the mural-size work is his strongest, if you are short of wall space, by all means look for the smaller paintings or drawings; they are also of great historical and cultural interest.

WHERE TO SEE ART Kennedy has been shown at many local museums and galleries in the San Francisco Bay Area, and he has had solo exhibitions at the Berkeley Civic Arts Commission, La Pena Cultural Center, and the Richmond City Hall. He was included in the show "Vernacular Art" at California State University in Hayward (1992) and "Emerging Talent: African American Artists of California" at Skyline College in San Bruno, California (1994). In 1994 Kennedy was also included in a group exhibition at the African American Museum in Dallas.

WHERE TO BUY ART Leon Kennedy is represented by the Liz Blackman Gallery in Los Angeles. Art Adventure in Boulder, Colorado, also has works by this artist.

REVEREND MARY LE RAVIN

Born September 1905 or 1906, Natchez, Mississippi. Died September 22, 1992, Los Angeles.

To Mary Le Ravin, bones symbolized resurrection and the passage from life to death to life again. Le Ravin, an ordained storefront preacher and member of a "celestial temple" in Los Angeles, said she was commanded by God to use bones to create her art: "Clean the bones lying on the kitchen table. Make art! Take sawdust and Elmer's glue and put it together." And so, working at night, in her private world peopled with unseen spirits, Mary Le Ravin followed the command of God, creating what she called "African bone art"— bone sculptures of popular black personalities, imaginary Africans, and visionary religious figures. Using her "God-given glue," she decorated her sculptures with bits of cloth, trinkets, artificial flowers, and whatever else was at hand and appealed to her.

W

During the day Le Ravin, who moved to Los Angeles in 1968, cooked for the poor, preached on the streets, and raised money selling second-hand items. She was known to her parishioners as Mother Mary.

COLLECTING TIPS There are scholars who believe that bone art is the continuation of an earlier African tradition and has been culturally transmitted to present-day black Americans via ancestors brought here from Africa on slave ships. Collectors of African-American art will, therefore, be particularly interested in Le Ravin's form of expression.

WHERE TO SEE ART Mary Le Ravin was included in the exhibition "Religious Visionaries" at the John Michael Kohler Arts Center, Sheboygan, Wisconsin, and illustrated in the catalog that accompanied the show (1991). Many of her works are also in the permanent collection of that museum.

WHERE TO BUY ART The estate of Le Ravin is being administered by J. Michael Walker in Los Angeles, and at the present time these works are not for sale. However, the Carl Hammer Gallery in Chicago has a few examples of Le Ravin's bone sculptures.

147
DWIGHT
MACKINTOSH

Born May 19, 1906, Hayward, California. Now resides Berkeley, California.

An artist with a private vision and a compelling need to draw, Dwight Mackintosh is, although we use the word "outsider" cautiously, perhaps the greatest American outsider artist working today. Mackintosh makes compulsive line drawings, intense and original, that sometimes contain sparse areas of color. Three of his recurring themes are human figures (predominantly male), animals, and a see-through yellow bus that is sometimes occupied by male and female riders. He often exaggerates genitalia and places rougelike circles on the faces of some of his figures, both male and female. Mackintosh also puts long, laborious scriptlike messages on his drawings; these messages, as well as his signature, add a beautiful touch of calligraphy—although largely unreadable—to the drawings.

Dwight Mackintosh was thought to be feebleminded and was institutionalized for fifty-six years before he was released to a board-and-care home. He began to make art at the Creative Growth Art Center in Oakland, California, only after his release. Irene Ward Brydon, executive director of the center, speculates that part of Mackintosh's disability is the direct result of long institutionalization.

COLLECTING TIPS Mackintosh's drawings are what all serious folk art collectors hope to find, and an outsider art collection that does not include this artist could not be called complete.

WHERE TO SEE ART In 1992 Mackintosh had a one-person retrospective at the Creative Growth Art Center. The center has also published a book on the artist, *Dwight Mackintosh: The Boy Who Time Forgot* (1992). Two 1995 exhibitions included Mackintosh's work:

"Visions from the Left Coast: California Self-Taught Artists," Santa Barbara Contemporary Arts Forum, Santa Barbara, California, and "Drawing Outside the Lines: Works on Paper by Outsider Artists," The Noyes Museum, Oceanville, New Jersey.

Mackintosh's drawings are in the permanent collections of L'Aracine, Neuilly-sur-Marne, near Paris, and the Collection de l'Art Brut, Lausanne, Switzerland.

WHERE TO BUY ART — Dwight Mackintosh is represented by the Ricco/Maresca Gallery in New York City, the Carl Hammer Gallery in Chicago, and the Creative Growth Art Center in Oakland, California.

148
ALEXANDER A.
MALDONADO

Born December 17, 1901,
Mazatlan, Sinaloa, Mexico.
Died February 10, 1989,
San Francisco.

A fan of science fiction and astronomy, Alex Maldonado painted a bright, futuristic world that included cityscapes and modernistic buildings of his own design. In many of his paintings, which also included extraterrestrial landscapes as subject matter, he redesigned American cities and buildings (concert halls and museums) so that they could handle the arrival of space-age travel.

For many years Alex Maldonado was a colorful and prominent San Francisco personality; he was a professional featherweight boxer and fought under the ring name "Frankie Baker." He did not take up painting until after his retirement and considered his art to be nothing more than a hobby. He often bought cheap dime-store frames for some of his pictures and painted them in bright colors to match the paintings.

COLLECTING TIPS — Maldonado is one of the few California folk artists who is equally well known on both coasts. His futuristic, almost utopian cityscapes in their original frames are considered to be his most valuable works; his best period was from 1965 to 1980.

WHERE TO SEE ART — The artist was included in more than twenty-seven shows between 1973 and 1989. In 1990 his work was exhibited in "The Cutting Edge" at the Museum of American Folk Art in New York City, and in 1991 he was included in "Made with Passion" at the Smithsonian Institution's National Museum of American Art in Washington, D.C. Both the Museum of American Folk Art and the Smithsonian, as well as the Oakland Museum in California, have Maldonado paintings in their permanent collections.

WHERE TO BUY ART — The estate of Alexander Maldonado is represented by the Ames Gallery in Berkeley, California.

149
DONALD
PATERSON

Born May 4, 1944,
Silver Springs, California.
Now resides Berkeley, California.

Donald Paterson is a visionary who believes he has had a series of adventures accompanied by his friend and constant companion, Elvis Presley. Because Paterson romanticizes his trips with Elvis, he has produced gaily painted pictures of the two of them together in the famous pink Cadillac on the banks of the Nile, in downtown Los Angeles, and even surrounded by hula girls on a tropical island.

Paterson is developmentally disabled, and as a result his ability to communicate, except through art, is somewhat inhibited. Fortunately he is truly gifted in this area—he is able to work in a range of media and has captured Elvis's likeness in paint, clay, and hooked rugs, among others—and he also loves and needs to make art.

The artist lives in a board-and-care home and spends his days at the Creative Growth Art Center in Oakland, California, where he has worked for more than sixteen years creating a very large group of remarkable geometric patterned drawings. Most of these feature his friend Elvis, but many also include Egyptian themes like the Sphinx.

COLLECTING TIPS Paterson's best works are his Elvis drawings. There are collectors who specialize in the art of the disabled, and there are collectors looking for outsider art; Paterson fits both categories. Other collectors who specialize in Elvis Presley objects will also find the artist interesting.

Some collectors may feel that Paterson's work is too cheerful or greeting-card sweet, but his drawings are easy to enjoy—the work of a real visionary on a real adventure.

WHERE TO SEE ART Donald Paterson has been included in more than thirty shows (group and individual), mostly in California. His art has been reviewed in a number of newspaper and magazine articles.

WHERE TO BUY ART Paterson is represented by the Creative Growth Art Center in Oakland. The center will supply additional documentation on Paterson upon request.

150
GREG PELNER

Born November 4, 1968, Los Angeles, California. Now resides Los Angeles.

Greg Pelner often travels in the unique world of his imagination, and this world, it would seem, is frequently populated with characters from the popular television show *Star Trek.* Pelner works in three media—clay, tinfoil, and paint. His clay and foil sculptures are likenesses of his *Star Trek* heroes, the spaceship *Enterprise,* and its futuristic equipment, but his paintings are quite different. In this medium Pelner draws portraits of the people he knows. His portraits include a few nudes as well as animals against starkly contrasting backgrounds. Even in his paintings, however, he'll occasionally include an insignia from *Star Trek.*

Pelner is mildly autistic and lives with supportive parents who have encouraged their son's artistic efforts. Pelner believes that "God wanted me to be an artist," and that is his goal in life. Whenever the family takes trips, Pelner sketches the landmarks around him, filling book after book with marvelous original drawings. (The family is retaining these for possible future publication).

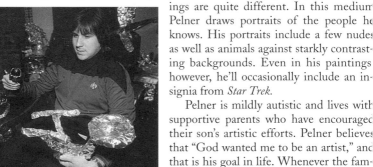

Greg Pelner

COLLECTING TIPS	Pelner has created a dream world occupied by space-age characters—real and unreal people. We believe that his nudes are particularly strong, but all of his drawings stand out as fine art. Although his paintings and drawings have attracted the most attention, his futuristic foil and clay works also merit consideration.
WHERE TO SEE ART	Pelner has been given one-man shows in eighteen libraries in the Los Angeles area; he also has had gallery shows and an exhibition at the University of California in San Diego (1992). The artist was included in "Contemporary Folk Art: A View from the Outside," Boca Raton, Florida, in 1995, and his work sold out.
WHERE TO BUY ART	Greg Pelner is represented by the Leslie Muth Gallery in Santa Fe, New Mexico.

I 5 I
STEPHEN POWERS

Born September 11, 1958, Santa Cruz, California. Now resides Aberdeen, Washington.

Visionary artist Stephen Powers believes that he is an architect "designing buildings from the inner space of my mind." The buildings that he designs are intended for outer space as well as for habitation here on earth. In outer space, for instance, he has designed a country town that is supported in space on a Persian carpet. His designs for earth encompass a half-moon-shaped apartment building. "I have a personal paranoia," the artist admits, "about the dangers of the world. I believe we will just pack up one day and go to outer space."

"I started out drawing underwater cities in fourth grade and never learned anything new in school from then on. Today I work in a mill cutting wood for doors, but at night I have to make art." Powers sometimes prints labels and instructions on his paintings, so that the viewer can better understand the intended architectural use for his projects. At first glance it may seem that Powers's brightly colored acrylic paintings are rendered in a tongue-in-cheek style, that the artist is not serious. After interviewing Powers, however, it became apparent to us that his projects are truly visionary and, as the artist says, "intended to be built."

COLLECTING TIPS	The artist's paintings are generally even in quality. Recently Powers has started creating 3-D sculptural objects such as futuristic yard totems; these are also of interest to collectors.
WHERE TO SEE ART	Powers was included in an exhibition at the Whatcom Museum, Bellingham, Washington, in 1992 and at the state's Bellevue Art Museum in 1993.
WHERE TO BUY ART	Stephen Powers's visionary architectural drawings have been exhibited at art fairs in New York and elsewhere. He is represented by the MIA Gallery, Seattle.

152 MARTIN RAMIREZ

Born March 31, 1895, Jalisco, Mexico. Died February 17, 1963, Auburn, California.

Martin Ramirez is known for his mysterious, symbolic drawings that he created while he was institutionalized with a severe mental illness. He developed an artistic vocabulary of highly personalized symbols—a *bandito* and a Madonna, for instance—and expressive designs that are instantly recognizable but cannot be decoded. His images, at one level primitive and at another highly organized and formal, often appear to be performing on a podium.

Ramirez is a classical example of an "outsider"; hospitalized, catatonic, delusional, and exhibiting the characteristics of a schizophrenic, his mental and social isolation from everyday life was complete. His delicate drawings with their haunting, formal beauty, however, transcend labels.

COLLECTING TIPS

Generally, the larger the Ramirez drawing, the more valuable it is. Collectors are anxious to acquire any of his three hundred known drawings, even small scraps of paper containing only designs without his figurative work. Some of the work is in poor condition, however, and the paper may be unstable, so care should be exercised before making a purchase. In some instances restoration may be necessary for preservation purposes.

WHERE TO SEE ART

Martin Ramirez was given a major retrospective at the Moore College of Art in Philadelphia in 1985. He was included in many other shows in the 1980s, such as "Transmitters: The Isolate Artist in America" at the Philadelphia College of Art (1981) and "Cat and a Ball on a Waterfall: 200 Years of California Folk Painting and Sculpture" at the Oakland Museum (1986). More recently Ramirez was included as one of the American self-taught artists in "Parallel Visions: Modern Artists and Outsider Art" (1992), an exhibition organized by the Los Angeles County Museum of Art that traveled to Europe and Japan. His work is illustrated in most books on contemporary folk and outsider art, and it is included in many public collections, including the Museum of American Folk Art, New York City, and the Abby Aldrich Rockefeller Folk Art Collection, Williamsburg, Virginia.

WHERE TO BUY ART

Martin Ramirez's drawings are sold by the Janet Fleisher Gallery, Philadelphia, and the Phyllis Kind Gallery, New York City and Chicago.

JOHN RATTO

Born March 12, 1928, northern California. Now resides Sacramento, California.

John Ratto, an autistic artist, spends his days drawing repetitive images of dogs or men walking with their fists balled and held stiffly at their sides. These images are consistent no matter what color—blue, black, or red—the artist uses to form their outlines. Because of Ratto's autistic condition, he spends much of his time in controlled environments; he lives in a board-and-care home, and he creates his compulsive drawings at the Short Center North in Sacramento, California.

Ratto's finished pieces are often colorful and intriguing, but his work has a certain sameness to it when he is left alone to draw. Thus, one of his teachers sometimes assists in selecting colors and advises Ratto on ways to make his drawings livelier.

Ratto's work was included in "Visions from the Left Coast: California Self-Taught Artists," Santa Barbara Contemporary Arts Forum, California (1995). His finished drawings were exhibited and sold well at the Outsider Art Fair held in New York City in 1994.

The artist is represented by the Ames Gallery in Berkeley, California.

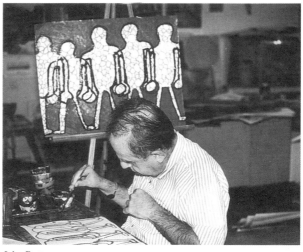

John Ratto

153
RAYMOND
"BAD RAY
KOMER"
RAYMOND

Born July 17, 1934,
Sioux City, Iowa.
Now resides Eugene, Oregon.

"Bad Ray Komer," whose real name is Raymond, paints wildly colorful and expressionistic paintings that emphasize sexual activity and social protest in various forms. "I have no philosophy of painting," the artist declares. "If I'm horny, I'll do sex; if I'm happy, I'll do children in the park; if I'm miserable, I'll do chairs." Raymond states that the first time he actually saw a painting was in 1989—it happened to be a de Kooning in the San Francisco Art Museum—and it inspired him to go home and try his hand at art. But there's not much of de Kooning in Raymond's work—he takes a bit from street graffiti, a bit from the drug culture, and a bit of his acquired smarts to formulate his own vision of what art is all about.

Raymond needed street smarts to survive—he was abandoned by his Sioux Indian mother, raised in Father Flanagan's Boys Town, then spent twenty years "doing drugs" as part of the California scene. "I can't stand normal people!" he emphatically declares. He lives in the attic of a home rented by Saw Belly, a local rock band, and paints all night.

Collectors should be cognizant of the fact that Raymond signs most of his work with the pseudonym "Bad Ray Komer." We prefer Raymond's larger expressionistic paintings containing multiple images to his smaller works, but some may find these latter more pertinent to their interests.

WHERE TO SEE ART "Bad Ray Komer" has not been exhibited outside of the galleries that represent him.

WHERE TO BUY ART Raymond is represented by Kralj Space (Double K Gallery) in Los Angeles, and by the Jamison/Thomas Gallery in Portland, Oregon.

154
SIMON "SAM" RODIA

Born April 15, 1875, Italy (probably near Naples). Died July 17, 1965, Martinez, California.

Watts Towers, now a major tourist attraction in Los Angeles, is the best-known folk art environment in America. Simon Rodia, the creator of the Towers, labored without assistance but with imagination and unbelievable perseverance for more than thirty years to build this remarkable structure constructed of steel reinforcing rods and wire mesh covered with cement. The largest tower is almost one hundred feet high; it is surrounded by several smaller towers and numerous arches, walkways, birdbaths, and fountains. Everything in the Towers complex is a multicolored mosaic, the surfaces embedded with thousands of fragmented and whole bottles, broken dishes, mirrors, and more than 72,000 seashells, as well as impressions of tools, hands, and corncobs.

Amazingly enough, not a single bolt, weld, or rivet was used to hold the Towers together, and despite imperfections in Rodia's construction methods, the Watts Towers have survived both earthquakes and riots (although, it must be added, with the help of a dedicated group of preservationists). They look much the same today as they looked in 1954 when Rodia simply moved away, leaving his massive project behind.

COLLECTING TIPS The Watts Towers, listed in the National Register of Historic Places, are now the property of the state of California and administered by the city of Los Angeles. The city's Cultural Affairs Department is in charge of restoring and preserving the Towers; a trust fund has been set up for restoration purposes, and contributions to the fund are always welcome.

WHERE TO SEE ART The Watts Towers are illustrated in many books on folk art and architecture and included in guidebooks to the Los Angeles area. In fact, it has been said that the Towers are the only art monument in Los Angeles. They can be seen from the freeways, but in order to really appreciate the site, a visit is required.

WHERE TO BUY ART The Watts Towers are a unique entity and not for sale. Rodia did no other work.

155

RODNEY "ROD" ROSEBROOK

Born October 16, 1900, Masonville, Colorado. Died March 5, 1994, Redmond, Oregon.

Rodney Rosebrook's unique collages made of black-painted welded iron buggy wheel rims and antique tools and farm implements are considered masterpieces of contemporary folk art. A retired "buckaroo," blacksmith, and rancher, Rosebrook maintained a roadside barn/museum where, inside and outside, he displayed discarded farm tools, hand-forged branding irons, and various ranch implements. "People came from everywhere—Australia, New York, Arabia—so I built me a fence of buggy wheel rims and such from the salvage place to keep 'em out," he said.

COLLECTING TIPS

Rosebrook's first fence was purchased in 1982 by Roger Ricco, an author/art dealer in New York City. Ricco dismantled the fence and sold the wheel units separately, as individual pieces of sculpture. On some of these early pieces the artist affixed a stamped metal tag with his name and date; these are the most valuable.

WHERE TO SEE ART

Rod Rosebrook

Unfortunately, the last of the contents of the Rosebrook barn and the fence were sold at auction in 1994. However, more than twenty of Rosebrook's buggy-wheel collages are on permanent display in the banquet room of the New Redmond Hotel in Redmond, Oregon. His work can also be found in the collection of the Smithsonian Institution's National Museum of American Art in Washington, D.C., and the Museum of International Folk Art in Santa Fe, New Mexico. Rosebrook is featured in the Museum of International Folk Art's 1996 exhibition "Recycled, Re-Seen: Folk Art from the Global Scrap Heap."

WHERE TO BUY ART

Theresa's Fine Framing and Gallery in Redmond, Oregon, has a few pieces of the artist's sculpture for sale, as does the Leslie Muth Gallery in Santa Fe. Possibly the Ricco/Maresca Gallery in New York City can assist in locating additional works.

156

JON SERL

Born November 7, 1894, Olean, New York. Died June 23, 1993, Lake Elsinore, California.

The major theme running through the renowned paintings of Jon Serl is the human condition—the personal relationships, the all-too-human foibles, and the perverseness of life. He painted men, women, and animals with a sense of wonder and witty humor; his powdered and rouged characters often look as though they are acting in unidentified roles on a stage lighted by old-fashioned gelatin-covered spotlights.

The legends surrounding Serl are bigger than life, and, since his death, he has become a folklore hero. He lived under

many names, told involved tales concerning his relationships with women, and shared his home and bed with egg-laying chickens. But each morning, until death claimed him, he rose with the sun and produced, one after another, extraordinary works of art.

COLLECTING TIPS Jon Serl's best period was between 1982 and about 1990. He did not always date his work, but experts can approximate the year of a particular painting. Serl sometimes worked on secondhand materials, but the condition of the underlying board or canvas on which he painted is not what determines the value of his art—look for strong images and subject matter that is appealing.

WHERE TO SEE ART The paintings of Jon Serl are in the collections of many major museums, including the Museum of American Folk Art, New York City; the Smithsonian Institution's National Museum of American Art, Washington, D.C.; the New York State Historical Association, Cooperstown; and the Laguna Beach Museum, Laguna Beach, California.

Serl was included in "Visions from the Left Coast: California Self-Taught Artists," at the Santa Barbara Contemporary Arts Forum, California, in 1995. His work also appeared in "The Cutting Edge" at the Museum of American Folk Art, New York (1990), "Works of Art . . . Worlds Apart," New York State Historical Association, Cooperstown (1993), and other West Coast and California exhibitions such as "Pioneers in Paradise," Long Beach Museum of Art (1984) and "Cat and Ball on a Waterfall: 200 Years of California Folk Painting and Sculpture," Oakland Museum (1986).

WHERE TO BUY ART The estate of Jon Serl is represented by the Cavin-Morris Gallery in New York City and by Jamison/Thomas in Portland.

157
JOHN STOSS

Born April 17, 1940, Great Bend, Kansas. Now resides Monterey, California.

John Stoss, a self-proclaimed ambassador for what he calls "the community on the fringe," paints the homeless, the down-on-their-luck, and the hopelessly addicted. Stoss's dramatic paintings are colorful, filled with compassion for the homeless, and expressionistic. He tends to work in series; these have included memory paintings of his youth in Kansas, depictions of street musicians, and a painted history of the short, unhappy life of an alcoholic poet by the name of Everett Maddox. "I am guilt-ridden," he summarizes, "by the ethnic Czech baggage of my youth."

Stoss lives in a gold 1978 Honda, encrusted with use, and spends his days painting in public parks in Monterey. He is, however, mobile, and he may spend weeks at a time in places such as Wilmington, North Carolina, and New Orleans. Stoss studied speech and journalism at Fort Hayes State University in Kansas and has even published a book of poems, *Machines Always Existed;* he has not, however, studied art.

COLLECTING TIPS	Collectors who are willing to go out and meet homeless artists are growing in number, but it often takes perseverance to locate the artist you want. We spent three years, off and on, trying to locate Stoss; he finally called us (collect), and we met in the lobby of a hotel in Monterey. Stoss's vivid paintings were well worth the effort spent in locating him.
WHERE TO SEE ART	Stoss has never been given a public exhibition. The Tartt Gallery in Washington, D.C., did have several of his paintings on hand at one time.
WHERE TO BUY ART	Debbie and Mike Luster, a photographer and folklorist team, met Stoss in Wilmington, North Carolina, and befriended the artist. The Lusters, who now live in Monroe, Louisiana, are considering the possibility of selling Stoss's work.

158

TERRY N. TURRELL

Born November 4, 1946, Spokane, Washington. Now resides Seattle.

The abstract message paintings with heavily built-up surfaces that Terry Turrell created in the 1980s have developed in the 1990s into subtly colored and expressive portraits and assemblages of men and women who are victims of an industrialized and militarized society. Although Turrell continues to build up the surfaces of his socially conscious paintings, he currently also employs a collage technique, attaching bits of industrial castoffs to their surfaces. These castoffs are the raw materials used in his expressionistic sculptures as well.

Turrell grew up in the 1960s and supported himself as part of the San Francisco hippie scene by making leather purses and hand-painted t-shirts. At some point during the 1980s, although untrained in art, he decided to "be an artist" and to use his art as a means for social commentary.

COLLECTING TIPS	Turrell and a number of other young self-taught painters and sculptors who are telling their stories in the 1990s may well represent the future of folk art. Some collectors prefer Turrell's large faces which are built up and appear to float out of the background of his board or canvas. Having followed the artist's career for some years, we seem to gravitate to his more recent sculptural objects.
WHERE TO SEE ART	Turrell has had many gallery showings in Seattle and New York City. He has been exhibited at art fairs and exhibitions like the art fair SOFA (Sculptural Objects and Functional Art) in Chicago, Illinois, in October 1994.
WHERE TO BUY ART	Turrell is represented by the MIA Gallery in Seattle, Washington, and by American Primitive in New York City.

159

JANE "IN VAIN" WINKELMAN

Born March 31, 1944, Long Island, New York. Now resides in Haight-Ashbury, San Francisco, California.

"The violence, sex, and politics of the streets," says Jane Winkelman, "make up the fabric of my life. They are what I know and what I paint. I was raised in a sheltered environment and never connected with a man who would take care of me. I ended up lost."

Winkelman paints the brutal life of women alone and troubled in metropolitan centers. She paints about the frustrating pattern of life (even though living outside the system, she "vainly" seeks understanding). Her palette includes the pastels of Marc Chagall—blues, greens, and rose. Her images include self-portraits, the Holocaust, and surreal monsters; much of her work is not for the squeamish.

In 1990 the artist found her way from the streets of the Tenderloin district to Hospitality House in San Francisco (a shelter that has a free art studio for the homeless) and gained almost immediate recognition on the West Coast for her work.

COLLECTING TIPS

Because Winkelman is a fresh new talent, it's too early to tell what will be her best work; we prefer her early pastels (pre-1993). The artist usually signs her work "Jane in vain" or "Jane the vain."

WHERE TO SEE ART

Winkelman is regularly exhibited at San Francisco's Hospitality House and was featured at the Yerba Buena Gardens Center for the Arts in that city (1994). In 1993 she was commissioned to do an Absolut Vodka ad; her depiction of a vodka bottle appeared in advertisements nationwide.

WHERE TO BUY ART

Jane "in vain" Winkelman is represented by the R. B. Stevenson Gallery in La Jolla, California.

Ⓜ *museum* Ⓖ *gallery* Ⓞ *other*
**denotes profiled artists*

MUSEUM AND GALLERY GUIDE

CALIFORNIA

University Art Museum Ⓜ
University of California at Berkeley
2626 Bancroft Way
Berkeley, CA 94720
(510) 642-0808

A contemporary art museum in a beautiful setting, the University Art Museum sponsors numerous special exhibitions, including folk art shows on occasion. In 1994 the museum was one of the sites for the traveling exhibition, "Passionate Visions of the American South: Self-Taught Artists from 1940 to the Present."

Ames Gallery Ⓖ
2661 Cedar Street
Berkeley, CA 94708
(510) 845-4949

The Ames Gallery has been in business for more than twenty years at the same site. It carries works by a number of contemporary folk and outsider artists (Jim Colclough, William Dawson*, Alex Maldonado*, John Ratto*, and Inez Nathaniel Walker*, for example). The gallery represents the family of Achilles G. Rizzoli. It also carries a variety of objects such as canes, face jugs, quilts, and tramp art.

John Natsoulas Gallery **G**
140 F Street
Davis, CA 95616
(916) 756-3938

Although the Natsoulas Gallery specializes in contemporary art (including California ceramicists), the gallery also shows works by folk artists such as Larry Clark* and Ira Watkins.

Autry Museum of
Western Heritage **M**
4700 Western Heritage Way
Los Angeles, CA 90027
(213) 667-2000

The museum is devoted to preserving and exploring the heritage of a region. The collection centers on western memorabilia and objects representing our western heritage, but it does include some folk art such as works by Nicholas Herrera* and Horacio Valdez. From time to time, it has exclusive folk art exhibitions, such as "Crafting Devotions: Tradition in Contemporary New Mexican Santos" (1995).

Craft & Folk Art Museum **M**
5814 Wilshire Boulevard
Los Angeles, CA 90036
(213) 937-5544

Closed for several years for renovation and earthquake-proofing, the museum reopened in May 1995. Among the artists in its permanent collection are Minnie Adkins*, Calvin and Ruby Black, and Mose Tolliver*. It has hosted such important exhibitions as "Black Folk Art in America: 1930–1980."

Southwest Museum **M**
234 Museum Drive
(P.O. Box 41558)
Los Angeles, CA 90065
(213) 221-2164

This museum specializes in American Indian art, of which it has an extensive collection. Its textiles are especially noteworthy, as is its basketry collection of approximately 13,000 items. The museum's exhibitions are often contemporary in nature.

Art Center **G**
3750 West Martin Luther
King Boulevard
Los Angeles, CA 90008
(213) 290-2000

Originally intended for children with disabilities, the center presently has workshops for all ages, and many talented artists work there on a regular basis. Among these artists are Raymond Chavoya* and Tommy Brackens.

Liz Blackman Gallery **G**
6909 Melrose Avenue
Los Angeles, CA 90038
(213) 933-4096

A lively gallery with a wide variety of artists, Liz Blackman has on hand well-known artists such as Eddie Arning*, Howard Finster*, Jon Serl*, and Mose Tolliver*. The gallery is also always on the lookout for new artists; Liz Blackman discovered Eileen Doman* and carries work by Raymond Chavoya* and Leon Kennedy*, among others.

Kralj Space
(Double K Gallery) **G**
660 North Larchmont Boulevard
Los Angeles, CA 90004
(213) 467-3584

The Kralj Space (Double K Gallery) has works by California artists Sanford Darling and "Possum Trot" artists Calvin and Ruby Black. Other artists include Raymond "Bad Ray Komer" Raymond*, Irwin Rabinov, and Robert E. Smith. The gallery has an extensive collection of art and objects by unknown artists, ranging from turn-of-the-century woodcarvings to quilts and tramp art.

W

House of Blues ◙
8430 Sunset Boulevard
West Hollywood, CA 90069
(213) 650-0247

The House of Blues is a restaurant featuring mostly blues-based music. The walls are covered with folk art, much of which is for sale. There is also a retail shop selling paintings by southern self-taught artists. There are similar restaurants—all of which display folk art—in Cambridge, Massachusetts (the original House of Blues, see page 65), and in New Orleans (see page 188). Additional restaurants are planned for New York, Orlando, and Chicago.

The Watts Towers of Simon Rodia* ◙
1765 East 107th Street
Los Angeles, CA 90002
(213) 847-4646 or (213) 485-2433

Although this book, as a collector's guide, does not emphasize environments, the Watts Towers (one almost 100 feet tall) deserve special mention as probably the best-known folk art environment in America. Open on weekends from 12–4 P.M. and other times by special arrangement.

Oakland Museum Ⓜ
1000 Oak Street
Oakland, CA 94607
(510) 238-3401

The Oakland Museum has a number of self-taught artists in its permanent collection, including Alex Maldonado*, Louis Monza, and John Roeder. In 1986, the museum organized an important exhibition, "Cat and a Ball on a Waterfall: 200 Years of California Folk Painting and Sculpture," which featured the work of the above artists and others. The Oakland Museum is actively seeking to expand its collection of California folk art.

Creative Growth Art Center Ⓖ
355 24th Street
Oakland, CA 94612
(510) 836-2340

One of the best known of the art centers for the disabled, Creative Growth provides materials and a place to work for disabled adults interested in art. Although professional staff is available to provide support and encouragement, the center's director stresses that every effort is made *not* to influence the work of the artists. The center has a sales gallery with regularly scheduled exhibitions, which has enabled some of the artists—Dwight Mackintosh*, for instance—to become self-supporting. Other center artists include Donald Paterson* and the Tyler twins.

San Diego Museum of Art Ⓜ
Balboa Park
(P.O. Box 2107)
San Diego, CA 92112-2107
(619) 232-7931

The San Diego Museum has become increasingly interested in folk art in recent years. In 1994 it hosted "Passionate Visions of the American South" and organized the traveling exhibition, "Discovering Ellis Ruley*," which opened in Atlanta in 1995 and traveled to a number of venues, including the sponsoring museum.

San Francisco Craft and Folk Art Museum Ⓜ
Landmark Building A
Fort Mason Center
San Francisco, CA 94123-1382
(415) 775-0990

Although the museum does not have a permanent collection, it presents changing exhibitions of folk art, such as "Working Folk" in mid-1995. That show, featuring artists like Jack Savitsky* and Alex Maldonado*, depicted the toils of labor as portrayed by folk artists.

Braunstein/Quay Gallery Ⓖ
250 Sutter Street
San Francisco, CA 94108
(415) 392-5532

Primarily a contemporary art gallery (paintings, sculpture, and works on paper), Braunstein/Quay is the principal representative of California artist Ted Gordon*. The gallery also exhibits several other folk artists, such as Bruce Burris.

Creative Spirit Gallery ▣
900 North Point Street
San Francisco, CA 94109
(415) 441-1537

This gallery, conveniently located on the lower plaza at Ghirardelli Square, is a satellite gallery of the National Institute of Art and Disabilities (NIAD) in Richmond, California, and carries most of NIAD's artists on a rotating basis.

National Institute of Art and Disabilities ◙
551 23rd Street
Richmond, CA 98404
(510) 620-0290

Founded in 1982 by the late Florence Ludins-Katz and Dr. Elias Katz, NIAD is an art center for people with disabilities. Today, there are 13 art workshops in California and several in other states that were established by the Katzes or based on the model they developed. NIAD's mission is to provide the freedom to create, together with the opportunity for the artists to earn income and recognition through the marketing of their work (NIAD maintains a professional exhibition program to display the work of its artists). The studio is under the guidance of artists/teachers who serve as facilitators. Like Creative Growth, NIAD practices a "hands off" policy so as not to interfere with the creative process. Among its better-known artists are Samuel Gant*, Juliet Holmes, and Audrey Pickering.

OREGON

Jamison/Thomas Gallery ▣
1313 NW Glisan Street
Portland, OR 97209
(503) 222 0063

A first-rate contemporary art and folk art gallery, Jamison/Thomas represents such artists as Ruza Erceg, Anne Grgich*, and Jon Serl*. For many years prior to Serl's death, Jamison/Thomas and Cavin-Morris in New York (see page 67) were the artist's principal representatives.

Theresa's Fine Framing and Gallery ▣
515 SW 6th Street
Redmond, OR 97756
(503) 923-5208

Theresa's Gallery still has a few pieces by Oregon folk artist Rodney Rosebrook* and occasionally handles work by other area folk artists.

WASHINGTON

MIA Gallery ▣
512 1st Avenue South
Seattle, WA 98104
(206) 467-8283

Newly relocated in spacious quarters, MIA shows the best of contemporary northwest folk art as well as a sampling from the rest of the country (for example, Leroy Almon, Bessie Harvey*, James Harold Jennings, and Mose Tolliver*). MIA's area artists include Anne Grgich*, Alan Keller*, Rosemary Pittman, Stephen Powers*, and Terry Turrell*.

W

APPENDICES

CONSERVATION ADVICE

ONCE A COLLECTOR HAS MADE THE DECISION TO BUY a work of art, he or she has the responsibility of caring for it. Part of our culture is preserved through the visual statements of our times and a work of art becomes part of the history and culture of our time. It must be preserved.

The technicalities of conservation are for experts, and we are not going to delve into those aspects. For instance, should a cracked pot be preserved in such a manner that the break shows, or should it be repaired to look like new?

We once gave one of Captain Walter Flax's boats to the Smithsonian Institution's National Museum of American Art. It was bug-infested and rotting in Virginia's deep piney woods when we bought it from an ailing Flax. Jan and I carried it out to the car in pieces. Lynda Hartigan, a curator at the museum, thought that it was significant enough to save, and she had it debugged, but to this day final restoration decisions have not been made. Most of Flax's famous landlocked navy has been destroyed—this boat remains—but what should it look like in a restored condition? We wish that we had photographed the boat in situ, but we did not.

Luckily, we did photograph a chewing-gum sculpture, *Purple Pig,* by Nellie Mae Rowe. One day in 1983 a conservator from the Field Museum in Chicago, where it was on loan, called us in trepidation and excitement; *Pig* had melted a bit under the heat from their spotlights. The conservator at the Field Museum had never worked on gum before, but thanks to her skill, and thanks to the photographs, *Pig* looks great today.

There are some general tips that collectors can follow:

1. Be careful of light. Some materials are fragile, so use UV glass on frames, for example, if the object will be exposed to sunlight.
2. Do not place objects outdoors if there is a chance they will be adversely affected by the weather.
3. Do not use Scotch tape or industrial tapes that are difficult to remove or will fade and discolor.

4. Have all objects that are to be framed placed in conservationally sound (acid-free) materials and properly mounted.
5. If paper is torn or discolored, see a paper restorer. Most museums can recommend one.
6. Do not overrestore a piece. *Santos,* for example, that have been used on an altar do not look right to us if they are heavily refinished (made to look like new), but sometimes recent layers of paint should be removed to bring the work closer to its original state.
7. Changes in climate, from humid weather to dry (or vice versa), can affect wood, paper, and paint. Proper climate control is important.
8. Watch out for bugs. Everything from termites and beetles to moths can be destructive.

Our general advice is to have fun with folk art and, if a problem exists, see an expert.

GLOSSARY

THE TERM "CONTEMPORARY FOLK ART" ENCOMPASSES a wide range of paintings, sculptures, and environments created, for the most part, in the second half of this century by individuals who did not study art formally. In other words, they are self-taught as opposed to trained artists. In a sense "contemporary folk art" is not as broad a term as "folk art" because, as used today, it does not include objects that commonly are considered folk art—fish decoys, waterfowl decoys, cigar store Indians, trade signs, carousel horses, and so forth— many of which were made in the earlier part of the century and some of which were manufactured. Our emphasis is on "art"—paintings and sculpture as opposed to utilitarian objects. And because this is a collector's guide, environments are only discussed in passing, as necessary for a better understanding of contemporary folk art.

A number of terms are used to describe particular types or categories of folk art. These terms are discussed below, but readers should be aware that the terms may overlap and that collectors, scholars, galleries, and museums may not agree in every instance, either on the definitions or on the artists who fit into a particular category. Thus, the terms are listed here merely as a matter of general reference.

ART BRUT The term was first used by the French artist Jean Dubuffet to describe the "raw art" he admired and collected. Although not specifically limited to the art of the insane, most of the artists in this category were institutionalized or almost completely isolated from society in one way or another. This art can best be seen today at the museum Dubuffet founded, the Collection de l'Art Brut, Lausanne, Switzerland, which

opened in 1976. While Dubuffet's collection was based on European art, the museum has substantially expanded and today includes examples of American art as well, including some of the artists in this book—Ted Gordon, Henry Darger, and Inez Nathaniel Walker, for example. This type of art is also featured at L'Aracine at Neuilly-sur-Marne, near Paris.

ENVIRONMENTAL ART These are usually large-scale works, often, although not always, constructed outdoors. For the most part environmental works are created primarily for display; they are not generally for sale. A well-known example is Simon Rodia's Watts Towers in Los Angeles. Howard Finster's Paradise Garden in Summerville, Georgia, is another example of environmental art.

"FAUX" FOLK ART As contemporary folk art has become increasingly popular, some trained artists have begun painting in a folk art style.

MEMORY PAINTING As our society has become more complex, some artists—often older ones—paint the memories of their youth, of disappearing life styles. Some of the work of 100-year-old Aaron Birnbaum fits into this category, as do some of Annie Wellborn's paintings. Clementine Hunter's paintings of Melrose Plantation and plantation life are also sometimes referred to as memory paintings.

OUTSIDER ART The term was initially used by Roger Cardinal, a British writer, as the English equivalent of Jean Dubuffet's French term *art brut*. This is the limited sense in which the term is used here.

SELF-TAUGHT ART An increasingly popular term for art by untrained artists. Synonymous with "contemporary folk art" as used in this volume.

VISIONARY ART Another term sometimes used to describe contemporary folk art, particularly when the art is religious in its theme and based on dreams, visions, or voices. Artists such as Minnie Evans and Sister Gertrude Morgan are often termed visionary artists. In a broader sense, "visionary art" may denote works by folk artists with a unique vision, religious or otherwise.

PRICE GUIDE

GENERAL RETAIL PRICE RANGES FOR THE WORKS OF artists included in this guide are listed here. For the most part, the price given represents typical gallery prices for high-quality paintings and/or sculptures by a particular artist. Smaller pieces are generally less expensive, and unusually large works

or particularly fine examples may cost more. Drawings are usually less expensive and are not represented in the price guide unless they are important or represent the artist's principal or best work.

In many instances, the price may be less if a piece is bought directly from the artist. However, as pointed out elsewhere, there are drawbacks in buying this way: the available work may not represent the artist's best period, and there may be less choice in selection. Nevertheless, it is without doubt interesting and educational to meet the artist, so readers may want to combine such visits with gallery purchases—that is what we have usually done. Keep in mind, however, that it is not fair to take up too much of an artist's time if you are not planning a purchase, and the artist may often be too polite to tell you he or she is busy.

Auction prices may often be lower than retail, and auctions serve as another method of acquiring an artist's work. Major auction houses maintain records of sale prices, and these can serve as useful reference tools.

The price ranges used in the guide are as follows:

1 — $300 or under
2 — $300 – $ 1,500
3 — $ 1,500 – $5,000
4 — $5,000 – $ 10,000
5 — $ 10,000 and over

In a few instances the artist's work involves a very broad price range. Howard Finster is an example; his multiples can be purchased for under $100, many of his better works can be purchased for between $3,000 and $ 12,000, and his early works—those that are unnumbered or have low numbers—sell for more than $20,000. The few exceptional situations such as this are starred and footnoted in the following list.

Listed prices are, of course, subject to change, depending on market conditions. At the moment, the market in contemporary folk art is fast-moving, as new artists are discovered and older ones disappear or reduce their output.

Minnie and Garland Adkins 2	Andrea Badami 5
Chelo Amezcua 3	Thomas King Baker 2
John Anderson 2	Linvel and Lillian Barker . 2
Linda Anderson 3	Ricky Barnes 2
Alpha Andrews 2	Jim Bauer 3
Clyde Angel 2	Ralph Bell 1
Johnson Antonio 2	Cyril Billiot 1
Felipe Archuleta 4	Patsy Billups 2
Leroy Archuleta 2	Aaron Birnbaum 2
Eddie Arning 4	William A. Blayney 5
Steve Ashby 4	Georgia Blizzard 3
	Hawkins Bolden 2

- To date, Butler has been unwilling to sell his work. However, he has expressed a willingness to sell "at the right price."
- Cahill may be willing to sell memorabilia, but his concrete sculptures are not for sale.
- The drawings of Thornton Dial, Sr., are also important, and they cost substantially less (category 4) than his paintings and assemblages.
- There are works by Howard Finster in every price range. Late multiples are inexpensive; early unnumbered and low-number paintings are very expensive; other works are in the middle price ranges.
- Recent works by these artists are relatively inexpensive; R. A. Miller drawings and whirligigs, for example, can often be found for $300 or less. However, the earlier works by Miller, Sudduth, and Tolliver are quite costly.

SELECTED READING

NOTE: Since this book emphasizes new artists, many of whom are still working, readers may want to refer to the *Museum of American Folk Art Encyclopedia of Twentieth-Century American Folk Art and Artists* (Chuck and Jan Rosenak, New York: Abbeville Press, 1990) for information on additional artists—some of whom are referenced in this book—and artists who worked primarily in the first half of the century (John Kane, Joseph Pickett, Horace Pippin, John Scholl, and Grandma Moses, for example).

Adele, Lynne. *Black History/Black Vision: The Visionary Image in Texas.* Austin: Archer M. Huntington Art Gallery, University of Texas, 1989.

Alabama State Council on the Arts. *Outsider Artists in Alabama.* Montgomery, 1991.

Another Face of the Diamond: Pathways through the Black Atlantic South. New York: INTAR Latin American Gallery, 1988.

Archer, Barbara. *Outside the Main Stream: Folk Art in Our Time.* Atlanta: High Museum of Art at Georgia-Pacific Center, 1988.

Artist Lee Godie: A 20-Year Retrospective. Chicago: Chicago Cultural Center, 1993.

The Artworks of William Dawson. Chicago: Chicago Public Library Cultural Center, 1990.

Ashe: Improvisation and Recycling in African-American Visionary Art. Winston-Salem, N.C.: Diggs Gallery, Winston-Salem State University, 1993.

Baking in the Sun: Visionary Images from the South. Lafayette: University Art Museum, University of Southwestern Louisiana, 1987.

Barrett, Didi. *Muffled Voices: Folk Artists in Contemporary America.* New York: Museum of American Folk Art, 1986.

Bishop, Robert. *American Folk Sculpture.* New York: E. P. Dutton, 1974.

——. *Folk Painters of America.* New York: E. P. Dutton, 1979.

Bishop, Robert, and Jacqueline Marx Atkins. *Folk Art in American Life.* New York: Viking Studio Books, 1995.

Black Art—Ancestral Legacy: The African Impulse in African-American Art. Dallas: Dallas Museum of Art, 1989.

Burrison, John A. *Brothers in Clay: The Story of Georgia Folk Pottery.* Athens: University of Georgia Press, 1983.

Cardinal, Roger. *Outsider Art.* New York: Praeger Publishers, 1972.

Common Ground/Uncommon Vision: The Michael and Julie Hall Collection of American Folk Art. Milwaukee: Milwaukee Art Museum, 1993.

Contemporary American Folk Art: The Balsley Collection. Milwaukee: Haggerty Museum of Art, Marquette University, 1992.

Contemporary American Folk, Naive and Outsider Art: Into the Mainstream? Oxford, Ohio: Miami University Art Museum, 1990.

Cubbs, Joanne. *The Gift of Josephus Farmer.* Milwaukee: Milwaukee Art History Gallery, University of Wisconsin, 1982.

A Density of Passions. Trenton: New Jersey State Museum, 1989.

Diving in the Spirit. Winston-Salem, N.C.: Fine Arts Gallery, Wake Forest University, 1992.

Drawing Outside the Lines: Works on Paper by Outsider Artists. Oceanville, N.J.: Noyes Museum, 1995.

Driven to Create: The Anthony Petullo Collection of Self-Taught and Outsider Art. Milwaukee: Milwaukee Art Museum, 1993.

Elijah Pierce: Woodcarver. Columbus, Ohio: Columbus Museum of Art, 1992.

Finster, Howard, as told to Tom Patterson. *Howard Finster, Stranger from Another World: Man of Visions Now on This Earth.* New York: Abbeville Press, 1989.

Glassie, Henry. *The Spirit of Folk Art: The Girard Collection at the Museum of International Folk Art.* New York: Harry N. Abrams with the Museum of New Mexico, 1989.

Hackley, Larry, curator. *God, Man and the Devil: Religion in Recent Kentucky Folk Art.* Lexington: Folk Art Society of Kentucky, 1984.

Hall, Michael D., and Eugene W. Metcalf, Jr., eds. *The Artist Outsider: Creativity and the Boundaries of Culture.* Washington: Smithsonian Institution Press, 1994.

Halstead, Whitney. "Joseph Yoakum." Manuscript, Archives, Art Institute of Chicago, c. 1977.

Hartigan, Lynda Roscoe. *Made with Passion: The Hemphill Folk Art Collection in the National Museum of American Art.* Washington: National Museum of American Art, Smithsonian Institution Press, 1990.

Hartman, Russell P., and Jan Musial. *Navajo Pottery: Traditions and Innovations.* Flagstaff, Ariz.: Northland Press, 1987.

The Heart of Creation: The Art of Martin Ramirez. Philadelphia: Goldie Paley Gallery, Moore College of Art, 1985.

Hemphill, Herbert W., Jr., and Julia Weissman. *Twentieth Century American Folk Art and Artists.* New York: E. P. Dutton, 1974.

The Image Weavers: Contemporary Navajo Pictorial Textiles. Santa Fe, N.M.: Wheelwright Museum of the American Indian, 1994.

It'll Come True: Eleven Artists First and Last. Lafayette, La.: Artists' Alliance, 1992.

Janis, Sidney. *They Taught Themselves: American Primitive Painters of the 20th Century.* New York: Dial Press, 1942.

Johnson, Jay, and William C. Ketchum, Jr. *American Folk Art of the Twentieth Century.* New York: Rizzoli, 1983.

Jones, Suzi, ed. *Webfoots and Bunchgrassers: Folk Art of the Oregon Country.* Eugene: Oregon Arts Commission, 1980.

Kahan, Mitchell D. *Heavenly Visions: The Art of Minnie Evans.* Raleigh: North Carolina Museum of Art, 1986.

Kalb, Laurie Beth. *Crafting Devotions: Tradition in Contemporary New Mexican Santos.* Albuquerque: University of New Mexico Press; Los Angeles: Gene Autry Western Heritage Museum, 1994.

Kaufman, Barbara Wahl, and Didi Barrett. *A Time to Reap: Late Blooming Folk Artists.* South Orange, N.J.: Seton Hall University; New York: Museum of American Folk Art, 1985.

Kemp, Kathy, with photographs by Keith Boyer. *Revelations: Alabama's Visionary Folk Artists.* Birmingham, Ala.: Crane Hill Publishers, 1994.

Lampell, Ramona, and Millard Lampell, with David Larkin. *O, Appalachia: Artists of the Southern Mountains.* New York: Stewart, Tabori and Chang, 1989.

Larson-Martin, Susan, and Lauri Robert Martin. *Pioneers in Paradise: Folk and Outsider Artists of the West Coast.* Long Beach, Calif.: Long Beach Museum of Art, 1984.

Lavitt, Wendy. *Animals in American Folk Art.* New York: Alfred A. Knopf, 1990.

Lipman, Jean, and Tom Armstrong, eds. *American Folk Painters of Three Centuries.* New York: Hudson Hills Press and Whitney Museum of American Art, 1980.

Livingston, Jane, and John Beardsley. *Black Folk Art in America, 1930–1980.* Jackson: University Press of Mississippi, 1982.

Local Visions: Folk Art from Northeast Kentucky. Morehead, Ky.: Morehead State University, 1990.

Luck, Barbara R., and Alexander Sackton. *Eddie Arning: Selected Drawings, 1964–1973.* Williamsburg, Va.: Colonial Williamsburg Foundation, 1985.

MacGregor, John. *Dwight Mackintosh: The Boy Who Time Forgot.* Oakland, Calif.: Creative Growth Art Center, 1990.

Manley, Roger. *Signs and Wonders: Outsider Art inside North Carolina.* Raleigh: North Carolina Museum of Art, 1989.

Maresca, Frank, and Roger Ricco. *American Self-Taught: Paintings and Drawings by Outside Artists.* New York: Alfred A. Knopf, 1993.

———. *Bill Traylor: His Art, His Life.* New York: Alfred A. Knopf, 1991.

Metcalf, Eugene, and Michael Hall. *The Ties That Bind: Folk Art in Contemporary American Culture.* Cincinnati: Contemporary Arts Center, 1986.

Minnie Evans: Artist. Greenville, N.C.: Wellington B. Gray Gallery, East Carolina University, 1993.

Ollman, John E. *Howard Finster: Man of Visions.* Philadelphia: Philadelphia Art Alliance, 1984.

Oppenhimer, Ann, and Susan Hankla, eds. *Sermons in Paint: A Howard Finster Folk Art Festival.* Richmond, Va.: University of Richmond, 1984.

Orr-Cahall, Christina. *Cat and a Ball on a Waterfall: 200 Years of California Folk Painting and Sculpture.* Oakland, Calif.: Oakland Museum Art Department, 1986.

Perry, Regenia A. *What It Is: Black American Folk Art from the Collection of Regenia Perry.* Richmond: Anderson Gallery, Virginia Commonwealth University, 1982.

Rambling on My Mind: Black Folk Art of the Southwest. Dallas: Museum of African-American Life and Culture, 1987.

Reclamation and Transformation: Three Self-Taught Chicago Artists. Chicago: Terra Museum of American Art, 1994.

Rosenak, Chuck and Jan. *The People Speak: Navajo Folk Art.* Flagstaff, Ariz.: Northland Publishing, 1994.

Roulin, Geneviève. *Made in USA: Collection of Chuck and Jan Rosenak.* Collection de l'Art Brut, Lausanne, Switzerland, 1993.

Sellen, Betty-Carol, with Cynthia J. Johanson. *20th Century American Folk, Self-Taught, and Outsider Art.* New York: Neal-Schuman Publishers, 1993.

A Separate Reality: Florida Eccentrics. Fort Lauderdale, Fla.: Museum of Art, 1987.

Smith, Glenn Robert, with Robert Kenner. *Discovering Ellis Ruley: The Story of an American Outsider Artist.* New York: Crown Publishers, 1993.

Thévoz, Michél. *Art Brut.* New York: Skira/Rizzoli, 1976.

Thornton Dial: Image of the Tiger. New York: Harry N. Abrams, 1993.

Transmitters: The Isolate Artist in America. Philadelphia: Philadelphia College of Art, 1981.

Tuchman, Maurice, and Carol S. Eliel. *Parallel Visions: Modern Artists and Outsider Art.* Los Angeles and Princeton, N.J.: Los Angeles County Museum of Art and Princeton University Press, 1992.

Turner, J. F. *Howard Finster, Man of Visions: The Life and Work of a Self-Taught Artist.* New York: Alfred A. Knopf, 1989.

Twentieth Century Self-Taught Artists from the Mid-Atlantic Region. Oceanville, N.J.: Noyes Museum, 1994.

An Unexpected Orthodoxy: The Paintings of Lorenzo Scott. Springfield, Ohio: Springfield Museum of Art, 1993.

Unsigned, Unsung... Whereabouts Unknown. Tallahassee: Florida State University Gallery and Museum, 1993.

Virginia Originals. Virginia Beach, Va.: Virginia Beach Center for the Arts, 1994.

Warren, Elizabeth V., cur. *Expressions of A New Spirit: Highlights from the Permanent Collection of the Museum of American Folk Art.* New York: Museum of American Folk Art, 1989.

Wilson, James L. *Clementine Hunter: American Folk Artist.* Gretna, La.: Pelican Publishing Company, 1988.

A World of Their Own: Twentieth-Century American Folk Art. Newark, N.J.: Newark Museum, 1995.

Yelen, Alice Rae. *Passionate Visions of the American South: Self-Taught Artists from 1940 to the Present.* New Orleans: New Orleans Museum of Art, 1993.

Zug, Charles G., III. *Turners and Burners: The Folk Potters of North Carolina.* Chapel Hill: University of North Carolina Press, 1986.

ACKNOWLEDGMENTS

IN ORDER TO WRITE THIS BOOK, WE TRAVELED THE country visiting artists, museums, galleries, dealers, and collectors. Wherever we went, we were amazed at the enthusiasm for contemporary American folk art. Almost everyone we visited had local favorites whose work was collected and championed. Unfortunately, all of the artists and all of the art that we discovered could not be included in one volume, but we are deeply indebted to everyone who participated in our search.

We have worked with Lee Kogan, Director, Folk Art Institute, the Museum of American Folk Art, for a number of years. She is dedicated to researching contemporary American folk art and teaching the subject in the belief that American folk artists and their work must be recognized. Her introductory essay is helpful to an understanding of this book, and we are in her debt.

We also wish to thank our editor, Jacqueline M. Atkins, whose extensive knowledge of folk art made our work easier. She is the author of a number of books, including the co-author with Robert Bishop of *Folk Art and American Life.* Ms. Atkins is an associate professor at New York University and the recipient of a 1995–1996 Fulbright Research Scholar Award to Japan.

Our thanks also to Nancy Druckman of Sotheby's. Her insightful essay should be very helpful to collectors. Now that contemporary folk art is becoming more widely known, it's time to think about possible future sales and the market place in general. Nancy Druckman is a real expert in this area.

Lynn Lown took many of the photographs that appear in

this guide and in our other books; his skill and understanding of the material have enhanced these pages.

Publisher Robert Abrams, Editorial Director Susan Costello, and Myrna Smoot, Vice President of Business Affairs, of Abbeville Press have worked closely with us since 1988 and, without their guidance and enthusiasm, this project could not have been completed. We would also like to thank the following individuals at Abbeville: Celia Fuller, the designer; Lou Bilka, the production manager; and in editorial Karel Birnbaum, Owen Dugan, Barbara Sturman, and Meredith Wolf.

And finally, we again thank all the individuals—collectors, gallery owners, museum directors, curators, and others—who participated and shared their knowledge with us. While many are listed in individual entries, we would like to single out the following: Joe Adams, Judith Alexander, Aarne Anton, Jim and Beth Arient, Jack Beasley, Liz Blackman, Russell Bowman, Irene Ward Brydon, Robert Cargo, Shari Cavin, Lesley Constable, Eason Eige, Gene Epstein, Kurt Gitter and Alice Yelin, Deborah Gilman, Ellin and Baron Gordon, Sally Griffiths, Bonnie Haight, Carl Hammer, Robert Hake, Marion Harris, Lynda Roscoe Hartigan, Rebecca Hoffberger, Barry and Allen Huffman, George Jacobs, Dr. A. Everette James, Dave Knoke, Suzanne Lacke, Jim Linderman, Charles Locke, Warren and Sylvia Lowe, Deborah and Mike Luster, Nanette Maciejunes, Frank Maresca, Mia McEldowney, Pat McNellis, Joy Moos, Leslie and Henri Muth, Ann Nathan, Ann and William Oppenhimer, Sherry Pardee, Pat Parsons, Bonnie and Nat Pelner, Heike Pickett, Susan Purvis, Jim Roche, Bill Rose, Luise Ross, Kerry Schuss, Suzanne Shawe, Mike Smith, Adrian Swain, Chuck Swanson, George and Sue Viener, Barbara Vogel, Robert Vogele, Julie and Bruce Webb, Marcia Weber, Tom Wells, Tina White, and Ginger Young.

And, of course, if it weren't for the artists and their families, there would be no *Contemporary American Folk Art: A Collector's Guide*. To them, our gratitude and mazel tov!

Chuck and Jan Rosenak

I N D E X

Page numbers in *italic* refer to illustrations. Page numbers in **boldface** refer to main biographical entry or gallery listing.

A

Aaron, Jesse, 67, 183
Abby Aldrich Rockefeller Folk Art Center (Williamsburg, VA), 24, 72, **116–17**
Ace Gallery (Columbus), 205
Adkins, Garland, 71, **73**, *81*, 112, 183
Adkins, Minnie, 71, **73**, *81*, 112, 116, 183, 221, 299
Adobe Gallery (Albuquerque, NM), **265**
African American Museum (Dallas), 226, **268**
Akron Art Museum (OH), **223**
Alberts, Sylvia, 68, 223
Albuquerque Museum (NM), **265**
Almon, Leroy, 65, 116, 186, 301
American Primitive Gallery (New York), 32, 43, 45, 47, **66**, 79, 80, 106, 163, 169, 175, 179, 202, 220, 281, 284, 297
American Visionary Art Museum (Baltimore), **64**, 70, 227
America Oh Yes (Hilton Head, SC), 151, 172, **189**, 212
America Oh Yes (Saint Helena Island, SC). *See* Rising Star (Saint Helena Island, SC)
Ames Gallery (Berkeley, CA), 96, 163, 171, 207, 258, 272, 283, 289, 293, **298**
Amezcua, Consuelo "Chelo" Gonzalez, 67, **229–30**, *241*

Anderson, John, 72, **74**, *81*
Anderson, Linda, **121–22**, *129*, 185, 186
Anderson Gallery, Virginia Commonwealth Univ. (Richmond, VA), **116**
Andrea Fisher Fine Pottery (Santa Fe, NM), 254, **267**
Andrews, Alpha, 120, **122**, *129*, 184
Angel, Clyde, *193*, **201–2**, 222
Ann Nathan Gallery (Chicago), 152, 153, 181, 190, 203, 204, 205, 207, 212, **222**
Antique Tribal Arts (Santa Fe, NM), 262, **266**
Anton Gallery (Washington, D.C.), 74, 103, 104, **117**, 152
Anton Haardt Gallery (Montgomery, AL), 95, 175, 176, 180, **182**
Anton Haardt Gallery (New Orleans), **188**
Antonio, Johnson, 15, **230–31**, *241*, 266
Archer-Locke Gallery (Atlanta), 103, 120, 122, 151, 154, 156, 158, 177, **184**
Archuleta, Felipe Benito, 229, **231–32**, *242*, 264, 265, 267, 268
Archuleta, Leroy Ramon, 229, *231*, **231–32**, *242*, 265, 267
Arizona State Museum, Univ. of Arizona (Tucson, AZ), **264**
Arkansas Arts Center (Little Rock, AR), **182**
Armstrong, Z. B., 115, 186, 189
Arning, Eddie, 65, 66, 68, 69, 72, 117, 223, **232**, *243*, 266, 268, 299
Art Adventure (Boulder, CO), 161, **265**, 287

Art Center (Los Angeles), **299**
Art Institute of Chicago, 190, **220**
Art Museum of Southeast Texas (Beaumont, TX), 226, **268**
Art Museum of Western Virginia (Roanoke, VA), **116**
Art on the Edge (New York), 37, **66**
Art Program for the Homeless. *See* Art on the Edge
Ashby, Steve, 16, 66, **74–75**, *82*, 185, 190, 240
At Home Gallery (Greensboro, NC), 99, 101, 107, 109, 111, **113**
Autry Museum of Western Heritage (Los Angeles), **299**
Avery, Milton, 17, 35

B

Badami, Andrea, 66, 68, 227, 228, **232–33**, *243*
Baer, Joshua (Santa Fe, NM), **266**
Baker, Thomas King, *193*, **202**, 221, 271
Baltimore Glassman. *See* Darmafall, Powell (Paul)
Barker, Lillian, 64, 71, **75–76**, *82*, 112
Barker, Linvel, 64, 71, **75–76**, *82*, 112
Barnes, Ricky, 192, *193*, **202–3**, 222
Barrister's Gallery (New Orleans), 119, 124, 154, 164, 169, 171, 176, 179, **187**
Bauer, Jim, 66, **281**, *281*
Beasley, Jack, 266
Beasley, Jason, 266
Beasley Trading Company (Farmington, NM), 231, 235, 237, 239, 263, **266**